MATERIALS and MEANING
in the FINE ARTS

Volume 1

Series Editors Andrea Kirsh & Rustin S. Levenson

Physical Examination in Art Historical Studies

Yale University Press
New Haven and London

Andrea Kirsh
Rustin S. Levenson

Seeing Through Paintings

Designed by Daphne Geismar and Colin Campbell, and typeset in
New Caledonia, Meta Plus, and Clarendon by Amy Storm.

Printed in Singapore by CS Graphics.

Library of Congress Cataloging-in-Publication Data

Kirsh, Andrea.
 Seeing through paintings: physical examination in art historical
studies / Andrea Kirsh and Rustin S. Levenson.
 p. cm. — (Materials and meaning in the fine arts)
Includes bibliographical references and index
ISBN 0-300-08046-8 (alk. paper)
 1. Painting—Expertising. 2. Painting, European. 3. Painting,
American. I. Levenson, Rustin S., 1947– II. Title. III. Series.

ND1635 .K57 2000
751.6'2—dc21
 99-051835

A catalogue record for this book is available from the British Library.

The paper in this book meets the guidelines for permanence and
durability of the Committee on Production Guidelines for Book Longevity
of the Council on Library Resources.

10 9 8 7 6 5 4 3 2 1

To our families

Contents

Contents

Preface

We have long felt the need for a book introducing nonspecialists to the physical examination of easel paintings and to the historical and critical implications of such study. Knowledge of a painting's materials, techniques, and condition can contribute to a range of scholarly approaches: iconography, regional and colonial studies, examination of artistic intent, study of interactions among artistic schools, and the history of collecting and display. An extensive literature exists—largely by and for conservators and conservation scientists—but little reaches the audience we have in mind: art history students and their teachers, artists concerned with the work of their predecessors, collectors, dealers, and interested laymen. Even among curators, conservators, and scientists studying the same paintings communication may be limited by the scholars' training, the languages of their disciplines, and the varying uses they make of the material.

Contributing to the problem is the fact that art history is increasingly taught from slides and photographic reproductions. These convey nothing of the finish, texture, or scale of a painting; the colors may be distorted and the borders cropped. Reproductions are unlikely even to raise the questions that might help a viewer understand a painting's technique or condition, much less to point to the answers.

In this book we address European and American easel paintings, medieval through contemporary. These involve relatively invariant materials and techniques that can be dealt with in one volume. By contrast, the existing literature addresses such questions for sculpture, decorative arts, works on paper, manuscripts, and paintings integral to architecture. We emphasize that these questions contribute as much to the study of modernist as to old master paintings, which have received the most attention from technical examination.

We have taken great pains with the illustrations, with help from numerous museum colleagues who arranged photography for this volume. We were eager to illustrate several topics never before presented to a general art historical audience: the implications of craquelure, the visual results of treatments such as lining, and subtleties involved in varnishing—or *not* varnishing—modernist paintings. We were also eager to explain the reading of technical images, such as radiographs, which are frequently published in art historical literature but nowhere explicated. Even so, reproductions can only approximate the information gained from viewing the actual artwork or from studying the technical images in conservation files. It is our intention that the book will send readers to the literature, to museum files, and especially to the works. We have drawn from a number of public collections and included many paintings whose technique and condition can be studied in visible light—so that interested readers can confirm the observations themselves. We have also emphasized published examples throughout the book so that readers can follow up on their own.

A major part of our research was directed toward assembling an annotated bibliography. We gave preference to literature that is readily available in art history and general research libraries, is well illustrated, and is in English. We include the standard sources and reference works on artists' materials and techniques, and we cite a selection of art historical studies that use technical information in varied and imaginative ways. Throughout the text we refer to additional and more scientific literature.

A number of previous studies inspired us. Gridley McKim-Smith, Greta Andersen-Bergdoll, and Richard Newman's *Examining Velázquez* (1988) and Robert Herbert's "Method and Meaning in Monet" (*Art in America,* 1979) demonstrate the larger art historical questions that develop in light of an increased understanding of a painter's methods. McKim-Smith, Andersen-

Bergdoll, and Newman trace a complex interaction between painting in different schools and periods and the writing it inspired. Not only must Spanish Baroque paintings be interpreted in light of the art theory of the day, but theoretical writings must be understood within a literary tradition and may not describe actual practice in all respects. Herbert's close study of Monet's complex layering and brushwork enabled him to dismantle the mythology of plein air painting and to refocus on the social implications of Monet's subject matter. We hope that our book will point the next generation of art historians along similar paths.

Any student of painting materials is indebted to Rutherford J. Gettens and George L. Stout. Their *Painting Materials: A Short Encyclopaedia* (1942; reprinted in 1966) is a model of thoroughness and clarity, and its longevity is an inspiration. The flow of publications from the Conservation Department of the National Gallery, London, has been invaluable: *National Gallery Technical Bulletin*, catalogues to the Art in the Making series (Bomford, Brown, and Roy 1988 and Bomford et al. 1989, 1990), monographs on single paintings (the Making and Meaning series), the Pocket Guides, and generations of catalogues to the collections. A number of museums (notably the Metropolitan Museum of Art, New York, National Gallery of Art, Washington, D.C., the Prado, and the Tate Gallery), as well articles published in *Burlington Magazine*, have consistently incorporated the physical examination of paintings into their art historical interpretation. We made extensive use of their information and examples.

A Note on the Illustrations

Media descriptions of the illustrations in this book are those given by the owners, and few have been subject to scientific examination. Museums frequently label paint media according to historical assumption: fifteenth-century panels are described as tempera, and seventeenth-century canvases are generally identified as oil. In the absence of analysis, more cautious owners describe the support but not the medium. We try to note cases in which testing was carried out.

It is sobering to write a book whose every part is subject to someone else's greater expertise. Although we have received immense help from other art historians, artists, conservators, conservation scientists, and curators, mistakes of interpretation are our own.

We met in the Paintings Conservation Department of the Fogg Art Museum, Harvard University. Levenson was training in conservation and Kirsh was an undergraduate fresh from a seminar on materials and technique taught by Arthur K. Wheelock, Jr. An exemplary teacher and curator, Wheelock has offered advice and help throughout the book's development. Joyce Hill Stoner made valuable suggestions at early stages of the project, generously sharing her experience as a conservator and leader in conservation training. Alfred Acres was our first and our ideal reader; we have relied on the judgment he brought as scholar, teacher, and friend. The annotations in the bibliography, as well as the list of videotapes, owe their existence to the counsel of Charles Rhyne, who encouraged us from the beginning of our research. Maureen Pelta reviewed the entire manuscript, and her generous criticism greatly improved its usefulness. Andrew Morrogh has been a rigorous critic and editor, as well as an ideal husband. Several other colleagues read drafts of chapters, significantly improving the text's accuracy and usefulness: David Bomford, Leslie Carlyle, Harriet Irgang, Marcia Steele, and two anonymous readers for Yale University Press. We are deeply indebted to them all.

The scope of this volume is a testament to our optimism, matched only by the generosity of individuals and institutions worldwide. The Conservation Department at the National Gallery of Art, Washington, D.C., provided extraordinary access to photographic material, examination records, and staff expertise. We are profoundly grateful to Ross Merrill, Sarah Fisher, and their colleagues for their endless generosity, for photographs taken for this publication, and for providing a home base for the final stage of research. Ann Hoenigswald, in particular, supported our project as if it were her own. We regularly relied on aid from Elizabeth Walmsley and would also like to acknowledge help from Barbara Berrie, Lucy Bisognano, E. Melanie Gifford, Jay Krueger, and Michael Swicklik.

Several other conservation departments supported the book by arranging new photography specifically for us. For this as well, as for research assistance, we offer great thanks to Jim Coddington, Museum of Modern Art, New York; Stephen Gritt, the Courtauld Institute; Stephen Kornhauser, Wadsworth Atheneum; Andrew O'Connor, National Gallery of Ireland; J. William Shank and Dawn Steele Pullman, San Francisco Museum of Modern Art; Elizabeth Steele, the Phillips Collection; and Marcia Steele, Cleveland Museum of Art.

We are also grateful to colleagues at the following institutions who made published and unpublished technical photographs available and shared their research: David Bomford, the National Gallery, London; Ann Creager, National Museum of American Art; James Cuno, Harvard University Art Museums; Joseph Fronek, Los Angeles County Museum of Art; Carmen Garrido, Museo del Prado; Rica Jones, Tate Gallery; Susan Lake, Hirshhorn Museum and Sculpture Garden; Mark Leonard, J. Paul Getty Museum of Art; Therese Lignelli and Mark Tucker, Philadelphia Museum of Art; Norman Muller, Art Museum, Princeton University; Nathalie Volle, Laboratoire de Recherche des Musées de France; Jørgen Wadum, Royal Cabinet of Paintings, the Hague; Frank Zuccari, the Art Institute of Chicago; and staffs at the Baltimore Museum of Art; Bayerischen Staatsgemäldesammlungen, Munich; Glasgow Museums; Hamilton Kerr Institute, University of Cambridge; and the Museum for Kunst, Copenhagen.

Keith Christiansen and Laurent Sozzani not only made their institutional resources available but also shared their enthusiasm for and extraordinary knowledge of the material. Many other colleagues eased access to institutional collections and records. We would like to acknowledge particular help from Guillermo Alonso, Kevin Avery, Claire Barry, Kenneth Bé, Peter Berkes, Steven Bonaides, Michael Conforti, Paula Di Cristofaro, Michael Desmond, Kerry Dixon, Barbara Heller, Nancy McGary, David Miller, Suzanne Penn, Martin Radicki, William Real, Daniel Schulman, George Shakelford, Suzanne Siano, Lowery Stokes Sims, Charles Stuckey, Peter Sutton, Jan Thurmann-Moe, Jim Wright, Fay Wrubel, and Eric Zaffran.

Staffs at both Rustin Levenson Art Conservation, New York, and Florida Conservation Associates, Miami, provided continuous support. Diana Dopson, Emily Hage, and Daisy Lackaff brought diligence and enthusiasm to their editorial and research assistance.

A number of scholars, colleagues, and friends were particularly generous with their research and expertise. We want to thank Joseph Bailliol, Maria Balderrama, Lucy Belloli, Annette Blaugrund, Edgar Peters Bowron, Spike Bucklow, Marcus Burke, Judith Colton, Lizzie Sanchez Farrah, Gloria F. Giffords, Frances Glibbery, Reinhold Heller, Robert L. Herbert, Vojtech Jirat-Wasiutynski, Alexander Katlan, Michelle Kay, Martin Kemp, the late Michael Kitson, Barbara Krulik, Gridley McKim-Smith, Dorothy Mahon, John Maseman, H. Travers Newton, Francis V. O'Connor, Perri Lee Roberts, Sheila Schwartz, Alison B. Snyder, Leo Steinberg, Suzanne Stratton-Pruitt, Edward J. Sullivan, Sherri Tan, Helène Verougstraete, Steven Weintraub, and many others.

Research was conducted at several libraries and video archives, and we would like to acknowledge valuable assistance from their staffs: Metropolitan Museum of Art (New York) Department of Film and Media Services, Thomas J. Watson Library and Uris Library and Resource Center; Museum of Modern Art (New York) Film Study Center; National Gallery of Art (Washington, D.C.) Library and Conservation Department Library; New York University, Institute of Fine Arts Library and Conservation Center Library, with particular thanks to Margaret Holben Ellis and Robert Stacy; University of Oregon, Knight Library and School of Architecture and Allied Arts Library, with ongoing assistance from Kaia Esau, Sheila Klos, and Christine Sundt. Nadine Covert of the Program for Art on Film, Inc., c/o Pratt SILS, provided information used in assembling the list of videos in the Bibliography.

Rustin would particularly like to thank Randal, Moss, Cormac, and Geddes for their support. This book would not exist without the faith that our editor, Judy Metro, showed in the project from its inception. We deeply appreciate the skill and attention that Colin Campbell and Daphne Geismar brought to the book's design, Heidi Downey to its editing, and Mary Mayer to its production.

1

Introduction

The history of painting is the history of visual ideas expressed in material form. Investigation of paintings as physical objects contributes knowledge of how paintings were made and of the ideas that influenced their crafting; it can also reveal changes that occur over time. Art historians routinely study transformations in the use, presentation, and exhibition of paintings, as well as shifting cultural and historical conditions that affect their interpretation. Yet paintings also change as physical objects; this enriches and complicates all other historical methodologies.

Physical transformation begins the moment a painting is completed. Changes result from interactions of the artist's materials, from exposure to light and ordinary atmospheric conditions, such as seasonal humidity changes, as well as from extraordinary conditions, such as fires and floods. Human intervention causes other significant changes, as when offensive subject matter is removed or obscured; artworks are reworked in an updated style; ensembles are disassembled, as with altarpieces; canvases are cut down; and works are restored, even with the best of intentions.

This handbook is an introduction to the study of materials and techniques used in Western easel painting, medieval through contemporary, as well as to the condition of these paintings. We address the works in their present condition, focusing on their physical structure, beginning with the support and progressing through the varnish.

The study of paintings as physical objects is termed technical examination—which we define as the study of artists' techniques, not high-technology examination. Although sophisticated scientific tools may be employed, technical examination always begins—and sometimes ends—with a close look at the actual work in available light. Study of paintings should not focus exclusively on technical examination, but it is an important aspect for art historians to consider. Much serious historical and interpretive study depends on material evidence. Through technical examination one can address the following questions:

—Is the painting correctly dated?

—What is the painting's condition, and how closely does it resemble its original appearance?

—Is the format original, or has it been reduced, enlarged, or otherwise altered? By the artist, or by later hands?

—Have the color relationships changed since the work was painted?

—Are there repainted areas?

—Does the painting betray evidence of change through use?
 Has a religious image been updated for iconographic or liturgical purposes? Was a group portrait altered to account for a birth or death, or was a fragment of a religious work "secularized" to appeal to the art market?

—Did more than one artist produce the work?

—How did the artist(s) achieve the effects?

—Were the painting's materials or technique chosen for theoretical or political reasons? Are they part of a larger debate about the role of culture?

—Did contemporary criticism influence the technique?

—Does the technique reflect the artist's education, travels, or exposure to foreign artistic traditions?

—Were substantial changes made during the painting's execution?

—What is the relation among known variants of a painting?

Wherever possible in this handbook we avoid scientific detail and terminology. We do, however, introduce those scientific and technical terms that could be found in a conservation report. More rigorous scientific information can be found in the sources lists that appear in the text. Throughout the book we emphasize the conditional nature of technical examination: interpretations must be made in light of historical knowledge.

To begin a technical examination one must understand the structure of a painting. Typically there are four strata: the support, the ground or priming, the paint or design layer, and the varnish. Both the composition and the condition of each of the layers affect the appearance of the painting.

A variety of materials have been used as supports. Among European and American paintings the most common supports are wood and fabric (canvas), although artists also use metal, stone, glass, cardboard, paper, various modern plastics, and synthetics. When an artist chooses an unusual support— as when Seurat used wood for his small sketches (Fig. 1)—there should be questions: Was he being frugal by recycling cigar box tops, or did he favor a hard surface? Both the quality and the stability of the support affect the paint layer. Each material carries the upper layers differently and ages distinctively, usually causing a pattern of cracks (craquelure) as it reacts to the environment over time. A support in poor condition may require extensive treatment, which can involve lining a deteriorated canvas or transferring the ground and paint layers of a badly damaged panel. Both lining and transfer treatments can profoundly affect the look of the painting. Can we assume that a prominent canvas weave was an artist's aesthetic decision, or might it have resulted from age and previous treatments (p. 29)?

The ground, or priming, and other preparatory layers are applied to the support to give it the texture and absorbency needed to carry the paint layer. By varying the color and texture of the ground the artist can significantly alter the appearance of the painting. Particular ground colors can reflect an artist's training or regional preference (pp. 74–77). Some artists incise the ground as a preliminary guide to their composition. Caravaggio's ground incisions are so unusual that most scholars of his work must address them (see Case Study 15).

The paint or design layer is the primary vehicle for the artist's visual idea. Choice of materials, such as Frida Kahlo's decision to use a metal support (p. 60), can contribute to a painting's iconography. Paint handling can suggest an artistic lineage, such as Velázquez' conscious *pentimenti* (p. 121), Cézanne's use of the palette knife (p. 130), and Pollock's incorporation of

sand into his paint (p. 151). The pigments and binding media of this layer react to both the environment and the surrounding layers of the painting. Even microscopic changes in the paint stratum can markedly change a painting's appearance. Although the dramatic cracking of some paintings is an obvious effect of time (p. 155), the fading of some of Van Gogh's pinks (Fig. 171) is more unexpected.

The varnish is the coating that protects the paint layer and provides a uniform surface that modifies its appearance. The varnish acts like a windowpane through which we view the painting. Both its color and its gloss will affect our perception of the artist's work, as will any grime that sits above the varnish. Attitudes toward darkened and discolored varnish not only have fueled conservation controversies for more than two centuries but also have influenced later practice, encouraging some artists to add toned or colored varnishes and others to avoid varnish altogether (pp. 231–37).

By late medieval times painting practice was highly codified, as is recorded in Cennino Cennini's manual for artists, *Il libro dell'arte*, written in the late fourteenth century, probably in Padua.[1] Cennini's text reads very much like a modern cookbook, offering precise instructions for all the work to be done in the painter's studio: preparing the panel, gessoing, gilding, punching, drawing, painting, and varnishing. Cennini recorded the standard technique that painters traditionally learned through apprenticeships. This technical knowledge continued to be passed on into the nineteenth century, when artists began to experiment with technique and with other aesthetic issues. Contemporary painting technique is varied and experimental and may lead to equally unconventional results as the works age.

Many readers will be studying paintings via slides, photographs, and printed reproductions. When the study of art history is isolated from the physical objects themselves, technical examination is extraordinarily difficult. We have worked hard to provide useful illustrations and to cite those published elsewhere that reveal technical points—as well as indicate the limitations of such reproductions. More fortunate readers will have access to the paintings, but only on museum walls. Only a privileged few will be able to examine them unframed, front and back, with the instruments and staff of a conservation laboratory. We hope that our audience will become excited by the potential contributions of the study of paintings as physical objects. This book should at least leave them well versed in the questions they should ask—indeed, in the historical and aesthetic issues raised by the technique and condition of any painting.

2

The Support

The most significant information revealed by study of the support is the approximate age of the painting and whether the work has survived in complete or fragmentary form. These are crucial questions for anyone interested in a painting's subject matter or history, or in its formal characteristics. Examination of the support can also reveal the painting's condition and any structural restoration that it has received. This can be essential in determining its authenticity or provenance.

The support can yield further information of historical interest, such as the original arrangement of polyptychs or whether two portraits were originally paired pendants. Study of a canvas constructed of multiple pieces can suggest how the composition evolved.

Although the support of a painting can be of almost any material, we will concentrate on the most common choices: wood and fabric, with a brief mention of stone, metal, artist's board, and paper mounted to wood or canvas.

Wood Supports

Paintings on wood panels are known throughout history; the first significant group of paintings on wood panels are the Fayum portraits dating from second-century Egypt. Although panel supports became less common by the seventeenth century, some nineteenth-century painters did sketches on wooden cigar box tops, and artists have continued to paint on wood panels through the

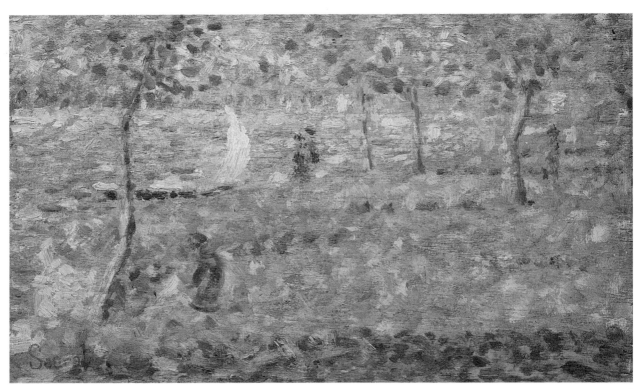

1

1 Georges Seurat, *Study for "La Grande Jatte,"* 1884–85, oil on wood, 15.9 x 25 cm. National Gallery of Art, Washington, D.C. Ailsa Mellon Bruce Collection.

Seurat was unusual in employing panels for his small sketches. He called them *croquetons*, although they were also described as *boîtes à pouce* or *boîtes à cigare*. While some may have been actual cigar box tops, others were certainly obtained from art suppliers. In this sketch, one of many for *Sunday Afternoon on La Grande Jatte* (Fig. 100), Seurat exploited the warm tones of the unprimed wood for coloristic effect.

present. For example, Georges Seurat (1859–91) preferred small wooden panels to canvases for his early sketches (Fig. 1), and Elisabeth Louise Vigée-Lebrun (1755–1842) began to use wooden supports in emulation of Rubens' technique (Fig. 2).[1]

The species of tree and the cut of wood help determine a panel's reactivity to moisture, which in turn affects a painting's life span and appearance. Each species of tree is characterized by its arrangement of wood tissues, called the wood plan. There are two main types of woods: softwoods (like conifers), which have a simple wood plan, and hardwoods (like oaks), which have a much more complex plan. The aptly named hardwoods are not easily marked with the pressure of a fingernail, as are soft woods. A panel can be cut from a tree longitudinally, tangentially, or radially. Each type of cut responds differently to changing atmospheric conditions as the wood ages.

Certain tree species and cuts of wood are typical of particular regions and eras, and this knowledge can suggest whether a panel's attribution is plausible. Like all technical information, this must be carefully interpreted, because the literature on preferred woods for paintings applies to purpose-made panels. So if, for example, an artist used a piece of furniture for a painting support, the wood may fall outside of the standard. The same caution applies to methods of dating panels, as well as means of identifying the wood according to region, as we discuss below.

Italian painters used soft poplar for supports because most of the country's scarce hardwood was reserved for such purposes as shipbuilding. Painters north of the Alps favored hardwoods, particularly oak. Thanks to their finer grain, hardwood panels have survived in much better condition than have softwood panels.

Panel Dating Through Dendrochronology

Dendrochronologists are scientists who study seasonal growth rings in trees. Not all panels display the rings necessary to date them with certainty. Dendrochronology has been applied most extensively to early Netherlandish panels and has also been useful with panels of English, Dutch, German, and French origin. It is not suitable for dating poplar nor mahogany.

Dendrochronologists can determine the date for the felling of a tree but can say nothing about the time needed for aging or drying a panel.

2 Elisabeth Louise Vigée-Lebrun, *Self-Portrait with Daughter*, 1786, oil on wood, 105 x 84 cm. Musée du Louvre, Paris.

Although canvas had been the favored support since at least the seventeenth century, Vigée-Lebrun turned to wood in the 1780s following a trip to Belgium, where she was impressed by Rubens' panels. Comparison of her portraits on panel with those on canvas (see Figs. 150, 151) reveals the qualities she sought: a very smooth surface that distorted minimally with time, producing limited craquelure. Examples of Vigée-Lebrun's portraits on both wood and canvas supports can be compared at the Louvre, at the Metropolitan Museum of Art, New York, and at the National Gallery of Art, Washington, D.C.

3 Detail of reverse. Leonardo da Vinci, *Ginevra de' Benci*, c. 1474, panel. National Gallery of Art, Washington, D.C.

The backs of most panels are unfinished. This painted device may indicate that Ginevra's portrait was designed to be seen from both sides. The application of paint on the reverse would also have counteracted the tendency of the wood to warp. For the face of the portrait, see Fig. 125.

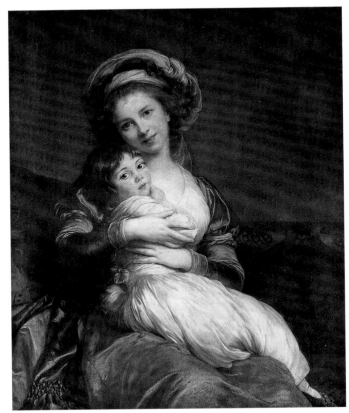

2

3

Sources on Dendrochronology

For a good description of dendrochronology and bibliography on its use, see Peter Klein, "Dendrochronological Analysis of Panels Attributed to Petrus Christus," pp. 213–14 in Maryan Ainsworth and Maximiliaan P. J. Martens, *Petrus Christus: Renaissance Master of Bruges*, catalogue (New York: Metropolitan Museum of Art, 1994). Also see Peter Klein and Joseph Bauch, "Analyses of Wood from Italian Paintings with Special Reference to Raphael," in *Princeton Raphael Symposium*, p. 85 n. 2.

Their findings must be interpreted alongside information about the rest of the painting's materials and history. As John Shearman has cautioned, ring dating is not conclusive if the artist used old wood, as has been documented in a number of instances. This would also be the case with modern fakes painted on aged panels—the panel may be old but the painting may not be. Nor can dendrochronological data be extrapolated to confirm authorship, particularly when a workshop is involved. For example, dendrochronologists confirmed that a single tree had supplied three panels, yet the Rembrandt Research Project attributed each painting to different hands.[2]

Aging and Treatment of Wood Panels

Wood panels are subject to continuous dimensional change as their environment fluctuates, which can have an enormous impact on the paint layer. In the language of cabinetmakers, wood moves, and softwoods move more than hardwoods do. The cut of the panel will determine how much it moves; swelling and shrinking occur mostly across the grain. Wood exhibits less movement in the radial direction and negligible movement longitudinally.

Panels are generally protected on the front by the ground and by the paint layers; wood usually is exposed on the back. The resulting uneven reaction to humidity causes the warping often seen in old panel paintings. Wood that has been coated with ground (and paint) on the reverse or that is protected from the back in some other way is much less likely to warp (Fig. 3).

As the structural components of wood age they become brittle, losing their cohesive properties, resulting in physical degradation. Wood is also subject to attack by organisms: fungi or dry rot can swiftly destroy a panel, and insects such as beetles, woodworms, and termites can seriously undermine its strength (see Figs. 4, 15).

To keep a panel flat, restorers may have added a cradle, or lattice of wood, to the back (Fig. 4). Cradles were glued along the grain, and free sliding members were fitted crosswise to complement the reactivity of the panel. Unfortunately, the cradle itself was also reactive and would lose mobility. Cradling often involved shaving the reverse of the panel, thereby

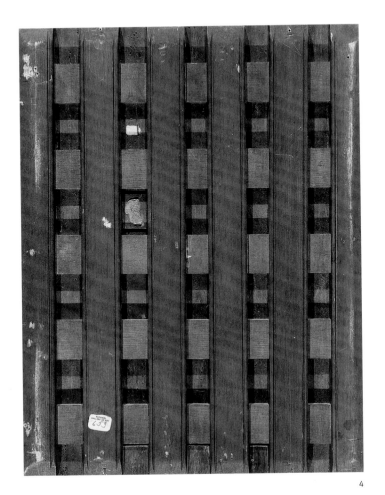

4

5

4 Reverse of panel. Raphael, *Small Cowper Madonna*, c. 1505, oil on panel, 59.4 x 44 cm. National Gallery of Art, Washington, D.C. Widener Collection.

The elaborate cradle—an interlaced brace of wood—was glued to the back at an unspecified date to prevent warping of the panel. Wormholes are visible, particularly at the lower right. For the recto, see Fig. 202.

5–7 Reverses. Raphael, *Madonna of the Oak* (poplar, 144 x 109 cm), *Holy Family (La Perla)* (poplar, 147 x 166 cm), and *The Cardinal* (poplar, 79 x 60.5 cm). Museo del Prado, Madrid.

Although none of these panels has a full cradle of interlacing verticals and horizontals, all have similar moveable horizontal reinforcements. These cross-bars, which fit into grooves cut in the panels, were very effective in stabilizing the panels. The brand at the center of *La Perla* is the seal of Charles I of England, who owned the painting before it was acquired by Philip IV of Spain. See pp. 242–43.

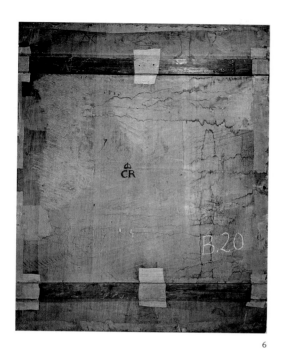

6

7

removing any natural moisture barrier and exposing the wood to further reactivity. These attempts to restrain the wood's natural movements with framing or cradling often resulted in the panel splitting or cracking. Conservators today seldom use traditional cradles because of these problems.[3]

Information on cradling can contribute to knowledge of a painting's provenance. This is the case with three Raphaels in the Prado; each panel is reinforced with mobile crossbars rather than with a full cradle (Figs. 5–7). They are among the eight paintings by Raphael (1483–1520) that Napoleon's army carried off from the Spanish royal collection to France.[4] The crossbars of the *Madonna of the Oak* (Fig. 5) reveal woodworking similar to that on early seventeenth-century Spanish furniture. Although the reinforcements are not identical on the three panels, and each may date from a different period, their common form suggests that all were applied in Spain rather than in France.

A panel may become so degraded that it no longer can support the paint layer. A radical operation is available: transfer of the paint (and usually ground) layers to another support—historically a canvas. As extreme as this procedure sounds, transfers date at least to the eighteenth century (Fig. 10). The invasive nature of a transfer, as well as the qualities of the new support, results in a significantly altered artwork. This is most obvious when the painting displays both the texture of the (new) support, as well as craquelure characteristic of a panel—such as long, vertical splits (Figs. 8, 9). The effects of a

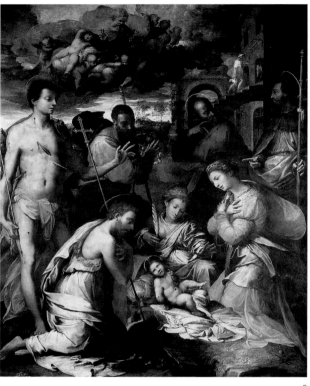

8

transfer are apparent, no matter how subtle. A conservator at the Prado
describes this eloquently when discussing four Raphael panels that had been
transferred: "The radical treatment of these works . . . altered their appear-
ance completely, for the transfer to canvas gave them a different quality and
texture, in which the weave of the cloth on which they were glued was
plainly revealed, instead of the smooth, even, refined surface of the panel.
Looking at these works in the Prado produces an odd sensation, as if
one were gazing at something that does not quite harmonize with Raphael's
aesthetic, or paintings which might even be old copies of the painter's
work done on canvas." Modern conservators attempt to forestall such massive
intervention—both through careful control of the panel's environment and
through periodic treatment.[5]

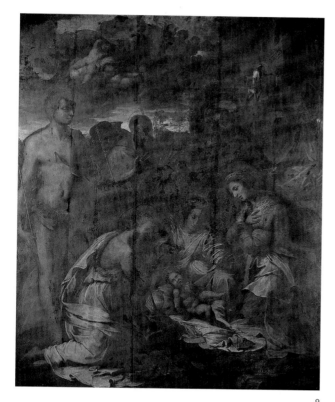

9

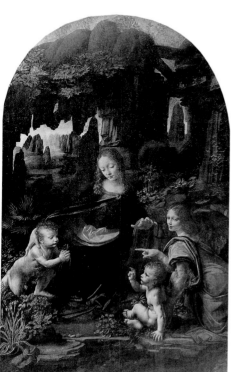

10

8 Perino del Vaga, *The Nativity*, 1534, oil on canvas transferred from wood, 274.4 x 221.1 cm. National Gallery of Art, Washington, D.C. Samuel H. Kress Collection.

The original panel for this large altarpiece was constructed from five vertical planks.

9 Ultraviolet photograph of Fig. 8.

The dark patches reveal repaint—in this case over not only scattered, local losses but also over four vertical lines where paint flaked at the joins of the multipart panel. These losses remain as a record of the aging of the original support even though the painting has been transferred to canvas. Signs of such losses are one obvious clue to whether a painting has been transferred.

10 Leonardo da Vinci, *Virgin of the Rocks*, 1480s, oil on canvas transferred from wood, 199 x 122 cm. Musée du Louvre, Paris.

The transfer of this painting in 1813 was unusually well documented (see Gilberte Emile-Mâle, "La Transposition de 'la Vierge aux Rochers' de Leonardo de Vince: Sa date exacte," *Raccolta Vinciana* 19 [Milan, 1962], pp. 118, 119).

Technical Examination of Wood Panels

Examination of a panel should reveal the type of wood, the cut of the wood, and the construction of the panel (which may have been assembled from multiple pieces). Carpentry details should be noted. These include the method of joining multiple pieces of wood, the means of attaching a panel to an integral frame, or the beveling at the edges to fit a panel into a separate frame. This information should be consistent with documented examples of the period and region. Unusual types of wood or methods of carpentry should raise questions of authenticity or later alteration; so should inconsistent treatment of the four sides of a panel. Visual investigation can be supported by X-radiography, which is usually performed to examine the paint layer (see Chapter 4). X-ray studies reveal the wood grain and panel construction, but the presence of a cradle will complicate the reading.[6] Studies of wood grain and panel construction have been useful in suggesting the original assembly of multi-part paintings that have been separated (see Case Studies 2 and 3).

Examination of the edges of an early panel will typically reveal saw marks—manual saws produce characteristically uneven marks, while machine saws leave regular marks. Evidence of machine saw marks on a painting dated before the Industrial Revolution indicates a later alteration (or, indeed, a later panel).

Sources on Panels

Concerning the choice of wood, the most complete source for information on European panels painted prior to the seventeenth century is Marette 1961. She found that early painters used wood from local forests, with minor exceptions in Spain (p. 73). This was no longer the case by the seventeenth century, when Dutch painters used wood from Poland and occasional tropical imports, such as mahogany. For literature on American panels, see the conservation journals; also see Case Study 4. Self-trained painters in the Americas have continued to use wooden supports. For a particularly well-documented collection, see *American Naive Painting* from the Collections of the National Gallery Systematic Catalogue, 1992. Nicolaus 1998, pp. 12–77, gives a clear overview with copious illustrations of wood structure, panel construction, and the range of aging and damage found in panels.

A short and general introduction to European panel construction can be found in Dunkerton et al. 1991, pp. 152–54. Panel construction is also covered by Marette. An extensive introduction to early Italian panel construction appears in Bomford et al. 1989, pp. 11–17, with detailed discussions throughout the catalogue entries. Early Spanish practice is described in Sobré 1989, pp. 49–71. Newbery, Bisacca, and Kantor 1990, pp. 11–30, addresses later Italian panel construction, while early Netherlandish practice is illustrated in detail in Verougstraete-Marcq and van Schoute 1989. Other books that address carpentry are noted in the Bibliography.

11

11 Detail. Sano di Pietro, *Virgin and Child with St. Nicholas of Bari and Mary Magdalen*, tempera and gold on poplar, 46 x 21.4 cm. Cleveland Museum of Art. Gift of Mrs. B. P. Bole, Mr. and Mrs. Guerdon S. Holden, Mrs. Windsor T. White, and the L. E. Holden Fund (1924.199).

A panel with an integral, or engaged, frame was constructed and gessoed as an ensemble. This example has retained the original frame, although the gesso has cracked along the join. The slightly raised lip of gesso where frame and panel meet is sometimes called a beard (*barbe* in French, *Malrand* in German).

With panel paintings that originally had an integral frame, one should look for the lip of ground that forms at the intersection of panel and frame during the ground's application. This is occasionally referred to as a beard—in French as *barbe*, and in German as *Malrand* (Fig. 11). Such a lip on a panel now missing its frame confirms the original dimensions. See Case Study 2 as well as Chapter 3, "Evidence of an Integral Frame."

The case studies below emphasize examination of the panels. The first focuses on determining the status of an individual work. Case Studies 2 and 3 use panel data to reassemble altarpieces that have survived as dispersed fragments. Case Study 4 demonstrates how technical examination can raise historical questions about regional painting practice.

1

Frans Hals' *Jacobus Zaffius*
A Panel Fragment?

A small portrait by Frans Hals (1581/5–1666) was assumed to be a fragment, based on evidence of a printed copy, before scholars looked closely at the panel's edges.[7] Hals' earliest known painting, the bust *Jacobus Zaffius*, is on an oak panel (Fig. 12). Zaffius (1534–1618), the archdeacon of St. Bavo's Cathedral in Haarlem, was imprisoned for his efforts to preserve Catholicism in the city. The sitter is known through a reversed engraving by Jan Van de Velde II, which names him (Fig. 13). The print shows Zaffius half-length and seated at a table, with his left hand upon a skull. We do not know why the engraving was made some dozen years after the cleric's death (and almost twenty years after Hals painted him). However, five other engravings by Van de Velde accurately reproduce paintings by Hals, so scholars assumed that the Zaffius engraving represented the complete composition, while the surviving panel was a fragment.

This interpretation held from the painting's discovery in 1919 until 1986, when Karin Groen and Ella Hendricks (a conservation scientist and a conservator at the Frans Halsmuseum, respectively) examined the panel as part of a general study of the artist's methods. They found that the panel was not cut down at a later date, as has been previously suggested: "Microscopic examination and paint samples show that the ground and paint layers continue around the top, left and bottom edges of the panel and have been lightly smoothed away along the right edge. This suggests that the panel was primed and painted in its current size." These findings are unambiguous. Examination of the back of the panel added additional confirmation: "Furthermore, the reverse of the panel retains its original beveling on all four sides, which appears to have been standard practice at the time in order to facilitate framing."[8] Perhaps Van de Velde copied another version of Zaffius in half-length. Technical evidence severs the dependence of the engraving on the surviving painted portrait.

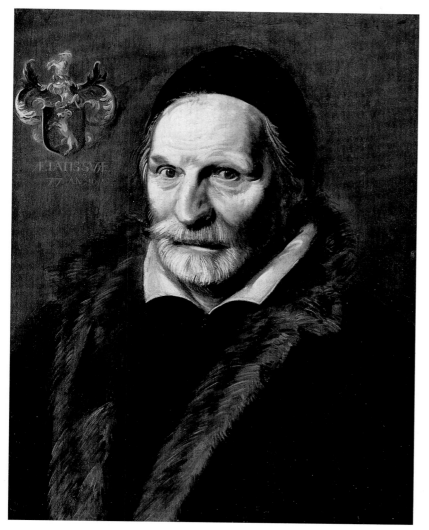

12

12 Frans Hals, *Jacobus Zaffius*, 1611, oil on panel, 54.5 x 41.5 cm. Frans Halsmuseum, Haarlem.

Although the sitter was identified from a later engraving by Jan van de Velde II, technical evidence contradicts the assumed relationship between print and painting.

13 Jan van de Velde II after Frans Hals' *Jacobus Zaffius*, c. 1630, engraving. Metropolitan Museum of Art, New York. Gift of Mrs. Carl J. Ulmann, 1929 (29.38.33).

Before the painting received close attention, scholars had assumed that it had originally been half-length, like this print.

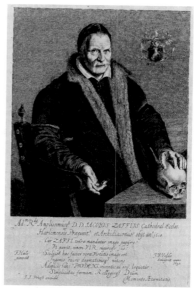

13

2

A Question of Format of a Giotto Altarpiece

Examination of seven small panels attributed to Giotto and his workshop tied them to a single altarpiece and confirmed an unusual format.[9] The seven panels are *Epiphany* (Metropolitan Museum, New York), *Presentation* (Isabella Stewart Gardner Museum, Boston), *Last Supper* and *Crucifixion* (Alte Pinakotek, Munich, Fig. 14), *Entombment* (Villa I Tatti, Harvard University, Florence), *Descent into Limbo* (Alte Pinakotek, Munich, (Fig. 16), and *Pentecost* (National Gallery, London, Fig. 18). The images had long been seen as related, despite their wide dispersal and the limited information on their history. They shared both similar size and an unusual method of gilding. Was the group complete? And what was their original arrangement? Scholars suggested that they were church fittings or served as cupboard doors or shutters. Recent technical evidence combined with art historical research suggests that the series is indeed a complete if rather unusual altarpiece.[10]

Keith Christiansen, curator at the Metropolitan Museum of Art, New York, proposed a horizontal format, either as an independent altarpiece or the predella of a larger work.[11] As evidence he indicated several technical points: vertical battens on the back of five of the panels that did not align (as they would have if the panels had been arranged one above the other); a similar horizontal grain to all seven panels; a lip of gesso on the left edge of *Epiphany*, and another along the right edge of *Pentecost*, indicating that these were at the beginning and end of the series where it attached to the integral frame (see Chapter 3).

Dillian Gordon, curator at the National Gallery, London, was able to compare X-ray studies of the panels (Figs. 15,17,19), which conclusively confirmed Christiansen's horizontal arrangement.[12] The studies revealed an exact correspondence of the wood grain. In fact, the seven scenes had been painted on a single plank of wood that only later was cut into pieces. Gordon concluded that the seven scenes formed a complete altar in dossal format (a simple type of low, horizontal altar). Her iconographic research suggested Riminese patronage; such dossals were known in Rimini from the thirteenth century but were somewhat old-fashioned by Giotto's day.

14

15

16

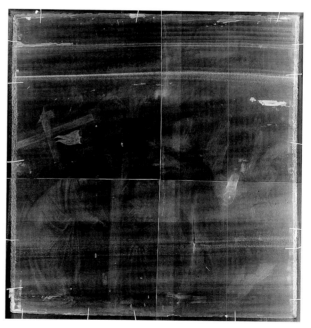

17

14 Giotto and workshop, *Crucifixion*, panel, 45 x 43.5 cm. Bayerische Staatsgemäldesammlungen, Munich.

One of seven separated panels whose stylistic and technical features, including matching woodgrain and unusual gilding, suggest a common origin.

15 X-ray study of Fig. 14.

All of the radiographs were taken from four films (hence the fine white lines where they meet) and all reveal nails attaching the panels to their frames. The scattered white areas seen only on this panel record insect damage, which has been filled. None of this information has any bearing on the historical interpretation.

16 Giotto and workshop, *Descent into Limbo*, panel, 45.4 x 44 cm. Bayerische Staatsgemäldesammlungen, Munich.

The next to the last in the sequence of seven scenes.

17 X-ray study of Fig. 16.

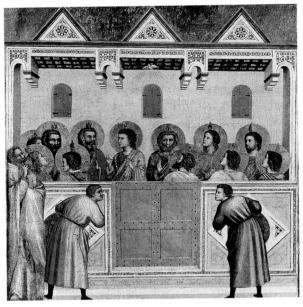

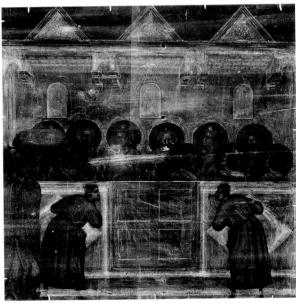

18

19

18 Giotto and workshop, *Pentecost*, panel,
45.5 x 44 cm. National Gallery, London.

The final scene.

19 X-ray study of Fig. 18.
An identical horizontal grain—
recorded here by undulating white
lines—continues across all seven
panels, confirming that they
were originally part of a single plank.
The figurative design is more
prominent here than on radiographs
of the Munich panels (Figs. 15, 17)
because they were taken with different
equipment.

3

The St. Victor Altarpiece in Siena Cathedral
A Polyptych Reassembled

Five panels, in four museums across Europe and the United States, have been associated with a single altarpiece (Figs. 20–25).[13] In linking the works a team of two art historians and a conservator also solved a long-standing question in Sienese art history: What became of the St. Victor Altar, the missing part of a major fourteenth-century ensemble commissioned for the cathedral? The identification and reconstruction of the polyptych (a work of four or more panels) was based on a combination of stylistic, iconographic, and technical information. We concentrate here on the contribution of the technical studies, particularly the unusual method of panel joining.

The Siena Cathedral had fourteenth-century altarpieces dedicated to the city's four patron saints. These were linked by a visual and iconographic program related to the feasts of the Virgin. Three of the altars are by well-known masters: Simone Martini, whose *Annunciation* from the St. Ansanus Altar is in the Uffizi, Ambrogio Lorenzetti, whose *Purification of the Virgin* from the St. Crescentius Altar is also in the Uffizi, and Pietro Lorenzetti, whose *Birth of the Virgin* from the St. Savinus Altar is in the Opera Del Duomo, Siena. Until recently the fourth altar, dedicated to St. Victor and credited since the late sixteenth century to Bartolommeo Bulgarini (fl. 1337–78), had not been identified. Elizabeth Beatson, Norman E. Muller, and Judith B. Steinhof were able to link five separated panels and to suggest ways to reconstruct the altarpiece based in significant part on the unusual Sienese method of joining the panels in a polyptych.[14]

The five panels were identified with the St. Victor Altar based on their subject matter and on the attribution to Bulgarini of the central panel (the Fogg *Adoration*, Fig. 20). The authors eliminated certain features of panel technique from their analysis: "Size, shape, molding design, and halo tooling have often been used as criteria to connect one painting to another, but all, with the exception of halo tooling, were of limited value in this study, particularly since the 'Adoration' had been severely cut down and cradled." They chose instead those aspects available for study in the surviving paintings: "We concluded that methods of panel joining, tooling of haloes, and, to a limited extent, the artist's choice of colors, offered the best evidence for establishing that the paintings were once part of the same commission."[15]

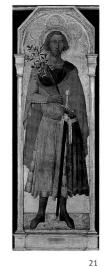

20 21 22

20 Bartolommeo Bulgarini, *Adoration of the Shepherds*, c. 1350, tempera on panel, 172.4 x 123.2 cm. Fogg Art Museum, Harvard University Art Museums, Cambridge. Gift of Friends of the Fogg Museum of Art Fund and Henry Goldman Fund.

The central panel of the St. Victor Altarpiece that survived as dispersed and incomplete fragments. Common woodworking tied it to two panels in Copenhagen (Figs. 21, 22).

21 Palazzo Venezia Master, *St. Victor*, tempera on panel, 155 x 48 cm. Statens Museum for Kunst, Copenhagen.

A side wing originally flanking Bulgarini's Adoration (see Fig. 25 for reconstruction). This panel retained significant traces of its original woodworking on its reverse (see Fig. 26).

22 Palazzo Venezia Master, *St. Corona*, tempera on panel, 155 x 52 cm. Statens Museum for Kunst, Copenhagen.

The iconography of the two wings suggested their relationship to the altarpiece; this was confirmed by technical studies.

23 24

23 Bartolommeo Bulgarini, *Blinding of St. Victor*, c. 1350, tempera on panel, 40 x 39 cm. Städelsches Kunstinstitut, Frankfurt.

One of the predella panels to the St. Victor Altarpiece.

24 Bartolommeo Bulgarini, *Crucifixion*, tempera on panel, 40 x 71 cm. Musée du Louvre, Paris.

A second surviving predella panel from the altarpiece. Millard Meiss had previously linked it with the *Blinding of St. Victor* (Fig. 23) because of common style, punchwork, and height. Similar punchwork and colors tied both predella panels to the rest of the fragmentary altarpiece.

25

26

28

27

25 Proposed reconstruction of the St. Victor Altarpiece according to Beatson, Muller, and Steinhof.

See Case Study 3 (drawing: Norman Muller).

28 Proposed reconstruction of the battens on the reverse of Simone's *Annunciation* (drawing by Norman Muller).

The vertical battens are like those that left a mark on Fig. 26.

26 Reverse. Palazzo Venezia Master, *St. Victor* (Fig. 21).

The top half of the panel retains its original surface, revealing chisel marks where the battens met. These reveal both a vertical batten (along the right side of the upper portion), as well as a horizontal batten at center. Such reinforcements suggest a Sienese origin.

27 Detail of reverse. Simone Martini, *Annunciation*. Uffizi, Florence.

Chisel marks of the same configuration and size as those on the *St. Victor* (fig. 26) suggest that the two altarpieces, both commissioned for the cathedral in Siena, were assembled by the same carpenters.

Sienese polyptychs were reinforced with horizontal wooden battens (strips of wood) attached to the back of the panels and additional wooden dowels inserted from the edges of adjacent panels—a method not used elsewhere in Tuscany. These dowel holes, which joined adjacent panels but did not join the end panels to the frame, have been used in other cases to relate separated panels to a single commission and to suggest their original placement.[16]

St. Victor (Fig. 21), which originally flanked *Adoration*, retained more evidence of its original joinery than its opposing *St. Corona* (Fig. 22). This panel showed traces of both horizontal and, most unusually, vertical battens attaching it to the central panel. Beatson and her colleagues identified the same structure of horizontal and vertical battens, as well as the same chiseled notches in Simone's *Annunciation*, done for the St. Ansanus altar, which mirrored the St. Victor altar in the Cathedral (Figs. 26–28). Such a close correspondence in joinery not only affirmed their common association with the Siena Cathedral but also suggested the use of the same woodworking shop for both commissions.

The Fogg *Adoration* (Fig. 20) had been significantly altered. It had been cut down and thinned before it reached the museum, so no traces of dowel holes remained to compare with the flanking panels in Copenhagen. The paint layer had been transferred to a new support, which might have eliminated all basis for comparison. But the museum had made X-ray studies of the panel before the transfer. These studies confirmed the presence of nail holes, which Beatson's group was able to align convincingly with the middle batten of the polyptych, as reconstructed. Thus, this jigsaw puzzle with missing pieces was painstakingly reconstructed to form a complete polyptych. The fact that its dimensions correspond closely to the opposing Simone altarpiece adds weight to the findings. This research has contributed to the reconstruction not only of the St. Victor Altarpiece but also of the cathedral ensemble, enabling a fuller appreciation of the liturgical setting as well as the artistic culture of fourteenth-century Siena.[17]

4

Case Study

Nineteenth-Century American Use of Textured Panels
The Hardships of War, or Aesthetic Choice?

American painters' use of textured as opposed to smooth panels in the early nineteenth century raises interesting historical questions.[18] Gilbert Stuart (1755–1820) was known to have favored textured grounds for panels, as well as panels that he had textured by scoring into the wood. The surface pattern is visible in ordinary light, particularly in the faces of the portraits. At first glance, the texture would suggest that Stuart had painted on twilled canvas, not panel. This is especially confusing when the panel warps or when the painting displays cracks characteristic of panel splits, as the visual evidence suggests conflicting interpretations (Figs. 29, 30). Stuart's choice demands attention because it runs counter to the European tradition of using wood panels for a smooth, hard surface.

Marcia Goldberg, an art historian specializing in nineteenth-century American art, traced the use of textured panels beyond Stuart to a number of his American contemporaries (Figs. 31, 32). She questioned the conventional interpretation—that the embargos of the War of 1812 had made twill canvas unavailable. Goldberg documented a long-term use of textured panels that requires an explanation other than hard times brought on by war: "Examples of textured ground and support by other artists indicate the practice was not limited to Stuart. As these examples date at least through the first four decades of the nineteenth century, the scarcity of imported canvas probably was not the rationale for texturing panels." Cynthia Curry, a painting conservator, extended Goldberg's findings with an example of a Stuart portrait on a scored panel securely dated seven years before the war.[19]

Historians have studied the relation between practices in art capitals and in provinces or colonies. Should differences be attributed to lack of artistic training, difficulty in obtaining materials, regional taste, or competing art traditions or theories? The choice of textured panels and grounds in early America raises an example of regional practice that clearly requires further research.

Sources on Artistic Technique in Center and Periphery

A number of studies compare technique in art capitals with that in outlying regions, provinces, or colonies. For early American and English technique with special reference to the scarcity of artists' materials in rural areas, see Kornhauser 1991; for eighteenth- and nineteenth-century Canadian versus British technique, see Levenson 1983. Other New World comparisons include Bargellini's article in *Copper as Canvas* 1999, pp. 31–44, on Andean and Mexican paintings on copper compared with European examples; Castedo 1976 for Cuzco school versus Spanish technique, and Rodas Estrada 1992 for Guatemalan variants on Spanish practice. For fifteenth-century Flemish practice versus Italian and Spanish copyists, see Maria Clelia Galassi, "A Technical Approach to a Presumed Memling Diptych: Original Work and Some Italian Copies," *Memling Studies*, Proceedings of the International Colloquium, Bruges, November 10–12, 1994, edited by Hélène Verougstraete, Roger Van Schoute, and Maurits Smeyers (Leuven: Uitgeverij Peeters, 1997); also see Maria del Carmen Garrido, "Géographie et Chronologie du dessin sous-jacent en Espagne," *Le Dessin Sous-Jacent dans la Picture*, Colloque VII, September 17–19, 1987 (Louvain-la-neuve: Collège Erasme, 1989): 163–70, and C. Perier d'Ieteren, "L'auteur du Diptyque de la Descente de Croix de Grenade attribué à Memling serait-il espagnol? *Annales de l'Art et d'Archéologie* 15 (1993): 39–64. Hendricks, van Grevenstein, and Groen 1991–92 looks at the relation between Haarlem mannerists and Venetian technique; McKim-Smith, Andersen-Bergdoll, and Newman 1988 analyzes the Spanish emphasis on competing Italian theories of paint handling; and Veliz 1981 investigates Zurbaran's distance from mainstream Spanish sources.

29 Gilbert Stuart, *Samuel Alleyne Otis*, 1811–12, oil on wood, 71.8 x 57.6 cm. National Gallery of Art, Washington, D.C. Gift of the Honorable and Mrs. Robert H. Thayer.

A cursory look at this portrait is confusing: its warped surface indicates a wood support, and the diagonal surface pattern suggests that it was painted on twilled fabric. Both features are clearly visible in front of the painting; only a bit of the scoring (in Otis' hair and to the right of his head) can be seen in this photograph.

30 Radiograph detail of Fig. 29.

The diagonal scoring in the wood simulates the appearance of a twilled canvas. The use of textured panels has long been associated with Stuart's work.

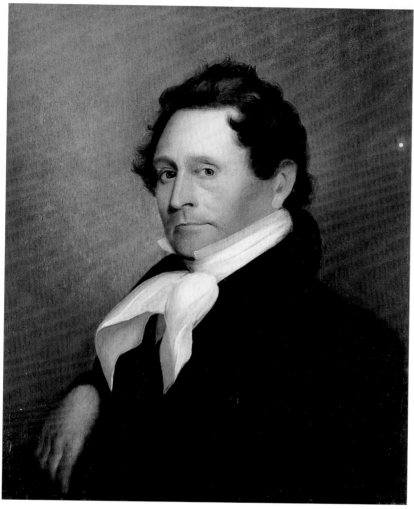

31 Matthew Harris Jouett, *Senator Thomas Hart Benton*, 1820s, oil on poplar, 71.4 x 59.6 cm. Cleveland Museum of Art. Gift of Mrs. Otto Miller (1941.597).

This panel was scored to produce a canvaslike texture, as were many of Gilbert Stuart's panels (see Fig. 29). The reason that American painters textured their panels is still unexplained.

32 Detail of the top edge of Fig. 31.

This image reveals the vertical scoring in the wood.

31

32

Fabric Supports

Textiles came into regular use as supports for easel paintings in about 1500. They are known generically as canvases, although *canvas* properly describes a coarse and sturdy fabric, such as that used for sails or tents. Vasari neatly summarized the advantages of a fabric support: "In order to be able to convey pictures from one place to another men have invented the convenient method of painting on canvas, which is of little weight, and when rolled up is easy to transport."[20] Canvases were favored in Venice earlier than elsewhere because of the city's climate: rising damp meant that fresco was an unstable medium for wall paintings.

Early canvases were usually made of flax (linen) or hemp. Linen continues to be the favored choice of painters, although artists have also used cotton since the nineteenth century. However, knowledge of the fiber is only rarely significant in studying canvases. All generalities must be tempered in the twentieth century, a time when artists have consciously experimented with nontraditional media.

Artists employed fabric that had been manufactured for other purposes until the eighteenth century: fine linen was intended for handkerchiefs or bedding, and coarse canvas was woven for sacking or sails. Despite the importance of canvas as a painting support, the literature on the subject is surprisingly sparse. Evidence suggests that prior to the development of specially manufactured artists' canvases painters selected the fabric because of its availability rather than because of its weave, size, or construction (whether the painting was made from a single piece of fabric or assembled from multiple pieces). Hence, all information about canvases is most useful in a comparative sense, and our examples show that similar technical evidence can support conflicting interpretations.

We emphasize here paintings on primed canvases that were used much the way paintings on panel were used. During the fourteenth through sixteenth centuries artists also made tempera paintings on fine, unprimed linen; these were designed as banners, organ door covers, cartoons, and cheaper substitutes for tapestries. The German term for such technique, *Tüchlein*, is often applied to all paintings in tempera on unprimed fabric.

Sources on Fabric Supports

The best general introduction to artists' canvases is still Wolters 1960, pp. 135–71. By far the most detailed examination of canvases, albeit limited to seventeenth-century Dutch practice, is Ernst Van de Wetering, "The Canvas Support," *A Corpus of Rembrandt Paintings*, vol. 2, pp. 15–43 (reprinted as chap. 5 in Van de Wetering 1997). While this covers Rembrandt's works only from 1631–42, it is the largest systematic study of any artists' canvases. It includes tables of canvas sizes and thread counts. The other significant comparative data on canvases also survey seventeenth-century painters: Velázquez (Garrido Pérez 1992) and Poussin (*Poussin et la peinture francaise* 1994). The exceptional use of silk, nettles, gorse, wool, and coco fiber for artists' canvases is discussed in Wolters 1960, p. 127.

The common occurrence of lining (affixing a reinforcing canvas to the back of a weakened canvas) has limited the possibility of direct, visual examination of most old master and many nineteenth-century canvases (see below). However, X-ray studies can contribute to our knowledge of the original canvas. Although they cannot detect the canvas itself, they often reveal the impression left on the ground layer by the original canvas.[21] This may provide detailed knowledge of the weave, thread count, seams of pieced canvases, and survival of distortions from the original stretching, known as scalloping, cusping, or garlands (see below).

Fabric texture is a product of different combinations of thread and weave. Threads may be thick or thin, smooth or knotty; different types or numbers of threads may be used for the warp (which run lengthwise on the loom) and the weft (crosswise threads that are worked through the warp with the weaver's shuttle). The most common choice for painting canvases was the tabby weave, also called plain weave or linen weave, with a simple alternation of warp over weft. Artists also occasionally used fabric of more intricate weaves, such as a twill or herringbone.

Unlike the smooth and fairly neutral surface of a typical panel, the canvas' weave can add a significant surface texture to the painting. The textural effects of the fabric increase with time and with treatments such as lining. There is reasonable doubt as to whether many sixteenth- and seventeenth-century painters intended for the fabric's texture to be visible, since all early artist's handbooks specify that the priming layer covering the canvas be sanded smooth. Nor do the texts mention the fabric's surface qualities.[22] This is contrary to accepted wisdom. One sees frequent comments on the intentional manipulation of fabric texture, especially during the seventeenth century; such observations actually may be misinterpretations of the effects of aging.

The use of a particular fabric, and hence a fine or coarse weave, *may* have been an artistic decision, but contemporary documents suggest that it often resulted from expedience. Van de Wetering proposes that the use of increasingly coarse fabric during the seventeenth century may have been due to the economics and technology of textile production rather than to aesthetic preference.[23] More historical research needs to be done on the reasons for artists' choices of canvases.

Sources on Glue-Size Painting (*Tüchlein* or Distemper)

Wolfthal 1989 gives an excellent overview, discussion, and catalogue of these rare works by Netherlandish painters. For a thorough and well-illustrated technical study of a Bouts distemper on linen, see Leonard 1988. The exceptional use of the technique in Italy is addressed in Rothe, "Mantegna's Paintings in Distemper," in Boorsch 1992. The technique will be discussed again in Chapter 4.

33

35

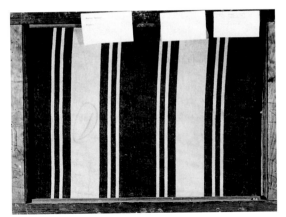

34

36

33 Rufino Tamayo, *Pueblo*, 1925, oil on fabric, 59.69 x 74.93 cm. University of California, Berkeley Art Museum.

The face of the landscape reveals nothing unusual about the canvas.

34 Verso of Fig. 33.

Tamayo used a prominently striped serape for the painting's support. The pattern of the handwoven fabric reflects its Mexican origin, although the uncommon choice was probably a result of expedience.

35 Gilbert Stuart, *Baron Fitzgibbon*, 1789, oil on canvas, 24.5 x 15.4 cm. Cleveland Museum of Art. General Income Fund (1919.910).

An exceptional canvas ties this small portrait to a specific location (see Fig. 36). It dates from a time when Stuart worked in Ireland.

36 Detail of the reverse of the unlined canvas (Fig. 35).

Baron Fitzgibbon was painted on a piece of textured linen, probably a tablecloth.

Expedient Choice of Support

Even after special artist's canvases were available, poverty or isolation led some painters to make unconventional choices. This is particularly the case with various regional and colonial schools. In discussing the period when Ralph Earl (1785–1838) worked as an itinerant portrait painter in New England, Stephen Kornhauser observes, "Once Earl left the cosmopolitan areas, artists' supplies were less readily available. On at least three occasions Earl painted portraits on bed ticking, an unusual, yet not uncommon, support."[24] Rufino Tamayo (1899? / 1900–91) painted one of his landscapes on a striped serape (Figs. 33, 34). Since he obliterated all evidence of the fabric's pattern—which is fully visible on the verso—we can assume that Tamayo employed it because it was at hand. A canvas used by Gilbert Stuart not only suggests expedience but also ties the work closely to the circumstances of its commission. The small portrait of Baron Fitzgibbon was painted while Stuart was in Ireland, and he used a piece of fancy-weave table linen for its support (Figs. 35, 36).

Expedience may also determine the choice of a hard support. Joyce Townsend notes that Turner (1775–1851) used not only makeshift canvases but also panels "strongly suggestive of cupboard doors" and another "group of panels of non-matching dimensions, likely to have been acquired as lumber." Gauguin (1848–1903) used the door to a piece of teak furniture for one small painting (see Fig. 249). Jacob Lawrence (b. 1917) acknowledged using hardboard for his sixty-panel *Migration* series because it was cheap (Case Study 12). Economy was probably William H. Johnson's (1901–70) reason for regularly painting on plywood rather than solid wood (Figs. 37–39).[25]

Expressive Use of Unusual Fabric

By the late nineteenth and early twentieth century fabric texture was certainly a conscious variable that painters manipulated. This is evident in the choice of exceptionally fine as well as unusually coarse fabrics. While Gauguin is often associated with paintings on jute (see Figs. 43, 86), he also exploited the delicacy of the handkerchief cotton on which he painted *Nirvana, Portrait of Meyer de Hahn* (Figs. 40–42).[26] The intentional use of a textured or patterned support is integral to the work of such artists as Sigmar Polke (b. 1941) (Fig. 44).

37 William H. Johnson, *Going to Market*,
1944, oil on plywood, 84.1 x 94.2 cm.
National Museum of American Art,
Smithsonian Institution, Washington, D.C.
Gift of the Harmon Foundation.

In spite of his academic training,
Johnson used inexpensive and
improvised supports for many of his
paintings. He often painted on ply-
wood and discarded burlap feed bags.
The painting is shown after treat-
ment of the highly distorted plywood.

38 Pre-treatment photograph of Fig. 37.

The delamination of the plywood
support had created a highly uneven and
unstable surface. The conservation
treatment is documented in Donald C.
Williams and Ann Creager, "Conser-
vation of Paintings on Delaminated
Plywood Supports," in *Saving the
Twentieth Century: The Conservation
of Modern Materials*, proceedings
of a conference, "Symposium '91: Saving
the Twentieth Century" (Ottawa:
Canadian Conservation Institute, 1991),
pp. 231–42.

39 Detail of Fig. 37, side view of the panel
before treatment.

This image shows the separating layers
of the plywood.

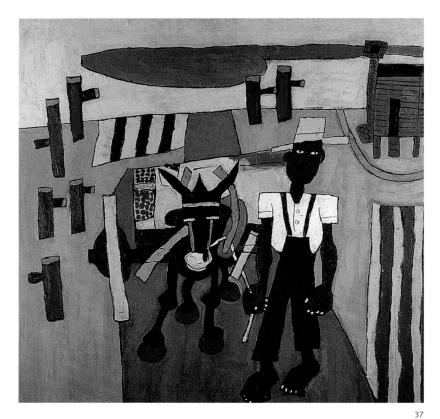

37

38

39

Aging of Textiles and Their Treatment

Like wood, fabric ages when its cellulosic content reacts to the environment. When the fabric decomposes it loses elasticity and darkens. The result is a painting that is more easily damaged, distorted, or torn, and more likely to need structural treatment.

Textiles expand and contract in response to the moisture in the surrounding atmosphere. The scientific term for this property is hygroscopicity. Cotton supports are significantly more hygroscopic than are linen ones, and thus they respond more actively to the surrounding humidity. The more recent a painting the less degraded the fabric support and the more it will react to moisture. However, no matter how old a fabric support, it will exhibit some reactivity to moisture. This response may be diminished by later conservation treatment, such as impregnation, in which the fabric is saturated with an adhesive in order to strengthen it.

Various chemical reactions cause damage to fabrics. Acids from the paint can accelerate their aging and damage, as can pollutants. The reverses of canvases can provide excellent locations for the growth of bacteria and fungi, both of which hasten the decomposition of canvases. Fabric supports are also subject to weakening through oxidation, a suite of chemical reactions that can be initiated by the drying of oil paint, contact with metals, and exposure to the environment and to the ultraviolet rays in unfiltered sunlight.

When a canvas is so weakened that it no longer safely carries the ground and paint layers, the usual procedure is to line it. Lining involves affixing a new canvas to the back of the original one as a physical support. When the lining canvas itself ages, a painting may be relined: the previous lining is removed and a new one is added.[27] The terms are used somewhat interchangeably, although British and Canadian usage tend to be stricter than American in employing *relining* only for a second or subsequent lining. Relining can also refer to the addition of a second lining canvas—that is, one added in addition to the earlier lining. None of these procedures is to be confused with transferring the paint layer to a new canvas; this radical treatment is akin to the transfer of a panel painting, which is usually avoided. Note that with lining or relining, the original canvas is retained.

40

40 Paul Gauguin, *Nirvana, Portrait of Meyer de Hahn*, c. 1890, distemper on fine cotton, 20.4 x 29.2 cm. Wadsworth Atheneum, Hartford. Ella Gallup Sumner and Mary Catlin Sumner Collection Fund.

The support of this small and jewel-like painting was thought to be handkerchief silk. Microscopic examination identified it as cotton. See p. 31.

41 Macro detail in raking light of Fig. 40.

Gauguin achieved a particularly seductive surface using a matte, glue-based paint (see pp. 112–13) applied almost like watercolor to the delicate, unprimed fabric. The painting is in extraordinary condition, neither lined nor varnished.

42 Macro detail in raking light of Fig. 40.

The unvarnished condition has preserved Gauguin's intended contrast between the very chalky colors and the highlights of gold paint.

42

41

Paintings have been lined since at least the seventeenth century, and almost no early canvases survive unlined. The same is true of much nineteenth-century work. In a discussion of an unlined canvas by Wright of Derby (1734–97), the staff of the National Gallery, London, noted, "The rarity of unlined paintings can be illustrated by the fact that, of approximately seven hundred canvas paintings in the National Gallery Collection which pre-date the year 1800, only three others are unlined." The Winslow Homer (1836–1910) exhibition (Washington, Boston, and New York, 1995–96) included only two paintings that had not been lined.[28]

Artists occasionally employed linings prophylactically or as a means of handling fragments of canvas, but linings typically were added long after the work was completed. According to David Bomford et al. 1990, "Impressionist painters were well aware of lining as a practice—were, indeed, occasionally in favour of it for their own pictures. Degas [1834–1917] is

43 Paul Gauguin, *Self-Portrait Dedicated to Carriére*, 1888–89, oil on canvas, 44.5 x 38.6 cm. National Gallery of Art, Washington, D.C. Mr. and Mrs. Paul Mellon Collection.

Here Gauguin made active use of an especially coarse fabric. Its crudeness reflects his stance as a modern primitive. Similar ideas inform his technique in other media: a crudely worked wood-block technique for his prints, and poly-chrome ceramics that rejected the refinement of European and Chinese traditions.

44 Sigmar Polke, *Hochsitz mit Gänse (Watchtower with Geese)*, 1987–88, artificial resin and acrylic on various fabrics, 299.7 x 223.5 cm. Art Institute of Chicago. Restricted gift in memory of Marshall Frankel; Wilson L. Meade Endowment (1990.81).

Polke assembled his canvas from three distinctively woven and printed fabrics: the upper left is quilted, the lower left fabric has woven stripes, and the vertical piece at right is printed with sunglasses, beach chairs, and umbrellas running upside down. Polke's superimposed image is both painted and stenciled, echoing the commercial patterning visible in the support.

43

quoted in Vollard's biography, however, as approving only the 'Italian' method. . . . Degas later rescued fragments of Manet's large 'Execution of Emperor Maximilian' and had them lined on to a second canvas [see Case Study 9]. Manet [1832–83] had some of his own pictures lined as he painted them: 'The Waitress' in the National Gallery and 'Au Café' in the Reinhardt collection, Winterthur—initially one large painting but separated by Manet himself—were both lined in the middle of the painting process." Georgia O'Keeffe (1887–1986) sometimes employed linings. She wanted a pristine surface and so had a conservator line and varnish her canvases as a means of maintaining their freshness.[29]

The lining process involves an adhesive and usually pressure or heat—all of which can affect the look of a painting. In Appendix 2 is a list of canvases painted before 1800 that have never been lined; readers can make their own first-hand comparisons. A poorly lined canvas may exhibit a stiffness uncharacteristic of the original. And if too much heat and pressure are applied during lining, the texture of the original canvas, and sometimes even the lining canvas, may be revealed (see Figs. 185, 186). Poor lining procedure sometimes flattens the paint surface—heavy impasto is especially vulnerable—and may discolor it. Uneven distribution of the lining adhesive can produce visible lumps. (We return to these issues in Chapter 4.) Lining also obscures information about the original canvas, such as its density and weave (which can usually be recovered through X-ray studies), as well as any signatures, materials makers' marks, collector's marks, or labels that may be affixed to the reverse of the canvas. Percival-Prescott (1974) gives a clear account of the history of lining treatments. He quotes contemporary sources and demonstrates that as the first generation of paintings on canvas began to show significant deterioration, restorers designed methods to impregnate them with adhesives and to line them.

Strip lining is a much less invasive procedure than is regular lining. New fabric borders are added to the original canvas to reinforce the tacking margins when the original margins are insufficient. The tacking margins are the first part of the canvas to weaken because they are pulled over the stretcher and thereby placed under pressure.[30]

Stretchers and Strainers

Early canvases were mounted on strainers: rigid frames that held paintings in plane for some years, until humidity cycles caused the canvas to slacken. The corners of a strainer could be butt joined, mortised, or lapped and held in place with a nail or pin. Strainers were considered functional devices that would be replaced as needed; few survive intact.

Artists eventually turned to stretchers, whose adjustable corners could be expanded (or keyed—through the addition of wedges) to take up the slack in a canvas (Fig. 45).[31] By the nineteenth century most artists used stretchers with variously designed expandable corners. Many corner designs were patented, and hence datable. The standard resource for identifying American stretchers is Katlan and Falk 1992; for an extensive bibliography of French artists' suppliers, see Bomford et al. 1990, pp. 215–18.

The tacking margin is formed along the canvas edges where tacks hold the fabric to the wood (Fig. 46 shows the tacking margins formed by the lining canvas). Because of the pressure on the fabric as it is wrapped around the stretcher, these borders are especially vulnerable to damage.

The uneven stress on the fabric caused by its original stretching and preparation creates distortions visible on the reverse of the canvas, and occasionally visible on the face of a thinly painted canvas. These distortions are known as scalloping, cusping, or garlands (see Figs. 49, 111).

Technical Examination of Fabric Supports

Examination of the canvas can yield clues to a painting's date and history. The tacking margins and the state of the fabric should be consistent with the given date of the painting. The tacking margins of an aged canvas tear easily. A new fabric is strong and flexible.

It is crucial that the fabric being tested be the original canvas, not a lining canvas. So, the first step will be to determine whether a canvas has been lined. There are several clues to the existence of a lining. The most obvious is the presence of two layers of canvas: a lining plus the original canvas. The tacking margins should be examined meticulously, since the presence of just one canvas at the tacking edges is no guarantee that the work is unlined. Until relatively recently, original tacking margins were routinely cut away during the lining process. In these cases, the original canvas can usually be seen

Array

45 Reverse of a canvas on a stretcher.

The keys, or triangular-shaped wedges at the corners, allow a stretcher to be expanded, taking up slack in the canvas that results from gravity and from humidity changes. This example has reinforcing cross-bars that are also keyed.

46 Macro detail of the edge of Velázquez, *Las Meninas*, c. 1656, 318 x 276 cm. Museo del Prado, Madrid.

This photograph was taken after a lining treatment. The tacking margin of the original canvas has been trimmed to the dimensions of the stretcher, and the lining canvas, which is larger, was used to tack the painting to the wood stretcher.

45

46

to overlay the lining at the fold of the stretcher (Fig. 46). The examination must be very painstaking, because the join can be obscured by filling and overpaint. Lined paintings also exhibit a characteristic stiffness that can be recognized with some experience.

With a lined canvas, identification of the adhesive and its condition can give a general indication of when the painting was treated. While this will not help date the painting, as with other information on treatment history it can contribute to knowledge of the painting's possible provenance. The earliest lining adhesives were water-based pastes and glues, which become brittle with time. The degree of embrittlement can give some indication of the age of the lining canvas and adhesive. By the nineteenth century, wax and resin mixtures were beginning to be used as lining adhesives (although wax linings became more prevalent in the mid-twentieth century). These usually leave a wax residue around the edges of the canvas that can be scraped off with a fingernail. Very recent linings are more likely to be attached with synthetic adhesives.[32]

Although X-ray studies of a lined canvas can reveal its weave, the presence of seams, or evidence of scalloping, the following section is based on direct examination and applies only to an original, unlined canvas.

After determining the age and condition of the original fabric one should note both the type of fabric and stretcher. These can help in attribution and dating, although such information must be used with great caution. Some artists, particularly by the nineteenth century, were known to use the same type of canvas and stretcher for many of their artworks—obtaining several pieces of the same fabric or having a set of stretchers assembled by a single materials dealer or cabinetmaker. Other artists used whatever canvas and stretcher were at hand.

Nineteenth- and early twentieth-century manufacturers of artists' materials often marked their products with stamps on the reverse of the canvas (Fig. 47), which can help date the painting. Directories are available listing the names, addresses, and dates of business of prominent firms.[33]

It is essential to determine that the canvas is intact before making judgments about a painting's composition or even its subject matter. Has the canvas survived in complete or in fragmentary form? Edges should be examined carefully for the presence of paint, ground, and tack holes. If the artist or his assistant primed the canvas it would usually be after stretching, hence the face of the canvas would be primed while the margins wrapped around the stretcher would be unprimed. If the tacking margins are covered with a ground layer but are not painted, the artist may well have used a preprimed canvas.

47 Detail of verso of Claude Monet, *Gardener's House at Atibes*, 1888, oil on canvas. Cleveland Museum of Art. Gift of Mr. and Mrs. J. H. Wade (1916.1044).

A stamp on the reverse of the canvas identifies the supplier.

48 Jan Miense Molenaer, *The Artist's Studio*, 1631, oil on canvas, 91 x 127 cm. Gemäldegalerie, Staatliche Museen, Berlin.

Molenaer shows an artist at work on a canvas mounted in a manner peculiar to Dutch seventeenth-century practice: laced to a large frame for working and later mounted over a smaller strainer for exhibition. The procedure occasionally left holes that appear in the tacking margins.

49 Detail of the reverse. Velázquez, *Prince Baltasar Carlos on Horseback*. Museo del Prado, Madrid.

This reveals a strip of canvas that has been added to the upper border. Further examination confirmed that Velázquez painted both the original canvas and the addition. The scalloping in the canvas below the seam indicates that the smaller canvas was stretched, during which time the fabric distorted under tension, before the artist enlarged the canvas. This is visible because the painting has never been lined. For a detail of the paint handling, see Fig. 114.

47

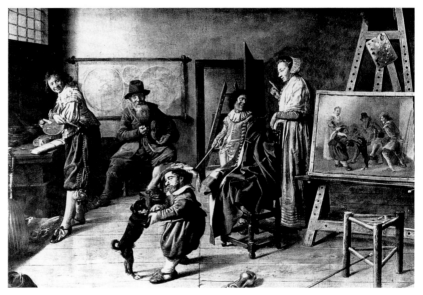

48

49

If the canvas' edges are both painted and primed, the painting was likely conceived on a larger scale and stretched on a smaller frame—possibly by the artist, or possibly by someone later. Studying the paint at the edges using magnification can reveal whether the canvas was cut before or after being painted.

Occasionally artists worked on unstretched canvas pinned to boards—this was especially true of painters working outdoors—and only later stretched the paintings for exhibition or sale. Such a procedure could have left tack holes in the corners and painted design on the tacking margins. These are cases in which technical information raises questions that can be answered only by comparative historical research. Technical examination may confirm that the tacking margins were both painted and primed—but only records of *that* artist's working methods or records of the early history of the specific painting can suggest whether the reduction was made in the artist's studio.

Some seventeenth-century Dutch painters worked on canvases laced to a large frame (Fig. 48) and then transferred to a smaller strainer for display. When the edges of such canvases have survived they reveal the holes for the lacing string, which are usually observable through X-ray studies of the canvas.

Surviving tacking margins yield significant information as to the originality of the composition. If the tacking margins are not painted and there is no evidence of their loss in lining, one can assume they are original. This is definite evidence of the painting's original dimensions. When original tacking margins survive one can determine whether the painting has been restretched by correlating the tack holes in the canvas with original nails: one set of tack holes filled with nails indicates that the stretcher is probably original to the work. Dimensions calculated through such examination can be compared with contemporary inventories or catalogues.

The former dimensions of a painting can sometimes be estimated even if the original tacking edges are missing. This is done by examining the distortions along the remaining edges of the canvas; these distortions are called scalloping, cusping, or garlands. The three terms are equivalent; we use only the term *scalloping*, although the authors we cite use all three interchangeably. Scalloping can be seen on the face of a thinly painted canvas (see Fig. 111). It can also be seen by examining the reverse of an unlined canvas (Fig. 49) or sometimes through X-ray studies of a lined one (scalloping is visible on all four sides of Fig. 193, and at the upper and lower edges of Fig. 212).

Primary scalloping is formed when a painting is initially stretched or prepared; it is reinforced over time as the painting is held on the stretcher by the nails. Distortions formed by subsequent restretching of the canvas are described as secondary scalloping. Primary scalloping should be approximately equal on opposing sides; if the left side of a canvas exhibits deep scalloping while the right does not, it is likely that the work has been cut on that side. The absence of scalloping on an old canvas should suggest that its original dimensions have been reduced.[34]

Study of scalloping is useful only comparatively because its depth and extent are influenced by how the fabric has been prepared as well as by the fact that the fabric's warp may distort somewhat differently than the weft. Comparisons of patterns of scalloping on opposing sides of the same canvas can be significant, whereas comparisons of scalloping on adjacent sides of a canvas, or on two canvases that may have been differently sized, are not useful.

The following two case studies involve paired portraits and the extent to which canvas studies can be used to link them. In Case Study 5, identical canvases were used to match husband and wife. In Case Study 6, differing canvases could not separate them.

5

Case Study

A Couple Reunited
Rembrandt's *Portrait of a Man Trimming His Quill* and *Portrait of a Young Woman Seated* Linked Through X-Ray Studies of the Canvases

Sufficient data exist on Rembrandt's canvases to suggest that he purchased them according to need.[35] Because he presumably ordered them from a supplier rather than cut them from a bolt in his studio, he rarely used the exact type of canvas repeatedly. Rembrandt's companion portraits, however, were usually done on matching canvases.[36] This information was used to bring together two paintings that had been separated, where historical evidence offered few clues to the sitters' identities.

The subject of *Portrait of a Man Trimming His Quill* (Fig. 50) was identified in the eighteenth century as the Mennonite teacher and calligrapher Lieven Willemsz. van Coppenol, who had portrait prints made by both Cornelis Visscher and Rembrandt

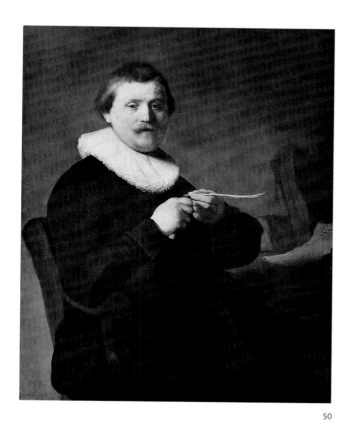

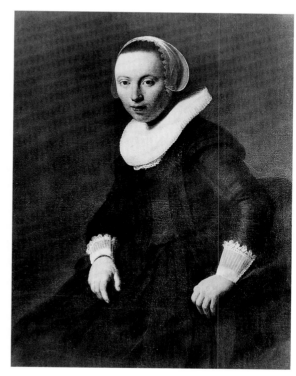

50

51

50 Rembrandt, *Portrait of a Man Trimming His Quill*, 1632, canvas, 101.5 x 81.5 cm. Staatliche Museen Kassel.

Canvas studies forced scholars to question the sitter's previous identity but provided him with a mate.

51 Rembrandt, *Portrait of a Young Woman Seated*, 1632, canvas, 92 x 71 cm. Akademie der bildenden Kunste, Vienna.

The identical canvas used for this and the male portrait suggested that they were a pair; Rembrandt's canvases have been studied sufficiently to enable such conclusions.

(1606–69). Various scholars had questioned the resemblance between the known print portraits and the Kassel painting. Who was the man trimming his quill? A study of the canvas provided some interesting evidence.

The style and composition of the Kassel portrait suggested to the Rembrandt Research Project a comparison with the unidentified *Portrait of a Young Woman Seated* (Fig. 51). Although of slightly different size, the Vienna portrait was also signed and dated 1632.[37] The scholars compared X-ray studies of the two canvases and found weaves so similar as to suggest that the canvases came from the same bolt. The identical canvases added weight to their matching dates, visual correspondence, and close original sizes.

The association of the Kassel and Vienna portraits as a pair makes the identification of the man as Coppenol even less likely, for his wife would have been in her fifties in 1632, considerably older than the placid young woman of the Vienna portrait. As the art historian Ernst van de Wetering commented, "The man thus lost his name but regained his lawful wife."[38]

As a cautionary counterexample, we turn to the following.

6

Case Study

Frans Hals' *Feyntje van Steenkiste and Lucas de Clercq*
An Ill-Matched Couple of Canvases

Two portraits by Frans Hals (1581 / 85–1666) are linked by an unbroken provenance of family ownership but have significant technical differences.[39] However, the conservator and conservation scientist most familiar with Hals' work did not consider these sufficient grounds to question the portraits' association as a pair. Paintings of Lucas de Clercq and his wife, Feyntje van Steenkiste, hang in the Rijksmuseum, on loan from the city of Amsterdam (Figs. 52, 53). One would expect a portrait pair to be on matching supports, as are other Hals pendants, notably the group portraits of the regents and regentesses of the Old Men's Almshouse (Frans Halsmuseum, Haarlem). The Rijksmuseum pair shows considerable technical differences: Lucas' portrait is on a coarse canvas primed with two layers, whereas Feyntje's portrait is on a finer canvas, with three priming layers. The primings are different colors in the two portraits.[40]

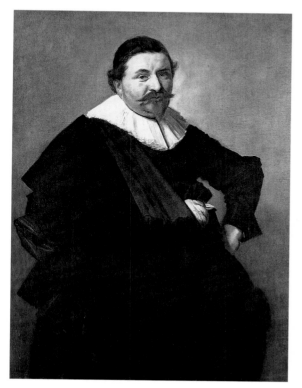

52

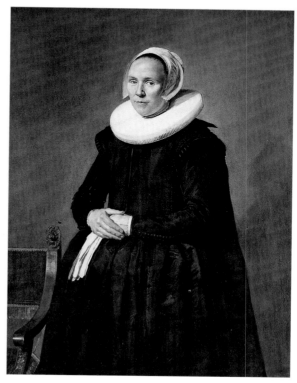

53

52 Frans Hals, *Lucas de Clercq*, c. 1635,
canvas, 126.5 x 93 cm. City of Amsterdam, on
loan to the Rijksmuseum.

Differences in both the canvas weave
and the priming layers do not provide
enough evidence to separate this
portrait from Fig. 53.

53 Frans Hals, *Feyntje van Steenkiste*,
c. 1635, canvas, 123 x 93 cm. City of
Amsterdam, on loan to the Rijksmuseum.

The portraits of Feyntje and her
husband, Lucas de Clercq, passed
together through generations of their
descendants.

54 Veronese (Paolo Caliari), *Virgin and Child with St. Justine, St. George, and a Donor*, c. 1562, canvas, 99 x 99 cm. Musée du Louvre, Paris.

The canvas has been extended on all four sides, probably to accommodate a different setting. Strips at the sides are seventeenth-century additions that produced a square format unusual for Véronèse. The additional strip along the top was barely distinguishable in ordinary light because yellowed varnish obscured the difference in paint handling; but the enlargements were clearly visible in raking light and X-ray studies (see Ségoléne Bergeon, *Restauration des Peintures*, catalogue [Paris: Editions de la Reunions des Musées Nationaux, 1980], pp. 54–55). None of the additions is clear in reproduction.

54

The differing canvases neither confirmed their relationship nor precluded it, for Hals' studio practice is not sufficiently documented to enable such certainty. Rather, Karin Groen and Ella Hendricks cite contemporary anecdotes about the artist's expedient methods: Hals would use preprimed canvases found in his studio.[41] While it would be convenient if such technical studies yielded conclusive results, they often simply add information of uncertain historical value.

Canvases with Altered Formats

Changes in the format of a canvas, such as added borders, raise questions of who made the changes, and when. An enlarged canvas often indicates a later change (Fig. 54). Still, such additions always bear investigation. The following is an unusual example in which technical evidence is reinforced by historical evidence in identifying a painting.

7

Case Study

Rembrandt's *Alexander the Great*
Canvas and Paint Studies Correlate with Historical Evidence in Identifying a Pieced Canvas

The identity of Rembrandt's *Man in Armour* at the Glasgow Art Gallery and Museum has been subject to a good deal of debate.[42] Technical examination of its unusual, multi-part canvas not only established that it was assembled in the artist's studio but also tied the painting to important historical evidence, thereby identifying it.

There is no question that the canvas was pieced from a smaller format, enlarged on all sides with five further strips. The seams are visible to the naked eye and show even in photographs (Fig. 55). X-ray studies reveal that the central canvas was reused (Figs. 56, 57): a hooded figure painted to smaller scale is visible below the helmeted man (and turned 90 degrees). The director of the Glasgow museum in the 1980s thought that the additions were later ones and proposed removing them. The chief restorer urged caution.[43]

A thorough technical examination was conducted prior to an international exhibition in 1991. This revealed that the added strips of canvas were primed differently from the central canvas and from each other, but all the primings were consistent with seventeenth-century Dutch practice. Scientists then studied the paint. Analyses of cross-sections from the central canvas and the adjoining strips showed similar technique for the multiple layers of glazes and scumbles in the man's red cloak. They also revealed a layering structure consistent with the matching required if the canvas had been pieced in the artist's studio.[44]

All of this information tied the painting to one of Rembrandt's better-documented commissions. We have unusual records about the group of paintings that Rembrandt sent to the Sicilian collector Antonio Ruffo (1610–78): one of them was on a pieced canvas. Ruffo filled his palace in Messina with works by his contemporaries; he owned numerous Guercinos and Salvator Rosas, as well as paintings by Ribera and Mattia Preti. He also collected several works by Rembrandt. It upsets our notion of regional taste that a collector in the outposts of the Spanish empire would equate a northern painter with those from the artistic centers of Rome and Naples. Yet we know that in 1654, Ruffo purchased Rembrandt's *Aristotle with the Bust of Homer* (now in New York), then ordered another work from the artist. Rembrandt sent a painting of Alexander that displeased his patron—it was made up of several pieces of canvas, and the seams, which were visible, disturbed him. Ruffo tried to negotiate the price downward and received Rembrandt's reply—that the painting of Alexander was fine; the seams would not show if it were hung in the proper light. Interestingly, this is the only seventeenth-century reference we have to visible seams in a canvas.[45]

This technical evidence does not confirm the authorship of this painting, which has been questioned, but it does suggest that whether by the master or his assistants, this *is* the painting sent by Rembrandt to Ruffo. Christopher Brown and Ashok Roy, chief curator and conservation scientist at the National Gallery, London, studied the painting and answered further questions tying the Glasgow painting to the Ruffo commission—namely the painting's size and the reading of the date. They concluded: "The technical evidence presented here supports the identification [with Ruffo's painting]. The alternative is that there were two paintings of Alexander by Rembrandt, each made up from smaller pictures of heads with added strips of canvas, and that surely would strain credulity too far."[46]

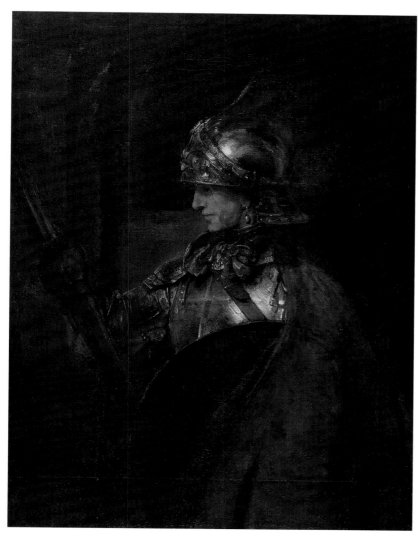

55

55 Rembrandt, *A Man in Armour*, 1655,
canvas, 137.5 x 104.5 cm. City Art Gallery
and Museums, Glasgow.

Even the photograph reveals the
horizontal seam across the lower section
of the canvas. In fact, the painting has
been enlarged on all four sides. Paint
sampling suggested that the canvas was
enlarged in the artist's studio, linking the
painting to a known commission.

56 X-ray study of Fig. 55.

If the image is rotated counterclockwise
90 degrees, the profile of a small-scale
hooded figure is visible at the far left—
a remnant of a prior composition on the
canvas. Most of the light areas are the
highlights on the armor. The patchwork
lines indicate multiple pieces of film,
and slight differences in exposure
explain the lighter tone of the two cen-
tral films. The light border is the
stretcher. The radiograph shown here
was supplied by the City Art Gallery and
Museums, Glasgow, and differs from
that published by Brown and Roy.

57 Diagram of the support of Fig. 55.

This image shows that five additional
pieces were used to enlarge the central
canvas. The sixth piece (along the
bottom, indicated with hatching) is an
even later addition (drawing after
Christopher Brown and Ashok Roy,
"Rembrandt's 'Alexander the Great,'"
Burlington Magazine 139, no. 1070
[May 1992]: 286–97, Fig. 2).

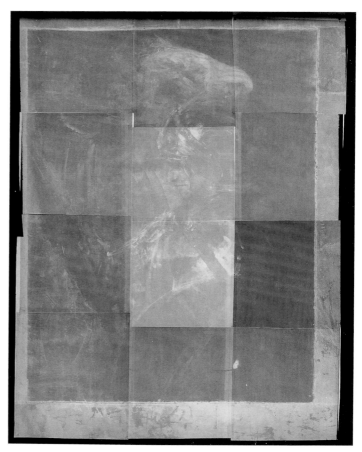

56

57

Although this is an exceptional early account of a work on expanded canvas, we know of other artists who employed the technique. Velázquez developed his compositions directly on the canvas and often had to add strips to accommodate his design changes (see Figs. 49, 230, 231). With other artists, as with the Rembrandt example, there are no definitive explanations for their reasons. Panels and canvases of idiosyncratic, almost patchwork design are notable in the oeuvres of Peter Paul Rubens (1577–1640) and Jacob Jordaens (1593–1678). Courbet (1819–77) used canvases pieced from fragments of his earlier works—a practice that may have influenced Manet and later modernists.

If a canvas has survived in fragmentary form, there are questions as to who cut it down and why. The following three case studies explore fragments. In Case Study 8 an artist created a painting from a fragment of an earlier work, cropping the canvas to alter the composition. Case Studies 9 and 10 involve obvious fragments resulting from intentional as well as accidental damage to paintings. All three serve as reminders that the paintings may have longer histories and other formats.

Sources on Pieced Supports

Velázquez' canvas additions are thoroughly documented in Garrido Pérez 1992 and Brown and Garrido 1998. For Rubens' pieced supports, see Brown 1996 and Hubert von Sonnenburg, "Rubens Bildaufbau und Technik," *Maltechnik-Restauro* 85 (1979): 77–100, 181–203. Robert D. Buck analyzes a single work, and Robert Feller provides technical examination in "The Gerbier Family: Examination and Treatment" and "Technical Examination of Pigments and Paint Layers," *Studies in the History of Art* 5 (1973): 32–74. Julius Held discusses six paintings by Jordaens on composite supports and suggests various reasons that the artist enlarged them: a change of intended venue, second thoughts by either the artist or the patron, or other outside considerations ("Nachträglich veränderte kompositionen bei Jacob Jordaens," *Revue Belge d'archéologie et d'art* 3 [1933]: 214 ff). Diane de Grazia and Erich Schleier cite several works by Orazio Gentileschi on artist-extended canvases ("St. Cecilia and an Angel: 'The Heads by Gentileschi, the Rest by Lanfranco,'" *Burlington Magazine* 136, no. 1091 [February 1994]: 73–74). For Courbet's composite canvases, see MacDonald 1969; for Manet's use of fragments, see Ann Coffin Hanson, "Edouard Manet: 'Les Gitanos' and the Cut Canvas," *Burlington Magazine* 112, no. 804 (March 1970): 158–67.

8

Case Study

Picasso's *Mother and Child*
An Artist's Gift Records His Change of Subject and Format

The Art Institute of Chicago acquired Picasso's painting of *Mother and Child* in 1954 (Fig. 58).[47] In the late 1960s, when a museum trustee visited Picasso (1881–1973) and showed him the work illustrated in a catalogue, the artist recovered a fragment of the original composition—which he offered to the Art Institute (Figs. 59, 60). Picasso had begun the painting with three figures: a mother, father, and child, representing himself with his wife, Olga, and their son, Paolo (born the year of the painting).

Following Picasso's gift, the Art Institute did X-ray studies of *Mother and Child* that revealed the remains of the man's outstretched left arm. This explains the gesture of the child—reaching toward his now missing father. We are left to speculate why Picasso removed his own figure from the group; indeed, we might also wonder why he kept the fragment in his studio for nearly half a century and how he was able to find it when the occasion arose.

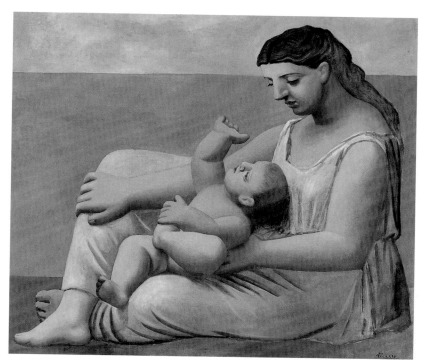

58

59

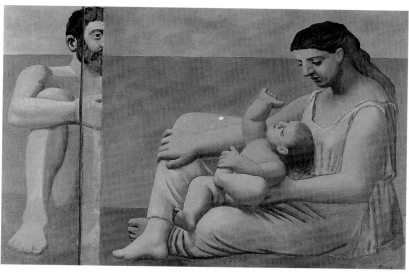

60

58 Pablo Picasso, *Mother and Child*, 1921, oil on canvas, 142.9 x 172.7 cm. Art Institute of Chicago. Gift of Maymar Corporation, Mrs. Maurice L. Rothschild, Mr. and Mrs. Chauncey McCormick, Mary and Leigh Block Charitable Fund, Ada Turnbull Hertle Endowment; through prior gift of Mr. and Mrs. Edwin E. Hokin (1954.270).

The painting as acquired by the museum showed only the mother and child. Subsequent information revealed that Picasso created the composition by truncating a larger family group.

59 Pablo Picasso, fragment from *Mother and Child*, 1921, oil on canvas, 143.4 x 44.3 cm. Art Institute of Chicago. Gift of Pablo Picasso (1968.100).

The long-separated fragment from the left side of the original painting was later given to the museum by the artist.

60 Reconstruction of *Mother and Child* prior to the removal of the father.

The thin strip of canvas with the father's face and right hand is the unfolded tacking margin at the left edge of Mother and Child.

9

Case Study

M. et Mme Edouard Manet by Edgar Degas
A Fragment of a Friendly Exchange

Contemporary anecdotal evidence explains the enigmatic condition of the portrait of *M. et Mme Edouard Manet* by Edgar Degas.[48] The painting survives as a defaced fragment, with a blank strip of canvas added to its right border (Fig. 61). Few paintings record such violent instances of artistic disagreement.

The painting began as part of a friendly exchange: Degas gave Manet the double portrait, Manet gave a small still-life in return. The account of the portrait's subsequent history has come to us from friends of each—Moreau-Nélaton telling Manet's side, Vollard recounting Degas' version. Both agree that Manet excised the portrait of his wife because he did not like the way Degas had portrayed her. Not surprisingly, this caused a rupture in the friendship. Vollard had seen the cropped canvas in Degas' apartment without the additional strip. Presumably Degas had taken it back, intending to repaint the offensive image. He never returned to the painting, and it survived in Degas' estate with the blank addition. It is an odd story of one artist defacing the work of another, and we would like more details. Instead, the painting's present condition records a collegial exchange, a visceral rejection, and incipient reconciliation.

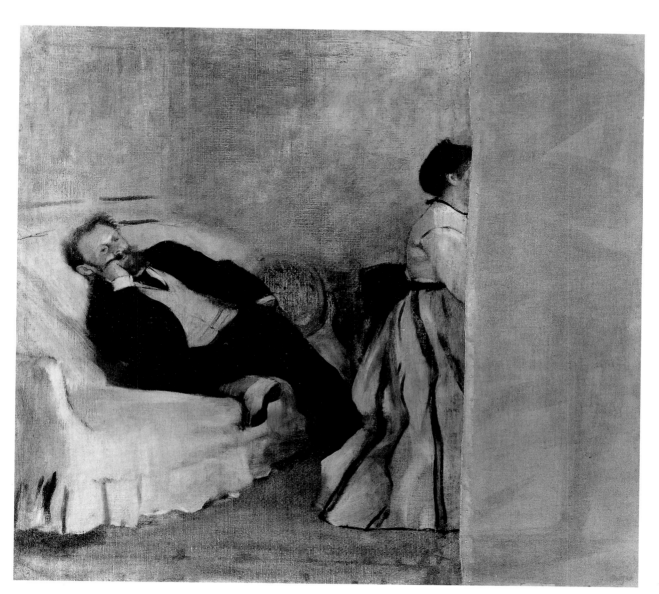

61 Hilaire-Germain-Edgar Degas, *M. et Mme Edouard Manet*, 1868–69, oil on canvas, 65 x 71 cm. Kitakyushu Municipal Museum of Art.

The startlingly blank canvas on the right was presumably added by Degas, who planned to repaint it after Manet cut his wife's portrait from the original composition.

10

Manet's *Execution of Maximilian*
Fragments of Studio Damage

Another fragmentary painting links the two artists, only this time evidence points to friendlier relations—for Degas rescued four pieces of a major, damaged canvas by Manet.[49] Manet made three attempts at painting the execution of Maximillian, emperor of Mexico. Both his final painted version and a lithograph of the same subject were censored for political reasons. Scholars have studied these works alongside newspaper reports of the archduke's execution by a Mexican nationalist firing squad, attempting to unravel their sequence and what they reveal of Manet's attitude toward the depiction of contemporary history.

Manet's second version (of 1872–73) survives as four fragments in the National Gallery, London (Fig. 62). A photograph taken to record Manet's estate shows the painting in one piece but missing a strip at the left. All that remained of Maximillian was his hand clutching that of General Miramón. The canvas had been damaged in Manet's studio. His stepson Leenhoff salvaged the least-damaged portions; the dealer Vollard claimed that Leenhoff had used the head of Maximillian as fire kindling. Degas purchased the three peripheral pieces from Vollard and found the central group of firing soldiers elsewhere—and had them mounted on a single canvas. The National Gallery purchased them in this format from Degas' estate, preserving an imperfect record of Manet's struggle with history painting.[50]

Stone and Metal: The Support as *Paragone*

Stone and metal (usually copper, less frequently aluminum, iron, or steel) have always been exceptional choices for painting supports. Their use during the sixteenth and seventeenth centuries may be associated with the *paragone*— or competition among the arts: painting was deemed superior to sculpture because color rendered its images more lifelike. Sculpture, it was argued, was superior because it represented three dimensions and because of its permanence. To paint on metal or stone would be to combine the advantages of both. Sebastiano del Piombo (c. 1485–1547) turned to slate (and occasionally marble) supports for his late murals in Rome, as well as for his easel paintings (Fig. 63); Michael Hirst suggests that he was concerned with creating lasting images. While other artists occasionally painted on stone, its weight and ten-

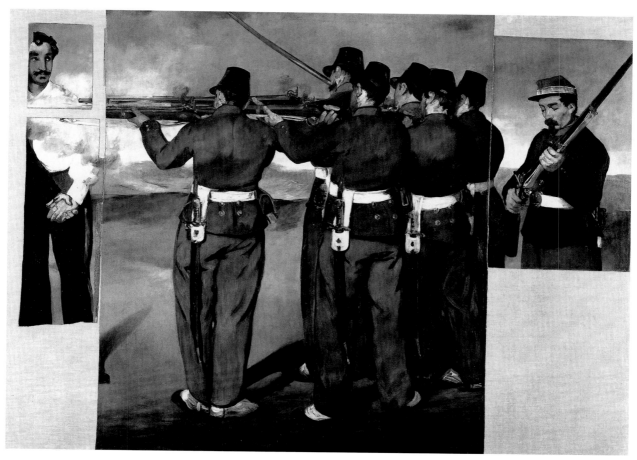

62

62 Edouard Manet, *Execution of Maximilian*,
1872–73, canvas, four fragments, approx.
190 x 160 cm, 99 x 59 cm, 89 x 30 cm,
35 x 26 cm. National Gallery, London.

Manet's second version of this contro-
versial, contemporary subject was
damaged in his studio. Four remnants of
the large composition were assembled
by Degas after Manet's death.

dency to crack were discouraging.[51] A stone support might have specific significance for regional schools. For example, the Brooklyn Museum owns an eighteenth-century Mexican devotional painting (Fig. 64) whose style reflects European tradition, but it is painted on a support of Tecali stone, the type most prized for indigenous carvings.

Painters began to use copper as a support during the sixteenth century at about the time it came into use in intaglio printing. Its disadvantage, as with all metal supports, is that it is flexible—more flexible than the paint layer it carries—and can be dented or bent. On the other hand it is hard, chemically stable, and does not expand and contract with changes in humidity, as does wood. Because of this, paintings on copper are often remarkably unblemished by time (Fig. 65). According to Edgar Peters Bowron, "Artists painted on copper with the deliberate intention of fashioning something that would be out-of-the-ordinary, and these small cabinet-pictures have always been treasured for their jewel-like surfaces and virtuoso brushwork."[52] The most comprehensive introduction to European and New World paintings on copper is *Copper as Canvas* (1999). For Mexican devotional paintings on metal, see Giffords 1992.

George Stubbs (1724–1806) experimented with baked enamel on both copper and ceramic supports beginning in 1769, producing almost forty examples in this technique usually associated with the decorative arts (Fig. 66). While Stubbs depicted variations of subjects that he also painted in oil on canvas or panel, his enamels were always distinguished by an oval format. Basil Taylor suggests that "Stubbs thought of these works as having a separate identity . . . whose durability was an attraction"—which links Stubbs with earlier painters who chose metal supports.[53]

Modern painters have used metal supports for a variety of reasons other than permanence or rarity. Miró (1893–1983) experimented with a number of unusual supports during the mid-1930s, playing with the varying look of paint on sandpaper, Masonite, and copper. With the six small coppers he exploited the smudginess of the oil paint on the resistant surface, producing effects that at times resemble children's fingerpainting (Figs. 67, 68). Frida Kahlo's (1907–54) use of metal supports for several small-format paintings has further implications, reflecting both contemporary concerns with *Mexicanidad* and her own exploration of identity. The technique, imagery, and style of *My Grandparents, My Parents and I (Family Tree)* are all part of her iconography, mutually reflecting their source in popular devotional images (Fig. 69).[54]

63 Sebastiano del Piombo, *Clement VII*,
c. 1531, oil on slate, 105.5 x 87.5 cm. J. Paul
Getty Museum, Los Angeles.

Following the Sack of Rome, Sebastiano
painted on stone for both easel paintings
and murals, combining the chromatic
possibilities of painting with the durabil-
ity of sculpture.

64 Eighteenth-century Mexico, *Our Lady of
the Rosary with Saints*, oil on *tecali* stone,
28.58 x 36.8 x 2 cm. Brooklyn Museum of Art.
Gift of John Wise (52.8).

Unusual materials employed by colonial
artists may reflect either local availability
or regional taste (see p.25). *Tecali* is a
Mexican alabaster from Puebla. Highly
valued before the conquest, it was used
during the colonial period for architec-
tural details and for religious and secular
objects (see *Converging Cultures: Art
and Identity in Spanish America*, cata-
logue [New York: Brooklyn Museum,
1986], cat. 31).

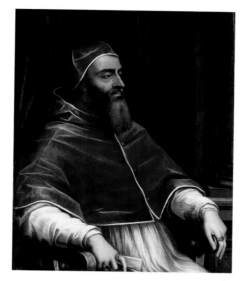

63

64

65 Joachim Wtewael, *Mars and Venus Surprised by the Gods*, c. 1606–10, oil on copper, 20.25 x 15.5 cm. J. Paul Getty Museum, Los Angeles.

The preciousness as well as the scale of Wtewael's small copper—fashioned to be held in the hand—is a particularly suitable alliance of subject and technique.

66 George Stubbs, *Horse Attacked by a Lion*, 1769, enamel on copper, 24.1 x 28.3 cm. Tate Gallery, London.

One of more than forty variants of his own oil paintings that Stubbs created in enamel on ceramic and copper supports. Such enamel was not a paint but a glasslike material that fused onto the support when baked. Stubbs was unique among fine artists (rather than craftsmen) in using the technique.

65

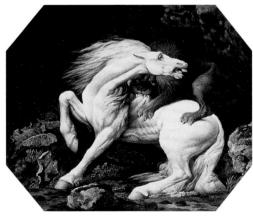

66

67

68

67 Juan Miró, *Two Personages in Love with a Woman*, 1936, oil on copper, 25.4 x 35.6 cm. Art Institute of Chicago. Gift of Mary and Leigh Block.

Miró produced six small coppers during a period when he was notably experimental with the texture of his painting supports.

68 Detail of Fig. 67.

Miró maximized the various ways the paint sat on copper's nonabsorbent surface. Copper plates, unlike wood panels, are not prepared with a ground layer prior to painting (see p. 70).

69

69 Frida Kahlo, *My Grandparents, My Parents and I (Family Tree)*, 1936, oil and tempera on metal panel, 30.7 x 34.5 cm. Museum of Modern Art, New York. Gift of Allan Roos, M.D., and B. Mathieu Roos.

Frida Kahlo collected local popular arts and incorporated their style, format, and materials into this work, since nineteenth-century Mexican *retablos* and *ex votos* were typically painted on tin laminate. Kahlo recorded her dual European and indigenous Mexican ancestry in an art form that was itself a product of the colonial mestizo.

Artists' Board and Paper Laid to Canvas or Panel

Pressed-paper boards have been manufactured for artists' use since the late eighteenth century. They were known variously as mill board, canvas board, and academy board. Their surfaces might be smooth or rough, in imitation of canvas. While boards were commonly employed by students and amateurs, they also formed a convenient, portable support for painters working out of doors (Fig. 70). Canvas boards might have fabric attached to the face of the paper board; academy board is typically a paper board whose surface is prepared for oil painting. Such artists' boards may retain maker's marks, which may be of help in dating them.[55]

Paintings in oil or watercolor on paper have occasionally been fixed to a sturdier support of canvas or wood. These are usually framed and presented as works on canvas (or panel) rather than as works on paper. Such laid down works are found over a wide chronological range; they raise the often unanswerable question as to who affixed the paper to the canvas or panel, and when (Fig. 71). Sales value is an obvious motivation, and many of these hybrids were certainly created by later collectors or dealers in order to fetch a price associated with a canvas or panel, rather than a work on paper. As such, they merit interest as a commentary on the history of taste and the hierarchy of artistic value.

On the other hand, a number of artists chose to paint on paper because of its handling properties and mounted it to canvas either before painting or after, for reasons of display. Paper is fairly porous, and while it may be sized, it is not primed as is fabric or wood. Hence the paint sits differently on paper, even if it is laid down (Fig. 72).

The choice of a paper support may also reflect historical or regional issues. Wifredo Lam (1902–82) may have painted some of his most important paintings on paper because large pieces of canvas were hard to obtain in Havana during World War II (Fig. 73). The paper support dramatizes these circumstances.[56]

The process of affixing a work on paper to canvas or panel may leave visual evidence of the secondary support; it may also cause stress and damage to the paper.

70

70 John Constable, *Weymouth Bay (Bowleaze Cove)*, 1816, oil on board, 20.30 x 24.75 cm. Victoria and Albert Museum, London.

This rapidly executed sketch, done during the artist's honeymoon, is painted on a piece of unprimed millboard. It corresponds exactly to the size of Constable's surviving sketch box. He probably had it at hand and used it to record a fleeting effect of the approaching storm (see Parris and Fleming-Williams 1993, cat. 84 and pp. 501–4).

71

72

71 Anthony Van Dyck, *Study Head of a Young Woman*, oil on paper, mounted on wood, 56.5 x 41.6 cm. Metropolitan Museum of Art, New York. Gift of Mrs. Ralph J. Hines, 1957 (57.37).

Van Dyck painted this head on an inscribed piece of lined paper, possibly from an account book. Some of the writing is Italian, which may date the study to the artist's sojourn in Italy, although scholars disagree about this. Two other sketches of the same model survive, also glued to wood, presumably at an early but undeterminable date. The numbers visible in the corners were likely added by collectors, as was the seal at the lower right (see *Flemish Paintings in the Metropolitan Museum of Art* [New York: Metropolitan Museum of Art, 1984], pp. 77–79).

72 Hilaire-Germain-Edgar Degas, *Self-Portrait*, 1854(6?), oil on paper mounted on canvas, 40.6 x 34.3 cm. Metropolitan Museum of Art, New York. Bequest of Stephen C. Clark, 1960 (61.101.6).

Degas is known to have ordered supports of paper laid to canvas from his supplier. Among his earliest paintings are a series of self-portraits, six of which are on these hybrid supports (see P. A. Lemoisne, *Degas et son Oeuvre* [Paris: Paul Brame et C. M. de Hauke, 1946], vol. 2; this painting is L. 2). It is reasonable to suppose that the mounting was the artist's choice.

73

73 Wifredo Lam, *The Jungle*, 1943, gouache
on paper mounted on canvas, 239.4 x 229.9 cm.
Museum of Modern Art, New York.
Inter-American Fund.

Lam painted both the New York and
Chicago versions of this subject on
multiple pieces of brown wrapping paper
that were later glued to canvas. His
choice probably reflects wartime scarcity
of art supplies in Havana. Visible tack
holes at the periphery of the entire field
indicate that Lam assembled the
wall-size paper surface before painting
the composition.

3

The Ground and Preparatory Layers

The ground is usually covered entirely by the paint layer, but since it affects the look of the painting, study of the ground is essential for historians in understanding the painter's intent. Did the artist prepare a rough or a smooth ground? How was it applied? Was it colored, and, if so, was it light or dark? Was it absorbent? Did the artist avoid a ground layer entirely, and why? As with other aspects of technique, the answers to these questions can sometimes identify a painting with a tradition or school—and can track the influence of painting methods from one school or period to another.

Ground studies have led to more dramatic art historical implications when they reveal that the artist blocked out all or part of the design with incisions. Such ground incising has been crucial in reconstructing how various artists worked out their perspectival schemes and compositions.

The Physical and Aesthetic Function of Grounds and Their Composition

The functions of the ground and preparatory layers are both physical and aesthetic. Their physical function is to prepare the wood or canvas support to hold the paint. Grounds for panels were thick—usually thicker than the paint layer. The flexibility of canvas requires a thinner, pliable ground layer.

The aesthetic function of the ground is to control the color, luminosity, and texture of the painted image. These are subtle effects, and the ground layer is usually not directly visible in a finished painting.

The ground and preparatory layers are applied between the support and the painted design. The terminology of grounds is not fixed, and we have made no attempt to standardize terms that are used variously by different authors (for an excellent discussion of grounds and their terminology, see van Hout 1998). A preparatory layer such as *size* may precede the ground. The term *priming* is sometimes used interchangeably with *ground* (a number of more specific terms may be used: *gesso*, *gesso grosso*, *gesso sottile*), but we prefer to use *priming* to describe the uppermost ground layer.

Some paintings lack a ground layer entirely, although they are exceptional cases. Works of glue-based tempera on linen (distemper or *Tüchlein*) usually lack grounds, although the canvas might be prepared with size. Metal and stone supports were sometimes rubbed with garlic to help the paint adhere. Copper supports might be prepared with a single layer of lead white in oil, but neither metal, stone, nor glass supports would have a gesso ground. Artists who use acrylic paints with a stained technique also employ unprimed canvas—sometimes sized, sometimes not (see Figs. 87, 88).

The preparation and ground usually consist of multiple layers. The first is a size, or water-based glue, that seals the panel or canvas and creates a bond between the support and the rest of the ground. The next layer is the gesso or plaster. Like paint, which consists of pigments in a binding medium, the ground is composed of inert solids (gypsum, whiting, or chalk) suspended in a medium of glue or oil. Early Italian panels were often covered with a layer of canvas, which formed a base for the gesso layer.[1]

Artists varied both the color and the texture of the ground for visual effect. White grounds were the norm until the end of the sixteenth century and became popular again in the mid-nineteenth century, although artists also used colored grounds to influence the tonality of the finished painting. Since paint tends to become more translucent with time, the choice of a colored ground will have an increasing effect on the appearance of the painting. When

Sources on Ground Composition

Gypsum or plaster of Paris grounds are known in Italian as *gesso grosso* or *gesso sottile*, depending on the fineness. The choice of ground was probably influenced by availability—gypsum is found near the Mediterranean, and chalk is more common in central and northern Europe. While gesso is Italian for gypsum, the term can be used to describe any white priming in an aqueous medium. Hence, chalk grounds might be described as gesso, especially if the description is from an early source in Italian (modern scholars would not describe chalk grounds as gesso). The choice of medium used to bind the ground was likely influenced by climate. For readers who want more information on the chemical composition of grounds, as well as their history and aesthetic implications, the best introduction is van Hout 1998. Percival-Prescott 1974 gives a detailed and lucid account of the choices that artists made in developing grounds suitable for canvas supports.

painters worked with translucent rather than opaque paints, the effect of a colored ground was present from the start.

The ground often had a third layer, the priming, which was finer and might be colored. The priming modified the color, texture, or absorbency of the gesso layer. The materials used in the priming would vary: boles (a colored clay, ranging from red to pale ochre),[2] shellac, or drying oils (these include linseed, walnut, and poppyseed, which form a film when exposed to air; see Chapter 4). Tinted oil-based primings are sometimes called *imprimatura*; these were commonly colored yellowish-brown by the addition of raw sienna. Again, the terminology is not standard: *imprimatura* are sometimes considered a layer of underpainting rather than part of the ground layer.

The texture of the ground could be manipulated with granular additives or by method of application: the use of a coarse brush, patting with the fingers or palms, stippling with a tool. Such textured ground effects might be produced in the artist's studio or by commercial suppliers if the canvas was purchased preprimed.

When a panel painting was constructed with an integral frame (also called an engaged frame), which was standard until the fifteenth century (see Figs. 168, 256), the entire ensemble would have been assembled by the carpenter and then primed in the artist's workshop. If the frame was later removed, an edging of gesso may remain—in German, *Malrand*, or raised lip of paint; in French, *barbe*, beard. Such information is useful in reconstructing the original dimensions and arrangements of polyptychs (see Case Study 2).

A common problem of the ground layer is poor adhesion to the support. This may result from faulty preparation or may be caused by aging factors, such as movement of the support (panels that warp, canvases that are rolled or bumped), insect damage, mold and fungal attack, or chemical interaction with the adjacent paint layer. Another problem of grounds, and one that occurs in the initial preparation, is a pockmarked surface, caused by small bubbles trapped in the gesso as it dries (see Fig. 84). Grounds can display a craquelure that may extend to the paint layer[3]; this usually results from movement in the support. Such ground craquelure is indicated in Vermeer's *Girl with Pearl Earring* (Figs. 152, 153).

The standard treatment for poor ground adhesion is impregnation, which involves saturating the ground and paint layers (as well as the support, in the case of a canvas) with an adhesive. Impregnation may accompany lining of a canvas or may be done independently (see Chapter 2).[4]

Examination of Grounds

The ground layer is difficult to study because it is sandwiched between the support and paint layers. However, examination of the edges of the painting with the naked eye and with magnification sometimes reveals useful information. A helpful tool in examining paintings is a jeweler's loupe or an optivisor, a precision-made binocular magnifier designed to be worn on the head; conservators typically use two times and two and a half times magnification, with focal lengths of 10 inches and 8 inches, respectively. They are moderately priced and available from suppliers for conservators and photographers.

The tacking margins of a canvas can offer insight. If no ground is visible, the painting was probably primed after the fabric was stretched. If the tacking margin is covered with ground, the canvas was preprimed either in the artist's studio or by an artists' supplier. Evidence of prepriming can help date a canvas, since the practice became more common during the late eighteenth century with the rise of artists' manufacturers (although there is evidence that Dutch painters relied on artists' suppliers, who preprimed their canvases as early as the seventeenth century).[5] Ground visible at the edge of a canvas or a panel can reveal color and layering, which can be compared to known examples of the artist or period.

Raking light is a simple and invaluable method for examining paintings. This involves placing a lamp to the side so that the illumination falls at a sharp angle, highlighting any textural changes in the painting's surface. Raking light may reveal evidence of an accidentally or intentionally textured ground (see Figs. 79–82, 85), as well as problems of poor ground application or ground incising—which can be examined further with X-radiography and infrared studies and will be reviewed in case studies below. Raking light is particularly valuable in examining the paint layer, as will be discussed again in the following chapter.

The effect of raking light can be employed without a special lighting source. Standing close and to the side of a painting enables oblique viewing—even in ambient light. This technique is crucial for studying works that can be seen but not handled, such as paintings in museum galleries.

Paintings are usually examined with X-rays to study the paint layers, but X-ray studies may also reveal intentional texturing, losses, or discontinuities in the ground layer, such as palm-prints, old flaking damage, punch holes, tack holes, or incising.

74 Photomicrograph of a cross-section. Giovanni Battista Tiepolo, *Madonna of the Goldfinch*. National Gallery of Art, Washington, D.C. Gift of Brown Foundation, Inc., Houston.

The thick red layer is the colored ground. It contains iron-earth reds and some black and white pigments. Four layers of paint are discernible above the ground.

74

Infrared examination is likewise most commonly used to study the paint layer, particularly the underdrawing. However, when the artist laid out the design by incising the ground layer rather than drawing or painting upon it, infrared studies have also made remarkable contributions. Examples will be given below. The methodology of X-ray and infrared studies will be discussed at more length in Chapter 4.

We have confined ourselves so far to methods that do not involve taking a sample—so-called nondestructive testing. These are obviously the preferred means of examining paintings. However, even small samples allow scientists to further study aspects of the layering of ground and paint, as well as their physical and chemical composition.

A cross-section is a minute sample, the size of a pinprick, taken perpendicular to the paint surface. The sample is mounted and examined under magnification (Fig. 74). The principle is exactly the same as cross-sections of earth studied by geologists, but on a different scale. Cross-sections reveal the successive layers of ground, priming, paint, and varnish, and their various properties (both composition and color). However, such samples result in extremely small but irretrievable losses. These are usually taken near areas of existing damage (with the use of a fine scalpel and the aid of magnification) when a painting is undergoing study prior to treatment. For an indication of the minute losses involved, see the comment by Ashok Roy, p. 105. The use of cross-sections to study paint layering will be discussed in the next chapter. The best survey of cross-sections is Plesters 1968.

75

75 Detail. Simone Martini, *Saint Luke* (Fig. 256), tempera on panel.

The painting is extraordinarily well preserved, retaining most of the original glazes and even its engaged frame. Even so, in some areas, such as the bridge of the nose, the green ground below the flesh tones is visible. This detail reveals the short, hatched brushwork characteristic of egg tempera, as well as the fine craquelure typical of a wood support.

76 Marie Victorie Lemoine, *Atelier of a Painter (Mme Vigée Le Brun) and Her Pupil*, 1796, oil on canvas, 116.5 x 88.9 cm. Metropolitan Museum of Art, New York. Gift of Mrs. Thornycroft Ryle, 1957 (1957.103).

Lemoine shows Vigée-Lebrun working on a gray-grounded canvas with a chalk underdrawing. Lemoine has used a similar gray ground to set the tonality of this portrait of her greatest female colleague.

Colored Grounds

The chromatic properties of the ground are controlled by the combination of colors used in the various layers. Colors range from pale gray and ochre to dark red and even black. A white ground might be toned locally with a colored priming—such as the green used beneath the flesh tones of early Italian paintings (Fig. 75). Artists could apply colored grounds quite flexibly to influence the painting's final tonality; Botticelli (1445–75) varied the ground color throughout his *Primavera*, using black beneath the dark foliage and white beneath the flesh tones. Marie Victorie Lemoine (1754–1820) represents a painter at work on a gray-grounded canvas (Fig. 76). Tiepolo (1696–1770) occasionally varied the ground color from one painting to another within a cycle, according to the chromatic requirements of his subject.[6] He used a warm, caramel-colored ground for his depiction of the sun god (Fig. 77). The choice of materials, method of application, number of ground layers, and their colors characterize various periods. For further information, see van Hout 1998 and other sources mentioned above. The following case study involves questions about the implications of the ground layer in attributing a painting to an artist or particular school.

77 Giovanni Battista Tiepolo, *Apollo and Phaëton*, c. 1731, oil on canvas, 64.1 x 47.6 cm. Los Angeles County Museum of Art. Gift of Ahmanson Foundation.

The glow of Apollo's sun that suffuses this oil sketch was established by the colored ground, visible at the corners where it is not covered by paint.

11

Judith Leyster or Circle of Gerard van Honthorst
Ground for an Attribution?

Ella Hendricks and Karin Groen made a systematic technical study of the work of Judith Leyster (1609–60) to see whether they could distinguish it from that of the senior Haarlem master Frans Hals.[7] Unfortunately, with the data available on the two artists' technique, they could not. But their ground studies revealed one painting whose technique was anomalous and caused its attribution to be questioned.

The ground layer of seventeenth-century Dutch painting has received enough investigation to enable generalizations about differences in practices from one city to another. All the studies were based on examination of cross-sections. Rembrandt's work from his first decade in Amsterdam reveals the use of a yellowish *imprimatura* over a chalk ground for panels, and a double-layer, gray-tinted lead over a red layer for paintings on canvas. The change in grounds may have been an Italian import, as was the use of canvas supports rather than panels. The technique of Hals and the Haarlem painters differed. Hals' grounds were mostly lead white, tinted with pale pink or ochre.[8]

One painting attributed to Leyster stood out because of its ground: *Laughing Youth with a Wine Glass*, which can be traced to an inventory of 1668 but without attribution (Fig. 78). It has a gray-over-red ground—unknown in Leyster's work, but typical of the Utrecht Caravaggisti. The curators of "Judith Leyster: A Dutch Master and Her World" were convinced by this technical evidence and attributed the painting to an unidentified Utrecht painter associated with Gerard van Honthorst. The attribution is comfortable on the basis of subject and style, as well as technique. Hendricks and Groen, a conservator and conservation scientist, were hesitant. While acknowledging that such double grounds were common among the Utrecht Caravaggisti, as well as in Rembrandt's circle in Amsterdam, they maintained that ground technique alone was not sufficient evidence for a reattribution. Dutch painters may have used canvases primed in other cities; Groen and Hendricks give the example of *Meagre Company*, commissioned in Amsterdam from Frans Hals. It has a ground typical of Amsterdam rather than Haarlem, which may reflect the origin of the canvas rather than of the painter.[9]

This is an interesting example of technical results being unquestioned while their interpretation is disputed by scholars from different disciplines working on the same project. In fact, the art historians working on the Leyster exhibition gave more weight to the implications of technique than the conservator and scientist did. This should encourage caution in interpreting technical information.

78 School of Gerard van Honthorst (Judith Leyster?), *Laughing Youth with a Wine Glass*, 1630s, oil on canvas, 78.8 x 69 cm. Staatliche Kunsthalle Karlsruhe.

The colored ground on this painting caused curators and conservators to disagree about its attribution.

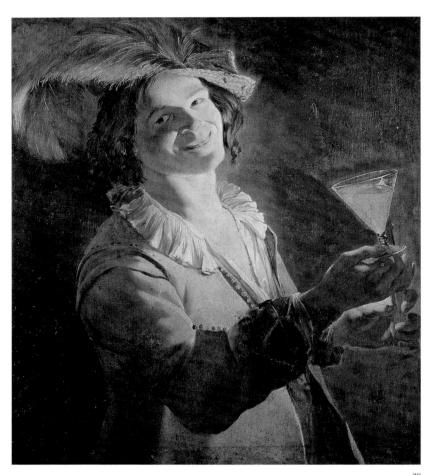

Textured Grounds

Early artists' manuals instructed that the grounds for panels be finished to a smooth and even surface—this was the reason for an upper layer composed of finer material than the initial gesso. Yet a handful of early panels exhibit evidence of intentional texturing.[10] (Case Study 4 illustrates an unusual preference for textured panels and grounds among American painters in the early nineteenth century.) We know that during later periods, using textured grounds for canvases was more commonly a matter of artistic choice. Some artists textured the grounds themselves (Figs. 79, 80, 85) while others relied on their suppliers (Figs. 81, 82). At least one English firm during the nineteenth century offered seven variations of stippled grounds on their preprimed canvases.[11] Twentieth-century artists have used textured grounds for various reasons. The case that follows indicates the possible misinterpretation of an artist's intentions in using a textured ground.

12

Case Study

Jacob Lawrence's *Migration* Series
The Creative Use of Accidents

The pockmarked grounds visible in several of Jacob Lawrence's narrative cycles were unusual enough to merit the inquiry of a conservator and conservation scientist.[12] Had Lawrence created the texture intentionally, in imitation of fresco?

Jacob Lawrence (b. 1907) prepared sixty small hardboard panels to begin his narrative series on the migration of African-Americans to the industrial cities of the American North and Midwest. He recalled choosing the hardboard for economy and preparing the panels, with his wife's help, in his unheated Harlem apartment. Lawrence's training at the Harlem Art Workshop and the American Artist's School was unlikely to have included instruction in tempera, which he used for several large series. Like a number of American artists who turned to tempera during the 1930s (Romare Bearden, Thomas Hart Benton, Isabel Bishop, Reginald Marsh, Ben Shahn, and Andrew Weyth, among others), Lawrence probably learned the technique from friends and from books.[13]

79

79 Paul Gauguin, *Why Are You Angry?*
(No te aha oe riri), 1896, oil on canvas,
95.3 x 130.5 cm. Art Institute of Chicago.
Mr. and Mrs. Martin A. Ryerson Collection
(1933.1119).

Gauguin avoided impasted paintwork
but used a variety of structural means to
create surface texture. For this canvas
he textured the ground. With others he
chose extremely fine or coarse fabrics
(Figs. 40, 43, 86).

80 Detail of Fig. 79.

The prominent texture is visible in the
ground. It appears that Gauguin created
the marks with a very coarse brush—
one that might have been made for
scrubbing rather than painting.

81 Jacques-Louis David, *Portrait of the
Sisters Zénaïde and Charlotte Bonaparte*,
1821, oil on canvas, 129.5 x 100 cm.
J. Paul Getty Museum, Los Angeles.

This portrait of Napoleon's nieces was
painted on a commercially primed can-
vas textured to resemble a plaster wall.

82 Detail of the artist's signature and date
in Fig. 81.

At close viewing the fine, granular
surface is particularly apparent.

81

82

83

Elizabeth Steele and Susana M. Halpine were curious about the particularly visible ground texture in certain areas of the *Migration* series (Figs. 83, 84). Had Lawrence meant to re-create the surface quality of fresco? Their question was based on two likely historical precedents: first, since the late nineteenth century, some artists (most notably Gauguin) had worked with oil paints on absorbent grounds in conscious imitation of fresco; and second, Lawrence had acknowledged an interest in the Mexican muralists who revived actual fresco technique. Steele and Halpine were fortunate to be able to ask Lawrence. His answer discloses a particularly twentieth-century appreciation of the accidental, with more obvious roots in jazz improvisation and surrealist practice. Lawrence said that he had not intended the effect. The bubbles in the gesso probably resulted from the cold working conditions, but the artist went further: "Pointing to an area in one panel in which the pinpoint white dots were prevalent, he remarked, 'If I see something happening which I like, I let it happen. . . . If I got something going like this and I liked it, I let it stay.'"[14]

84

83 Jacob Lawrence, "Migrants left. They did not feel safe. It was not wise to be found on the streets late at night. They were arrested on the slightest provocation." Panel 22 from *The Migration Series*, 1940–41 (text and title revised by the artist, 1993), tempera on gesso on composition board, 30.5 x 45.7 cm. Museum of Modern Art, New York. Gift of Mrs. David M. Levy.

To save money, Lawrence used composition board rather than wooden panels for this narrative series. The pitting in the ground layer probably resulted from the cold temperature in the artist's studio.

84 Detail of Fig. 83.

The textured ground, created by bubbles that formed during drying (the bubbles appear white), prompted researchers to ask whether Lawrence was trying to simulate the look of fresco.

Absorbent Grounds

A matte surface was one means by which nineteenth-century artists experimented with new aesthetic effects. They achieved the effect variously: by using aqueous media, by leaching their paints of oil, by rejecting a surface coat of varnish, and by using absorbent grounds.[15] Anthea Callen has traced the history of absorbent grounds from economic to aesthetic impetus: "The desire for enhanced mattness and opacity of paint surface among avant-garde artists during the 1880s is affirmed not only by their interest in pastel, gouache and distemper, but by their adoption of absorbent canvas primings for work in oil. Pissarro, always an experimenter, was probably the first to do so, but there were earlier precedents. So-called 'absorbent' grounds were introduced c. 1800, seemingly as a manufacturer's expedient rather than as a response to artistic demand. Mérimée noted in 1830 that the colourman Rey was responsible for introducing what he named 'absorbent canvases.' . . . Mérimée's comments that absorbent or distemper grounds were used both by Titian and Veronese would have encouraged avant-garde artists influenced by the Venetian colourists (from Delacroix to Degas and Cézanne) to emulate their effects."[16]

Carol Christensen discusses Gauguin's preference for matte grounds within an established tradition, suggesting various motivations: "Absorbent grounds had many advantages; those noted by Bouvier in his 1844 edition include speed of drying, lack of discoloration, good adhesion, and absorption of excess oil in the paint layer to enhance purity and stability of the colors painted on them." Matte grounds could also be used to simulate the chalky surface of fresco. According to Maurice Denis, Gauguin "loved the matte effect of frescoes, and that is why he prepared his canvases with thick coats of white gesso." Gauguin's interest in achieving the matte quality of fresco was shared by his contemporaries. Several critics of the sixth impressionist exhibition of 1881 commented on the archaizing look of Mary Cassatt's technique. Confirming their remarks, Cassatt (1844–1926) wrote to her brother that one canvas was painted "to look as much like frescoe [sic] as possible." Edvard Munch (1863–1944) used various idiosyncratic means to achieve a dry and distressed surface that resembled fresco: he applied grounds bound in casein (a glue derived from milk), worked on unprimed panels and canvas, scratched into half-dry or dry paint surfaces and exposed his work to weather and bird-droppings (see Fig. 248).[17] George Braque's *Round Table* (Fig. 85) is a particularly clear example of an artist handling oil on canvas so as to simulate fresco. Braque used a matte ground textured with sand, combing into the gesso for further texture.

85

85 Detail. Georges Braque, *The Round Table*,
1929, oil on canvas, 145.4 x 113.6 cm.
The Phillips Collection, Washington, D.C.

Braque took numerous steps to produce
an oil on canvas that looks remarkably
like fresco on a plaster wall: he used an
absorbent ground to which he added
sand for texture, combing it in places
for additional surface effect. The artist
wanted a matte finish, and fortunately
the painting has never been varnished.

It is difficult to distinguish the matte effect of an absorbent
ground from mattness resulting from leached (blotted) paints or from an unvar-
nished surface. The artist's interest in a dry and chalky surface is certainly
more crucial to historians than is the exact means of achieving them. Moreover,
these effects are almost impossible to reproduce in book illustrations or
slides, which makes teaching about them problematic. One needs original, com-
parative examples, and it helps to visit them regularly. The conclusions about
absorbent grounds in this section were made through direct visual study of the
works in question, in consultation with knowledgeable conservators. We
encourage readers to seek out such guides.

86

86 Paul Gauguin *Self-Portrait, Les Misérables*, 1888, canvas, 45 x 55 cm. Van Gogh Museum, Amsterdam. Collection Vincent Van Gogh Foundation.

Gauguin's use of a raw, unprimed canvas is particularly visible in this exceptional example that—as the artist wished—has never been varnished (nor has it been lined; the painting's technique and condition are described in Jirat-Wasiutynski and Newton 1999, chap. 5).

Painting on Raw Canvas

The primitivizing impulse behind the use of matte grounds to emulate fresco was also manifested by a number of nineteenth-century artists working directly on the raw canvas—sometimes sized, but without a ground layer. This also produced a matte surface with a prominent canvas texture, perhaps in imitation of glue-size (distemper or *Tüchlein*) paintings. Gauguin employed such a technique in several works (Figs. 40, 86). It was also used by Degas (Figs. 141, 142), Morisot, Van Gogh, and Bernard, among others.[18] A number of twentieth-century artists have worked on raw canvas, exploiting the permeability of the support to create aesthetic effects possible only with staining (Figs. 87, 88).

Grounds for Gilding and *Pastiglia*

Early paintings with gilded backgrounds, sometimes called gold-ground paintings, required special preparation of the areas to be gilded. The ground beneath the leaves of gold (or silver or tin) foil needed to be scraped to an exceptional degree of fineness so that the metal could be burnished. The preferred ground was usually a red bole above the gesso, which not only formed a smooth enough surface but also imparted a warm color beneath the extremely thin layer of gold. This process is called water gilding because the metal leaf is applied to a wet ground. When gold was used for small details within a painted area, rather than background areas, it was attached with an

88

87 Helen Frankenthaler, *Blue Jump*, 1966, acrylic on canvas, 154 x 119 cm.
Miami Art Museum. Gift of Tina and Lee Hills.

Frankenthaler used unprimed canvas because of the unique possibilities it offered for stained effects.

88 Detail of Fig. 87.

Frankenthaler pioneered the technique of producing soft edges by allowing acrylic paint to seep into a canvas surface. A ground would render the canvas impermeable, precluding these flowing boundaries.

87

adhesive (mordant) in a process known as mordant gilding. A variation of mordant gilding is the use of shell gold, which is powdered gold used as a paint. (See also Chapter 4.) The process of preparing a panel for gilding and the subsequent gilding and punching is illustrated with great clarity in Bomford et al. 1989, pp. 21–26. Gilding is also demonstrated in the videos *Art in the Making: Italian Painting Before 1400* and *Exploring a Renaissance Masterpiece by Masaccio and Masolino in the John G. Johnson Collection* (see Bibliography).

Gold-ground paintings might include low-relief decoration called *pastiglia* (Fig. 89), built up from layers of liquid gesso, as well as decoration with punching and tooling. Scholars of early Italian painting have been able to identify various workshops through study of characteristic *pastiglia* work as well as the decorative gilding, tooling, and punching.

Ground Incising

Artists usually laid out their designs on the prepared ground with underdrawings in ink, chalk, or paint. Some artists, however, scratched into the ground to define architectural elements, to construct the perspectival scheme or as a form of preliminary or transfer drawing. Such an incised underdrawing was visible in raking light, even as the artist covered portions of it with paint. Examination of these incisions has yielded the most far-reaching implications of ground studies for art historians. Ground incising is sometimes visible with raking light or may be detected with infrared or X-ray studies.

Ground incising was commonly used as a guide for architecture in medieval painting (Figs. 90, 91). Maryan Ainsworth describes the incisions that Hans Memling (c. 1430 / 35–94) used to place the architectural elements in his *Annunciation* (New York) and Donne Triptych (London) within works in which he laid out the figures with chalk or ink underdrawings. Ground incising could also be used to construct the perspective scheme prior to placing the figures.[19]

The case studies that follow examine the ground for evidence of the artist's planning process. Case Study 13 addresses Vermeer's perspective construction. He did not incise the converging orthogonals but drew them with the aid of a string pinned to the vanishing point, which left its mark in the ground. Case Study 14 examines ground incising for hard evidence of how Uccello constructed a perspective scheme for a complex panel. Case Study 15 looks at Caravaggio's incisions in light of contemporary commentary about his radical method.

89 Detail. Gentile da Fabriano, *Coronation of the Virgin* (Fig. 107), tempera and gold leaf on panel.

The splendor of gold-ground painting was enhanced with various specialized techniques. Pastiglia was used for the Virgin's crown; the pattern in low relief was formed with plaster, then gilded. This detail also reveals incised and punched decoration and sgraffito (see pp.109–10).

89

91

90 Paolo di Giovanni Fei, *Presentation of the Virgin in the Temple*, c. 1400, tempera on hardwood, transferred from panel, 147.1 x 140.4 cm. National Gallery of Art, Washington, D.C. Samuel H. Kress Collection.

The artist used incised lines to lay out the complex architecture but not the figures. This was fairly common practice among fifteenth-century Sienese painters.

91 Detail in raking light of Fig. 90.

Lines were incised with the help of a compass and straight-edge. These differ from the free-hand incisions that some artists used to draw figures or to distinguish painted from gilded areas (see Fig. 103).

13

Case Study

Vermeer's Perspective Construction
Pinpoint Proof

Johannes Vermeer's (1632–75) methodology has provoked a great deal of speculation, much of it centering on whether he used a camera obscura to produce such apparent verisimilitude.[20] This has interested historians attempting to explain his extraordinary effects, as well as those wanting to correlate advances in the visual arts with contemporaneous scientific developments. How does Vermeer's art relate to cartography and optics? Did he know his fellow Delft citizen Antonie van Leeuwenhoek, who was famed for his work with microscopes? Technical studies of the paintings indicate that whatever optical effects he may have observed with the camera obscura, Vermeer constructed his perspective according to the standard painter's practice of the day, as described in numerous books. Jørgen Wadum, senior conservator at the Royal Cabinet of Paintings, The Hague, explains the method: "He inserted a pin, with a string attached to it, into the grounded canvas at the vanishing point. With this string he could reach any area of his canvas to create correct orthogonals, the straight lines that meet in the central vanishing point. . . . To transfer the orthogonal lines described by the string, Vermeer would have applied chalk to it. While holding it taut . . . [he] would have drawn the string up a little and let it snap back onto the surface, leaving a line of chalk."

Although no signs of the chalk lines remain, Wadum documented Vermeer's use of this method in thirteen paintings: he found evidence of the pinhole in the ground at the vanishing point, observed through X-ray studies. In the Dublin painting *Woman Writing a Letter* the pinhole is visible in ordinary light (Figs. 92, 93). Vermeer's illusionistic effects are no less remarkable despite being achieved by more conventional means than have often been assumed.[21]

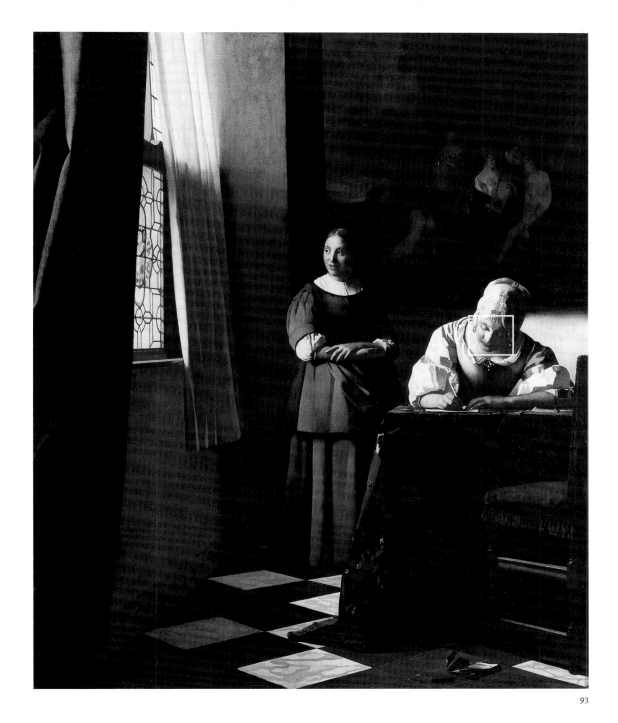

92 Macro detail in raking light of Fig. 93.

The ground hole is especially clear in this enlarged detail.

93 Johannes Vermeer, *Woman Writing a Letter*, c. 1670, oil on canvas, 71.1 x 60.5 cm. National Gallery of Ireland, Dublin.

The hole in the ground where Vermeer fixed a string at the vanishing point was observed through X-ray studies of twelve other examples. In this work it is visible in ordinary light, in the seated woman's left eye.

14

Uccello's *Hunt in the Forest*
Ground Incising Is Key to Perspectival Reconstruction

The study of ground incising proved crucial to an art historian, a conservator, and
conservation scientists who unraveled one of Paolo Uccello's (1397–1475) perspectival
schemes.[22] Uccello's devotion to mathematics and perspective is legendary. Vasari
recounts that the artist would work throughout the night; when his wife called him to bed
he put her off with the remark, "Oh, what a sweet thing is this perspective!"[23] Uccello's
work has continued to interest viewers for its emphasis on the artifice of perspective,
although his means have been uncertain.

The charming panel *Hunt in the Forest* (Fig. 94) has been discussed in art
historical literature since the nineteenth century. According to Martin Kemp and Ann
Massing, "No picture painted in the period between 1400 and 1900 represents a more
sustained attempt to subjugate a natural scene to the kind of pictorial ordering normally
reserved for architectural subjects or settings." This pictorial ordering was the subject
of a 1972 article by F. Sindona, who proposed a complex perspectival scheme (Fig. 96).[24]

Kemp and Massing studied the painting following its cleaning. With
the aid of raking light they were able to make out significant ground incisions; further
incisions and underdrawings were revealed with infrared reflectography. This was
new and crucial evidence that the authors contrasted with theoretical studies: "The evi-
dence of the perspectival underdrawing and of the incised lines revealed during the
technical examination show that previous attempts to unravel the spatial construction of
Uccello's composition have failed to uncover the underlying scheme. Indeed, previous
attempts may serve as cautionary tales for anyone who attempts to understand the
perspectival procedures behind a particular painting without direct physical or written
evidence of the design methods involved. The most elaborate of these attempts
[Sindona's, Fig. 96] also shows the danger of forcing a spurious regularity on a composi-
tion in order to achieve a desired level of geometrical intricacy."

They distinguished two stages in Uccello's perspectival planning. First he
incised orthogonal guide lines (Fig. 95) to situate the four major tree trunks, as well as a
group of lines that converge near the vanishing point. In a second stage (observable
only with infrared reflectography) he ruled lines indicating the horizon, alternate orthogo-
nals, a central vertical line, and a horizontal line halfway to the horizon. Combining
both stages, Kemp and Massing reconstructed Uccello's scheme (Fig. 97) based on a sin-

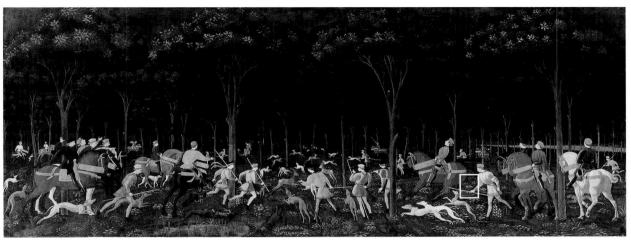

94

94 Paolo Uccello, *Hunt in the Forest*,
1460s, egg tempera and oil glazes on panel,
73.3 x 177 cm. Ashmolean Museum, Oxford.

This decorative panel, not attributed to
Uccello until the nineteenth century,
has attracted repeated scholarly interest
in its perspectival scheme. The paint
media were established by testing (see
Kemp and Massing 1991, p. 176).

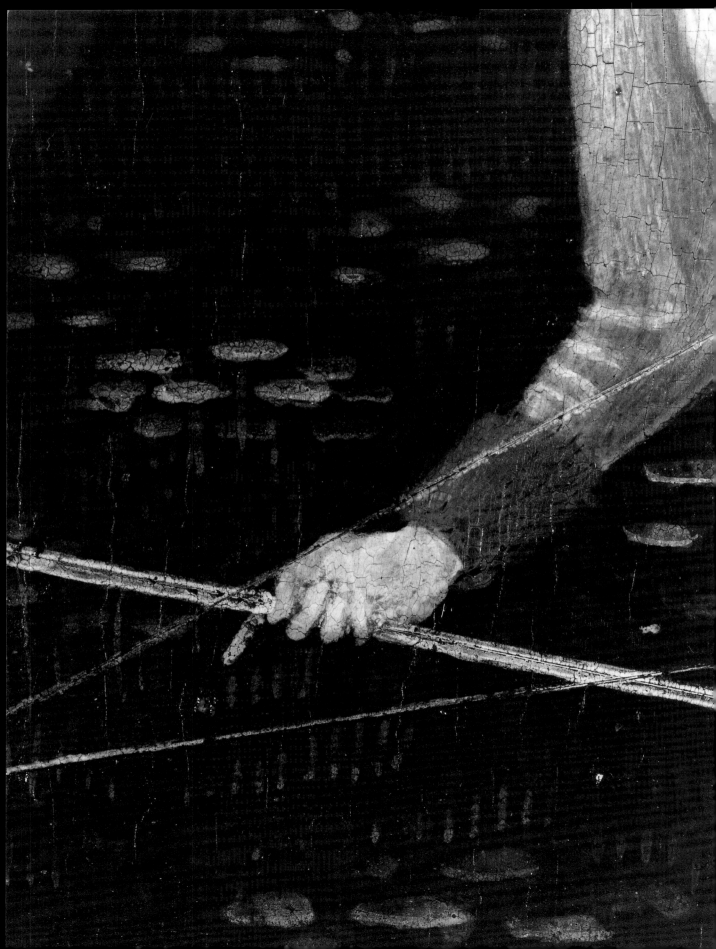

96

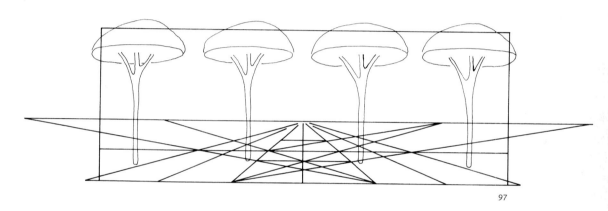

97

95 Raking light detail of Fig. 94, showing three of the incised lines that Uccello used to create the perspectival scheme. The hunter's lance sits on one of the converging orthogonals.

96 Analysis of the perspective of Fig. 94, according to Sindona in 1972. In attempting to explain the complexity of Uccello's surface design, Sindona proposed multiple vanishing points along a horizon line (drawing after Sindona).

97 Kemp and Massing analyzed the perspective of *Hunt in the Forest* in 1991, after infrared studies had revealed two phases of lines, incised in as well as drawn on the ground layer. Their scheme reveals a single, central vanishing point (drawing after Kemp and Massing 1991).

gle, central vanishing point. They summarize their results: "Compared with previous analyses of this picture, and indeed of other paintings by Uccello and his fellow perspectivists, the reconstruction suggested here has the merit of relating to a series of credible choices and procedures during the course of the conception and physical execution of the painting on its panel. It remains to be seen how far such an approach might yield a more realistic understanding of related paintings. . . . The underlying perspectival means are thus more simple than has often been assumed, while the results, following the restoration, are even more magical than we previously realized."[25] As with Vermeer's paintings, Uccello's enchanting results cannot be explained by technical novelty.

15

Caravaggio and Grounds for Argument
Incising as Evidence of Drawing from Life

Scholars had noted incisions in Caravaggio's (1571?–1610) work since the 1920s, yet there was no consensus in explaining their most unusual feature: they were not the result of transferring cartoons, as one finds in fresco painting, but were drawn freehand (Figs. 98, 99). As curator Keith Christiansen described them, "Caravaggio's incisions have, instead, the character of summary indications, and the finished picture frequently departs from them considerably, a sure sign that they were used at an early stage of the designing process."[26] Christiansen further stated that "although Caravaggio may have adapted fresco practice to his own ends, his technique is quite different both in appearance and in function from any of the examples cited above, and, so far as I have been able to ascertain, it is evidently unique."[27]

Christiansen used evidence from technical study to support observations, by the artist's contemporaries, that the most notable feature of Caravaggio's practice was his painting directly from live models. He studied a large number of paintings in raking light, as well as with X-rays and infrared, and consistently found incisions in the paintings

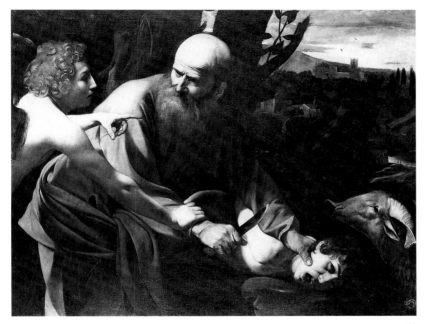

98

98 Michelangelo Merisi da Caravaggio, *The Sacrifice of Isaac*, 1603, oil on canvas, 104 x 135 cm. Uffizi, Florence.

Technical study of the painting, focusing on the role of incisions, was compared with the reports of his contemporaries that Caravaggio painted from live models. His incisions were drawn free-hand, not transferred with a cartoon.

99 Christiansen's diagram of the incisions in Fig. 98.

The white lines indicate a general placement of the figures that was adjusted in the final painting. The long diagonal line defining Abraham's right arm slices through the area where Caravaggio later painted the angel's hand. Parallel lines located Isaac's thigh, although the area was later masked with Abraham's cloak.

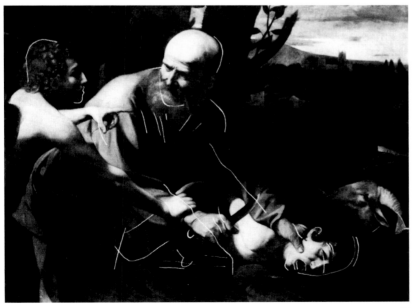

99

done between 1595 and 1605. Combining this with historical commentary about the artist's methods, Christiansen was able to resolve an outstanding question about Caravaggio's procedure: "To a degree, the question posed more than fifteen years ago by Alfred Moir—did Caravaggio draw?—may now be answered. Preliminary drawings, in the traditional sense, seem to have played no important role in the creation of Caravaggio's pictures, either in the early 'genre' paintings or the more complex pictures of his early maturity. Rather, Caravaggio seems to have begun directly with a canvas and a model, as Mancini's comments would lead one to believe." [28]

Christiansen's final question—whether the presence of such incisions can be used as the basis of attributing a work to Caravaggio—is likely to fuel ongoing debate. Even more certain is that future work on the artist will necessarily include discussion of his technique.

4

The Paint Layer

Technical examination of the paint layer can confirm a work's age or authenticity and add to knowledge of the painting's execution and the artist's intended effects. Examination can address either the materials or the ways they were handled—the techniques. Study of paint materials offers information that is specific but of limited interpretive use to the art historian. Pigment identification can deny (but rarely confirm) a painting's age, or can identify areas of repaint. Precise identification of binding media has led to a more general understanding of art history and the influence of one school of painting on another. Investigation of a painting's technique can answer a range of questions: Does the brushwork and layering structure correspond to other examples by the artist or school? Did multiple artists collaborate on the painting? What is the relationship among known variants of a painting? How did the artist(s) achieve the effects? Did the painting undergo substantial changes as the artist developed the composition, and how might such changes relate to known sketches, other paintings, historical information, or photographic records? Does the technique reflect a particular theory of painting or the influence of another artist or regional school? Why might the painter have rejected conventional tools?

Examination of the materials and techniques yield information about a painting's condition: To what extent does the present work resemble the one that left the artist's studio? Most historical and critical studies depend on

this question. Pigment analysis can reveal colors that have changed over time; examination of craquelure can reveal evidence of a painting's history. Can we date any changes, and do they have historical meaning? That is, was the format or subject altered because of a change of venue? Did changing religious doctrine or taste dictate "modernization"? Was a work repainted to erase signs of age and damage?

In this chapter we look at paint materials and then survey the implications of paint handling before turning to aging effects. Finally, we review a range of analytic techniques useful in studying the paint layer.

Pigments

An artist's palette, or range of colors, is a product of availability, expense, training, and personal choice. From earliest times colors were prescribed by tradition and legend. Earth colors predominated because of their accessibility: iron oxide reds, ochres, and brown earth were used in Paleolithic cave paintings. Other ancient colorants were obtained by grinding minerals, such as malachite (bright green) and azurite (blue), or were synthesized by simple techniques: charring animal bones to produce bone black, burning oil for lamp black and wood for charcoal black, or hanging copper strips over fermenting grape skins to make verdigris (a bluish-green).

Animal and vegetable dyes (organic compounds, as opposed to the inorganic earth colors) have also been used since prehistory; the most common are indigo (blue), madder (pink), lac (red), and saffron (yellow). Dyes processed to function as pigments are known as lake pigments. Since the mid-nineteenth century lake pigments have also been synthesized from mineral-based dyes, such as anilines. Whether natural or artificial, lake pigments tend to be impermanent, or "fugitive": they react to light by fading.[1]

The palette expanded in the late eighteenth century as artists' suppliers added modern synthesized pigments. These offered various advantages. (1) More colors were available, particularly blues, greens, and yellows. (2) The new colors were chemically and physically stable, precluding the need for artists to have detailed knowledge of which materials would interact with others. (3) They cost less. The earliest modern synthetic pigment, Prussian blue, was an affordable substitute for natural ultramarine (made from grinding the semiprecious stone lapis lazuli, which was more expensive than gold). (4) They were safer to produce and handle; the use of zinc and titanium for

whites lessened the danger of lead poisoning in the paint manufacturing industry. From the late eighteenth century on, artists were able to purchase their pigments already prepared and increasingly machine-ground. This eliminated much of the routine preparatory work from the artist's studio and produced more standard paints.[2]

Although very precise, pigment identification is of relatively limited use to art historians. If testing discloses a pigment that is too modern for the purported date of the painting, the most obvious question is whether the sample is representative of the original paint or of later repaint (see Case Study 16).

Pigment use assumes historical and critical importance when it appears to be influenced by intellectual rather than practical factors—because it affiliates the painter with a specific artistic tradition or because it reflects ideas in philosophy, alchemy, or the natural sciences. In one example, David Bjelajac discusses Washington Allston's (1779–1843) choice of pigments for both their historical and alchemical associations. Allston favored certain pigments because they were mentioned in classical writings on color-mixing or used by Venetian painters of the sixteenth century. Allston's choice of other pigments was influenced by Masonic ideas as well as contemporary writing on natural philosophy and empirical science. Sigmar Polke's (b. 1941) exceptional use of such colorants as tellurium and mica dust has attracted similar alchemical interpretation. Seurat's *Grande Jatte* offers an interesting example because it was painted in several campaigns during a period of active debate over color theory (Fig. 100). Inge Fiedler's research indicates that Seurat eliminated earth pigments and black in later stages of the painting. He was following the advice of Signac, who was influenced by such color theorists as Chevreul and Rood. Furthermore, Fiedler's pigment analysis confirms Felix Fénéon's comments that the painting had suffered noticeable color changes within a few years (Fénéon cited shifts in the greens and oranges).[3]

For a chronology of common pigment use, see Appendix 1.

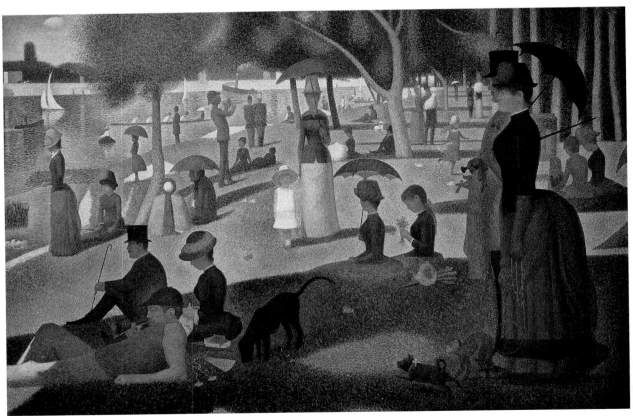

100

100 Georges Seurat, *Sunday Afternoon on La Grande Jatte*, 1884, oil on canvas, 207.6 x 308 cm. Art Institute of Chicago, Helen Birch Bartlett Memorial Collection (1926.224).

Examination of paint samples disclosed that Seurat, influenced by writings on optics, narrowed his palette over three successive stages of work (see p. 103). The painting remains unvarnished and displayed under glass, as the artist intended.

Examination of the Paint Layer
by Cross-Sections and Destructive Sampling

Paint examination usually requires samples—either tiny flakes or cross-sections. As we discussed in Chapter 3, these are usually taken from the edge of the painting or near an area of damage. The description of cross-sections as destructive is literally correct, but some researchers consider it alarmist. Ashok Roy, conservation scientist at the National Gallery, London, made the point most clearly. He calculated that, based on the size of the samples taken from Titian's *Bacchus and Ariadne* during its treatment in 1967, "erosion of Titian's painting by 1% of its surface area by this means would take over 5 million samples, or putting it another way, campaigns of sampling removing fifty samples in each campaign every ten years would take a million years to do this level of damage." Cross-sections allow the study of paint layering as well as identification of pigments. Cross-sections have been used to compare a painting with known examples of an artist's work, to distinguish different campaigns of work by the original artist or later hands, and to identify repaint in an upper layer.

Identification of pigments other than lakes is straightforward, and in fact pigments can occasionally be identified simply through optical examination of the painting's surface under magnification. Identification of binding media always requires samples and is more difficult. Both physical and chemical identification of pigments is commonly done in conservation laboratories.[4]

Sampling of pigments—as opposed to analyzing them—can lead to disputed results. It must be carried out by researchers knowledgeable about scientific examination *and* about the specific issues of examining paintings. The samples are the size of a pinprick; their usefulness depends on whether they are representative of the entire painting. A sample of repaint says nothing about the earlier paint. We will demonstrate the importance of paint sampling in the following study, a cautionary tale. Critics had based a negative assessment of a painting on details that turned out to be repaint. The painting's age is supported by the identification of lead-tin yellow, the only pigment known in earlier paintings that had dropped out of use.

101 Georges de La Tour, *The Fortune-Teller*,
c. 1630–1634, oil on canvas, 102 x 123 cm.
Metropolitan Museum of Art, New York.
Rogers Fund (1960).

Twenty years after the painting's
purchase its authenticity became the
subject of scandal. Pigment analysis
confirmed its age.

16

La Tour's *Fortune-Teller*
Pigment Identification Confirms the Fortune

Few curatorial files in the Metropolitan Museum of Art are as bulky as that devoted to *The Fortune-Teller* by Georges de La Tour (1593–1652) (Fig. 101).[5] Four bulging folders are stuffed with articles documenting an unusually public and nasty argument among scholars of seventeenth-century painting. The crux of the controversy is summarized in the title of Christopher Wright and Diana de Marly's article in *Connoisseur*: "FAKE?"[6] Had the Met purchased a forgery?

The painting's authenticity was questioned a few years after its acquisition in 1960, first by Benedict Nicholson and subsequently by de Marly and Wright. The suggestion that Anthony Blunt suppressed a negative article on the painting only added to the aura of scandal. When the museum acquired the painting it had only a brief recorded provenance dating from the twentieth century ("provenance" is the history of a work's location and ownership). Doubts about the painting's authenticity focused on the historical accuracy of the costumes and a scatological inscription (the word *merde*) that appeared to be worked into one of them, provoking Wright and de Marly to comment, "Is this to be explained as Lunéville humor of the 1620s? If this is so, we are all dupes. 'MERDE' should mock at us across the single generation which probably separates us from the creation of the painting in its present form." More subjective criticism included charges of "psychological weakness" and dissimilarity with most of the rest of the artist's work.[7]

Enough comparative technical information has been published about La Tour's oeuvre since 1993 to establish *The Fortune-Teller* as a characteristic example of the artist's work. But in 1981, when the museum responded to its critics, the most convincing argument for the painting's authenticity came from a series of technical studies, most notably paint sampling. As John Brealey and Pieter Meyers, head of paintings conservation and conservation scientist at the Metropolitan Museum of Art, explained: "The signature has not been overpainted and is entirely original. The only other genuine writings on the picture are the words 'AMOR' and 'FIDES.' . . . The word 'MERDE' is a modern invention done by turning the free brush strokes simulating

102

103

102 Agnolo Gaddi, *Madonna Enthroned with Saints and Angels* (middle panel), 1389–90, egg and glue tempera (medium analyzed) and gold leaf on panel, 203.8 x 80 cm. National Gallery of Art, Washington, D.C. Andrew W. Mellon Collection.

The artist used a variety of techniques to create a rich effect, including punching and tooling the gilded areas and employing *sgraffito* on the steps leading to the Virgin's throne. For a detailed technical study of the altarpiece, see Mary Bustin, "Recalling the Past: Evidence for the Original Construction of 'Madonna Enthroned with Saints and Angels' by Agnolo Gaddi," *Studies in the History of Art* 57 (1997): 35–65.

103 Raking-light detail of the bottom center of Fig. 102.

This closeup reveals incising used to lay out the composition and mark off areas for gilding and *sgraffito* work (in which the gilded layer is first overpainted, then the paint is partially removed) to simulate brocade or tooled leather. The vertical split and associated paint loss is a characteristic aging effect of wood.

the decorative design of the collar (worn by the second female figure on the left) into letters. The false paint is executed in a coarsely ground black which does not match the dark greenish-grey of the original brush strokes and fills the cracks. The 'R' and the 'D' are additions while the other letters are formed by altering original brush strokes. Examination of the painting by means of infrared-reflectography and ultra-violet illumination confirmed the observations described above."[8]

So, a restorer's joke had misled the painting's critics. Analysis of the rest of the paint confirmed its age. A variety of tests identified pigments standard in the seventeenth century, most notably lead-tin yellow. The presence of this last pigment was crucial, as Brealey and Meyers explained: "Because this pigment was not used in oil painting after 1750 and its existence was unknown until its rediscovery in 1941, the presence of this lead tin yellow is in strong support of the authenticity of the painting. . . . *The Fortune-Teller* was known to exist before the rediscovery."[9]

Gilding, Tooling, Punchwork

Gilding is a different technique from painting, but we address it here because it is part of the design layer. As we pointed out in the previous chapter, the gold (or possibly silver or tin) leaf is fixed to the ground and then burnished. The metal leaf frequently covers significant areas of the panel, and its surface was often embellished with incised decoration. This was frequently done to delineate haloes (Figs. 102, 103) or simulate brocade, in a technique known as *sgraffito*, in which gilding is covered with paint that is selectively removed to reveal the gold (see also Fig. 89). The artist employs either a stylus or a series of punches—tools that also are used to create decorative patterns in leather and metal. Specialists in gold-ground paintings, who study the works with low magnification and correlate evidence from many examples, have been able to trace punches to specific artists' workshops. Scholars have used punchwork evidence in attributions, in reassembling polyptychs, in studying workshop practice, and in establishing the interaction among communities of artists.

Gilding is subject to two distinct problems with age: discoloration and losses. Silver gilding tarnishes, becoming black, and for this reason almost none of it remains in its original form (see Fig. 168). The thin layer of gold or silver is generally subject to the same flaking and abrasion as the

rest of the paint layer. Areas or cracks where the colored ground is visible were not part of the original design. Gilding is also subject to theft because of the value of the gold; some early panels exhibit scratch marks as evidence of such pilferage. It is important to examine gilded areas for signs of repair or even complete regilding. This usually involves microscopic examination of the surface or of samples, the same methods used for examining the rest of the paint layer.

Sources on Gilding, Tooling, and Punchwork

Dunkerton et al. 1991, pp. 174–82, gives a concise overview of gilding and *pastiglia* as used by both Italian and northern European artists during the fourteenth and fifteenth centuries and illustrates a variety of decorative effects. Bomford et al. 1989, pp. 21–26, illustrates the process of gilding through sequential photographs of a re-creation of medieval technique. Beatson, Muller, and Steinhoff 1986 and Frinta 1993 incorporate studies of tooling and punchwork within art historical studies, as do several articles in *Simone Martini: Atti del covegno* 1985 and *La pittura nel XIV e XV secolo. Il contributo dell'analisi tecnica alla storia dell'arte*, Atti del 24 Congresso Internazionale di Storia dell'Arte, III, Bologna, edited by H. van Os and J. R. J. van Asperen de Boer, Comité International d'Histoire de l'Art (1979), pp. 211–36, 293–95, 253–82. On *sgraffito*, see Cathleen B. Hoeniger, "Cloth of Gold and Silver: Simoni Martini's Techniques for Representing Luxury Textiles," *Gesta* 30, no. 2 (1991): 154–62.

Binding Media

The binding media hold the pigments and fix them to the support. The choice of medium affects the paint's handling and aging properties. Although paint handling has varied greatly throughout the history of Western art, there are only two significant periods when new paint media have made pervasive contributions: during the fifteenth and sixteenth centuries, when drying oils came into general use, and during the mid-twentieth century, when acrylic paints became readily available.

One can use the term *tempera* for paint in any medium, including oil; "to temper" is simply to mix—a usage found in early artists' manuals. However, tempera more commonly refers to pigments bound not in oil but in egg or other water-based media (animal glues or vegetable gums). Until the late middle ages temperas of one sort or another were the primary media for panel paintings. Wall paintings were usually executed in fresco, in which pigment is applied directly to wet plaster without a binding medium.

Paint bound in wax, sometimes termed encaustic, is of ancient origin but used only rarely in easel painting. Wax has distinctive handling characteristics and produces a unique surface appearance: murky yet translucent and with a variable sheen. These are presumably the reasons that several modern artists have chosen it as a binder. The most familiar ancient examples are the Egyptian burial portraits from Fayum.

Although scientific analyses allow one to distinguish among binding media, the tests are difficult and sometimes inconclusive. This is because egg contains many of the same chemical compounds as drying oils, but in slightly different proportions. It is equally difficult to distinguish egg binders from glue. All the tests require samples.[10]

The more important question for art historians concerns the range of effects possible with different media. In practice, one can often identify the medium by scrutinizing the paint, perhaps aided by magnification. However, visual analysis alone will rarely allow one to distinguish among various types of temperas, nor will it disclose the use of mixed media.

Mixed media can refer either to the use of tempera to bind certain colors and oil to bind others within the same painting, or to a combination of binding media throughout. The first usage, which is discussed below (Drying Oils), resulted from artists' long experience: certain pigments interacted badly with specific binders—for example, copper resinate greens could be bound only in oil, while smalt worked better in tempera. This type of pigment-by-pigment mixed media was common through the sixteenth century but is still incompletely documented. Analytical evidence for the use of a mixed binder throughout a painting (such as oil or wax combined with resins) is not common; however, historical sources suggest that it enjoyed some use among eighteenth- and nineteenth-century British and American artists, and some are well documented. These truly mixed media can sometimes be recognized by characteristic drying problems, described below. Another minor variation on mixed media is the use of tempera for some layers and oil for others within the same painting. This practice was used in the fifteenth and sixteenth centuries and was revived by a handful of twentieth-century artists who experimented with technique.[11]

Sources on Encaustic

For an excellent introduction to painting in wax that includes ancient examples and eighteenth- through twentieth-century revivals, see Danielle Rice on "Encaustic Painting" in *The Dictionary of Art* (London: Macmillan, 1996), vol. 10, pp. 196–200. Also see the exhibition catalogue "Waxing Poetic" (Stavitsky 1999), which includes historical background and essays on the contemporary use of the technique. Jirat-Wasiutynski and Newton 1999 discusses Gauguin's use of wax as a binder and surface coating; Jasper Johns' wax and collage technique is covered in Francis 1984 and Fred Orton, *Figuring Jasper Johns* (Cambridge: Harvard University Press, 1994); Brice Marden comments on his use of encaustic in Götz 1992. Arthur Dove (1880–1946) was notable in his use of wax, which Elizabeth Hutton Turner credits to his reading Doerner: "The fall of 1935 found Dove reading 'every inch' of Max Doerner's technical compendium, *The Materials of the Artist*, a translation of which had appeared the previous year. 'Wish I had it years ago,' Dove wrote to Stieglitz, 'Georgia [O'Keeffe] said she reads it like the Bible'" (*Arthur Dove: A Retrospective*, catalogue [Andover, Mass., and Washington, D.C.: Addison Gallery of American Art and the Phillips Collection, 1997], p. 104). For a technical study of Dove, see Justine S. Wimsatt, "Wax Emulsion, Tempera, or Oil? Arthur Dove's Materials, Techniques, and Surface Effects," Preprints, American Institute for Conservation's Tenth Annual Meeting, Milwaukee, May 26–30, 1982, pp. 183–88.

Egg Tempera

Egg tempera was the primary medium of Western easel painting through the early Renaissance. Recipes varied, most commonly employing just the yolk, although some early and modern authors recommend using the whole egg. Eggwhite alone, known as glair, was more commonly used for painting on parchment (illumination) than for panel paintings, although glair was sometimes used as a varnish on panels (see Chapter 5). Egg tempera dries

very quickly.[12] This property determines both the paint handling, since the artist could not make corrections, and the planning required—the daily color requirements had to be estimated, since pigment mixed in egg medium would not last.

The demand for precise technique and thin application produces the characteristic look of tempera—short, parallel brushstrokes.[13] Such paintings in good condition constitute a stroke-by-stroke record of the artist's handwork (see Figs. 75, 89). Egg tempera develops a characteristically delicate crackle pattern as it ages (see Figs. 11, 95, 103, 256).

Sources on Media Identification

Research in medium identification and the limitations of existing techniques are discussed by Joyce Plesters, "Investigation of Materials and Techniques," pp. 60–61, and appendix B in David Bull and Joyce Plesters, "Feast of the Gods: Conservation, Examination, and Interpretation," *Studies in the History of Art* 40 (1990). For a detailed discussion of analytic techniques for distinguishing egg from glue binder, see Raymond White, "The Characterization of Proteinaceous Binders in Art Objects," *National Gallery Technical Bulletin* 8 (1984): 5–14. For a study using current methods to identify both glue and oil binders, see David Bomford, Ashok Roy, and Alistair Smith, "The Techniques of Dieric Bouts: Two Paintings Contrasted," *National Gallery Technical Bulletin* 10 (1986): 39–57.

Size (Distemper) and Other Temperas

Artists have used other water-based paint media, most commonly size, or glue made by boiling animal organs and bones or parchment. Glue could likewise be made from fish—the term for it is *isinglass*. It was a regular supply in pantries of the past, used for making jellies. Glue-based paint is also known as distemper or *Tüchlein* (the modern Italian for a glue-based paint is *tempera magra*). Distemper dries somewhat more slowly than egg tempera does, and details can be added over dry paint, offering the painter more flexibility. Paintings in distemper (Figs. 40, 41, 42, 104, 105, 141, 142) have a distinctive look because of a combination of factors. (1) The canvas, being unprimed, is particularly prominent; these paintings might be mistaken for tapestries, and some were consciously painted as cheaper substitutes for woven hangings. (2) Additional details can be added as they cannot in egg tempera, but they must be applied very lightly, in a manner of brushwork that resembles penwork (Fig. 105). (3) Glue-size temperas were not originally varnished; if they remain unvarnished they have a chalky look. The characteristic appearance of the technique was captured vividly by Vasari when he described the self-portrait that Dürer (1471–1528) had exchanged with Raphael: "This portrait was an exquisite thing, for it had been coloured in gouache [the Italian is *guazzo*, which indicates a water-based paint but does not specify the binder] with much diligence with water-colours, and Albrecht had executed it without using lead-white, availing himself in its stead of the white of the cloth, with the delicate threads of

which he had so well rendered the hairs of the beard, that it was a thing scarcely possible to imagine, much less to do; and when held up to the light it showed through on either side."[14]

Any later addition of varnish to paintings bound in glue significantly alters both the reflectivity and the colors. The lack of varnish and the reactivity of the paint to water has meant that most distemper paintings have survived poorly—it is hard to imagine the "miraculous" effect that Vasari described from some of the ghostly remnants now visible in museums. For a study list of paintings in distemper that have survived without varnish, see Appendix 2.

Casein is a glue made from skim milk. It is another aqueous paint medium but has been used only rarely for easel painting. Jacob Lawrence painted his *Migration* series in casein (Case Study 12); other exceptions are cited below.

Vegetable gums (gum arabic, from the sap of the acacia tree, and gum tragacanth, from the sap of *Astragalus* shrub), deserve a footnote among tempera media, but their visual identification is difficult and is not of significance to art historians. They produce a paint that handles similarly to other water-based media, and their use is not limited geographically or historically.

Drying Oils

The transition from tempera to oil as the primary binding medium is surrounded by legend. As with most traditional sources, the stories contain some verifiable truth and a good deal of speculation. Vasari attributed the modern (that is, sixteenth-century) style of painting to the new medium and credited the invention to the Van Eycks. The difference between fifteenth-century Netherlandish paintings and those done in traditional Italian technique (Figs. 106, 107), or indeed between Florentine painting of the early fifteenth century and that of Vasari's day (Figs. 89, 107–9), is so great that it begs an explanation. Unfortunately, neither literature nor the limited evidence from scientific examination

Sources on Tempera Revival in the Twentieth Century

A number of European and American artists revived the practice of tempera painting during the 1920s and '30s. Some derived recipes from handbooks on medieval technique, notably Max Doerner's *Materials of the Artist and Their Use in Painting* (1921, English translation of the 3rd ed., 1934) and Daniel V. Thompson's *Practice of Tempera Painting* (1936). Formulas also circulated among artists. During the 1920s Otto Dix developed a complicated technique of oil glazes over layers painted in tempera; while the technique supposedly was based on his study of Dürer and other old masters (he was nicknamed "Old Master Dix" and "Otto Hans Baldung Dix"), Bruce Miller argues convincingly that he probably derived the recipe from Doerner (Miller 1987, p. 350). Jacob Lawrence, who had initially used a casein-based tempera (with a recipe learned from Romare Bearden), turned to an egg-tempera recipe in Ralph Mayer's *Artist's Handbook of Materials and Techniques* (1940). For an example of Lawerence's use of casein, see Case Study 12. In an unpublished interview by Harriet Irgang, Lawrence said that he switched from casein to egg because he preferred the gloss of the latter (July 23, 1990, recorded in the files of Rustin Levenson Art Conservation Associates, New York City). Jacob Kainen recalls that Kenneth Hayes Miller and his students at the Art Students League taught a form of tempera technique that was employed in painting stage sets; Kainen termed it "show-card tempera" and said that it had chalk added (in phone conversation, September 19, 1996). Paul Cadmus remembered learning tempera technique from a colleague as well as from Thompson's manual. Cadmus said that such artists as George Tooker, who initially learned tempera using the whole egg from Kenneth Hayes Miller, later learned to use only the yolk from colleagues who had read Thompson (in phone conversation, September 11, 1996).

104

104 Dieric Bouts, *The Annunciation*, c. 1450–55, glue tempera (distemper) on canvas, 90 x 74.5 cm. J. Paul Getty Museum, Los Angeles.

The distinctive appearance of glue (size) painting results from the handling properties of the paint medium and the lack of a ground layer—hence the prominence of the finely woven canvas. The medium of the painting was identified optically but not analytically, although its companion in London has been tested (see David Bomford, Ashok Roy, and Alistair Smith, "The Techniques of Dieric Bouts: Two Paintings Contrasted," *National Gallery Technical Bulletin* 10 [1986]: p. 47 and n. 10).

105 Detail of Fig. 104.

Bouts' handling of the Virgin's hair is characteristic of glue (size) painting, which dries more slowly than does egg tempera, allowing the artist to add details over other paint. Paintings executed in this technique were not originally varnished; rare examples, such as *The Annunciation* (and companion paintings in London and Pasadena; see Appendix 2), have retained the chalky surface associated with the medium.

106 Jan Van Eyck, *Double Portrait of Giovanni di Arrigo Arnolfini and His Wife Giovanna*, 1434, oil, perhaps with some egg tempera on oak panel (description supplied by the National Gallery; the medium has not been analyzed scientifically), 81.8 x 59.7 cm. National Gallery, London.

Oil-based paint allowed smooth transitions, such as the cast shadows and the subtle chromatic effects achieved through glazing. Van Eyck exploited the possibilities of the medium to produce the illusion of light permeating the space. With tempera, such visual richness had not been possible, but it was enhanced with gilding and its associated decorative techniques (Figs. 102, 107).

107 Gentile da Fabriano, *Coronation of the Virgin*, c. 1420, tempera and gold leaf on panel, 87.5 x 64 cm. J. Paul Getty Museum, Los Angeles.

The range of handling effects of tempera was limited by the rapidly drying medium. Gentile enriched the surface with specialized gilding techniques: tooling, or decorative scoring in the gold (the haloes and clothing details); *pastiglia*, or applied plaster decoration (the Virgin's crown, see detail, Fig. 89); and *sgraffito*, where the gold is partially covered by paint (the mantles of Christ and the Virgin, as well as the green and gold drapery behind them).

107

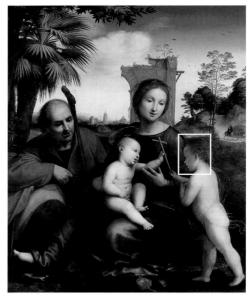

108

108 Fra Bartolommeo, *The Rest on the Flight to Egypt with St. John the Baptist*, c. 1509, oil on panel, 129.5 x 106 cm. J. Paul Getty Museum, Los Angeles.

The flexible handling properties of an oil medium allowed for the illusion of solidity of the figures and their integration within the landscape.

109 Detail of Fig. 108.

Oil paint enabled Bartolommeo to model forms with seamless gradations that had not been possible with tempera.

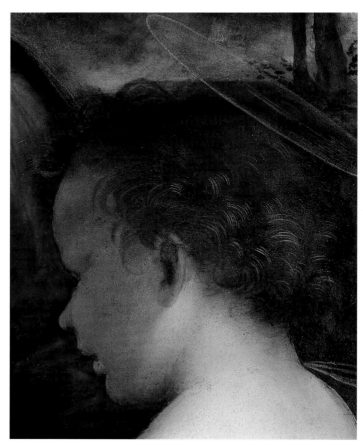

109

provide a simple one. Oils had had limited use by painters since at least the sixth century. Medieval artists used oil for various purposes: as a mordant (adhesive) for gilding, as a binder for certain pigments requiring a transparent medium, and for glazes over gilding within paintings that were otherwise bound in tempera. The transition from tempera to oil is further complicated by the fact that long after oil was the predominant medium of choice, artists continued to use temperas to bind specific pigments (such as azurite), or combinations of oil and egg binders, because of their physical or chemical properties. Botticelli added oil to an egg medium to produce a *tempera grassa* for his *Primavera*, and recent research reveals that Rembrandt added egg to his oil medium to influence its handling properties. Painters did not need to define their work strictly according to medium; they cared about the handling properties, and the handling properties of the medium are what should concern us.[15]

Some time during the fifteenth century artists began to solve the problem of getting oils to harden. They learned to select those oils that dry and to hasten the process by adding drying agents ("siccatives," metallic salts). Drying oils are those that form a hard film in contact with air and include walnut, linseed, and poppy oils. Olive oil, which was easily available in the Mediterranean, will not dry. Compared to temperas, however, oils dry slowly. This slowness in drying and variable thickness of the resulting mixture yields the characteristics that we associate with oil paints: (1) Oil paint can be applied in layers either transparently, so that the upper layer forms a colored glaze influencing the reading of the lower layer, or opaquely—allowing the painter to make corrections (*pentimenti*). (2) The prepared paint stays viscous from day to day, eliminating the need to estimate the precise amount of color needed. (3) An oil binder allows flexible mixing of colors and gradual transition from one color to the next. (4) Oil paints can be applied with a surface texture (impasto), and substances can be added to give additional texture to the paint. (5) They can be used to create luminous and shiny effects—virtual highlights, beyond the actual highlights achieved with gilding.[16]

By its nature, an oil medium allows a variety of approaches. Within the first century that oil became the dominant medium, competing methods of painting developed, championed by warring theories. The debate over paint application has continued throughout its use; this is reflected in nineteenth-century controversies over "finish," in Signac's disgust at Matisse's thick, unmodulated outlines, and in turn by Matisse's response to early cubism.

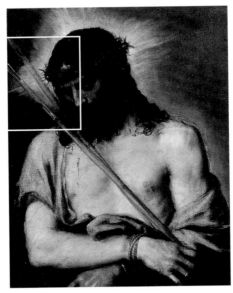

110 Titian (Tiziano Vecellio), *Ecce Homo*,
c. 1558–60, oil on canvas, 73.4 x 56 cm.
National Gallery of Ireland.

Titian's technique had a major
influence on subsequent artists. His
visible changes of design as he
worked (*pentimenti*) and his flexible
brushwork were particularly impor-
tant to Baroque painters. *Pentimenti*
are clearly visible in the position
of the staff, Christ's left shoulder and
the ropes binding his wrists. Such
pentimenti fueled the debate over the
Venetian emphasis on *colore* versus
the Florentine reliance on *disegno*.

111 Detail of *pentimento* in Fig. 110.

Note the significant change in the
position of the staff. Although some
reworkings may have become more
visible with age, contemporary
accounts suggest that the artist allowed
others to show, emphasizing the
spontaneity of his method. Scalloping
is visible along the left border,
where the canvas distorted during its
initial stretching (see pp. 43–44).

110

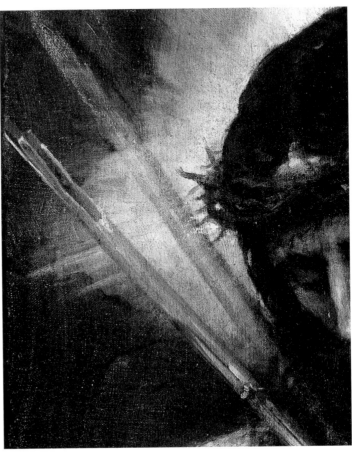

111

Paint Handling

Oil paint lends itself to two distinct methods of application. The first type, layering (also known as glazing and scumbling), involves the methodical building up of paint in stages. Some layers are more or less opaque; others are more or less transparent. Glazes are transparent throughout, and scumbling is a means of applying opaque paint in variable thickness to render it partially transparent. Layering technique always involves some areas of transparency where the color is the product of more than one paint layer. The second type, *alla prima* painting, also called wet-in-wet painting, employs fairly opaque paints and lends itself to spontaneity of both design and brushwork. The methods are not exclusive; an artist could use both within a single painting.

In the sixteenth century, these competing methods of painting became associated with the theoretical debate between the Florentine tradition of *disegno* ("drawing," in which the artist thoroughly worked out the composition through drawings that were transferred to the primed support—an approach that lent itself to layering) and the Venetian emphasis on *colore* ("coloring," associated with Giorgione's and Titian's method of painting without carefully worked out and transferred drawings; the Venetians made compositional revisions at the painting stage) (Figs. 110, 111). Philip Sohm has charted the development of the concept of painterly brushwork and its reception in Italy through the seventeenth and eighteenth centuries. Gridley McKim-Smith has shown that sixteenth-century Italian art theory was central to several topics that were hotly contested by seventeenth-century Spanish painters and critics: *borrones*, or spontaneous paintwork that looked like splotches when viewed up close (Figs. 112–14), as well as visible changes (*pentimenti*) (Figs. 115, 116). Ernst van de Wetering's research confirms that Titian's example was also a model for Rembrandt's *pentimenti*.[17] Despite the predominance of *alla prima* technique, the Baroque masters retained a system of layering, as had Titian; Venetian *alla prima* technique employed glazes for specific color effects.

Art theorists continued to take sides over the politics of brushwork, and it has been fertile ground for historical study. The debate would reappear in the nineteenth century when the impressionists rejected the layering technique of the academy in favor of *alla prima* painting, in yet another conscious emulation of the Venetians.

Alla prima painting does not have to be impromptu; it simply allows for effects that are unplanned at the start of work. A number of modernists used techniques that confound the terminology. Ensor (1860–1949) painted *alla prima* for deliberate effects that suggested spontaneity (see Fig. 135).

112 Titian (Tiziano Vecellio), *Doge Andrea Gritti*, 1546–48, oil on canvas, 133.6 x 103.2 cm. National Gallery of Art, Washington, D.C. Samuel H. Kress Collection.

Titian's impasted surface effects were also of crucial importance to Baroque painters.

113 Detail of Fig. 112.

The exceptional unlined condition of this canvas (see p. 174) has left Titian's paintwork intact. Such expressive impasto became a model for Velázquez (see Fig. 114) and others.

112

113

Mondrian (1872–1944), on the other hand, applied opaque paint with many reworkings to produce paintings that look thoroughly planned (Case Study 22). In his late work Monet (1840–1926) applied layers of opaque paint for textural rather than coloristic effect (Figs. 131–34). His technique is usually described as *alla prima*—incorrectly. He worked in multiple sessions, painting over dry layers when manipulating surface effects.

Painters developed conventions of paint application according to local tradition, influence of other traditions, or personal experiment. For glazing and scumbling, work began with some form of underdrawing on the prepared ground (in chalk, ink, or a thin wash of paint—the choice determines its detectability by such methods as infrared photography and reflectography). During certain periods the entire composition was then developed in monochrome, a stage known as dead-coloring, or in polychrome as an initial lay-in. The artist then built the forms and details in color. The working order varied. Some artists developed the composition from background to foreground, bringing part of a painting to completion while other areas were not yet begun; other artists worked the entire canvas to the same state of completion, layer by layer. It has been hard to learn how consistently different artists or schools sequenced their paint application. We are dependent on scant written records or on the evidence of unfinished paintings (Fig. 117). Appendix 2 contains a very preliminary list of unfinished paintings that reveal the artist's working order.

It is impossible to generalize about oil technique from the sixteenth through twentieth centuries. As with many aspects of painting practice, analysis of paint layering and brushwork is most useful when comparative studies exist for the particular artist or school. This makes the large and systematic studies invaluable. These include the Rembrandt *Corpus*, Garrido on Velázquez 1992, Groen and Hendricks on Frans Hals (in Slive et al. 1989), *Lucas Van Leyden Studies* 1978, Parris and Fleming-Williams 1991 on Constable, C. Périer d'Ieteren, *Colyn de Coter et la Technique Picturale des Peintures Flamandes du XVe Siècle* (Brussels: Lefebre et Gillet, 1985) on early Flemish painting, *Poussin et la peinture française* 1994, *Princeton Raphael Symposium* 1990, Townsend 1996 on Turner, and van de Wetering on

Sources on Drawing Within Venetian Painting Technnique

Venetian *alla prima* technique is more complex than the stories it inspired. Underdrawings by both Giorgione and Titian have been revealed; none, however, look as though they were transferred via cartoons or through squaring, as would have been Florentine practice. For Giorgione's underdrawings, see Charles Hope and J. R. J. van Asperen de Boer, "Underdrawings by Giorgione and His Circle," *Le dessin sous-jacent dans la peinture*, Colloque VIII, September 8–10, 1989 (Louvain-la-neuve: Collège Erasme, 1991): 127–40, and Jaynie Anderson, *Giorgione: The Painter of "Poetic Brevity"* (Paris: Flammarion, 1996; English ed., 1997), chap. 3. For Titian, see Bert W. Meijr, "Titian Sketches on Canvas and Panel," *Master Drawings* 19 (1981): 276–89+, and Volle et al. 1993, p. 65 and fig. 15.

114

114 Detail. Diego de Velázquez, *Prince Baltasar Carlos on Horseback*, 1635, canvas, 209.5 x 174 cm. Museo del Prado, Madrid.

The free paint application seen in the golden highlights on the prince's costume were termed *borrones* (splotches). Their use, which reflected an admiration of similar effects in Titian's work, was defended in seventeenth-century Spanish theoretical writings (see p. 121). The paintwork is in extraordinary condition on this unlined canvas.

115 Diego de Velázquez, *Phillip IV*, 1623, canvas, 198 x 101.5 cm. Museo del Prado, Madrid.

Changes (*pentimenti*) to Phillip's stance—originally wide-legged—and to the outline of his cape may have been visible initially, but they have become more prominent as the paint has aged.

116 X-ray study of Fig. 115.

This image not only clarifies those changes observable in visible light but indicates that Velázquez adjusted the position of both hands as well. The stretcher, cross-bar, and wedges of wood used to adjust the tension of the stretcher appear light. The narrow white horizontal lines are the edges of the multiple films used to assemble the X-ray image.

115

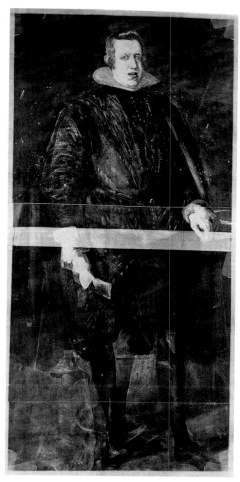

116

Rembrandt, 1997. We have noted other studies in the Bibliography that are based on a body of work rather than a single painting. They will be useful for comparisons.

Pentimenti are signs of reworked areas in the paint layer (Figs. 110, 111, 115, 120), places where the artist covers original paintwork with a revision. Art historians find *pentimenti* interesting for several reasons: they demonstrate that the artist actively developed the design during the painting process and suggest that the painting is not an exact copy of another work; *pentimenti* sometimes indicate changes that have historical or iconographic interest; and they reveal an intimate phase of the artist's working process. *Pentimenti* may be visible initially or may become apparent in ordinary light as a painting ages. The term has also been extended to cover those changes that are revealed by such analytic techniques as radiography or, more rarely, by infrared reflectography. *Pentimenti* become visible for several reasons: (1) the upper layer of paint may turn increasingly transparent with time (Fig. 118); (2) cracks may develop in the upper paint layer, revealing different colors in the layer below; or (3) on some occasions the heavy impasto of the original design may show through the upper layer in ways that do not conform to the visible image (Figs. 119, 120, 196).[18]

Pentimenti carry no fixed meaning; their interpretation always depends on the context. We have referred to the way that *pentimenti* became involved in theoretical debates during the sixteenth and seventeenth centuries; examples and case studies (see p. 193 and Case Studies 19 and 20) show various interpretations of the presence—or absence—of *pentimenti*.

Sources on the Politics of Brushwork

In addition to works cited in the Bibliography (Bomford et al. 1990, Callen 1982, Herbert 1979, and Miller 1987), see Albert Boime, *The Academy and French Painting in the Nineteenth Century* (London: Phaidon, 1971); Yve-Alain Bois, *Painting as Model* (Cambridge: MIT Press, 1990); Anthea Callen, "Impressionist Techniques and the Politics of Spontaneity," *Art History* 14, no. 4 (1991): 599–608; Christopher B. Campbell, "Pissarro and the Palette Knife: Two Pictures from 1867," *Apollo* 136 (November 1992): 312–14; Anne Coffin Hanson, "Edward Hopper: American Meaning and French Craft," *Art Journal* 41 (Summer 1981): 142–49, and "Manet's Pictorial Language," in *Manet, 1832–1883*, catalogue (New York: Metropolitan Museum of Art and Harry N. Abrams, 1983), pp. 20–28; Reinhold Heller, "Concerning Symbolism and the Structure of Surface," *Art Journal* 45 (Summer 1985): 146–53; John House, *Monet: Nature into Art* (New Haven: Yale University Press, 1986); Fred Orton, *Figuring Jasper Johns* (Cambridge: Harvard University Press, 1994); Charles Rosen and Henri Zerner, *Romanticism and Realism* (New York: Viking, 1984), chap. 8; Mary D. Sheriff, *Fragonard: Art and Eroticism* (Chicago: University of Chicago Press, 1990), especially chap. 4; and Richard Shiff, "Cézanne's Physicality: The Politics of Touch," in *The Language of Art History*, edited by S. Kemal and I. Gaskell (Cambridge: Cambridge University Press, 1991), pp. 129–80.

Beyond the Brush: Experimental Paint Application

When an artist employs unconventional means to apply paint, the results always command art historical interest. Artists' brushes date back to prehistory, and modern brushes closely resemble their ancient ancestors except for the metal ferrule—the band that secures the hair to the handle. The ferrule,

117

117 Rosso Fiorentino, *Allegory of Salvation*, 1521, oil on poplar, 161.3 x 119.4 cm, Los Angeles County Museum of Art. Gift of Herbert T. Kalmus.

Rare unfinished examples such as this are the best indication of an artist's order of painting. Some painters worked up the entire composition evenly, others finished figures while leaving adjacent areas blank. For other examples, see Appendix 2.

118 Winslow Homer, *Milking Time*, 1875, oil on canvas, 61 x 97.2 cm. Delaware Art Museum, Wilmington. Gift of the Friends of Art and other donors.

Homer would probably be startled to see how prominently the fence shows through the milkmaid's skirt. This is an effect of the increasing transparency of the white paint over time.

118

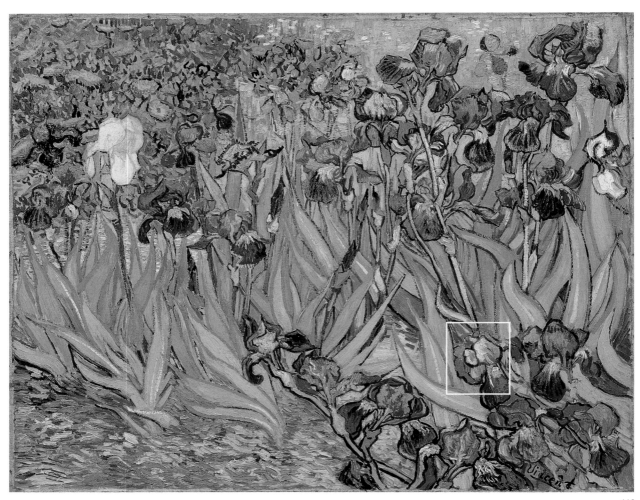

119

119 Vincent Van Gogh, *Irises*, 1898, oil on canvas, 71 x 93 cm. J. Paul Getty Museum, Los Angeles.

Van Gogh used such a heavily loaded brush that his impasto becomes a form of draftsmanship. He contrasted the dense texture of the paintwork with that of the bare, exposed canvas.

120

120 Macro detail (lower right corner) of
Fig. 119.

The impasto in this area is confusing
because of a pentimento. The long
vertical stroke betrays an earlier idea:
the stalk of an iris in the middle ground,
later obscured by the flower in the
foreground. The texture discloses
the change.

121

121 Paul Cézanne, *The Etang des Soeurs, Osny*, c. 1875, oil on canvas, 60 x 73.5 cm. The Courtauld Gallery, London.

When Cézanne joined Pissarro in Osny during the 1870s, both artists experimented with palette-knife application. Cézanne described his crude paintwork of 1866 as *couillarde*, derived from the French for testicles. The closest English equivalent is "ballsy," although more circumspect scholars translate it as "virile."

which became standard in the early nineteenth century, allowed for flat as well as round brushes, enabling artists to paint with different effects.

Palette knives (or small spatulas) are also ancient tools traditionally used to mix oil paint and transfer it to the palette. Since the nineteenth century some artists used palette knives instead of brushes to apply paint to the canvas; Turner's and Courbet's palette knife work influenced numerous successors. The trowel-like application of paint produces a characteristic surface quite different from a brushed-on impasto. Lawrence Gowing suggests that Cézanne (1839–1906) used the palette knife for his Osny landscape (Fig. 121) "as a last reminiscence of Courbet, who had lately died, and of the style that Cézanne had based on him." The coarseness of such paintwork might reflect social or political aggression; this was captured in a letter from the painter Guillemet (1841–1918) to a friend: "Let's take up arms, let's seize with a febrile hand the [palette] knife of insurrection, let's demolish and reconstruct . . . paint with heavy impasto and dance on the belly of the terrified bourgeois."[19] The palette knife could also be used to vary the surface of a work painted primarily with brushes: Edward Hopper used it to simulate the stuccoed wall in *Ryder's House* (Figs. 122, 123).

Throughout history a small number of artists have rejected both palette knives and brushes. A few used their fingers to spread the paint. Artists turned to such primal means for various reasons, including display of skill,

122 Edward Hopper, *Ryder's House*, 1933, oil on canvas, 91.6 x 127 cm. National Museum of American Art, Smithsonian Institution, Washington, D.C. Bequest of Henry Ward Ranger through the National Academy of Design.

Rather than depicting the texture of the stuccoed house, Ryder simulated it with palette-knife work (see Fig. 123) that contrasts with the brushwork used for most of the canvas. He also used a palette knife for some of the foreground landscape.

123 Mid-cleaning detail of Fig. 122.

The paint application that re-creates the effect of troweled-on plaster is particularly clear in this detail. Discolored varnish has been removed on the right.

122

123

experimental playfulness, or nose-thumbing at convention. Chuck Close (b. 1940) painted a series of portraits using fingerprints (Fig. 124); they are a virtuosic performance with multiple referents. They reflect the romantic interest in children's art as well as comment on the equivalence of mugshot and fingerprint in criminal identification. To those critics who objected that photo-realist painting lacked "handwork," Close responded with literal traces of his hands to create startling likenesses. Close's use of his fingers was also an extension of his ongoing work as a printmaker.[20]

Sources on Brushes and Other Tools

Gettens and Stout 1966 presents a clear introduction to paint brushes (pp. 279–81) and palette knives (pp. 301–4). The implications of flat brushes for artists' paint handling, most notably the *tache* or discrete dab of paint that is so central to analyses of late nineteenth-century paintwork, are discussed clearly in Bomford et al. 1990, pp. 91–98.

In a famous earlier example of painting without brushes, Carel van Mander recounted some unusual paintings by Cornelis Ketel (1548–1616). In van Mander's seventeenth-century biography he described Ketel's precocious skills but was at some loss to explain his later rejection of standard tools in favor of his fingers and toes: "Although Ketel's mind was productive, he had desires that were apart from his love for painting. He obeyed these inner voices, and he found forms of self-expression which were harmless. . . . In 1599, he conceived the idea of painting without brushes, by using only his hand. Many persons think this is a ridiculous notion and not in accordance with good taste—as the cravings of pregnant woman for strange food. . . . One is surprised that he succeeded so well. . . . Stranger yet is the fact that, in 1600, Ketel got the idea of painting with only his feet. He wanted to find out what he could do by painting this way. This method made many persons laugh; their scorn was more than before, because feet are less able than hands for such work. But they were wrong. No-one could be harmed by this experiment, except the brushmaker." Van Mander suggested that Ketel's contemporaries saw these oddities as a form of parlor entertainment, noting that they appealed to aristocratic taste: "Many gentlemen of high rank fancied pictures that were painted by Ketel's foot. The Duke of Nemours bought *The Crying Philosopher* out of curiosity." Wolfgang Stechow situates Ketel's conceit as a manifestation of Northern Mannerism and suggests Italian antecedents. He cites an altarpiece that Ugo da Carpi painted with his hands for St. Peter's, Rome, as well as Boschini's remarks that the aged Titian used his fingers to add final touches—in imitation of the Creator, who fashioned man with his own hands. A more mundane possible explanation is that Ketel suffered increasingly from rheumatic disease, which ultimately prevented him from holding a brush.[21]

The young Leonardo's use of his fingers can be linked to the properties of the newly available medium of oil painting.

124 Chuck Close, *John/Fingerpainting*, 1984, oil on canvas, 62.25 x 52 cm. Courtesy of PaceWildenstein.

In applying the paint with his fingers Close undermines the common association of fingerpainting with children's play. He also puns on the fact that head-on portraiture and fingerprints are both used as means of identification.

124

17

Case Study

Playing with Viscosity
Leonardo's Finger Painting

When conservator Thomas Brachert studied Leonardo da Vinci's portrait of *Ginevra de'Benci* he discovered fingerprints throughout the work (Figs. 125–26).[22] Leonardo, the student and theorist of the most subtle visual effects, had not merely wiped his hands on certain areas of the portrait but had used his fingers as a primary tool to manipulate the paint. Brachert's X-ray studies showed that Leonardo worked even the detailed areas with his hands. Such finger painting had occasionally been noted in works by Giovanni Bellini and a few other masters, but never in Tuscan painting.[23]

Brachert went on to study other works by Leonardo and his contemporaries. Extensive fingerprints were found in a Verrocchio workshop *Madonna and Child* (Berlin-Dahlem), suggesting Leonardo's involvement, and in just those areas of the Uffizi's *Baptism of Christ* attributed to the young Leonardo. Brachert also found some finger painting in Leonardo's *St. Jerome* (Vatican Museum) and *Annunciation* (Uffizi). He concludes: "Examination shows that the 'finger-painting technique' represents a distinguishing feature of Leonardo's early works. Apart from this it appears to be a typical mark of the painting method of a few masters of the transition period from the old tempera techniques to 'modern' oil painting around the last quarter of the fifteenth century to about 1520."

Leonardo was notably experimental in his painting technique, which produced several grand failures, including the loss of the *Battle of Anghiari* and the rapid deterioration of the *Last Supper*. It should not surprise us that he played with the tackiness of the new oil medium, palpating the paint as he sought new effects. Brachert suggests that "Leonardo, in Verrocchio's workshop, was himself the innovator of the 'finger technique' for the minutest distribution and structuring of an oil paint."[24] He certainly left us a remarkably intimate impression of his probings.

Sources on the Occasional Use of Fingers

The use of the fingers for occasional details as opposed to their use as a principal tool has been noted across a range of painters, all of whom left fingerprints. Brachert 1970 cites Piero della Francesco's Montefeltro portrait (n. 8); Dunkerton notes fingerprints in unfinished areas, presumably underpaint, of Michelangelo's *Entombment (Making and Meaning: The Young Michelangelo*, 1994, p. 117 pl. 110); Goya used his fingers as well as other tools unconventional for the time (Alfonso Pérez Sánchez and Eleanor A. Sayre, *Goya and the Spirit of Enlightenment*, catalogue [Boston: Museum of Fine Arts, 1989], p. 41). Denis Rouart discusses Degas' extensive use of his fingers in his later work as his eyesight declined: *Degas in Search of His Technique* (New York: Skira/Rizzoli, 1988 [translation of 1945 French ed.]), pp. 78–81; Francis Bacon's fingerprints in the *Portrait of Isabel Rawsthorne* are illustrated in Ades and Forge 1985, p. 232. Pollock left prominent handprints in *Number 1A, 1948* (Varnedoe with Karmel 1998, figs. 138–39).

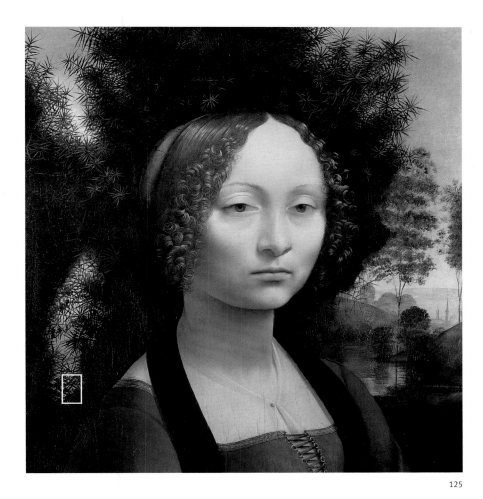

126

125

125 Leonardo da Vinci, *Ginevra de'Benci*, c. 1474, oil on panel, 38.2 x 36.7 cm. National Gallery of Art, Washington, D.C. Purchase Fund (1967).

Leonardo trained as a painter at the moment of transition from tempera to oil as the standard paint medium in Italy. His early paintings record his interest in the qualities of his paint media.

126 Detail of the background of Fig. 125.

Fingerprints in the underpaint are visible in ordinary light and are more prominent on the enlarged details of X-ray studies published by Brachert. Although other artists occasionally left fingerprints by accident—especially at the edges of paintings when they handled the still-wet paint—the fingerprints throughout Leonardo's early works required an explanation.

127

127 Daniel Vladimir Baranoff-Rossiné, *Capriccio Musicale (Circus)*, 1913, glue-based paint, oil and pencil on canvas, 130.4 x 163.1 cm. Hirshhorn Museum and Sculpture Garden, Smithsonian Institution, Washington, D.C. Gift of Mary and Leigh B. Block.

Baranoff-Rossiné created the impression of movement and theatrical lighting by spraying paint over stencils. Aerosol applicators, forerunners of the airbrush, were first available in the 1890s.

128 Detail (right edge) of Fig. 127.

This image shows the artist's experimental paint application, as well as significant chromatic changes. The red strip at right, originally protected from light by the frame, indicates that the painting was once much more intense. All of the exposed reds have faded.

129 Yves Klein, untitled anthropometry 82, 1960, oil on paper mounted to canvas, 155.5 x 281 cm. Yves Klein Archives, Paris.

The figures in Klein's large compositions maintain a one-to-one correspondence with their means of creation—the imprint of the human body.

130 Yves Klein, anthropometry performance, Galerie International d'Art Contemporain, Paris, March 9, 1960.

The artist explained: "The time of the brush had ended and finally my knowledge of judo was going to be useful. My models were my brushes" (cited by Sidra Stich in *Yves Klein*, catalogue [Ostfildern: Cantz Verlag, 1995], pp. 171–72). Klein directed the models in performances for small audiences on several occasions.

128

129

130

Twentieth-century artists have rejected conventional tools for a variety of reasons; these have all received critical attention. Vladimir Baranoff-Rossiné sprayed paint over stencils to re-create the impression of motion and lights at the circus (Figs. 127, 128). Max Ernst favored the tactile over the visual dimension of picture-making with his *frottage* (rubbings, done in a similar manner to tombstone rubbings), which was related both to collage and printmaking. Artists including Yves Klein, Robert Rauschenburg, and Jasper Johns applied and manipulated paint through direct bodily contact to emphasize the painting as a site of activity (Figs. 129, 130). Siqueiros experimented with sprayed paint application as a rejection of high-art preciousness. Artists of the 1960s embraced commercial technology (via the airbrush) to the same ends. The rebellious impulse behind these industrial techniques was characterized by

Roy Lichtenstein: "It was hard to get a painting that was despicable enough so that no one would hang it—everybody was hanging everything. It was almost acceptable to hang a dripping paint rag, everybody was accustomed to this. The one thing everyone hated was commercial art; apparently they didn't hate that enough either." Pollock's technique of the late 1940s, in which he poured industrial paint directly from gallon cans, squirted it with turkey-basters, and rubbed it onto the canvas with rags, manifests a similar distancing from fine art traditions. As Pollock acknowledged in an early statement, "I continue to get further away from the usual painter's tools such as easel, palette, brushes, etc. I prefer sticks, trowels, knives and dripping fluid paint or a heavy impasto with sand, broken glass and other foreign matter added."[25] See Figs. 146, 147, 148.

Paint handling has been a highly contested arena for modernist painters. A number of scholars have made use of close visual examination to expose the gap between the modernist effect of spontaneity and the slow and deliberate paint application that produced it. Robert Herbert describes the time-consuming and complex method by which Monet achieved the look of improvisation in his later work. Monet applied a heavily impastoed lower layer whose texture suggests spontaneity; once it dried he added thin, untextured "surface colors." The texture comes from the first layer, the color from the second (Fig. 131). Herbert terms these effects "corrugated textures." In an interesting note on Baroque antecedents, Ernst van de Wetering describes a remarkably similar technique that Rembrandt used in his late paintings. He suggests, moreover, that it led to confusion among mid-nineteenth-century viewers as to how the Dutch master had achieved his effects: "An important cause of that confusion must have been the fact that the underlying *pasteuse* paint determined to a large extent the image of the brushwork while the visible differences in colour and tone do not correspond with that underlying pattern of brushstrokes." Carol Christensen has documented a similar disparity in Gauguin's work. Despite his statements that his paintings were produced quickly and extemporaneously, the work reveals a deliberate process that proceeded from sketches to squared drawings and sometimes pounced cartoons to final work.[26] The lush and energetic paint handling in James Ensor's work has also led to misinterpretation of his methods. A fresh look at his masterpiece, *Entry of Christ into Brussels in 1889*, suggests that art historians have misread its brushwork in light of later developments. Shortly after the painting's acquisition, staff at the J. Paul Getty Museum examined and cleaned it (Figs. 135, 136).[27] When

131

132

133

134

131 Detail of the surface of Figs. 132, 133, 134 during varnish removal.

This shows the effect that Robert Herbert termed "corrugation," in which the dense surface texture betrays multiple campaigns of work. The left side shows the paint after later varnish was removed, revealing Monet's intended matte and chalky surface. The varnish at right had obscured the colors. The shininess of the later varnish is not captured in this photograph. The recent treatment is described and amply illustrated in color in Christopher Lyon, "Unveiling Monet," *MoMA: The Members' Quarterly of the Museum of Modern Art 7* (Spring 1991): 14–23.

132, 133, 134. Claude Monet, *Water Lilies* (triptych), c. 1920, oil on canvas, 200 x 425 cm. each. Museum of Modern Art, New York. Mrs. Simon Guggenheim Fund.

The apparent spontaneity of Monet's surfaces has antecedents in Rembrandt and anticipates Pollock.

conservators removed a forty-year accumulation of darkened varnish and grime they found no major revisions across the fourteen-foot breadth of canvas. Every figure within Ensor's massive, advancing crowd had been preplanned, and the paintwork exactly followed his elaborate underdrawing.

The fiction of spontaneity is further supported by the romantic image of the artist under the influence of madness, drugs, or, in the case of Jackson Pollock, alcohol. Although his biography might allow such interpretation, the sequence of paint layering of *Blue poles* offered counterevidence. The following Case Study uses available-light examination of the painting's surface and minimal magnification.

135

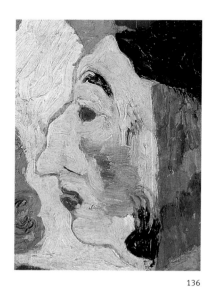

136

135 James Ensor, *Entry of Christ into Brussels in 1889*, 1888, oil on canvas, 252.5 x 430.5 cm. J. Paul Getty Museum, Los Angeles.

This monumental painting had been described as prefiguring expressionism in its brushwork. A careful look following cleaning reveals that it was thoroughly planned, with no revisions in any of the figures and only minor changes in the banner text (see p. 138).

136 Detail (second row, third head from the right) of Fig. 135.

As evidence of Ensor's planning, Leonard and Lippincott (1995, p. 21) pointed to this detail, where adjacent colors do not abut and the bare ground can be seen between them.

18

Case Study

Jackson Pollock's *Blue poles*

The Myth of Inebriation Versus the Evidence of Deliberation

Jackson Pollock's *Blue poles* (Fig. 137) was the subject of a great deal of press attention in 1973 for two reasons.[28] The first was the record $2 million (U.S.) paid by the National Gallery of Australia for the painting. The second reason concerned the painting's execution almost twenty years prior, which came to light in the international publicity surrounding the sale. In a *New York Magazine* story the sculptor Tony Smith recalled beginning the painting during a drinking bout with his friend Pollock. Smith told of a subsequent visit to Pollock's studio, accompanied by Barnett Newman, during which Newman added the eponymous poles. As if to confirm the anecdote the article was illustrated with a photograph showing Newman, Pollock, and Smith sitting together on a bench. Both topics collided in headlines like this one, which appeared in the *Australia Daily Mirror* on October 23, 1973: "$1 MILL. AUST. MASTERPIECE. DRUNKS DID IT!"[29]

The *New York Magazine* article provoked an angry response from critics who knew the artists. They disclaimed that any paint added by others contributed significantly to the finished work. The scholars researching Pollock's catalogue raisonné then examined the painting and rejected all stories of joint participation. Michael Lloyd and Michael Desmond, curators at the National Gallery of Australia, turned to the painting itself for evidence of its process. Is *Blue poles* substantially the product of Pollock's drinking and a little help from his friends?

Their examination involved scrutiny of the painting surface in visible light (Fig. 138); they did not require further analytic techniques. From the overlapping paint, Lloyd and Desmond were able to distinguish at least five separate campaigns of work. By studying the way the fluid paint had pooled or flowed, they determined that Pollock moved the huge canvas repeatedly from floor to wall. Pollock began his work on the floor, where he could approach the canvas from all four sides. At the next stage he moved the large canvas to the wall, allowing rivulets of white to spread over the dark pools of the first layer. The third stage again involved fluid paint, this time bright colors applied while the canvas was horizontal. The blue poles were added later: "It can be seen how the blue paint rides over the thick ridges of the earlier paint layers without any blurring of these, indicating that they were quite dry by that time." A final finishing layer reveals that Pollock applied paint with brushes and rags as well as by pouring it. Desmond and Lloyd conclude, "It is the evidence of Pollock at work, in a long

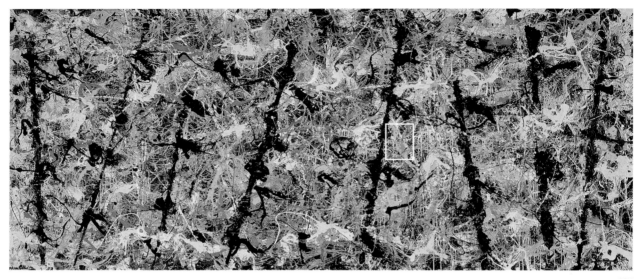

137

137 Jackson Pollock, *Blue poles*, 1952, oil, enamel, and aluminum paint on canvas ("aluminum" describes the paint's colorant, not the binder, which is enamel; it has become standard terminology in describing Pollock's work), 210.4 x 486.8 cm. National Gallery of Australia, Canberra.

Sensational stories surrounded the painting's origin. Close but unaided visual examination set the record straight.

138 Macro detail of Fig. 137.

Desmond and Lloyd's careful study of the painting's surface reveals how long and hard Pollock worked at such "casual" effects: the painting resulted from at least five distinct sessions, separated by enough time for the paint to dry: (1) initial black puddles, above which sits (2) fluid white paint that was allowed to drip from the canvas as it was tacked to the wall (seen especially at lower left) followed by (3) skeins of yellow, orange, and aluminum paint applied when the canvas again placed on the floor—the yellow and orange marbling at lower right was produced by the liquid paint applied to a horizontal surface; (4) the eponymous poles, which are barely recorded in the dark area at the left of this detail, and (5) fine skeins of white, black, and blue paint that "lace" the poles into the composition.

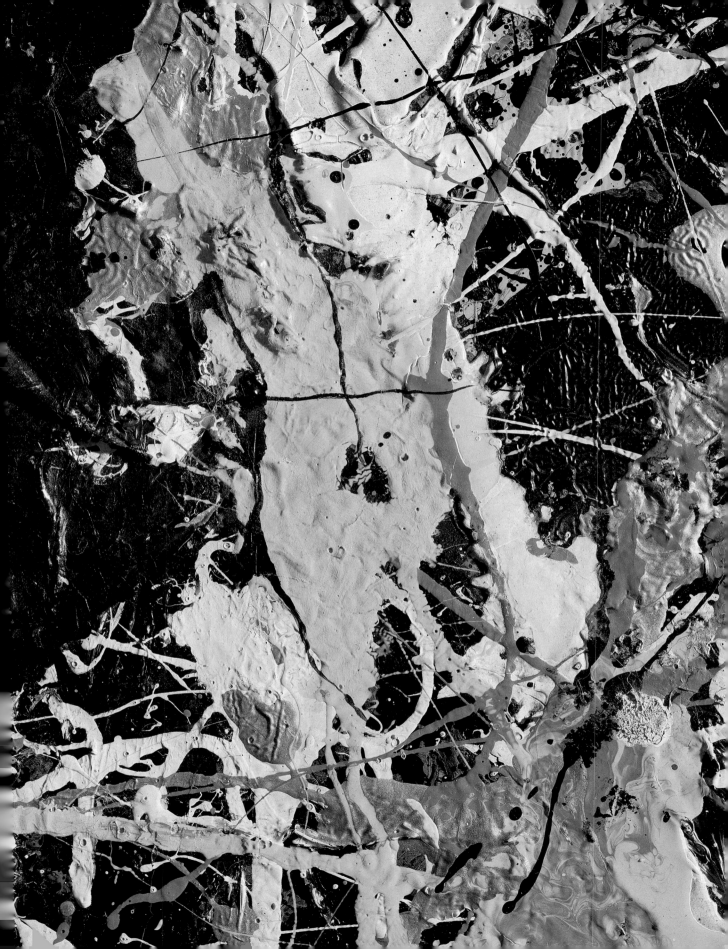

and exacting process, that is most clearly revealed by a close inspection of *Blue poles.* Although it appears marvelously spontaneous, exactly as Pollock wished it to appear, close inspection of *Blue poles* shows that this effect was achieved neither effortlessly nor instantaneously, neither in a moment of inspired 'action painting' nor drunken fury, the kind of misconceptions about Pollock's working method created by Friedman's [*New York Magazine*] article." [30]

Ideological Concerns Behind Modernist Paint Experiments

Most painters chose their binding media because of availability or handling properties, but for a number of modernists the choice was based on its history of use. This might be termed the "idea of the medium." Such ideological choice of materials always bears art historical significance. Several artists employed paints manufactured for non–fine arts purposes and used commercial means of application. Picasso used a commercial enamel for lettering a sign in *Landscape with Posters* (1912), a work otherwise executed in artists' oil paints. He also used a commercial technique, the stencil, to apply the enamel paint (see Fig. 44 for Sigmar Polke's recent use of stencil to similar ends). The lettering in enamel was meant to stand out; it represented the sign itself, becoming a collage element by analogy. [31]

David Alfaro Siqueiros believed that a politically revolutionary art demanded new materials and that advances in art should track those in science and industry. He explicitly rejected the bourgeois tradition of easel painting. Instead, he produced publicly oriented murals and chose non–fine art media for smaller paintings. His politics determined his use of industrial tools as well as paints. In his New York Experimental Workshop in 1936, Siqueiros applied pyroxylin enamel with a spray gun to paint Communist posters. He was ironically called Il Duco after his use of Duco paint (du Pont's proprietary name for pyroxylin). He carried both the medium and the sprayed application into his easel paintings (Figs. 139, 140). [32]

Sources on Revivals of Medieval Technique

See Callen 1994, pp. 745–46, on nineteenth-century primitivism of materials with particular reference to Degas' use of size and casein. Denis Rouart, *Degas in Search of His Technique* (1945), also discusses Degas' attempts to reproduce earlier techniques, as does Theodore Reff (*Degas: The Artist's Mind* [London: Thames and Hudson, 1976], p. 272 and chap. 7). Jirat-Wasiutynski and Newton 1999 suggests a primitivizing source for Gauguin's use of wax binders in his Pont-Aven works. Reinhold Heller places Edvard Munch's experiments with tempera and casein within the context of European interest in fresco painting in *Munch: His Life and Work* (Chicago: University of Chicago Press, 1984), p. 118, and Thurmann-Moe 1997 documents Munch's experiments with both media and paint handling to simulate the look of fresco. Gloria Groom traces Vuillard's use of glue-size tempera for several decorative commissions to his work as a theater set designer ("Landscape as Decoration: Edouard Vuillard's Ile-de France Paintings for Adam Nathanson," *Museum Studies* 16, no. 2 [1990]: 147–65). Seckler 1952 and Braun and Branchick 1985 discuss Thomas Hart Benton's use of tempera. However, Benton's technical experiments were not simply revivalist. Although he employed medieval tempera technique during the 1920s, he also made the first significant use of Liquitex (a synthetic emulsion paint) for a mural in 1958 (Lodge 1988, p. 126).

139 David Alfaro Siqueiros, *Collective Suicide*, 1936, enamel on wood with applied sections, 124.5 x 182.9 cm. Museum of Modern Art, New York. Gift of Dr. Gregory Zilboorg.

Siqueiros was known for his experiments since the 1930s with commercial paints and industrial methods of application; both supported the political aims of his art.

140 Detail of Fig. 139.

Siqueiros used an airbrush and a stencil to apply an enamel paint normally used for furniture and automobiles. He employed various special characteristics of the enamel for effects not possible with artists' oil paints: the swirling pattern at top and the holes at bottom where light-colored paint pulled away from a darker layer.

139

140

141 Hilaire-Germain-Edgar Degas, *Portrait After a Costume Ball (Portrait of Mme Dietz-Monnin)*, 1879, distemper or gouache, charcoal, pastel, metallic paint, and oil on unprimed canvas, 85.5 x 75 cm. Art Institute of Chicago. Joseph Winterbotham Collection (1954.325).

Degas was notably experimental in technique. He painted on unprimed fabric and paper mounted to canvas (Fig. 72), as well as conventionally primed canvases. He worked with a variety of pastels, chalks, oil paints (sometimes leached of oil then thinned with turpentine, known as *peinture à l'essence*), as well as aqueous media, including gouache, size, and casein.

142 Raking-light detail of Fig. 141.

The painting has never been varnished, and its intentionally chalky surface is exceptionally well preserved. It is executed primarily in an aqueous medium, although tests have not been carried out to confirm whether it is bound in size (distemper) or vegetable gum (gouache). The painting is displayed under glass for protection; although Degas sometimes presented works under glass, there is no record of his preference here.

141

142

A primitivism of technique may have determined the choice of a number of nineteenth- and twentieth-century painters who revived the practice of tempera painting (Figs. 141–43; see also Figs. 40, 83). Similar ideas inspired many of the same artists to use matte surface effects.

Acrylics and Other Synthetic Media

The second major breakthrough in artists' paints was acrylic resins, which came into wide use after World War II. Magna was available commercially since 1949, Liquitex since 1954, and both were used increasingly by the late '60s.[33] Synthetic paints had been available earlier: automobile and furniture enamels were used experimentally by a few artists, including Picasso, Siqueiros, and Pollock. Some artists used alkyd resin paints that had first been sold as house paints in the 1930s. Proper artists' paints based on alkyd resins were not available until the 1970s and have never been as popular as acrylics.

Acrylic resins dry quickly and allow flexibility of handling. They can be applied in layers (as can oils) and can produce a paint film that looks similar to that of oil but is neither as translucent or as saturated in color. Acrylics are available premixed as tube colors or in fluid consistency, and some are compatible with water or oil. They also offer certain health advantages, since they preclude the need for a turpentine solvent, which may cause allergies. Contemporary artists who choose traditional oil paints rather than acrylics usually do so because of the optical and handling differences, or because they prefer the slower-drying oil medium, which allows time to manipulate the paint.

Textural Paint Additives

Painters have exploited the textural possibilities of oil paint since the sixteenth century. They created a surface impasto using coarsely ground pigments, richly bound paints, thickening additives (Turner added beeswax or sperm whale wax), thick application with brushes (see Figs. 113, 114, 119, 131, 136) or with palette knives (Figs. 121–23), and occasional scraping with the butt end of the brush or other tools (Figs. 144, 145). A number of twentieth-century painters

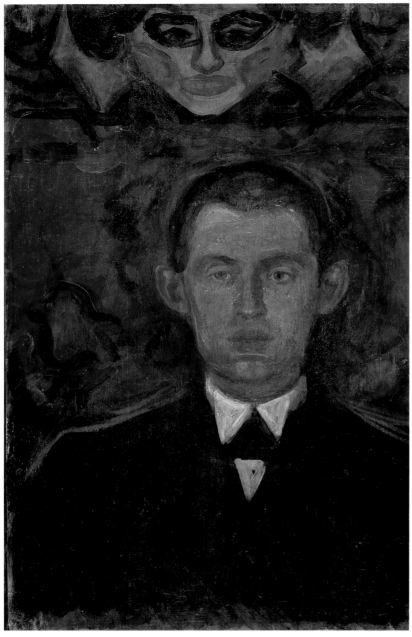

143 Edvard Munch, *Self-Portrait Beneath a Woman's Mask*, c. 1893, mixed media on panel, 70 x 44.5 cm. Munch Museum, Oslo.

By the early 1880s, Munch was employing various unusual means to manipulate the surface of his paintings. For this self-portrait he used paint containing casein, and he created the brown, blistery patches on the cheeks and forehead by scraping away the paint to reveal the bare wood of the panel. Casein in the binder was confirmed with tests, according to Jan Thurmann-Moe (in correspondence, March 1989).

143

144

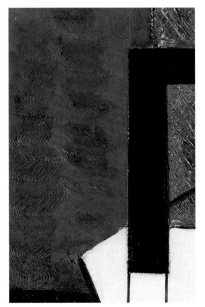

145

144 Irene Rice Periera, *Two White Planes*, 1938, oil on canvas, 71.44 x 86.68 cm. Lowe Art Museum, University of Miami, Coral Gables. Gift of John V. Christie.

Periera, who taught in the Federal Art Project's Design Laboratory, was probably influenced by Bauhaus ideas in her technical experiments (see Bearor 1993). This painting is a sample book of textural effects achieved by scraping and combing upper layers of paint to reveal colors below.

145 Detail (upper left) of Fig. 144.

Within the red rectangle Periera used a comblike implement to create the pattern. The texture in the blue area at right was produced by scraping, perhaps with the butt end of the brush.

146

147

146 Jackson Pollock, *Bird*, 1941, oil and sand on canvas, 70.5 x 61.6 cm. Museum of Modern Art, New York. Gift of Lee Krasner in memory of Jackson Pollock.

This is one of the earliest paintings in which Pollock used additives for textural effect. Likely precedents for his use of sand include Native American sand painting, André Masson's work, and Pollock's experience in Siqueiros' workshop.

147 Jackson Pollock, *Full Fathom Five*, 1947, oil on canvas with nails, tacks, buttons, key, coins, cigarettes, matches, etc., 129.2 x 76.5 cm. Museum of Modern Art, New York. Gift of Peggy Guggenheim.

While the catalogue of materials sounds like a collage, Pollock thoroughly imbedded all the "foreign matter" in the paint to create an extraordinarily rich surface.

148 Detail of Fig. 147.

This area, the size of a handprint, contains a cigarette (at upper left), multiple nails and tacks—some of which point out at the viewer—as well as a washer and the cap from a paint tube.

148

added foreign materials for further textural effects; these have included sand, marble dust, ground glass, palette scrapings, and various studio debris. The surrealists Andre Masson and Max Ernst made notable use of paint additives.

Jackson Pollock's use of sand in *Bird* raises provocative questions about his sources (Fig. 146). Like a number of his American contemporaries, Pollock was interested in European surrealism, as well as Native American art. He had worked with Siqueiros and had adopted the Mexican master's use of spray-painted enamels. All three are possible sources for his use of sand.[34] Pollock's mature paintings incorporate a range of outside materials, usually detritus of his working process—cigarette butts, spent matches, floor sweepings (Figs. 147, 148), and bits of broken glass from the basting tubes he used to apply paint. Using such items was a conscious part of the laborious process by which he built up his paint surfaces (see Case Study 18).

Aging Effects of the Paint Layer

The paint layer is subject to various physical and chemical reactions as it dries; some cause problems. Some aging effects occur because of atmospheric conditions. Other defects arise from the painting's materials or their interaction with one another and with adjacent layers of the painting. The latter, termed inherent vice, include the effects of fugitive pigments and colors that change, additives and media that inhibit drying, and various adhesion and layering problems, including under-bound paint and interlayer cleavage (see below). Once dry, the paint layer will continue to change because of its inherent components, the environmental conditions, and human intervention.[35] The most common aging effects occur in five categories: craquelure, increasing transparency, fugitive pigments and color changes, losses, and the effects of prior treatments.

Craquelure

In a culture that shuns signs of age in humans, we prize them as a mark of authenticity in artwork. Age cracks usually occur throughout the paint layer and follow the obvious stresses to the support. Crackle patterns characterize specific schools of painting because of distinctive combinations of support and ground layers. Some systematic research has been done toward using such patterns in attributions.[36]

As the paint layer ages and loses elasticity, major external pressures or movement in the support may cause fractures. Such movement includes the separating of panel joins and rolling of canvases, which is a common practice for transit or storage of large paintings. Minor humidity fluctuations also cause expansion and contraction of the wood or canvas support, resulting in cracks. Confirmation comes from observing the surfaces of paintings on copper, which do not react to humidity cycles. Unless they have been bent or have received a direct blow (and barring adhesion problems that cause the paint to flake), coppers usually exhibit jewel-like, ageless surfaces with no craquelure.

Craquelure is studied by direct visual examination, perhaps aided with low magnification, as through a jeweler's loupe. Nicolaus 1998 illustrates details of a range of craquelure (pp. 165–87).

Stress to a panel is commonly reflected by a fine pattern of cracks (in the direction of the grain for early Flemish oak panels, perpendicular to the grain for Italian panels of poplar), with larger cracks and likely paint loss at the

panel joins (see Fig. 103). When a panel painting has been transferred to canvas, the craquelure from the panel is a permanent part of the paint layer (Figs. 8, 9). A visible canvas texture, in addition to craquelure typical of a panel, should alert the viewer to a transfer.[37]

Canvases are less rigid than panels and display a wider variety of craquelure. It is common to see cracks arcing at the corners of a canvas; this is stress crackle, which betrays tension from an opened expandable stretcher (Figs. 153, 155). Stress from the stretcher and any reinforcements (such as cross-bars) may cause cracks in the paint layer or deformation of the canvas itself, called stretcher marks (Fig. 149). The canvas is impressionable to sharp

149 Detail of the upper left corner of a canvas with characteristic stretcher bar marks visible in the paint layer.

149

150 Elisabeth Louise Vigée-Lebrun, *The Marquise de Pezé and the Marquise de Rouget with Her Two Children*, 1787, oil on canvas, 123.4 x 155.9 cm. National Gallery of Art, Washington, D.C. Gift of the Bay Foundation in memory of Josephine Bay Paul and Ambassador Charles Ulrick Bay.

Vigée-Lebrun usually painted on canvas, as did most of her contemporaries, although she sometimes chose wood (see Fig. 2), which ages differently.

151 Raking-light detail of Fig. 150.

The dramatic and irregularly swirling crackle in the center of the canvas is caused by stress to the thick ground layer. This sort of pattern characterizes certain schools, notably late eighteenth- and early nineteenth-century French, and some English and American painting.

150

151

blows or to prolonged but gentle pressure—such as a piece of furniture leaning against the painting. The canvas may even distort under the weight of the paint itself, causing stress and cracking in the paint layer.[38]

A change in the craquelure from one area to another within a painting should raise questions. A concentric pattern of circular cracks within an otherwise regular crackle pattern is usually the result of stress or a blow— impact crackle (Figs. 153, 155). In some cases not only the paint layer but the canvas itself reflects damage or distortion because of the impact. A predominance of directional cracks may indicate that a canvas has been rolled.[39]

Examination of the edges of the canvas can be telling in studying craquelure: if the tacking margins are missing and the paint is broken along the craquelure pattern, it is likely that the painting was cut after the paint layer dried and the craquelure had been established. This should raise the question of the painting's having been reduced.

In addition to revealing age, cracks can indicate faulty paint application or problematic materials. When different colors are visible in areas of cracking throughout a painting, it can indicate several possibilities: (1) a reused canvas, (2) paint layers separating from one another (known as interlayer cleavage, which also causes losses and will be described below), or (3) *pentimenti*. The current rule for artists is "fat on lean"—meaning that slower-drying, thicker paint should be applied over thinner and leaner paint. When an artist ignores this rule the rapidly drying upper paint can pull apart the still tacky paint below, causing disfiguring cracks known variously as traction craquelure, drying craquelure, shrinkage craquelure (Figs. 156–61), or alligatoring. Such cracking can also be caused by paint additives that inhibit drying, such as bitumen (asphaltum). Bitumen was most commonly used by British and American painters during the eighteenth and nineteenth centuries; paintings from that era regularly exhibit dramatic craquelure.[40]

Cracks can also result from tension in the layers adjacent to the paint, either the varnish or the ground (Fig. 153). The very large, arcing crackle seen on eighteenth- and nineteenth-century French canvases occurs because of their thick grounds (Figs. 150, 151); the craquelure reflects tensions in the ground rather than in the underlying canvas. While cracking in the ground or paint layers is always permanent, cracks in the varnish layer are eliminated when the problematic varnish is removed.

152

153

153 Partial diagram of the crackle patterns on Fig. 152, drawn by staff at the Royal Cabinet of Paintings, The Hague.

Several types of crackle are visible: A) stress or impact crackle that produces a radiating circular pattern; B) fine cracks from drying of the ground layer; C) ordinary aging crackle; D) stress cracks that arc from the corners (because of the expandable stretcher); and E) painted cracks, deliberately darkened to make the work appear older. Such painted cracks (which were added later) are a rarity. This diagram was originally published in Jørgen Wadum et al., *Vermeer Illuminated: A Report on the Restoration of the 'View of Delft' and 'The Girl with a Pearl Earring' by Johannes Vermeer* (Wormer and The Hague: V & K Publishing/Inmerc and Mauritshuis, 1994) as part of the full documentation of the painting's treatment.

152 Johannes Vermeer, *Girl with a Pearl Earring*, c. 1665–66, oil on canvas, 44.5 × 39 cm. Royal Cabinet of Paintings, The Hague.

This well-preserved painting displays a range of craquelure typical of a canvas its age.

154 Mid-treatment photograph of Fig. 152.

This records the painting in its stripped state—after old repaint had been removed but the losses had not yet been inpainted. Such flaking losses are consistent with the crackle pattern and are a normal result of age.

154

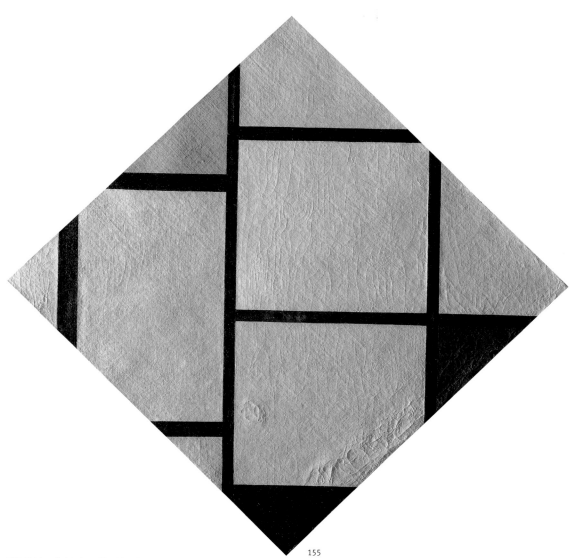

155

155 Raking-light view. Piet Mondrian, *Tableau No. IV: Lozenge Composition with Red, Grey, Blue, Yellow, and Black* (Fig. 220).

This photo reveals a range of crackle. Concentric circles of impact crackle can be seen in the upper left quadrant of the central white field, and again in the left side of the gray field below it. Stress cracks from the expansion of the stretcher are most visible in the left corner. The lower right edge shows an area of cracking characteristic of intense, localized damage.

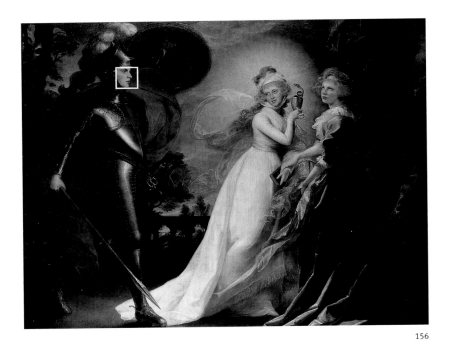

156

156 John Singleton Copley, *Red Cross Knight*, 1793, oil on canvas, 213.5 x 273 cm. National Gallery of Art, Washington, D.C. Gift of Mrs. Gordon Dexter.

Another example of drying crackle appears in this painting.

157 Detail of Fig. 156.

The cracking in the Knight's helmet probably resulted from a faster-drying paint layer applied over a slower-drying layer.

157

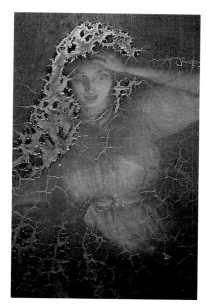

158

158 Detail. William Hilton the Younger, *Editha and the Monks Searching for the Body of Harold*, 1834, oil on canvas, 50.2 x 64.8 cm. Tate Gallery, London.

An extreme drying effect probably caused by the presence of bitumen in the paint caused a wide fissure in the upper paint layer. The result, known as alligatoring, exposes the layers below. Bitumen was used to create a glaze that simulated a patina of age. Although artists liked the initial visual effect, long-term drying problems led to its abandonment.

159 Henry Ossawa Tanner, *Salomé*, c. 1900, oil on canvas, 116.5 x 89.4 cm. National Museum of American Art, Smithsonian Institution, Washington, D.C. Gift of Jesse O. Tanner.

Tanner was notably experimental. He produced luminous surfaces with many layers of glazes, sometimes bound in mixed media. This often led to drying crackle.

160 Raking-light photograph of Fig. 159.

This photo highlights the significant drying crackle throughout the upper half of the painting.

161 Macro detail of Fig. 159.

Note the marked pattern of cracks throughout the face, characteristic of drying problems; these can be caused by mixed media, paint layering, or such additives as bitumen.

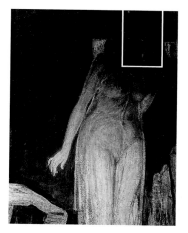

159

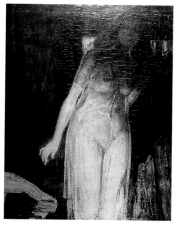

160

161

163

162

162 Detail. Raphael, *Small Cowper Madonna* (Fig. 202).

Shows underdrawing in the hand of the Christ Child, visible in ordinary light. This is probably an effect of increasing transparency of the paint and was unlikely to have been visible initially. The infrared reflectogram reveals more extensive changes in the underdrawing throughout the composition (Fig. 203). For a treatment report on the painting, see Ross M. Merrill, "Examination and Treatment of the 'Small Cowper Madonna' by Raphael at the National Gallery of Art," *Studies in the History of Art* 17 (1986): 139–47.

163 Jan Van Goyen, *View at Rehnen*, 1656, oil on wood, 55.5 x 81.9 cm. Baltimore Museum of Art. Mary Frick Jacobs Collection.

When the grain of a panel is visible through the paint, it is usually a result of the paint having become transparent with age. Van Goyen, however, purposely employed the color and grain of the panel, as did a number of modernists (see Fig. 1).

164

164 Macro detail of Fig. 163.

Detail shows birds swooping over the water at center. Gifford has shown that Van Goyen intentionally allowed the panel to show, taking advantage of the resemblance of the grain to the stipple and dash technique of etching. In his later paintings he used a transparent ground made of colorless smalt and chalk that Gifford suggests "must have looked more like varnished wood than the usual prepared panel" (E. Melanie Gifford, "Jan van Goyen en de techniek van het naturalistische landschap," in Christine Vogelaar et al., *Jan van Goyen*, catalogue [Zwolle and Leiden: Waanders Uitgevers and Stedelijk Museum De Lakenthal, 1996]).

Increasing Transparency

Some paint becomes increasingly transparent as it ages, exposing underlayers of paint, ground, or support that the artist thought thoroughly obscured. The extent of this shift in hiding (or covering) power is determined by the amount of pigment used, as well as the physical properties of the pigment and the binding medium.[41] Underdrawings or *pentimenti* that are partially visible to the naked eye usually indicate that the upper layers of paint have become more transparent. While the futurists painted figures in multiple positions to record motion, such images in earlier paintings are typically remnants of change (Fig. 162).

A support visible through the paint may also suggest increasing transparency. When one sees the color or grain of a panel through the paint of an old master painting one can suspect the effect of age or overcleaning, although further historical and technical study may be required to determine if the effect was intentional. E. Melanie Gifford has established just such purposeful employment of the panel grain by Jan Van Goyen, tracing its influence not only to the practice of his teacher Esias van de Velde but also to developments in landscape prints and in the use of stippling in the new technique of etching (Figs. 163, 164).[42] In the late nineteenth century Seurat made use of visible areas of panels, which he used only for sketches (Fig. 1); he treated these small panels like paper, with which the support is commonly allowed to show.

Whites lose their hiding power with clear but unintended results; this was the case with Winslow Homer's *Milking Time* (Fig. 118). When Homer (1836–1910) painted the woman's skirt, he certainly expected it to hide the fence before which she stood. Had he realized that the white skirt would become transparent, he could have scraped off the outline of the fence or hidden it with an intervening ground layer. Increasing transparency within the dark areas may be less obvious; it causes a murkiness and lack of definition known as sinking.[43] When the darks have sunk, a painting typically becomes less legible. There are no certain tests for increased transparency. One must use common sense and be guided by otherwise unexplained aspects of the image.

Fugitive Pigments and Color Changes

Some pigments are known to change over time and with exposure to light. Those that lose their color (fade) are termed fugitive. The word evokes an image of rapid transition—and indeed this is sometimes the case. Reynolds' sitters complained that their own likenesses aged, Fénéon remarked on color changes

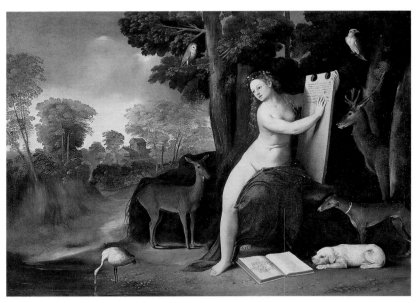

165

in Seurat's *Grand Jatte* within ten years, and fading was observed in Rothko's Harvard murals within just five years. Other color changes are gradual and would not be noticeable within a generation. Artists with traditional training were aware of the problems of fugitive pigments, and the instability of certain colors prompted the adoption of newer and more permanent substitutes.[44]

Several common pigments are subject to change: copper resinate greens often turn brown—which distorts the landscapes of so many old master paintings (Fig. 165); azurite can darken to almost black when bound in oil (Fig. 166); blue smalt sometimes darkens to black (Fig. 167); silver leaf regularly tarnishes to black (Fig. 168); and vermillion can darken and discolor (Fig. 169).[45]

The lake pigments, whose colorants derive from animal, vegetable, or mineral dyes, are inherently unstable and tend to fade. This is a problem for the natural lakes as well as many mineral-based lakes synthesized since the nineteenth century. The impermanence of the modern synthetic lakes was recognized early on. A Royal Commission of 1863 advised London's Royal Academy to set up a laboratory to test pigments for stability, to publish its results, and to train artists in the necessary chemistry.[46]

Looking at a painting whose color harmonies have changed is like trying to appreciate chamber music with one of the players missing. It is more difficult because we do not always have the score. Scientific analysis can

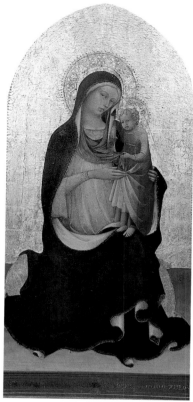

166

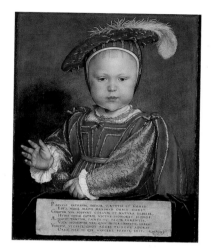

167

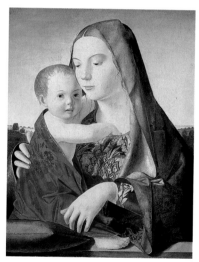

169

168

166 Lorenzo Monaco, *Madonna and Child*, 1413, tempera on panel, 116.8 x 55.3 cm. National Gallery of Art, Washington, D.C. Samuel H. Kress Collection.

The Virgin's mantle became dark and unmodulated as the azurite blue pigment discolored. Ultramarine, which was the preferred blue pigment (although a very costly one), was more stable.

167 Attr. Hans Holbein, the Younger, *Edward VI as a Child*, probably 1538, oil on panel, 56.8 x 44 cm. National Gallery of Art, Washington, D.C. Andrew W. Mellon Collection.

The background was once blue. It became gray as the smalt (a blue pigment made from colored glass) turned black.

168 Bernardo Daddi, *St. Paul*, 1333, tempera on panel, 233.7 x 89.2 cm. National Gallery of Art, Washington, D.C. Andrew W. Mellon Collection.

The black sword was gilded in silver leaf. Before it tarnished it would have sparkled within a candlelit interior. Artists used silver even though by medieval times they were aware of its tendency to darken. They sometimes used tin to avoid the problem. The engaged frame on this panel is original.

169 Antonello da Messina, *Madonna and Child*, c. 1475, oil-type paint on panel, 59.1 x 43.8. National Gallery of Art, Washington, D.C. Andrew W. Mellon Collection.

Strokes of red vermillion in the Christ Child's robe have blackened and flaked, leaving the child rather shabbily clad. The change is caused by a reaction of the pigment to light.

confirm the presence of pigments that cause frequent problems, and historians can suggest when such pigments were likely to be used. Still, even when we know that a color has changed it is difficult to imagine the original and then use the "restored" mental image to adjust the color balance of a given painting.

Changed lake pigments pose a further problem, since it is often impossible to identify their dyes precisely; the available samples are too small and the organic chemistry too complex. The original color of a faded lake must usually be established by means other than analysis, such as the survival of an unfaded area hidden by the frame (see Fig. 128), an indication from the subject matter, copies made in stable colors, or written evidence. A letter from the artist identified the faded red lakes in Van Gogh's *Irises*; he described the flowers against a bright pink background (Fig. 171). It is surprising to find dramatic color changes in a painting from 1939 (Fig. 170), yet a bit of canvas covered by the frame revealed that Hopper's sub-marine trees were originally a conventional green. He used a mixture of blue and a yellow lake that was fugitive. Confirmation of the original palette came from a color reproduction published in the 1940s, as well as from a description of the painting by the artist's widow.[47]

Changes in modern pigments present further difficulties: they may occur in colors that are usually stable (such as blacks), and abstract images (unlike Hopper's trees) rarely contain clues to their original colors (Figs. 127, 128). Photographic evidence has been crucial to our understanding of these changes—and scholars should be suitably cautious about works whose original appearance was not documented, and indeed, about the permanence of color photographic records as well. Perhaps the best-known example of such a change occurred in the murals that Mark Rothko painted for Harvard University in 1962.[48] Photographs record such a major chromatic shift—formerly red paintings turned blue—that by 1980 the entire series was withdrawn from public view and even from academic scrutiny (Figs. 172, 173).[49] In fact, concern for the permanency of the photographic records prompted Harvard's Conservation Center to publish the before and after images of this tragic loss.

None of these color changes is reversible. However, computer imaging now allows the colors to be reconstructed in virtual form; some museums have discussed publishing or exhibiting these adjusted images for educational purposes.

170

170 Edward Hopper, *Cape Cod Evening*, 1939, oil on canvas, 76.8 x 102.2 cm. National Gallery of Art, Washington, D.C. John Hay Whitney Collection (1982).

One might assume that the blue trees are a metaphorical interpretation of *l'heure bleu* (French for "twilight"). That would be a mistake. Hopper painted them a conventional green, but the yellow he used in the mixture has faded.

171 Vincent Van Gogh, *Irises*, c. 1890, oil on canvas, 73.7 x 93.1 cm. Metropolitan Museum of Art, New York. Gift of Adele R. Levy, 1958 (58.187).

There is no visual evidence that the white background was once pink. However, in a letter that the artist wrote to his brother, Theo, he described two versions of *Irises*: one on a pink background (this painting) and another on a citron background, now in Amsterdam (Ronald Pickvance, *Van Gogh in Saint-Rémy and Auvers*, catalogue [New York: Metropolitan Museum of Art, 1987], p. 185, cats. 51, 52).

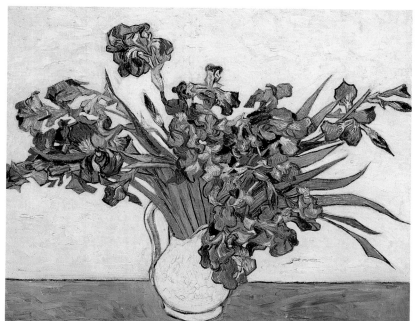

171

166

172 Mark Rothko, Panel Five of the *Harvard Murals*, 1962, glue-size and probably oil paint on canvas, 267.3 x 458.4 cm. Fogg Art Museum, Harvard University Art Museums. Gift of the artist, on deposit to the Harvard University Art Museums.

This 1963 photograph records the original colors. One contemporary observer noted the match between the paintings and the dark red cords of the stanchions protecting them (see p. 164).

173 Panel Five of the *Harvard Murals* (Fig. 172), 1988 photo.

The murals changed from crimson to blue because of prolonged exposure to high levels of unfiltered natural light. Unbeknownst to Rothko, the lithol red he used was inherently unstable.

172

173

174 Joshua Reynolds, *The Ladies Amabel and Mary Jemima Yorke*, c. 1761, oil on canvas, 195.9 x 171.8 cm. Cleveland Museum of Art.

The girls' blanched pallor is a result of red lake glazes that were fugitive. This is common in Reynolds' portraits (see below). For a full historical and technical study of the painting, see Barbara A. Buckley, "Sir Joshua Reynolds, 'The Ladies Amabel and Mary Jemima Yorke,'" *Bulletin of the Cleveland Museum of Art 73,* no. 9 (November 1986): 350–71.

174

Artists' Anticipation of Color Changes

One question that art historians might well raise is: Did the artists anticipate these chromatic changes, and might they have taken them into account? In other words, although the colors have changed, could they still represent the painter's intention? With abstract painting this is surely crucial, as color is a major vehicle of its meaning.

Joshua Reynolds (1723–92) was famously experimental, and his paintings suffered within his lifetime. His portraits were said to age and fade along with their subjects. One of his subjects, Sir Walter Blackett, complained in verse:

> Painting of old was surely well designed
> To keep the features of the dead in mind,
> But this great rascal has reversed the plan,
> And made his picture die before the man.

Reynolds was cavalier when criticized. It is said that he "joked himself at times on the subject, remarking that he might say of his works that he came off with '*flying* colours.'" Still, it is worth remembering that his pale portraits of women and children once had rosy cheeks (Fig. 174). The change distressed his patrons, and presumably their descendants.[50]

175 Francis Bacon, *Painting*, 1946, oil and pastel on linen, 197.8 x 132.1 cm. Museum of Modern Art, New York. Purchase.

Some of the raspberry-colored areas faded to pink. Although Bacon initially wanted to repaint them, he later preferred the change.

175

According to contemporary accounts, both Manet and Renoir knew that certain pigments would fade, and they purposely applied them too bright. That still leaves the question of when they reached the intended tonality, since, unlike fine wines, they were not withheld from the public until properly aged. Still, it may help explain viewers' shocked response to the initial colors.[51]

Francis Bacon's *Painting* (Fig. 175) illustrates some of the ambiguities around the artistic intent regarding such changes.[52] The Museum of Modern Art, New York, acquired the work in 1948, and museum files record that as early as the 1970s the artist was disturbed by the fading of certain colors—the ones he had worked in pastel rather than oil. Bacon (1909–92) informed MoMA that he hoped to repaint them in the original colors—something the museum was unlikely to allow. However, when the artist saw the painting again in 1984 he decided that he preferred the faded colors to his originals. What can we say was Bacon's intent?

Losses

Paint losses occur because of internal problems in the paint structure (inherent vice), or because of external injury, such as water damage, insect infestation, tears, scrapes, or holes in the canvas, abrasion, and overcleaning. If such losses are not covered they will be readily apparent. Pinpoint flaking, as seen in Vermeer's *Girl with Pearl Earring* (see Fig. 154) can result from age, drying problems, movement in the support, or insufficient binding medium (the paint is underbound). Losses are usually inpainted when a painting is conserved, as these were (see Fig. 152). Another type of flaking caused by structural problems is known as interlayer cleavage: the layers of paint separate. This usually occurs when several layers of rich paint have been overlaid and do not bond well; it is a problem inherent in certain painters' technique (Fig. 176).

Although losses are often obscured by repainting, various clues can alert the viewer to areas of likely damage. Panels frequently separate at the joins, causing characteristic losses in straight lines that may be repainted (see Figs. 9, 103). With canvases, clues can be found on the reverse: water stains are signs to look for corresponding losses on the face; patches indicate damage and likely paint loss; insect sacs or frass (droppings, which resemble sawdust) suggest the possibility of holes and paint loss. Further clues are on the painting's face: projecting paint either from impasto or cupping (the raised edge of paint along a crack) are particularly subject to abrasion.

176

176 Photomicrograph detail (using a microscope) of Claude Monet's *Waterloo Bridge, London, at Dusk* (Fig. 244).

The flake of missing paint is a result of interlayer cleavage—a condition in which paint layers separate parallel to the surface. It is an inherent problem for the works of certain artists (Monet, among them) who applied multiple layers of richly bound paint.

177 Photomicrograph detail of Fig. 244.

This area reveals surface abrasion. At the high points of the canvas the paint layer has been completely worn off, revealing the pale ground.

177

The most likely cause of abrasion is cleaning damage. Unlike the previously described losses, this is subtle and may not be easy to distinguish. Fragile areas of paint, such as transparent glazes, signatures painted with varnish-thinned paint, or the projecting paintwork mentioned above (impasto and cupping) are particularly vulnerable. If the canvas weave is pronounced one can sometimes detect abrasion losses because the paint color varies from the peaks to the troughs of the surface (Fig. 177). Recognizing these effects requires patience, experience, and comparative examples.

Visible Effects of Prior Treatment

Most paintings have been cleaned and restored periodically. The intervals will be more or less frequent depending on several factors: a painting's inherent structural problems, the atmospheric conditions and changes to which it has been subjected, accidents that have befallen it, taste or inclination of its owner or owners, and the frequency with which it has changed hands. An old master painting is likely to have been treated multiple times through the centuries. Few of these treatments have been recorded (although a number of paintings in the Louvre have treatment records as far back as the eighteenth century[53]),

and they likely varied with the period, training, and ability of the restorers. The same is true of modern paintings, but to a lesser degree.

A very general rule of thumb is that paintings need treatment every forty to fifty years. This may not be necessary for the fortunate works that have remained in the same location for centuries (such as those from the Spanish royal collection, now in the Prado). According to records, several paintings have received especially frequent attention. Research on Rembrandt's *Anatomy Lesson* documented twenty-one treatments, and his *Night Watch* was restored at least twenty-five times prior to 1947. The seven campaigns of restoration on Eakins' (1844–1916) *Swimming* in less than a century is also rare. Repeated treatment to a modern work usually points to a history of multiple sales, although with the Eakins work the cause was inherent problems, coupled with accidents and frequent loans.[54] Even paintings less than a decade old may have received treatment because of structural problems or accidents.

Although some treatments leave visible effects, this does not always mean that they were unnecessary or poorly done. Still, scholars need to distinguish aspects of a work's present appearance caused by later intervention. Common and detectable effects of treatment include abrasion from cleaning (discussed above), repainting (inpainting) and regilding, staining from impregnation, stiffness from the lining adhesive or fabric, flattened impasto and increased canvas texture due to lining, and changed appearance due to transfer. These effects vary by degree in each instance. A trained eye can spot some at a distance, but others require microscopic examination, paint sampling, and ultraviolet or X-ray studies. Effects of treating the varnish layer will obviously affect the readability of the paint layer (see Chapter 5).

Although current conservation standards limit retouching to actual areas of loss, past standards were not so rigorous. Some heavily restored paintings are, in effect, collaborations by numerous hands over a long period (see the example of the Mellon Madonna, Figs. 187–89). Inpainting to obscure losses is usually found in areas of flaking or random damage and in overcleaned parts of a painting. Facial features, significant details, and signatures attract the most attention from cleaners and are therefore the most vulnerable. One should always scrutinize them for possible loss.

Retouches are more or less visible to the naked eye depending on when they were applied, the skill with which they were done, and the intended effect. Methods of inpainting such as *tratteggio* involve a stripped technique that is intentionally distinguishable up close (Figs. 178–80). Retouches age dif-

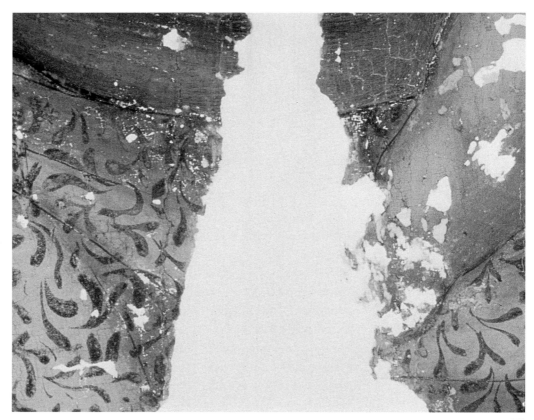

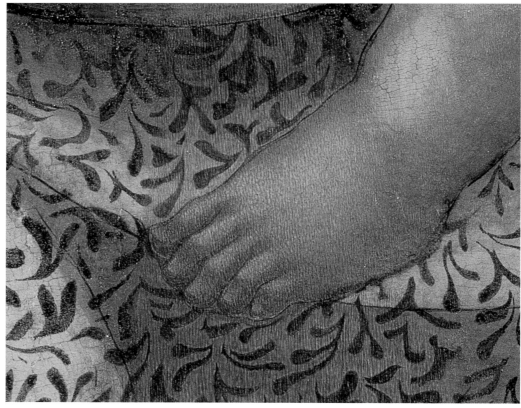

180

178 Detail. Pietro Lorenzetti, *Enthroned Virgin and Child* (Fig. 180) during treatment.

Note large loss in the area of the Christ Child's left foot. The loss has been filled but not inpainted.

179 Detail (after inpainting using *tratteggio*) of Fig. 180.

The method of inpainting produces corduroylike stripes that are clearly distinguishable at close range. It is particularly suitable for such large and significant losses. In this instance conservators at the Philadelphia Museum of Art reconstructed the foot from evidence in the painting itself and from other closely related works by Lorenzetti.

180 Pietro Lorenzetti, *Enthroned Virgin and Child*, 1320s, tempera on panel, 126 x 75.6 cm. Philadelphia Museum of Art. Johnson Collection.

Overall view after treatment. The foot reconstructed with *tratteggio* allows a clearer reading of the subject than would large areas of neutrally toned losses. *Tratteggio* was developed in Italy in the late 1940s. It is demanding and time consuming and has not been widely practiced elsewhere.

ferently from the surrounding paint. When they are not readily apparent to the naked eye, various methods of examination can reveal them: raking light, and ultraviolet and X-ray studies. Regilding can usually be distinguished from original gilding through microscopic examination.

Repaint intended to alter a painting's iconography, to account for changing standards of modesty, or to make a work more salable is identified by the same means, although its motivation was different. Historical factors should alert the scholar to the possible later addition of drapery and other "modernizations." A fascinating example is the *Icon with Military Saints George, Theodore, and Demetrios*, late eleventh and early twelfth centuries (State Hermitage, St. Petersburg). A poem records alterations carried out by the early fourteenth century that reflected a changing emphasis on the saints' youthfulness: "Wanting the warriors' features to appear younger, I scrape away the wrinkles of old age from their representations." ("On the Icon of Three Warriors Restored by Andronikos Kamateros," Cod. Marc. gr. 524).[55]

Impregnation and lining are often necessary for weakened canvases, but they carry inherent risks. The waxes that were commonly used as lining adhesives during the late nineteenth- through mid-twentieth centuries tend to seep through the canvas and ground layers and into the paint layer. This wax seepage can darken and disfigure light-colored grounds or areas of paint, and even obscure the paintwork (Figs. 181–84). Lining sometimes gives paintings a stiff appearance that seems out of character with works on canvas; this can result from either too much adhesive or too heavy a lining canvas. Furthermore, the heat and pressure involved in lining can alter the painting's surface. A heavy impasto is especially subject to flattening during lining. Lining can also exaggerate the prominence of the canvas. Too much heat or pressure may even reveal the weave of

Sources on Conservation Controversies

Concern over conservation treatments has a long history, but most of the best literature on the subject does not lend itself to interdisciplinary discussion; it frequently is directed primarily at conservators and often lacks illustrations. Two excellent works that illustrate multiple examples for nonspecialist audiences are Bergeon 1990 and Bomford 1997.

For readers who want to go further (keeping in mind the aforementioned limitations), an interesting discussion of the philosophical problems is found in Thomas Brachert, "Restaurierung als Interpretation," *Maltechnik Restauro* 89, no. 2 (April 1983): 83–95. The issues in painting conservation that attract the most disagreement are inpainting (also called "loss compensation") and varnish removal. For a clear and unpolemical overview of inpainting, see "Long Lost Relations and New Found Relativities: Issues in the Cleaning of Paintings," in Hedley 1993, pp. 172–78. On varnish removal, Hedley 1993 is again the most balanced: "On Humanism, Aesthetics and the Cleaning of Paintings," pp. 152–66. A well-known debate about varnishing was conducted over two years in the *Burlington Magazine* (cited as Gombrich et al. 1962–63), to which Hedley refers. Two recent books provide welcome information on historical restoration practices and the background to twentieth-century restoration theory: *Studies in the History of Painting Restoration*, edited by Christine Sitwell and Sarah Staniforth (London: Archetype Publications and National Trust, 1998), and *Historical and Philosophical Issues in the Conservation of Cultural Heritage*, edited by Nicholas Stanley Price, M. Kirby Talley Jr., and Alessandra Melucco Vaccaro (Los Angeles: Getty Conservation Institute, 1996). The latter addresses a range of media; the sections most pertinent to paintings are the articles by Paul Philippot and Cesare Brandi in part 3, the articles in part 4, and part 5. The various conservation journals and conference proceedings regularly publish divergent views on these subjects, but the art historian must expect to encounter a lot of scientific detail.

181 Macro detail of Fig. 184 prior to treatment.

The painting had been varnished and lined, using a wax adhesive. Both treatments significantly marred its appearance. This detail shows the surface distorted by varnish and brown wax that have seeped onto the face of the painting from behind. The wax almost completely obscures the impasto in the center of the photograph.

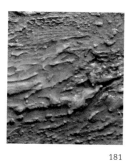

181 182 183

182 Macro detail of Fig. 184 during treatment.

Although the varnish has been removed, the brown wax remains.

183 Macro detail of Fig. 184 during treatment.

The varnish and most of the wax have been removed, revealing the original texture of the paintwork.

184 Mid-treatment photograph. Claude Monet, *Rouen Cathedral, West Façade*, 1893, oil on canvas, 100.1 x 65.9 cm. National Gallery of Art, Washington, D.C. Chester Dale Collection.

The removal of varnish and wax from the left half of the painting leaves the work much closer to the original colors and chalky surface that the artist desired.

184

185 Pierre-Auguste Renoir, *La Loge*, 1874, oil on canvas, 80 x 63.5 cm. The Courtauld Gallery, London.

Renoir painted on a finely woven canvas that has been permanently distorted by a wax lining.

186 Detail (woman's left shoulder and bodice) of Fig. 185.

Too much pressure was applied during lining, and the prominent horizontal weave of the coarse lining canvas has become visible on the face of the painting. This is clearest in the upper part of the photograph, where light bounces off the surface. Such "weave emphasis" is an irreversible deformation of the paint. This was not the artist's original effect.

185

186

the lining canvas as well as that of the original canvas (Figs. 185, 186). Unlined canvases are prized because they are much more likely to retain their original textural effects (see Figs. 40, 86, 113, 114; see also Appendix 2).

It is important to remember that an old painting that has been spared interventive treatments will not look like a painting fresh from the easel; it is simply a work that has been allowed to age naturally. Changed color harmonies, paint transparency, and craquelure inevitably have an effect. They must all be considered when comparing the present appearance with that noted by the painting's original and subsequent viewers.

Transfer of a painting from its original support, a procedure more common for panels but occasionally performed on canvases, is a radical treatment (see Chapter 2 and Fig. 10). We mentioned the changed appearance of a work painted on a rigid wooden support and with aging craquelure characteristic of a panel which has been transferred to a more flexible and more textured canvas (Figs. 8, 9). Some additional paint loss typically accompanies the transfer.[56]

Maroflage, the adhering of the canvas to a rigid support rather than to a lining canvas, also visibly affects a painting. The procedure can involve wood, cardboard, Masonite, or even aluminum as a backing. Canvases have been affixed to such hard backings throughout the centuries, and the results may exhibit a loss of flexibility visible on the canvas face. Maroflage will always be detectable from the reverse.

Nondestructive Examination of the Paint Layer

It is preferable to examine paintings nondestructively—that is, without taking samples. Some nondestructive methods: unaided examination in ambient light, examination in raking light, and study of the painting's surface under magnification. Enlargement can be achieved with a magnifying lens, a camera lens, or a microscope. Other nondestructive methods use light beyond the visible range of the spectrum: ultraviolet, infrared, X-rays, and autoradiography.

Visible Light

All examination of paintings begins with visual scrutiny in ordinary, or ambient, light; it is the standard against which all other studies are compared. Direct viewing is essential because it encompasses the entire painting at once, and in normal conditions. Daylight is ideal, although we discuss some of the implications

of lighting in Chapter 6. The slight magnification of a loupe will increase the visible detail, or a camera lens can be used to enlarged the image. Photography done with a lens using up to ten times magnification is called macro photography.

A useful second step is examination with raking light—either by means of an angled lighting source or by standing close and to the side of the painting, using ambient light to exaggerate the surface relief (see Chapter 3). Raking light is invaluable in detecting discontinuities in the paint surface; these include seams or joins in the support, irregularities and incisions in the ground (Figs. 92, 103), and changes in texture or reflectivity of the paint layer that do not correspond to the design (Fig. 222). These last are likely signs of damage, repair, or possibly *pentimenti* and signal the need for further investigation. Examination with ambient raking light requires no equipment, and with some practice, anyone should be able to employ it. The authors have observed wonderful raking light effects when viewing very large works in skylit galleries, where the top half of the paintings are inevitably lit at a sharp angle.[57]

A third step, possible only with the help of an equipped laboratory, is study of the painting's surface under a microscope. This will occasionally be sufficient to identify certain pigments (such as azurite from natural ultramarine) or to distinguish the large and irregular particles of hand-ground pigments from the fineness of those ground by machine—and may preclude the need for sampling. Microscopic examination of the surface is also useful in studying brushwork or craquelure, in observing layers of paint or possibly ground between the cracks, and in identifying the order of paint layering. Microscopic examination can also help distinguish repaint and regilding. Magnification can disclose paint that sits above an established crack line; this was probably applied over aged paint and is usually a sign of repaint. The differences between aged and recent layers are also more distinct under magnification: aged paint has a hard translucency, whereas new paint is more opaque, sometimes muddy. A variation in translucency of the paint warrants closer examination with ultraviolet, infrared, or X-ray studies.

Photographs can also be taken through a microscope; this is called photomicroscopy, and the magnification is much more intense than that available with a camera lens—from 100 to 40,000 times, depending on the instrument. Photomicroscopy can be performed on a painting's surface or on samples.

Beyond Visible Light

We are all familiar with medical X-ray imaging; similar and analogous techniques have been used in the examination of paintings. These involve visual discrimination of subtle effects and require experience and comparative studies. A physician trains for years in order to interpret the shadows of an X-ray image. Conservators and conservation scientists admit that long experience with these techniques may leave their interpretation open to question. Art historians who first encounter ultraviolet, X-ray, infrared, or autoradiographic studies should expect to be baffled; they expose different aspects of the painting from ordinary light, and it takes time and training to make use of them. The loss in resolution when radiographs, infrared reflectograms, or ultraviolet photographs are published leads to additional difficulties.

Ultraviolet (UV or black light) examination uses radiation just beyond the eye's ability to see and is most useful in examining the surface condition of a work (see Chapter 5). It sometimes reveals repaint as dark spots, though the varnish layer may interfere if it is aged, producing a strong fluorescence, or if ultraviolet inhibitors have been added to the varnish. These inhibitors have been developed over the past fifteen years; they are intended to slow the aging and discoloring of the varnish, but they also fit the interests of anyone wishing to hide the extent of damage and repainting. UV examination can be done with modest tools (a darkened room and a handheld ultraviolet lighting source) and can be documented photographically in black and white or in color. When conditions are right, the retouches will stand out dramatically, appearing bright purple, which translates as dark areas in black and white photographs. UV examination can sometimes even distinguish various campaigns of retouching, because the older retouches fluoresce differently. When the surface of an old painting appears unblemished under ultraviolet light, it is worth considering the possibility that fluorescence of the varnish is masking problems in the paint layer.

Ultraviolet examination was helpful in sorting out the relationship of two Byzantine madonnas in Washington. The Mellon Madonna (Fig. 187) had long been associated with another panel in Washington, the Kahn Madonna (Fig. 188), because of stylistic similarities. Were they by the same artist? Technical studies suggest another relationship (Fig. 189): significant differences in pigments, paint handling, and the use of incisions indicate that the panels were the work of different artists, while ultraviolet examination revealed extensive repaint on the Mellon panel. According to conservator Ann Hoenigswald,

187

188

187 Byzantine, *Madonna and Child on a Curved Throne*, 13th century, tempera on panel, 81.5 x 49 cm. National Gallery of Art, Washington, D.C. Gift of Andrew W. Mellon.

When Berenson published this panel in 1922 it showed no surface damage. Based on stylistic similarities, he attributed it to the same artist as the Kahn Madonna (Fig. 188). By the time the painting entered the National Gallery of Art it had been significantly restored.

188 Byzantine, *Enthroned Madonna and Child*, 13th century, tempera on panel, 113.1 x 76.8 cm. National Gallery of Art, Washington, D.C. Gift of Mrs. Otto Kahn (1949).

Studies of paint and incisions established that the two madonnas were from different workshops. Ultraviolet studies of the Mellon Madonna suggested reasons for their resemblance (see pp. 179, 182).

189 Ultraviolet photograph of Fig. 187.

The dark areas indicate that the entire pattern of cracks and all the highlights of the figures, drapery, and throne have been retouched. Very recent paint does not fluoresce, as does the original paint.

189

190 Judith Leyster, *Self-Portrait*, c. 1630, oil on canvas, 72.3 x 65.3 cm. National Gallery of Art, Washington, D.C. Gift of Mr. and Mrs. Robert Woods Bliss.

Technical studies reveal not only losses after the painting was complete, but a significant change by the artist.

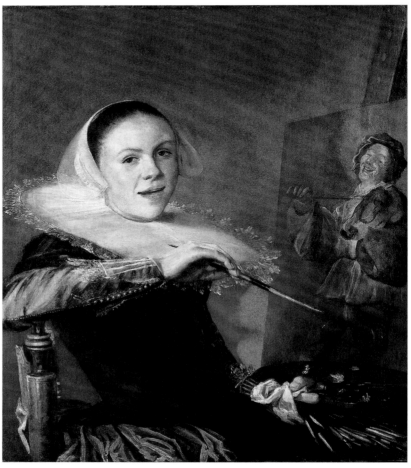

190

"a possible explanation for the stylistic similarities may well be that the Kahn Madonna was the model for the restoration of the badly abraded Mellon panel."[58] Ultraviolet examination more routinely exposes localized areas of repaint that do not flouresce, as does the original paint (Figs. 9, 191).

X-ray examination (radiography or X-radiography) is employed to study the way a painting is developed and to detect damage. The use of X-rays to study paintings goes back to Röntgen and his colleagues in the 1890s and has become broadly known since 1938, when Alan Burroughs published *Art Criticism from a Laboratory*.[59] X-ray examination is valuable in revealing *pentimenti* or an image that preceded the visible one (from an earlier state of the same painting or a reused support; Figs. 194–97). Painting materials are more or less transparent to X-rays, depending on their chemical composition. Lead is particularly absorptive of X-rays, so that lead-containing pigments, such as white, appear light on the X-ray film. The frequent use of lead-

191

193

192

191 Ultraviolet photograph (detail) of Fig. 190.

The old paint fluoresces, while the retouches do not—registering as dark spots in this photograph. They can be seen throughout the artist's hair and face, where they follow fine losses along the cracks, and in the background above her head.

192 Infrared photograph of Fig. 190.

Seventeenth-century painting technique rarely involved underdrawings that are sensitive to infrared. However, infrared studies revealed a surprising change in the paint layers of Leyster's self-portrait: the painting on the easel was originally itself a self-portrait rather than the merry fiddler we see in the finished work.

193 Radiograph of Fig. 190.

The most prominent feature revealed by X-ray is the patched canvas in the lower left corner (the area of her skirt). The *pentimento* seen in the infrared photograph is much less clear in the radiograph. For a full description of the painting that includes these technical studies, see National Gallery of Art, Washington, D.C. 1990–, Wheelock 1996, pp. 155–59.

194 Joaquín Torres-García, *Composition*, 1932, oil on canvas, 72.5 x 60 cm. Hirshhorn Museum and Sculpture Garden, Smithsonian Institution, Washington, D.C. Gift of Jon N. Streep through the Joseph H. Hirshhorn Foundation (1972).

The X-ray study discloses a grid that differs from the visible one.

195 X-ray study of Fig. 194.

The study reveals extensive changes. The masklike form at the upper right of the painting is clearly visible on the radiograph, whereas the two light rectangles at the center of the radiograph do not correspond to the final work. Because of the artist's modular compositions it is difficult to know whether he made major changes in the course of painting or reused a canvas.

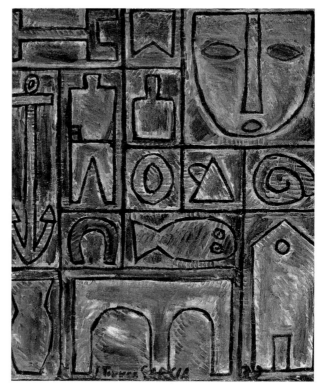

194

195

196 André Derain, *Biblical Subject*, c. 1906, oil on canvas, 27 x 34.9 cm. San Francisco Museum of Modern Art. Gift of Wilbur May.

In many areas brushwork does not correspond to the figures; this suggests significant compositional changes. X-ray examination confirms the presence of a previous work. Derain had reused a canvas.

197 X-ray study of Fig. 196.

The image registers very little of the figure group. More prominent is Derain's previous composition. When rotated 180 degrees, a cup at the right and several pieces of fruit remain from a still life. The radiograph also records the grain of the stretcher and the tacks used to attach the canvas at the periphery. More unusually, it reveals a crackle pattern that corresponds to the earlier still life. The white vertical seam is the gap between the two films used for the X-ray image.

196

197

containing underpainting means that radiography often reveals the application of otherwise invisible layers of paint. Repairs and repaint absorb radiation differently from the surrounding paint and become visible through X-ray studies (see Fig. 223). Extensive comparative radiography of some artists' oeuvres have contributed significantly to our knowledge of their manner of working. The most complete bibliography of radiographic studies is van Schoute and Verougstraete-Marcq 1986.

Radiography reveals all the layers of the painting at once. These may include joins in the support, reinforcements or cradling of a panel, stretcher bars and nails holding a canvas to the stretcher, the ground (see Case Study 24), any impression on the ground from seams, weave, or distortions in the canvas, previous compositions or earlier states of a painting (Case Studies 21, 22), and any paint or labels on the reverse or the face of the painting. All of these are potentially confusing but can be distinguished with experience and in combination with other analytic techniques.[60] X-ray studies also require expensive, bulky, and potentially hazardous equipment and knowledgeable technicians, although such studies are standard in the conservation laboratories of larger museums.

The value of X-ray studies depends on the nature of the painting and the questions being asked. They are most useful comparatively, particularly in studying working method. If significant prior studies reveal a sure hand in an artist's underpainting, a radiograph showing murky or reworked underpainting should be cause for concern about the authenticity of the work. However, if comparative studies show that an artist always reworked his compositions, radiographs without *pentimenti* should raise questions: Is the work a copy of a prior composition? We will illustrate some of the uses of X-ray studies in the cases that follow.

Infrared examination uses another range of the spectrum, which is also absorbed differently depending on the paint materials. Although X-rays are most readily blocked by lead-containing pigments (usually the whites), infrared is most sensitive to carbon-containing pigments—the blacks. Because of this, infrared studies often reveal underdrawings when they were done with carbon-containing paint or ink on a light ground. They can also reveal ground incising. Neither infrared nor X-ray studies will divulge chalk underdrawings done on a dark ground or underdrawings in watercolor or even in thinned oil paint unless a lead or carbon-based pigment was used. The inability to detect underdrawings does not guarantee that the artist worked without preliminarily drawing on the canvas or panel. During the past twenty years, infrared studies have

revealed a particular wealth of underdrawings beneath early Netherlandish paintings—a period in which few independent drawings exist. Less well-known studies of Byzantine through contemporary paintings have yielded equally valuable underdrawings (Figs. 198–203). Infrared studies occasionally reveal *pentimenti* that may not show up with radiography (Figs. 192, 193; see also Figs. 235, 236). Infrared studies can be done with photographic film sensitive to the proper wavelength (infrared photography), although better results are obtained with an infrared vidicon system (infrared reflectography), which employs a closed-circuit television camera and a monitor that are sensitive to the infrared. Photographs taken from the video screen, often detail-by-detail and assembled patchwork fashion, are termed infrared reflectograms, abbreviated IRR (Figs. 199, 203). Computer manipulation of these assembled images has produced studies with fewer distracting marks. While infrared vidicon systems are not quite as common as radiography equipment, increasing bodies of infrared reflectography studies have been published.

Sources on Infrared Reflectography

Molly Faries gives a clear, short introduction to the technique in Faries 1975, pp. 92–97. This will perhaps be superseded by the same author's *Discovering Underdrawings: A Guide to Method and Interpretation* (in press by Brepols [Turnhout, Belgium]). Ainsworth 1989 introduces the study of underdrawings within the general context of drawings and their varying uses in Northern Renaissance practice.

Proceedings are published for the biennial conference on underdrawings, *Colloque: Le dessin sous-jacent dans la peinture*, Collège Erasme, Louvain-la-neuve. Most of the contributors use infrared reflectography, and some volumes contain bibliographies of infrared research. While the bulk of the studies address early Netherlandish paintings, they also include articles on English, French, German, and Italian paintings up to the twentieth century. (See the Bibliography for individual and comparative studies that may be easier to obtain than the Louvain-la-neuve proceedings.)

Infrared reflectography yields deceptively clear results that need to be interpreted with caution. The physicist who invented the technique, J. R. J. van Asperen de Boer, includes such a caveat: "The method employed in this study has been to try to correlate such 'types' of underdrawing in various paintings, and thus to establish 'links' between aspects of the underdrawing phase. *Obviously this does not necessarily apply to further stages in the painting process*" (emphasis added). He supports his reservations with several examples, citing changes of style within a single underdrawing as well as differences in the underdrawings of secure works by the same artist. Interpretation of underdrawings must be made in light of historical knowledge about a particular artist's workshop practice. Burton Frederickson makes this clear when talking about Raphael's work: "Extensive underdrawing—or the lack of it—on panels from Raphael's workshop cannot be taken in and of itself as a conclusive indication of authenticity. Raphael did not always follow the same formula. Indeed, the actual process of transferring a composition with the use of a cartoon would most likely not have been done by the master himself but rather by an assistant, suggesting that the contour drawings retrievable through infrared reflec-

198 Willem de Kooning, *Queen of Hearts*, 1943–46, oil and charcoal on fiberboard, 117 x 70 cm. Hirshhorn Museum and Sculpture Garden, Smithsonian Institution, Washington, D.C. Gift of the Joseph H. Hirshhorn Foundation (1966).

The painting retains evidence of the artist's developing ideas in changes to both drawn and painted passages. As with the earlier example of Velázquez (Fig. 115), de Kooning intended these changes to be visible.

199 Infrared reflectogram of Fig. 198.

De Kooning's process of simultaneously drawing and painting throughout successive layers is evident. This working method is especially clear in the area of the figure's shoulders and breasts. Only some of this drawing is visible in the final work. Susan Lake and Judith Zilczer, conservator and curator at Hirshhorn, used these infrared studies to demonstrate that De Kooning's procedure blurred the distinction between underdrawing and painting stages. This is a composite of adjacent details—hence the patchwork appearance—termed an "infrared reflectogram assembly."

198

199

200 John Singleton Copley, *Watson and the Shark*, 1778, oil on canvas, 182.1 x 229.7 cm. National Gallery of Art, Washington, D.C. Ferdinand Lammot Belin Fund.

Multifigure historical subjects were typically worked out in detail at the drawing stage. Infrared reflectography indicates that Copley adjusted this composition on the canvas.

201 Infrared reflectogram detail (1.5–2 microns) of Fig. 200.

This detail discloses significant adjustments to the underdrawing of the head of the balding man at center. These images are typically clearer on the vidicon screen and lose some resolution when photographed.

200

201

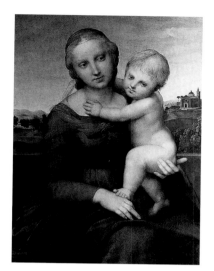

202

202 Raphael, *Small Cowper Madonna*, c.
1505, oil on panel, 59.5 x 44 cm. National
Gallery of Art, Washington, D.C. Widener
Collection.

The visibility of underdrawing in some
of the flesh areas, even in ordinary
light (Fig. 162), suggested that infrared
studies might reveal further drawing.

203 Infrared reflectogram assembly
of Fig. 202.

The subtle changes throughout
both figures (most notably to the torso,
left shoulder, hand, and foot of the
Christ Child) indicate that the composi-
tion was adjusted on the panel,
not transferred directly from a drawing.
Such changes may suggest Raphael's
own hand in the underdrawing, because
one of his many assistants would have
worked from a finished cartoon.

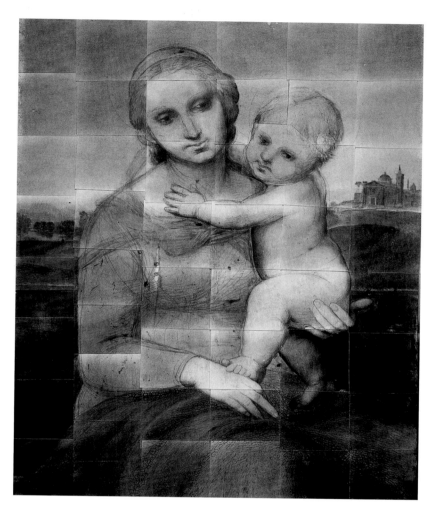

203

tography are very possibly not by Raphael at all, and that only in those instances where the underdrawing has been enlarged upon, such as in the *Small Cowper Madonna*, can one expect to see his hand" (Fig. 203).[61]

 Autoradiography has produced valuable information but is unlikely to be a routine method of examining paintings (the concept is not to be confused with radiography, which applies only to X-ray examination). It is particularly useful in combination with other analytic methods, such as cross-section analysis and radiography. It can reveal some underdrawings in pigments that are not sensitive to infrared and may disclose the manner of paint application. Autoradiography can also distinguish pigments and illuminate paintwork within dark areas that have faded or sunk. The method requires the cooperation of a nuclear physics laboratory, to which the paintings must be transported and housed for several months. It also demands comparative studies that are published for only some half-dozen artists. The interpretation of autoradiography is more counterintuitive than the other imaging techniques. It produces successive images of a painting, and the initial temptation is to read these as successive layers of the painting. In fact, they represent different pigments according to their radioactivity, and they may record the same pigment used in multiple layers, so that carbon blacks in both the underdrawing and the upper paint layers will appear together on the same autoradiograph.

Sources on Autoradiography

Ainsworth 1982 is the fullest discussion of autoradiography, investigating paintings by Rembrandt, Van Dyck, and Vermeer and combining the technique with radiographic and cross-section studies. Brown, Kelch, and van Thiel 1991 and Hubert von Sonnenburg, *Rembrandt/Not Rembrandt in the Metropolitan Museum of Art: Aspects of Connoisseurship*, vol. 1: *Paintings: Problems and Issues*, catalogue (New York: Metropolitan Museum of Art and Harry N. Abrams, 1995) compare the use of autoradiography and other imaging techniques in studying numerous paintings by Rembrandt. Claire Barry (Conisbee et al. 1996, pp. 287–301) studies three La Tours with autoradiography; Hobbs, Cheng, and Olin 1990 use autoradiography to study several paintings by Thomas Wilmer Dewing, and Doreen Bolger employs it in studying several works by Albert Pinkham Ryder (*American Paintings in the Metropolitan Museum of Art*, vol. 3 [New York and Princeton: Metropolitan Museum of Art and Princeton University Press, 1980], pp. 7–34). A single painting by Picasso is examined with autoradiography as well as radiography in Lucy Belloloi, "The Evolution of Picasso's Portrait of Gertrude Stein," *Burlington Magazine* 1411, no. 1150 (January 1999): 12–18.

204

205

204 Raphael, *Julius II*, 1511–12, oil on panel, 108 x 87 cm. National Gallery, London.

The pattern of crossed keys and tiaras on the background curtain had been painted out but became visible in ordinary light following conservation treatment in 1970. X-ray studies revealed these *pentimenti* even more clearly. This information was used to confirm the primacy of the London variant.

205 X-ray study of *Julius II* (Fig. 204).

The crossed key design is particularly clear just above the pope's left hand and to the proper right side of his head. The wavy verticals record the grain of the wood and the horizontal bars the battens used to strengthen the panel from behind.

The Uses of Radiographic Studies

Radiography is commonly used when comparing variants; even so, different examples raise varying questions, and interpretation of the studies must always be grounded in historical research. An obvious question with variants of the same composition is that of primacy. The London version of one of Raphael's most important and influential portraits, that of Julius II (Fig. 204), had long been disfavored by comparison with the panel in the Uffizi, which could be traced to the pope's family. Cecil Gould discovered significant *pentimenti* in visible light, clarified with X-ray studies, which forced him to reconsider the painting's provenance (Fig. 205). Subsequent research of early collection inventories confirmed what radiography had suggested: the London variant is both autograph and the prime version. As Gould put it, the National Gallery had a "goose that turned into a swan."[62] We refer to the contribution of inventory numbers in identifying the painting in Chapter 6.

The four case studies that follow make significant use of radiography. Case Studies 19 and 20 compare variants, looking at the presence or absence of *pentimenti* in an attempt to determine priority and understand studio practice. In Case Studies 21 and 22 the X-ray studies reveal prior compositions. In both instances these initial attempts were recorded elsewhere, and the examinations clarified the artists' working process.

19

Chardin's Three *Soap Bubbles*
X-Ray Studies Draw a Blank

While X-ray studies could not determine the sequence of three paintings by Jean-Siméon Chardin (1699–1779), they helped fix the paintings within the artist's working process.[63] Chardin's *Soap Bubbles* survives in three versions, all in American collections (Figs. 206–8). All are considered autograph, and technical studies suggest that Chardin may have painted a fourth version.

Chardin's earliest biographer records that *Soap Bubbles* was the artist's first figure painting. His image stands midway between allegorical interpretations of the subject by seventeenth-century Dutch artists and nineteenth-century scenes of everyday childhood experience. The subject must have appealed to Chardin, for an image of a boy blowing bubbles—it is not clear whether it was one of these three—was recorded in the artist's estate. Chardin worked slowly and usually painted from life rather than from preliminary drawings. His paintings often contain evidence of revisions. He also notably copied himself, producing many autograph replicas. The radiograph of *Knucklebones* shows reworkings common in Chardin (Figs. 209, 210). This painting was probably a pendant to *Soap Bubbles*, for both were engraved at the same time, and the engravings were sold as a pair. Curators at the three museums naturally looked for similar *pentimenti* in attempting to identify the primary version of *Soap Bubbles*, yet the X-ray studies revealed no revisions at all (Figs. 211, 212). As Martha Kupfer, curator at the National Gallery, explained, "Superimposing X-radiographs confirms that the central figures in all three *Soap Bubbles* correspond in size and silhouette. Such precise replication, we may infer, would have required Chardin to use some kind of drawing as a template or pattern, even though transfer marks cannot be detected."[64] This suggested that Chardin based the three surviving versions on a fourth painting, whose whereabouts is unknown.

206 Jean-Siméon Chardin, *Soap Bubbles*,
c. 1733–34, oil on canvas, 61 x 63.2 cm.
Metropolitan Museum of Art, New York.
Wentworth Fund (1949).

207 Jean-Siméon Chardin, *Soap Bubbles*,
c. 1733–34, oil on canvas, 60 x 73 cm.
Los Angeles County Museum of Art. Gift of
Ahmanson Foundation.

208 Jean-Siméon Chardin, *Soap Bubbles*,
1733–34, oil on canvas, 93 x 74.6 cm.
National Gallery of Art, Washington, D.C.
Gift of Mrs. John W. Simpson.

Like many of Chardin's paintings,
this exists in multiple variants. Could
technical studies determine which work
was painted first and reveal more about
Chardin's working methods?

206

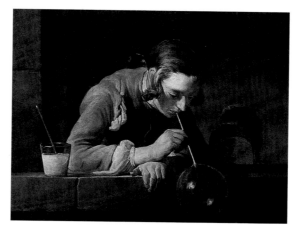

207

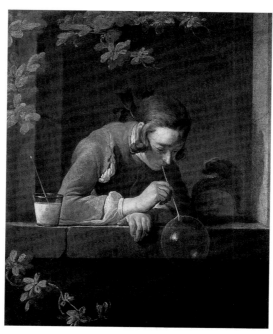

208

209 Jean-Siméon Chardin, *The Game of Knucklebones* (*Les Osselets*), c. 1734, oil on canvas, 81.9 x 65.5 cm. Baltimore Museum of Art. Mary Frick Jacobs Collection (BMA 1938.193).

This painting was possibly a pendant to *Soap Bubbles*.

210 X-ray study of Fig. 209.

This image reveals many reworkings—in both hands, the profile of the head and body, and the neckline—that characterize Chardin's initial attempts at figure compositions. It also indicates that the painting was once an oval format. The white lines are the edges of the multiple films used to assemble the X-ray image. The pattern of white lines at the borders reveals tacks that hold the canvas to the stretcher.

211 X-ray study of Fig. 207.

This image offers no clue to priority: it betrays none of the reworking that was seen in radiograph of *The Game of Knucklebones* (Fig. 210). The stretcher and its vertical reinforcement, as well as the tacks, appear white.

212 X-ray study of Fig. 208.

This radiograph shows that the painting also lacks *pentimenti*. Based on knowledge of Chardin's usual practice, the lack of revisions as well as the exact correspondence of the figure in the three versions suggests that the composition was worked out elsewhere and transferred to all three paintings using the same cartoon.

211

209

212

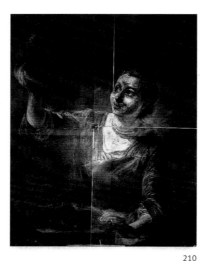

210

20

Varying Questions of El Greco
Working Procedure, Iconography, Art Theory

With multiple variants, the questions examined with radiography can be more complex.[65] El Greco (1541–1614) left many variant images and numerous records of compositional changes. Gridley McKim-Smith, María del Carmen Garrido Pérez, and Sarah L. Fisher studied El Greco's work, posing three distinct questions. The technical studies were examined in relation to historical accounts of El Greco's technique and contemporary Spanish treatises on painting. This yielded a subtler understanding of El Greco's practice rather than conclusive answers.

The researchers' first question concerned the paintings' sequence. While of similar composition, the paintings ranged significantly in size: a small painting in Washington (Fig. 213), a medium-sized painting in the Prado (Fig. 214), and a larger version in Toledo. The small scale of the Washington painting suggests that it was either a study (*modello*) for the larger paintings, which would have served as private devotional images, or a copy (*ricordo*) made as a pattern for future workshop use.

The radiograph of the Washington painting revealed few and minor changes (Fig. 215).[66] This would tend to rule out its function as a preliminary study for the larger works. But the comparative evidence is not so simple. The radiograph of the Prado painting (Fig. 216) revealed one change that suggests the Washington painting may have preceded it: St. Joseph was originally white-haired, as he is in the small painting in Washington, whereas he has dark hair in the finished Prado version. Comparing radiography of all three paintings, the authors conclude, "Perhaps the very question of *modello* as opposed to *ricordo* needs recasting for El Greco. In view of the many similarities . . . , the slight adjustments of placement and expression within any single painting seem to indicate that the Virgin and Child combined with Saints Anne, Joseph, or John the Baptist was a generic model within El Greco's oeuvre. El Greco tended to think within a formula, and one is tempted to see his collection of paintings 'on smaller canvases' as a hanging pattern book. But the fact that such formulas could constitute his routine pictorial vocabulary suggests that searching for sequences is pointless. Even *modelli* were likely to contain *ricordi* of earlier versions."[67]

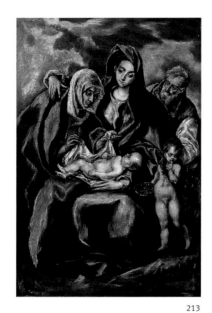

213

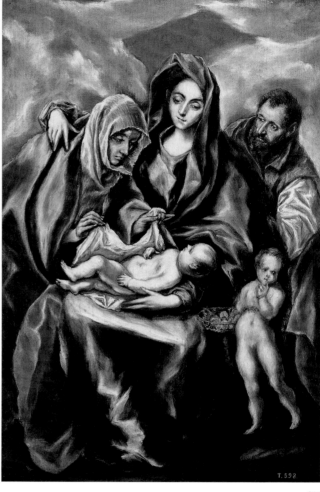

214

The second question concerned El Greco's varying representations of
Joseph: What was the relationship between El Greco's imagery and contemporary reli-
gious thought? The authors situate El Greco's work in a period of active debate over
Joseph's age and suggest that the vacillation between a wizened and a youthful Joseph
reflects the theological climate.

Finally McKim-Smith, Garrido Pérez, and Fisher used the comparative X-ray
studies to illuminate the place of revisions within Spanish art theory of El Greco's
day as it reflected the competition between Florentine and Venetian technique. Although
most Spanish treatises on painting tended to follow Vasari's model and emphasize
Florentine technique, Spanish painters had in practice emulated Venetian technique ever
since Charles V had patronized Titian and ennobled the artist. As the authors conclude,

213 El Greco (Domenikos Theotokopoulos), *The Holy Family with Saint Anne and the Infant Saint John*, c. 1595–1600, oil on canvas, 53.2 x 34.4 cm. National Gallery of Art, Washington, D.C. Samuel H. Kress Collection.

El Greco's works often exist in multiple variants of differing sizes and minor variations.

214 El Greco (Domenikos Theotokopoulos), *The Holy Family with Saint Anne and the Infant Saint John*, oil on canvas, 107.95 x 68.9 cm. Museo del Prado, Madrid.

While obviously related to the Washington, D.C., painting, this much larger version has a youthful St. Joseph.

215 X-ray study of Fig. 213.

This radiograph reveals none of the major revisions one would expect to find in preliminary studies, which suggests that the composition was worked out previously. Several prominent features visible on the radiograph have no significance in comparing the two paintings: the stretcher, with its cruciform reinforcement and keyed corners (the light area), and the peripheral tacks.

216 X-ray study of Fig. 214.

This shows one significant change: St. Joseph was originally painted with white hair and beard, whereas in the painting these are dark. This suggests that the Washington version might have served as the model for the Prado painting. This image reveals a keyed stretcher with no cross-bars, as in the Washington painting.

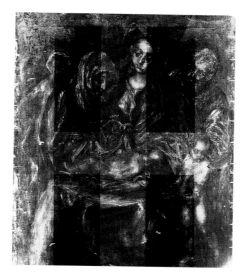

215

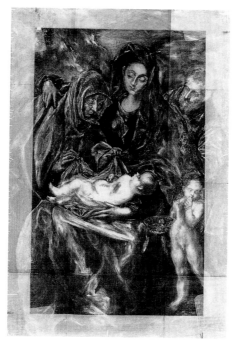

216

"If one wishes to focus upon the content of both his revisions and his brushwork, then one can argue that they were more than mere tools for constructing the subject of a painting. As conventions of pictorial execution, they were also signs, and as signs they could communicate a painter's allegiance to the Venetian school."[68]

The previous cases involve radiography to compare closely related groups of paintings. X-ray studies have also made important contributions when they reveal a significantly different composition that lies beneath a finished painting.

21

Case Study

Determining the Status of Constable's *White Horse* Sketch

When Constable's (1776–1837) *The White Horse* (Fig. 217) was donated to the National Gallery of Art in 1942, its surface was so darkened by thick, discolored varnish and marred by shrinkage craquelure that its status was difficult to determine.[69] Had the landscape been overpainted by Constable or by a later hand? Was it a copy? The size and composition matched those of another version, now in the Frick Museum (New York), a painting that Constable had used as his successful bid for entry into the Royal Academy in 1819. If the Washington painting was indeed a full-size sketch for the work in New York, it would constitute the earliest of Constable's six-foot sketches. These large oil sketches have been considered Constable's greatest achievement; their spontaneity on a grand scale has caught the twentieth-century imagination. Yet in Constable's day they were not intended for public view. His presentation works were meticulously finished, in marked contrast with his sketches, which were broadly handled.

X-ray studies taken in 1984 (Fig. 218) suggested a reason for the shrinkage craquelure: a previous composition was hidden beneath *The White Horse*. Charles Rhyne identified the earlier composition as a view of Dedham Vale, based on a smaller surviving sketch of the same scene (Fig. 219). Moreover, paint sampling disclosed that there is no layer of ground separating the two. Rhyne considered this convincing evidence that Constable had begun *The White Horse* as a *sketch*—he would certainly have started a

217 John Constable, *The White Horse* (full-size sketch), after cleaning, 1818–19, oil on canvas, 127 x 183 cm. National Gallery of Art, Washington, D.C. Widener Collection.

Prior to cleaning, the status of the painting was unclear. Was it a copy of a painting in New York, or was it Constable's first large-scale oil sketch?

218 X-ray study of Fig. 217.

This radiograph shows that Constable painted the image over a prior view of Dedham Vale (Fig. 219). The two roof gables and the white horse of the later painting overlay the higher horizon and foreground architecture of Dedham Vale. Rhyne noted that the lack of intervening priming suggests that *The White Horse* sketch was *not* intended for exhibition, despite its scale.

219 John Constable, *Stour Valley with Dedham in the Distance*, c. 1800–5, oil on paper laid to canvas, 49.8 x 60.3 cm. Victoria and Albert Museum, London.

Study for Constable's first attempt at a large-scale landscape for exhibition. Constable rejected the large painting and subsequently painted over it with the sketch for *The White Horse*.

217

218

219

painting intended for exhibition on a prepared ground. He reasoned that Constable was unhappy with the six-foot *Dedham Vale* and had made use of a full-scale sketch to resolve the composition before his second attempt at an exhibition painting.[70] But Rhyne was writing about a painting whose surface was still largely obscured. Subsequent testing and treatment confirm that Washington's *White Horse* is Constable's first completed large sketch but suggest a much more complicated relationship between it and Constable's earlier start on the same canvas.

Michael Swicklik began his painstaking treatment (carried out in 1992–97) by examining the paint layering. He was particularly eager to determine who was responsible for applying the final layers of paint. Cross-sections confirmed that the overpaint was added by someone other than Constable, and Swicklik began its slow removal. He described the results: "To universal delight, a stunning, fresh, lively, and well-preserved fully realized sketch for the Frick painting was revealed" (Fig. 217).[71]

The cleaning also revealed something highly unusual in Constable's method. In painting *The White Horse* sketch over the *Dedham Vale*, Constable incorporated some of the earlier paintwork into the later composition: part of a tree, a cloud, and most clearly some vines at the lower left. Cross-sections of these areas revealed only a single paint layer. The implication is that Constable developed a composition by appropriating parts of a prior and unrelated painting. This foreshadows both the radically modernist practice of Courbet, who worked fragments of earlier compositions into new ones, and Picasso's reused canvases, in which he cannibalized parts of his own earlier images.[72] The cleaning of Constable's first six-foot sketch has raised as many questions about the artist's practice as it has answered.

22

Mondrian's *Tableau No. IV*
An Earlier State Lost and Found

The donation of Mondrian's (1872–1944) *Tableau No. IV: Lozenge Composition with Red, Grey, Blue, Yellow, and Black* (Fig. 220) to the National Gallery of Art in 1971 reopened a puzzle for Mondrian scholars.[73] The painting had been published on three occasions paired with a variant whose most obvious difference was the narrower width of its black armature lines (Fig. 221). Curators began to search for the variant, hoping to compare it with their new gift. They found a trail of publications and several photographs, but no painting.

As E. A. Carmean Jr. and William R. Leisher studied the Washington painting and compared it to the photographs of its "lost" mate they began to unravel the mystery. What if the photographs recorded not a second version but an earlier state of the painting in Washington? Visual examination supported their conjecture, which was further confirmed by X-ray studies and paint sampling. Not only was a "lost" Mondrian recovered, but the results led to a greater understanding of the artist's working procedure.

Examination of *Tableau No. IV* in raking light (Fig. 222) revealed that its black lines had, indeed, been widened: the original lines were glossy, while the additions were more matte. The thin lines that could be discerned matched those in the photograph of the "lost" variant. Radiography provided further evidence of the change (Fig. 223) as did studies of the paint layering from cross-sections. The elegance and subtle geometries of Mondrian's painting were the result of a long process of trials and revisions. Evidence was embedded in the painting itself.

Examining Underdrawings with Infrared Reflectography

Infrared studies have revealed splendid preliminary drawings that show how the artist laid out and sometimes changed the design prior to painting. Occasionally they solve more complicated problems. They helped the Getty Museum solve a mystery in connection with a newly acquired panel, matching it to a known painting elsewhere. But the composition scheme revealed with infrared also suggested that something was missing.

220

221

220 Piet Mondrian, *Tableau No. IV: Lozenge Composition with Red, Grey, Blue, Yellow, and Black*, c. 1924–25, oil on canvas on hardboard, 142.8 x 142.3 cm. National Gallery of Art, Washington, D.C. Gift of Herbert and Nannette Rothschild.

This painting was repeatedly published alongside a variant (Fig. 221) whose location was unknown.

221 Piet Mondrian, *Composition in a Square with Red, Yellow and Blue*, as illustrated in Frank Elgar's *Mondrian* (Praeger, 1968).

The "variant" of the Washington diamond painting was known only from photographs. Where was the missing Mondrian?

222 Raking-light detail (upper right edge) of Fig. 220.

Mondrian's additions to the black lines of the Washington painting are revealed by a raking-light source. They are also visible in ambient raking light, as the painting hangs on the museum's walls.

223 X-ray study (upper right edge) of Fig. 220.

Radiographs confirmed the addition to the black lines that was observed in raking light. The narrower lines conform to those recorded in photographs of the "lost" painting. Tacks holding the canvas to the stretcher are prominent, and the crackle pattern is also visible. Patchy areas are filling material of differing density (hence lighter or darker) from repairs. These losses characteristically follow the crackle pattern.

222

223

23

Perspective Lines in Carpaccio's *Hunting on the Lagoon*
Guides to a Reconstruction

When the J. Paul Getty Museum purchased the charming panel of bird hunters on the Venetian Lagoon (Fig. 224) it was accepted as a work by Vittorio Carpaccio (c. 1460–1525 / 26) but was otherwise the subject of some disagreement.[74] The painting had surfaced in a Roman antiques shop in 1944. During the 1960s art historians Giles Robertson and Carlo Ragghianti separately suggested that the panel was the upper section of a well-known panel in the Museo Corer depicting two Venetian ladies sitting on their balcony (Fig. 225). Their argument was based largely on the alignment between the cut flower stem emerging from a vase at upper left of *Two Venetian Ladies* and the lily in the left foreground of the hunting panel, whose presence and scale are otherwise unexplained. Robertson soon renounced the idea, and it was not accepted by subsequent scholars.

The Getty examined its new painting in the course of restoring it and shed light on its original function. More significantly, technical studies linked the painting to the two ladies in Venice and confirmed that together the fragments form only half a composition.

Technical examination confirmed that the panels were mates by noting consistent paint handling and aging, perfectly matched wood grain, matching holes from hinges and even aligned worm holes. The more surprising information came from the infrared reflectography (Fig. 226). Carpaccio had planned his composition carefully; the underdrawing is extensive and shows few signs of change. The reflectogram records not only the figures but also the formal perspectival scheme. The horizon line is visible, as are a series of horizontal lines below it and faint diagonals that converge at a single vanishing point. As conservator Yvonne Szafran noted, the convergence of the diagonals at the side of the panel suggests that only half the original composition survives. The dog's head cut by the edge of the Corer panel corroborates the idea (Fig. 227).

The Getty's panel has a trompe l'oeil still life on the reverse that the museum determined to be contemporary with the hunting scene and probably by Carpaccio. This evidence, as well as the panel's painted edges and the presence of a hinge suggest that it originally functioned as a bifold shutter or door to a small room. Both the subject and the history of the missing half await further research.

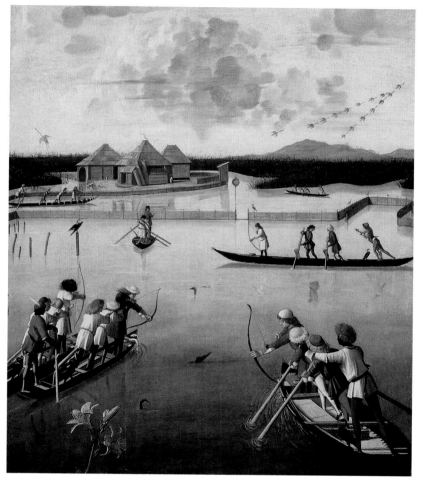

224

224 Vittorio Carpaccio, *Hunting on the Lagoon*, c. 1490, oil and tempera on panel, 75.2 x 63.6 cm. J. Paul Getty Museum, Los Angeles.

Technical studies confirmed a previous suggestion that this was the top half of a well-known painting in Venice. It also raised the likelihood that the two panels constitute only half of the original composition. The paint media were established by testing (see Szafran 1995, p. 157).

225

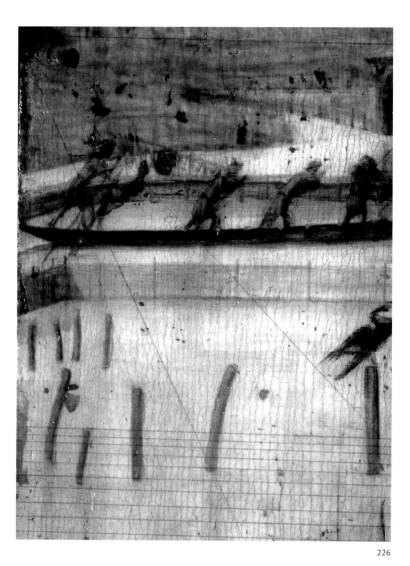

226

Complementary Use of Radiography and Infrared Reflectography

While infrared reflectography is usually done to examine underdrawings and radiography to examine paintwork, their usefulness depends on the technique of the painting in question. We have mentioned that infrared studies reveal underdrawings made with a carbon-containing ink or paint on a light ground, while radiography commonly discloses information about paintwork when the composition is built up with lead-containing pigments—usually white. If the painter's technique involved non-carbon-containing drawings, a lead-containing ground, or a paint layer substantially free of lead, the examination techniques must be chosen differently, as demonstrated in the following case.

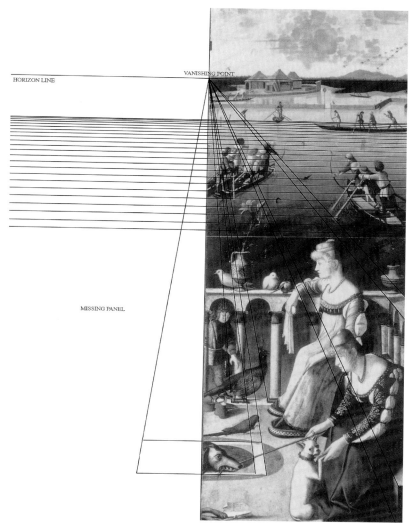

HORIZON LINE

VANISHING POINT

MISSING PANEL

225 Vittorio Carpaccio, *Two Venetian Ladies*, c. 1490, oil and tempera on panel, 94.5 x 63.5 cm. Museo Correr, Venice.

This rare Venetian genre scene was long known to be a fragment, but the ladies were assumed to be sitting on a balcony with the sky behind them. The vase at top aligns with the flower at the bottom of the Getty panel.

226 Infrared reflectogram detail (upper left, the distant boat closest to the shore) of Fig. 224.

The detail reveals many horizontal perspective lines and two converging orthogonals running from upper left to lower right.

227 Photocomposite.

Reconstruction by the Getty Museum's Department of Paintings Conservation proposes a missing half of the panel based on evidence of the perspective lines revealed with infrared reflectography.

227

24

Changing Means to Study Velázquez' Evolving Technique

In their large and systematic study of Velázquez (1599–1660), Carmen Garrido and her colleagues at the Prado's Department of Technical Documentation traced significant changes in the painter's technique which demand parallel studies with X-ray and infrared.[75] His Sevillian paintings employed dark grounds (hence transparent to X-rays) with the compositions modeled in lead white paints. X-ray studies of these early works reveal the figures clearly (Figs. 228, 229).

After visiting Rome in 1630 the artist switched to a ground containing lead. X-ray studies of these paintings show the pattern of ground application competing with that of the figure design (Figs. 230–32).

Several years later Velázquez varied his technique further. He retained the lead-based ground he had adopted in Rome but applied the paint thinly. He also switched from lead white to calcite—with the results that the radiography shows almost nothing of the figure compositions (Figs. 232, 233). With these late works, infrared reflectography yields more significant information about Velázquez' paintwork than radiography (Figs. 234–36). The Prado researchers comment on the interrelatedness of the two techniques: "Indeed it is impossible to study the works of Velázquez after this date [the 1630s] without this complementary documentation [infrared reflectography], . . . because radiography does not show the numerous changes made. The reason can be found in the painter's technique, increasingly more X-ray transparent in the paint layers and more opaque in the grounds. Infrared helps to explain the radiographic invisibility of the compositions, as through it we can observe the special characteristics of the artist's style: quick brushstrokes which only settle a little paint at the edges, leaving a wash-like centre."[76]

228

228 Diego de Velázquez, *The Adoration of the Magi*, 1619, canvas, 204 x 126.5 cm. Museo del Prado, Madrid.

Because of their technique—dark grounds and lead-containing paint— the designs of Velázquez' Sevillan paintings are easily studied through radiography (Fig. 229).

229 X-ray study of Fig. 228.

The composition reads clearly because Velázquez used lead white.

229

230

231

230 Diego de Velázquez, *The Forge of Vulcan*, 1630, canvas, 222 x 290 cm. Museo del Prado, Madrid.

The radiograph of this work is more confused than that of the earlier painting because of a change in Velázquez' technique. He continued to use lead-containing paints but switched to a ground that also contained lead. Visible seams, also seen on the radiograph, reveal that Velázquez added strips of canvas at both right and left, enlarging the field as he adjusted the composition.

231 X-ray study of Fig. 230.

This study records both the figurative design as well as an all-over pattern of curving strokes left by the ground application. A number of compositional changes are discernible: the head of

Vulcan (second from the left, facing frontally) was angled differently, the figure seen from behind originally wore a turban and his limbs have been adjusted, and the right arm of the far right figure has been moved. The prominent dark horizontal and vertical bands at center and at the left edge reveal the stretcher and its reinforcements.

232

233

232 Diego de Velázquez, *The Court Jester Barbarroja, D. Cristóbal de Castañeda y Pernia*, c. 1633, canvas, 200 x 121.5 cm. Museo del Prado, Madrid.

Even in visible light *pentimenti* can be seen in the jester's right foot, the sword (two prior positions are visible), the lower edge of his coat, and the bottom of the cape.

233 X-ray study of Fig. 232.

This radiograph reveals only the stretcher and the prominent marks left by the application of the lead-based ground. Velázquez had switched from lead white to calcite white in the paint layer, which is not recorded in X-rays studies.

234

235

236

234 Diego de Velázquez, *Surrender of Breda*, 1635, canvas, 307.5 x 370.5 cm. Museo del Prado, Madrid.

Although infrared studies usually reveal underdrawings, they are a much more useful technique than radiography for studying the painted designs of Velázquez' late works.

235 X-ray study of Fig. 234.

As with Fig. 232, the paint layer here is also transparent to X-rays. The gestural pattern records the ground application. The radiograph also indicates three areas of damage to the canvas (one at right center, the other two along the central vertical), which appear dark.

236 Infrared reflectogram (detail, the lances at furthest right) of Fig. 234.

This indicates that all of the lances in *Surrender of Breda* have been lengthened. For another example of *pentimenti* revealed more clearly with infrared than with radiography, see Figs. 192, 193.

5

The Varnish Layer

Varnish has traditionally been considered, by both painters and collectors, a renewable coating somewhat apart from the artist's handwork. Varnish was usually applied at least a year after the painting was completed so that the paint could dry. Some artists shipped paintings coated with a temporary varnish, expecting someone else to replace it with a proper varnish. By the nineteenth century, varnishing was routinely performed by professionals such as artists' colormen. The practice of replacing discolored varnish dates from at least the seventeenth century. Therefore, examination of the varnish layer always begins with the question of whether it is contemporaneous with the rest of the painting. It rarely is; that is why physical examination of the varnish layer rarely contributes historically useful information, other than data on a painting's care—and hence possibly its provenance.

If the varnish is original it can indicate the artist's or at least the period's ideas about the desired gloss and tonality of the painting, although the varnish will have changed optically over time. During times of active debate about varnish, its presence or absence can indicate a painter's allegiance to a theoretical position. Indeed, there is evidence that certain artists were particularly concerned with the aesthetic effect of the varnish. If the varnish is a later addition or replacement, it is most useful as an index of changing taste about standards of picture "finish."

Although technical examination of most varnishes will not yield historical data, the condition of the varnish inevitably has a major effect on our understanding of the painting—for the varnish literally filters our vision. To interpret or recover the painting's original look, we must turn to written sources.

The Physical and Aesthetic Function of the Varnish Layer

A surface coat of varnish has two functions: protecting the paint layer from attack by solvents and airborne pollutants, and altering the look of the paint surface. In the words of Delacroix (1798–1863), "Varnishes should be a kind of protective armour to the picture, as well as a means of bringing out its brilliance."[1] The use of varnish goes back to ancient times. Varnish protects tempera paintings from moisture, something less necessary with paint bound in oil. Varnish also protects the paint layer from grime, smoke, and pollution, which leave a distorting film on the paint surface. A varnish coating makes it easier to remove such dirt.

Surface accretions of dirt above the varnish betray a painting's recent history. A work that has hung in a traffic-clogged city acquires a layer of grime quite different from one that has hung in a rural setting. If an ancestral portrait is brought to a conservator, he or she can readily tell whether there have been smokers in the family (from the characteristic film of yellow-brown tar), if the painting was hung over a fireplace (from residue of burned wood or coal), or even over a sideboard (from food remains). Herman Melville describes such a painting, which Ishmael saw in the Spouter-Inn, "so thoroughly besmoked, and every way defaced, that in the unequal cross-lights by which you viewed it, it was only by diligent study and a series of systematic visits to it, and careful inquiry of the neighbors, that you could any way arrive at an understanding of its purpose."[2] Airborne pollutants may cause more than temporary disfiguration of the painting. If corrosive, they can react with the paint film and do permanent damage.

Sources on Seventeenth-Century Aesthetics of Varnish

There is almost no hard evidence as to varnishing preferences prior to the eighteenth century, although a few scholars have turned to artists' manuals and critical writing for indications of seventeenth-century varnishing practice. Robert Ruurs cites Northern sources (de Mayrne and Hoogstraeten) that confirm a seventeenth-century preference for glossy oil or resin varnishes to matte varnishes of gum or egg white. However, resin and oil varnishes also have different physical and protective properties that might have determined their use ("Matte or Glossy? Varnish for Oil Paintings in the Seventeenth Century," *Intermuseum Conservation Association Newsletter* 16, no. 1 [November 1985]: 1–6, translation from the German as published in *Maltechnik Restauro* 3 [1983]). Helen Glanville gathered references to visual implications of varnish from a number of seventeenth-century Italian critics, including Félibien, Bellori, Boschini, Baldinucci, and Symonds, but it is unclear to what extent this literature describes standard practice. Glanville connects the seventeenth-century discussion of varnishing to the concept of proper viewing distance and questions of lighting ("Varnish, Grounds, Viewing Distance, and Lighting: Some Notes on Seventeenth-Century Italian Painting Technique," in *Historical Painting Techniques, Materials, and Studio Practice*, Preprints of a Symposium, University of Leiden, June 26–29, 1995 [Los Angeles: Getty Conservation Institute, 1996], pp. 12–19).

237 Detail. Kazimir Malevich, *Girls in the Field*, c. 1928, oil on canvas, 106 x 125 cm. State Russian Museum, St. Petersburg.

Malevich, like a number of modernists, consciously varied the surface qualities of his paints in several ways: in the right-hand girl he added surface varnish to the lower right quadrant of her face. In the girl at left he used different paints to contrast the shininess of the halves of her head (see Hoenigswald 1997, pp. 112–16).

237

The aesthetic function of a varnished surface is to saturate the colors (an optical effect that causes a slight darkening) and create a more uniformly reflective surface than paint in an unvarnished state.[3] The artist can vary the type or amount of varnish for a more or less glossy coating and can add small amounts of pigment (usually called toners) to the varnish to affect the chromatic reading of the painting. Until the late eighteenth century there is limited written evidence that most artists were concerned about the aesthetic rather than protective effects of varnish.

Since the mid-nineteenth century there has been active debate about the desirability of a uniformly saturated and glossy surface. The evenness of a varnished surface was antithetical to many artists who worked with matte paints or grounds, or intentionally varied the shininess of their paints from one area to another by varying the oiliness of the binder, by adding varnish directly to the paint, or by other means (Fig. 237; see Fig. 42). Therefore, the decision to varnish or not can reflect an aesthetic or ideological stance.

A Note on the Use of Varnish
for Purposes Other than Coatings

Varnish was occasionally incorporated into the paint layers or used between the layers to isolate them. Jean-Baptiste Oudry in his 1752 lecture "Underdrawing, Underpainting, and Retouching" recommended a thin layer of varnish on top of the initial sketch to keep the paint from sinking in, then another thin varnish before adding the highlights; although Oudry did not discuss a final varnish layer, he likely intended it. Michael Swicklik situates Oudry's lectures as a response to criticism of lack of technical instruction within the academy. His research suggests that Oudry's procedure of intermediate varnish layers was not standard practice. Van Gogh used eggwhite, rather than a resin varnish, to create an isolating layer before adding details; there is some evidence that this was common among painters of the Hague School in the nineteenth century.[4]

Later French academic texts recommended mixing varnish directly with the paint.[5] This had the effect of varying the paint's transparency and shininess—hence providing some of the aesthetic effect of varnish but not its protective effect. Use of either isolating layers of varnish or varnish-thinned paints does not produce paintings that would be described as "varnished" unless the surface has a final coat of varnish. French academic practice always included a surface coating of varnish to achieve the expected finish. Some twentieth-century artists who added varnish selectively to their paints eschewed the uniform gloss of this final coating.

The Composition of Varnishes

Traditional varnishes are made from resins (saps secreted from trees) or, on rare occasions, from insect secretions (shellac). Until the 1930s most varnishes were either spirit varnishes, which are easy to remove, or oil varnishes, which include a drying oil. There is no firmly established chronology for the use of spirit as opposed to oil varnishes. Eggwhite (glair—which was a standard paint medium for manuscript illumination) has been employed infrequently as a varnish for easel paintings. Often it was used as a temporary coating, as when an oil painting had to be exhibited or shipped before it was thoroughly dry. Wax has also been used occasionally as a varnish or as an

Sources on Varnish Composition

Detailed information on the physical and chemical properties of various resins and varnishes can be found in Gettens and Stout 1966. There are separate entries on copal, dammar, mastic (resins from three different trees), and various synthetic resins. Numerous early varnish recipes are cited in Caley 1990. For a scientific study of the optical qualities distinguishing different varnishes, see René E. de la Rie, "The Influence of Varnishes on the Appearance of Paintings," *Studies in Conservation* 32, no. 1 (February 1987): 1–13.

additional coating above the varnish.[6] Since World War II synthetic varnishes have been available for use by painters and conservators. While traditional varnishes are applied with brushes, sponges, or occasionally with the hands, modern varnishes can also be sprayed for very thin application.

Aging of the Varnish Layer

Varnishes are usually clear when applied, but most discolor with time. Both spirit and oil varnishes discolor to yellow or yellowish-brown. Modern synthetic varnishes were developed in an attempt to avoid such a color change, but they too can discolor or become less transparent with time. Any grime on the varnish causes further darkening. The color shift caused by dirty and discolored varnish distorts both the spatial relationships and color balance of a painting. The implications of discolored varnish are extremely interesting to art historians and have had demonstrable effects on how artists and scholars have understood the work of earlier periods. This has influenced subsequent painting production and interpretation. It is central to the argument over patina, which provides ongoing disagreement over conservation standards.[7] One response to discolored varnish was the decision of some nineteenth-century artists to use dark glazes and toned varnishes on their own work, as we will discuss.

In addition to discoloring, varnish is subject to other changes that affect how it transmits light and can significantly obscure or disfigure the paint layer. Bloom causes the varnish to become opaque and is usually a reaction to moisture. Blanching is a permanent change in the varnish—like the white ring left by a hot coffee cup on a wooden table (Fig. 238). Crazing, a fine pattern of surface cracks, is a mechanical breakdown of the varnish; it can result from climatic change or from properties inherent to the particular varnish recipe.

Renewing the Varnish Layer

The extent to which paintings were routinely cleaned of dirt and discolored varnish is not well documented prior to the late eighteenth century, despite the ancient lineage of complaints about improper cleaning—Pliny records that a painting by Aristides was thus ruined. Tom Caley has found that "their absence in earlier sources notwithstanding, many cleaning recipes suddenly appear in the seventeenth-century technical literature." Ingredients cited by Caley

238 Mid-treatment photograph. Charles Shannon, *The Bath of Venus*, 1898–1904, oil on canvas, 146 x 97.8 cm. Tate Gallery, London.

Damaged varnish can obscure a painting's composition as well as its true colors. This photograph was taken after the very disfiguring, blanched varnish was removed from the upper part of the canvas. Venus' attendants seem to rise from the mist.

238

include soap and water and various bodily fluids (from urine to spittle) that would remove the dirt but *not* the varnish. He found few recipes involving chemical solvents to dissolve the varnish layer—although a number entailed abrasives that would take off dirt, varnish, and even the paint if not employed with care. Caley is cautious about the conclusions to be drawn from such sources: "The question of how much these literary examples mirror the real practice of the day is open."[8]

The effects of blanching, crazing, or discoloration are eliminated if the old varnish is removed, and the transformation can seem magical (see Fig. 238).[9] Bloom can sometimes be reversed by the addition of another layer of varnish that saturates the disfigured coating and restores its transparency, or by exposing the varnish to a solvent; conservators describe the process as "renewing" the varnish. During certain eras, periodic revarnishing was standard practice, even in the absence of bloom. It was intended to keep the painting's surface glossy and transparent and was termed "feeding" the varnish. Regular revarnishing creates an ever-thicker coating and can trap intervening layers of dirt, resulting in an increasingly obscured surface; for this reason the practice is uncommon today.

Examination of the Varnish Layer
with Natural Light

Examination of the varnish layer begins with viewing in natural light. Discoloration can sometimes be determined by clues from the subject matter or comparisons with other paintings. Because snow and clouds are usually depicted as white, yellowed snow or a greenish sky with yellow cloud formations are often keys to discolored varnish (Fig. 239; see Fig. 123). Monet described one technique that he and his friends used to detect discolored varnish: "As young painters, we used to go to the Louvre and put our cuffs up close to the Rembrandt collars; originally white like our cuffs, they had gone terribly yellow."[10] A uniformly jaundiced look in the flesh tones of figures might also indicate yellowed varnish. Examination of a painting out of its frame can reveal information covered by the rabbet—the edge of the frame that sits against the face of the painting. This area may disclose a paint layer with no varnish or with older varnish that was not replaced or renewed with subsequent layers.

The reverse of a canvas can yield information about the varnish and treatment history. Stains that match the crackle pattern on the canvas face indicate seepage from liquid varnish (Fig. 240): such stains are caused either by old varnish that dissolved and seeped through the paint and canvas during a cleaning, or by new liquid varnish that seeped through an already-aged and cracked paint layer.

Partial Varnish Removal and Selective Cleaning

Selective cleaning is the process of removing discolored varnish from only the highlights; it is a quick fix. Untrained restorers or those interested in rapid results will clean the light spots but leave discolored varnish in the dark and shadowy areas. This emphasizes the chiaroscuro and distorts the original spatial balance. Signs of selective cleaning include a cloudy, darkened background with aggressively bright light areas, and a pattern of stains on the reverse of the canvas that match the craquelure of only the light areas of the composition. Ultraviolet examination will clearly reveal a history of selective cleaning. At best, such a treatment will confuse viewers for a generation or two. At worst, it can do permanent damage, abrading the light areas and leaving tide lines of solvent-filled varnish that permanently affect the paint layer. Selective cleaning

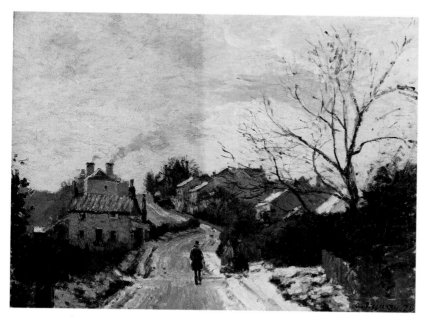

239

240

239 Mid–varnish removal photograph.
Camille Pissarro, *Fox Hill, Upper Norwood*,
1870, oil on canvas, 35.25 x 45.75 cm.
National Gallery, London.

The yellow snow was a clue to the
discolored varnish. This photograph was
taken when dirt and varnish had
been removed from the right half of the
painting.

240 Detail of a canvas reverse with dark
varnish stains following the craquelure on
the face of the painting.

Either a new, liquid varnish was applied
long after the painting was completed
(seeping through established drying
cracks), or old varnish dissolved during
cleaning and seeped through the
cracks. A varnish coating on a recently
completed painting with no drying
crackle would not display such a pattern.

performed as a quick treatment should not be confused with the partial varnish removal practiced by some well-trained conservators, who leave a thin layer of old varnish to even out the color balance or may clean selectively for the same reasons. Gerry Hedley discusses such partial cleaning in the context of the philosophy of treatment decisions.[11]

Examination of the Varnish Layer with Ultraviolet Light

The most common application of ultraviolet examination in studying paintings involves the varnish layer. Ultraviolet can be used to distinguish among types of varnish: aged damar fluoresces a yellow-green, shellac appears orange, and synthetic varnishes fluoresce clear or lavender. New retouches or retouches painted over the varnish appear purple; but unlike the purple glow of the varnish that covers the entire surface, retouches appear only in discrete areas. Old and new retouches can also be distinguished because the newer ones appear darker.

Ultraviolet examination should reveal whether the varnish is evenly applied. Heavy varnish over the darks and little or no varnish over the light areas may indicate selective cleaning. Some experience is necessary to distinguish selective cleaning from the natural fluorescence of the pale areas of a lightly varnished painting.

In the following example, identification of old varnish several layers below the surface indicates that much of the visible paint was a later addition. Ultraviolet examination of paint samples disclosed two different types of red glazes, each characteristic of differing periods. A sixteenth-century painting lay hidden beneath layers of repaint.

25

A Famous Gossaert Rediscovered with the Help of Ultraviolet Studies

A small panel of the Virgin and Child (Fig. 241), attributed to Jan Gossaert (c. 1478–c. 1532) was long considered a late copy.[12] The details were weakly painted, and the surface exhibited a craquelure characteristic of eighteenth- or nineteenth-century paintings. The work languished in the storerooms of the National Gallery, London, until 1994, when, in the course of preparing a collection catalogue, gallery curators and conservators performed a number of tests. These included studying the panel's surface and two cross-section samples with ultraviolet light (Figs. 242, 243). This helped clarify the presence of a varnish layer as well as of repainting that had changed the color of the Virgin's mantle, and to identify them both as nineteenth-century additions—which explained the visible craquelure. A cross-section through the Virgin's cloak revealed the original paint layers, including a red lake glaze characteristic of the sixteenth century (probably kermes), covered by the nineteenth-century additions, a varnish layer, then a slightly different red glaze that resembles those commonly used in the nineteenth century (a strong madder). Above these sat two further layers of varnish. Since paint sampling had revealed sixteenth-century pigments in the lower layers and dendrochronology confirmed the panel as old, the museum decided to remove the distorting repaint and later varnish. This treatment revealed that the panel matches an engraved copy of 1589. The London version turns out to be the original among the six closely related paintings that survive.

Has the Painting Been Varnished?

This sounds like a straightforward question, but answering it can be problematic even for conservators with long experience. The visual effect of varnish can be subtle; its presence is most easily detected while a painting is being cleaned. The thin layer characteristic of a sprayed varnish can be difficult to detect by direct visual examination or even by examination with ultraviolet light. Moreover, a media-rich (or "fat") oil painting can exhibit a gloss usually associated with a varnished work, whereas a matte or underbound paint layer can appear unvarnished even when it has a coating. Few of these effects can be distinguished in even the best reproductions (photographic prints, slides, or printed halftones). Most authors who discuss varnish simply give up; as our bibliography indicates, the best articles on varnish are unillustrated.

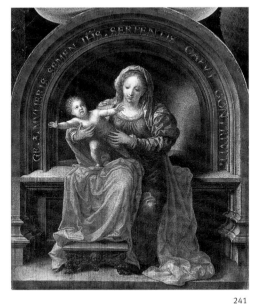

241

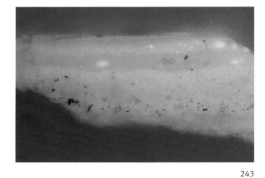

243

242

241 Jan Gossaert, *Virgin and Child*, 1589, oil on panel (medium has been analyzed), 30.7 x 24.3 cm. National Gallery, London.

Visible drying cracks on the paint surface led scholars to believe that the panel was an eighteenth- or nineteenth-century copy. The gallery had considered selling it shortly after its donation in 1860 but had been disappointed at the prices fetched at a recent sale. Examination followed by cleaning of the painting revealed a surprising discovery. See Case Study 25.

242 Ultra-violet light photograph of Fig. 241, mid-treatment.

The left half of the panel fluoresces blue-green because it is covered by a layer of nineteenth-century varnish. This varnish has been removed from the lower right, where the orange-pink fluorescence indicates nineteenth-century overpaint (later varnish and paint are also seen on the cross-section, Fig. 243). Both the later paint and varnish have been removed from the Virgin's mantle at upper right; the original paint in this area does not fluoresce.

243 Microphotograph of a cross-section of Fig. 241 in ultraviolet light.

The thin line in the center that fluoresces pink is the sixteenth-century red glaze. Below it are thick layers of ground and priming. The layers above it are the nineteenth-century overpaint and varnish, both of which strongly fluoresce blue-green.

When discussing the single unvarnished Monet in an exhibition of his late work, Anthea Callen observes, "The difference perceptible to the naked eye between it and its companions in the same show was staggering; it is not a difference apparent in reproduction, and so the presence of varnish does not affect what is now the principal mode of consumption of impressionist art: the glossy color plate." Mid-treatment photographs of varnish removal, while not the same as direct observation, are the best chance of demonstrating these effects (Figs. 244, 245; see Fig. 131).[13] When observing the effect of varnish directly, the eye moves, whereas the camera is still. So the photographs can record either the color differential or the shininess differential, but rarely both at once.

The determination of whether a painting has been varnished begins with ambient light (Fig. 246) and then raking light examination (see Figs. 40, 41, 42), with particular attention to the media-rich paint areas (which are not as likely to absorb varnish as the leaner ones), to the impasto (since varnish may accumulate in the interstices; see Figs. 181, 182, 183), to the area hidden by the rabbet, and to the tacking margins. The next step is microscopic examination, which may reveal varnish that cannot otherwise be seen. However, the only certainty is from physical or chemical testing of samples—from swabs used during cleaning, small surface scrapings, or cross-sections. As with all destructive tests, the value of the information would have to justify the sampling.

How to Identify Original Varnish

Confirmation that varnish is contemporaneous with the paint layer can come only from physical and chemical analysis of samples. Even so, it is a subtle process of determination. Analyses can confirm the presence of proteins that identify egg, glue, or oil, and determine the age of the varnish from its relative solubility—older varnish being less soluble. Cross-sections provide additional information as to the sequence of varnish, cracks, grime, and possible later varnish (see Case Study 25).

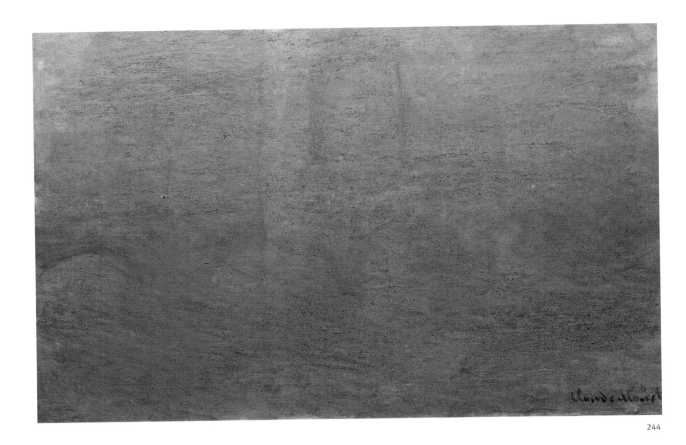

244

244 Mid–varnish removal photograph.
Claude Monet, *Waterloo Bridge, London, at
Dusk*, 1904, oil on canvas, 65.7 x 101.6 cm.
National Gallery of Art, Washington, D.C.
Collection of Mr. and Mrs. Paul Mellon.

The varnish at left not only altered the
matte surface that the artist wanted
but darkened the colors. The color shift
rather than the glossiness caused by
varnish is most apparent in this photo-
graph. Both effects would be clear in
front of the painting. For a detail of
another Monet mid–varnish removal,
see Fig. 131.

245

246

246 Detail. Pierre Bonnard, *The Palm*, 1926, oil on canvas, 114.3 x 147.0 cm. The Phillips Collection, Washington, D.C.

This painting has never been varnished, so Bonnard's high-keyed but chalky colors have survived unaltered. On another work by Bonnard, *The Bathroom Mirror* (1908; Pushkin Museum), a penciled inscription on the reverse reads "n'est pas de vernis—P. B."

245 Specular light photograph during varnish removal. Henri Matisse, *Flowers*, 1907, oil on cardboard, 34 x 26 cm. San Francisco Museum of Modern Art. Bequest of Harriet Lane Levy.

The fauve artists generally avoided varnishing their surfaces. In this image, the later varnish has been removed from the right side. The lighting of this photograph emphasizes the differential reflectivity of the varnished and unvarnished surfaces; some of the darkening caused by the varnish is also perceptible. Sensitivity to the presence of varnish on modernist paintings is a fairly recent phenomenon. Later varnish can sometimes, with difficulty, be thinned or removed.

Examples of Varnish Identification

Mary Allden and Richard Beresford found a gray layer on a painting by Philippe de Champaigne (1602–74) that they chemically identified as eggwhite; however, cross-section analysis showed that the layer was applied after the painting was old enough to have an established craquelure (1989, p. 405). An eggwhite glaze applied in the artist's studio would have covered a fresh, uncracked surface—hence this glaze was not original. Jill Dunkerton, Jo Kirby, and Raymond White found remains of discolored varnish, which was chemically identified as oil based, on a fourteenth-century Florentine altarpiece. By studying the construction and later dismembering of the polyptych, as well as reviewing documentary evidence of its original varnishing, they concluded that the oil-based varnish is the one for which the recorded payments were made in 1371 ("Varnish and Early Italian Tempera Paintings," in *Cleaning, Retouching, and Coatings*, pp. 63–69, IIC Preprints of the Contributions to the Brussels Congress, September 3–7, 1990). Sam Hodge, Marika Spring, and Ray Marchant chemically identified an oleo-resinous varnish remaining under the framed areas of a fifteenth-century Castillian polyptych ("The Construction and Painting of a Large Castillian Retable: A Study of Techniques and Workshop Practices," in *Painting Techniques: History, Materials, and Studio Practice*, Contributions to the Dublin Conference, September 7–11, 1998 [London: International Institute for Conservation of Historic and Artistic Works, 1998], pp. 70–76).

"Original" Varnish: A Caution

Determining that the varnish layer is original does not mean that it was applied by the artist or even according to the artist's wishes. It means only that the painting was varnished soon after it was painted—before the paint surface had developed significant craquelure or a layer of dirt. Varnish should be applied only after the paint is dry, and a one-year delay is often recommended for the varnishing of oil paintings. Varnish might be added by specialists, possibly under the artist's supervision. If a painting was sold before it was thoroughly dry (in which case it might be protected by a temporary varnish), the choice of final varnish might well be made by the collector. Nicholas Poussin (1594–1665) sent a shipment of paintings from Rome to Paris in 1644 and directed his patron: "When you receive them you can stretch each one onto their stretcher, and with a sponge and clean water perhaps with some orange juice added,

remove the temporary coating. When they are good and dry have them varnished by someone who knows how." Leslie Carlyle's research on nineteenth-century British technique supports the suggestion that varnishes might well have been chosen by the patron. She notes, "It is significant that the one source to concentrate most heavily on bloom and chill (Robert White . . .) was writing for the picture owner, not to the artist. This is indicative of the overall regard for the role of varnishing: it was not restricted to the artist as part of the art of painting per se, but could be left to subsequent owners."[14]

Both French and English practice at the annual academic exhibitions institutionalized the varnishing of paintings. Constable was routinely late in preparing his academy entries and often sent them unfinished (neither dry nor varnished)—but later reworked them. When he had the time, Constable always varnished his finished works. Turner famously added multiple layers of paint, glazes, and varnishes during the three Varnishing Days when the paintings hung on the Royal Academy's walls; yet if these works were sold, they would be given a final varnish after at least a year's delay for the paint to dry. Even with this knowledge it is impossible to be certain of Turner's original varnishes. Joyce Townsend, the conservation scientist who has studied the definitive collection of his work, surmises: "So far as one can tell from restorers' observations in the past, Turner's earlier paintings were varnished with a mastic-like alcohol-soluble varnish, *now removed in almost every case* (emphasis added)."[15]

The French Academy allowed a day for varnishing prior to the official Salons. The work was usually carried out by artists' colormen, who typically applied a standard varnish to works of quite varying tonality and style—whether the artist wanted it or not. The dealer Vollard quotes Renoir from 1879: "The day before the opening, a friend came and told me that he had just been to the Salon, and that something queer seemed to have happened to my *Mademoiselle Samary*. I dashed to the Salon and found the picture almost beyond recognition—it looked as if it were melting away. It seems that the framer instructed the delivery boy to varnish another picture that he was delivering at the same time. The boy had a little varnish left over and decided to give me the benefit of it. I didn't varnish mine because it was still wet, but he thought I was being economical! The result was I had to repaint the whole thing in an afternoon."[16]

While the concerns of some impressionist and post-impressionist artists for a matte look are well documented, their dealers' interest in salability

is equally a matter of record. Pictures needed to look "finished" to sell, and varnish, as codified by the academy, was one component of the concept of "finish." Many impressionist paintings were varnished by dealers prior to their initial sale; Durand-Ruel even used bitumen-darkened varnish to temper the intense colors of impressionist canvases during the 1870s.[17] Such a varnish layer would be considered "original" as to period, even if varnishing was directly counter to the artist's wishes. Technical examination will not clarify whether varnish represents a decision of the artist, his dealer, or the initial collector.

Varnish on Early Panels

The question of whether and how early tempera paintings were varnished has been open to debate. The answer will determine our understanding of the original surface qualities of these panels. Cennini, in his handbook, mentions the use of *vernice liquida* but does not give a recipe. The term as used elsewhere describes an oil varnish. Such varnishes are viscous and tricky to handle; they need to be applied after the paint is chemically dry (which takes up to a year) and in proper conditions—not too cold or damp or drafty (the surface would pick up dust). Such oil varnishes are generally glossy. Cennini does provide a recipe for a varnish made from whipped eggwhite that can be used if time is a constraint—perhaps as a temporary coating until the paint is dry enough for an oil varnish. Such a coating is rather matte and turns gray with time; shinyoil varnishes yellow with age.[18]

Few paintings of the fifteenth century or earlier have retained their original varnish. Still, conservators, curators, and art historians need some basis for determining what look is appropriate in treating these paintings. It had long been thought that early panels were not varnished, despite Cennini's brief references to varnishes. Conservators and conservation scientists have recently identified original varnish on several twelfth- to fourteenth-century Tuscan altarpieces. Marco Ciatti reports finding oleo-resinous varnishes on Giotto's *Crucifix* as well as on the *Madonna di Santa Maria Maggiore* and the *Rosno Crucifix*. Alfio del Serra found both a gray film from an eggwhite layer and uneven amounts of a yellowed layer, presumably an oil varnish, on Jacopo del Casentino's *Madonna and Child* (S. Stefano, Pozzolatico). He interprets the eggwhite layer as a protective intermediary intended to remain between the tempera paint and the final oil varnish. Staff at the National Gallery, London, have identified an oil-based varnish on the San Pier Maggiore Altarpiece that

may date to its initial documented varnishing of 1371. Original varnish has
been identified on Spanish panels: Marta Presa, Rocío Bruquetas, and Marco
Connor found a linseed oil varnish on an altarpiece (itself an early example
of oil technique) from Toledo of c. 1430, and Sam Hodge, Marika Spring, and
Ray Marchant identified an oleo-resinous varnish on a Castillian retable of c.
1490. Remnants of original varnish have also been found on early Flemish pan-
els, although the latter have not been subject to analysis.[19] Some uncertainty
over varnish and early paintings is likely to continue; the paucity of physical evi-
dence suggests that clarification is likely to come from a combination of his-
torical and technical research.

Nineteenth-Century Darkening Glazes and Tinted Varnishes

Numerous examples document an awareness by artists and connoisseurs of
the darkening caused by aged varnish and dirt. Such evidence of age was prized
as far back as the seventeenth century, exemplified by John Dryden's verses
to his contemporary, Sir Godfrey Kneller:

> For Time shall with his ready pencil stand;
> Retouch your figures with his ripening hand;
> Mellow your colours, and imbrown the teint;
> Add every grace, which Time alone can grant;
> To future ages shall your fame convey,
> And give more beauties than he takes away.[20]

One result of the veneration of "every grace, which Time alone can
grant" was the simulation of such effects through the use of darkening glazes
and tinted varnishes. These were particularly popular with artists of romantic
persuasion. The painter Charles Leslie recalled that Washington Allston
"first directed my attention to the Venetian school, particularly to the works of
Paul Veronese, and taught me to see, through the accumulated dirt of the
ages, the exquisite charm that lay beneath." Despite his purported ability to dis-
tinguish the exquisite charm of Veronese's original palette, Allston's response
to more than two centuries of dirt and darkened varnish was emulation. Joyce
Hill Stoner describes Allston's darkening glazes mixed from asphaltum,
Indian red, ultramarine, and megilp—which he called "Titian's dirt"—as well
as Richard Wilson's toning recipe of India ink and Spanish licorice dissolved in
water. Albert Pinkham Ryder is reported to have darkened his paintings with

tobacco juice from the spittoon next to his easel. The practice of adding a patina implying age was not limited to paintings. According to Baron d'Uklanski, writing in 1808, "Canova usually washed his statues, when completely finished, with a kind of yellow tinge, to give them a colour similar to that of Parian marble, and an appearance of antiques."[21]

Yet the admiration for darkening glazes was hardly universal, even among English and American painters during the eighteenth and nineteenth centuries. John Constable's contempt for such taste was clear when he described one of his clients who commissioned a copy of a Teniers: "I have grimed it down with slime & soot—as he is a connoisseur and of course prefers filth & dirt, to freshness and beauty." Hogarth (1697–1764) was dismissive of all ideas about time's improving effects on paintings. In *The Analysis of Beauty* he argued against Dryden: "Notwithstanding the deep-rooted notion, even amongst the majority of painters themselves, that time is a great improver of good pictures, I will undertake to shew, that nothing can be more absurd. Having mentioned above the whole effect of the oil [which takes a yellowish cast after a little time], let us now see in what manner time operates on the colours themselves; in order to discover if any changes in them can give a picture more union and harmony than has been in the power of a skillful master, with all his rules of art, to do. When colours change at all it must be somewhat in the manner following, for as they are made some of metal, some of earth, some of stone, and others of more perishable materials, time cannot operate on them otherwise than as by daily experience we find it doth, which is, that one changes darker, another lighter, one quite to a different colour, whilst another, as ultramarine, will keep its natural brightness even in the fire. Therefore how is it possible that such different materials, ever variously changing (visibly after a certain time) should accidentally coincide with the artist's intention, and bring about the greater harmony of the piece, when it is manifestly contrary to their nature, for do we not see in most collections that much time disunites, untunes, blackens, and by degrees destroys even the best preserved pictures."[22]

In addition to using dark glazes, some artists added colorants to the varnish itself to feign the effects of age. A memorandum by Joshua Reynolds in 1766 records that a portrait was "varnished with gum mastic dissolved in oil. . . . Yellow lake and Naples [yellow] and black mixed with the varnish." Anthea Callen suggests that the Barbizon painters, who also added yellow to their varnishes, were copying the effects of time on the seventeenth-century Dutch

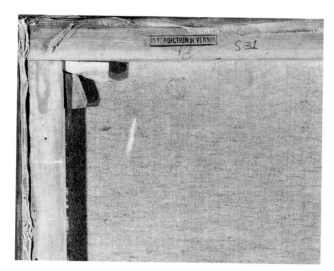

247 Detail of the reverse. Maria Elena Vieira da Silva, *Easels*, 1960, oil on canvas. The Phillips Collection, Washington, D.C.

Vieira da Silva stamped instructions on the stretcher that the painting not be varnished. Camille Pissarro inscribed directions against varnishing on canvas versos, and his son had labels printed with the same instructions (see Callen 1994, Fig. 2, and Bomford et al. 1990, p. 101). Although many modernists rejected varnishing, relatively few left such unequivocal directives.

247

landscapes they admired. Their technique would be copied later in the century: Elizabeth Broun cites the Barbizon influence on a group of Scottish painters in the last quarter of the nineteenth century "dubbed the 'Magilp school' for the artists' love of the brown mastic varnish that imparted a mellow richness to 'raw' color."[23]

Nineteenth- and Twentieth-Century Opposition to Varnishing

Alongside, or perhaps in response to, the interest in old master techniques, nineteenth-century artists manifested various reactions to traditional and academic ideas about a painting's surface, often characterized as debates over "finish." One of these was a vehement reaction *against* the use of varnish, a well-known stance of the late nineteenth-century avant-garde that has persisted into the late twentieth century (Figs. 246, 247). The ideas behind the rejection of varnish were various. Both Michael Swicklik and Anthea Callen have documented an ongoing questioning of the shiny and saturated effect of varnish that goes back to Delacroix. Swicklik suggests that the impressionists' rejection of varnish was a reaction to academic practice, as well as a response to mid-century controversies concerning the cleaning of old master paintings. Callen situates the matte surfaces favored by impressionists and fauves within a primitivizing impulse—in their case a return to the look of fifteenth-century tempera and fresco painting. The rejection of varnish can also be related to a distaste for the shiny attraction of consumer commodities, which can have connotations of class or gender.[24]

It is important to remember that the reaction against varnish must usually be established by historical research; the paintings in their present state rarely offer technical evidence of the artist's initial practice. This caution may apply even to paintings produced after World War II. The historical evidence itself can be too vague to provide a definitive answer about any single painting. According to Swicklik, "The impressionists' rejection of varnish . . . cannot be generalized to include all the artists of the school from the beginning of their careers. Most impressionists cautiously accepted the use of varnish in the 1860s and 1870s. By the 1880s, however, many deliberately left their paintings unvarnished to achieve specific aesthetic effects. Yet, while Pissarro and Monet were committed to an unvarnished look, Renoir seemed to advocate precisely the opposite approach for most of his career." Research on their American contemporaries suggests equal caution.[25]

Artists who sought a matte surface through the use of absorbent grounds and leached paints were particularly sensitive to the optical effects of surface coatings. Many of the neo-impressionists avoided varnish. According to Carol Christensen, "Gauguin was adamant that his paintings not be varnished with the glossy natural resin varnishes common during his time." He wrote a colleague in 1901: "While I am thinking about it, have you well instructed Vollard on the maintenance of my paintings using wax? because I am always worried that they will be ruined with this dirty disgusting varnish which picture dealers use, and which is so common." Munch's aversion to varnish is well established (Fig. 248). Jan Thurmann-Moe quotes an outraged letter published by Jappe Nilssen, the critic and a friend of Munch's, after the National Gallery (Oslo) displayed three newly varnished Munchs. Three years later the artist wrote Nilssen about the Sonderbund Exhibition in Cologne: "Here there is hardly a varnished picture to be seen—Never have words of warning been so rightly said as in your article concerning the varnishing of my pictures— here it is considered vandalism."[26]

The rejection of a glossy surface has continued among twentieth-century artists, but with no great consistency. The topic has received little systematic study, and the available knowledge suggests caution rather than categorical statements. Some information can be gleaned from anecdotes. Further data is offered by the survival of numbers of paintings without varnish; not only is it extraordinarily difficult to take a varnished painting back to an unvarnished state, but it is unlikely that such a procedure would be attempted on significant numbers of works. Moreover, such sensitivity to the presence of varnish is very recent.

248 Edvard Munch, *Death and the Maiden*, c. 1893, mixed media on canvas, 129 x 86 cm. Munch Museum, Oslo.

Munch used a variety of idiosyncratic means to create a matte and distressed surface; this painting reveals large water stains (the wavy brown tide line at the upper left corner) as evidence of its intentional exposure to outdoor weather. The artist remarked that varnishing such paintings amounted to vandalism.

248

One problematic exception is works from an artist's estate. These may have survived unvarnished because the artist waited to varnish until the paintings were exhibited or sold; or they may be unvarnished because of the artist's aesthetic decision. This determination must be made on historical, not technical, grounds. Artists' estates present a variety of problems in determining whether works are complete and how to present them—not only questions of varnish and framing but also of cropping and orientation.[27]

John Richardson took a polemical stance against the varnishing of cubist paintings, an action that he insisted had been carried out by dealers, collectors, and museums counter to the artists' expressed intent. In an article titled "Crimes Against the Cubists," Richardson traced Picasso's and Braque's aversion to varnish to their emphasis on the nonillusionistic nature of their paintings' surfaces. Even so, Richardson deflates Picasso's absolute dogmatism on the issue: "Indeed the artist [Picasso] maintained—not altogether truthfully—that he refused to sign any canvas that had been polished up with varnish."[28]

The German expressionists were usually thought to eschew the glossiness of a varnished surface. Max Beckmann (1884–1950) "emphatically rejected varnish or any other final lacquer, and any kind of sheen on the surface." Bruce Heimberg describes his technique: "The subtlety of Beckmann's color is partly due to the variety of levels of surface gloss. These can vary markedly within a single color surface, between different colors, or between the individual layers on top of one another. . . . This contrast produces further surface effects which have a lasting effect on the coloration as well as on the sense of depth. . . . We can be sure that Beckmann intended these effects and consciously considered them in his artistic deliberations, since he strictly refused to varnish his paintings. Unfortunately, some of Beckmann's paintings have been varnished over the years, causing some of his intended effects to be lost."[29]

A conservator faced with paintings by Ernst Ludwig Kirchner (1880–1938) and Emil Nolde (1867–1956) discussed the complexity of interpreting artists' wishes about varnishing; the problem was exacerbated by physical changes that the painters may not have anticipated, as well as the options offered by new materials. Kenneth Katz combined historical research with technical study of unrestored works by the same artists to determine a treatment. He summarizes: "These criteria appear to confirm the proscription on varnishing the works of German Expressionists, particularly Kirchner and Die Brücke. However, the evidence concerning Emil Nolde, primarily his autobiographical books and his technique, indicates that it may be appropriate to use varnish in the treatment of his paintings."[30]

We have similarly incomplete records for the abstract expression-
ists. It is documented that Franz Klein (1910–62) did not varnish his paintings.
Mark Rothko (1903–70) experimented with various binders and methods of
staining unprimed canvases, all of which precluded the effect of a final varnish
layer. Rothko specifically rejected a conservator's suggestion that he varnish
his Harvard Murals to protect them. The work of Clyfford Still (1904–80)
is more problematic. Michael Auping describes the care with which Still manip-
ulated the glossiness from one area to another within his paintings. The
large groups of work that Still and his estate gave to the Metropolitan Museum
of Art, New York, the Albright-Knox Gallery, Albany, and the San Francisco
Museum of Modern Art are case studies in subtle effects of variable reflectiv-
ity—particularly within the large, black fields. These effects would be signi-
ficantly diminished, if not indistinguishable, had the paintings received a uni-
form coat of varnish. However, in the one technical study of his work, conserv-
ators Dee Ardrey and J. William Shank conclude that "Still's use of varnish
was erratic."[31] He was aware of the aging effects that caused some of his paints
to sink into the unprimed canvas, becoming a dry surface deposit. He is
known to have applied varnish or oil to selective areas to resaturate them, and
he directed others to do the same. The problem for custodians of the paint-
ings is that it is not clear which areas the artist wanted resaturated.

Robert Motherwell (1915–91) expressed his dislike for the shini-
ness of a varnished surface, yet when the National Gallery of Art commissioned
the monumental *Reconciliation Elegy* (1978) Motherwell opted for the protec-
tive function of varnish, despite the aesthetic implications. He explained
what led him to use a varnish applied differentially to the black areas, the white
areas, and the charcoal lines, and he hinted at gendered and class associations
of glossiness: "A painting has to be varnished to be protected . . . against finger-
prints and scratches, against *air*. Everybody knows nowadays that the atmos-
phere is the enemy of any object, that everything is slowly oxidizing. Varnishing
is a clear, transparent veil between the object and air. But the whole concep-
tion of this painting was to be extremely matte. . . . The difficulty with varnishes
is that they are shiny, glossy, so there is a problem: for example, if one made
a drawing on white rag paper, and if one varnishes it, it immediately becomes
shiny, like the illustrations in popular women's magazines on glossy paper. . . .
But my greatest anxiety was to get a varnish that was not shiny. We came as
close to that as is technically possible."[32]

Glazing as an Alternative to Varnish

With the availability of large plate glass in the nineteenth century, some artists chose to display their paintings behind glass rather than coating them with varnish as a means of protection. Seurat's *Grande Jatte* continues to be displayed under glass, as the artist intended (Fig. 100). Although glass is itself highly reflective, it offers a window to a matte surface below and does not yellow with time. The term that commonly describes paintings under glass is *glazed*—not to be confused with the use of transparent paint layers as glazes. Context is the key to the distinction. Framing paintings behind glass has long been termed the "English style," and its transmission to France is associated with Pissarro, who left a clear record of his aversion to varnish. Gauguin, who was equally adamant about rejecting conventional resin varnishes, left a number of written directives that his paintings be glazed. *Three Tahitian Women* (Fig. 249) once carried a note by the artist: "To the unknown collector, I salute you. That he may excuse the barbary of this little picture: the state of my soul is, no doubt, the cause. I recommend a modest frame and if possible one with a glass, so that while it ages it can retain its freshness." Henry Ossawa Tanner (1859–1937) was particularly interested in rich and luminous surfaces in his late paintings; he experimented with layers of paint in different binders and complex mixtures of oil, glue, and varnish (Figs. 159–61). When a Chicago collector wrote the artist with concerns about the effect of pollution on a small panel, Tanner instructed her to glaze it. The extent to which glazing is still a strong tradition in England is confirmed by the preference of such painters as Francis Bacon and Lucien Freud, whose very large canvases are displayed under glass, following the artists' wishes.[33] Increasingly, museums are pressured to display both varnished and unvarnished paintings under glass, regardless of the artists' intent. This is for reasons of protection rather than historicism.

Revivalist Eggwhite Varnish

We have seen how certain painters since the late eighteenth century, hoping to restore a purer and truer method, turned to aspects of earlier technique. Such revivals (some of which we termed "primitivism of technique" in the last chapter) included the use of wooden supports, experiments with encaustic and tempera, and methods of paint handling, whether glazing or *alla prima* painting. Another such revival was the use of eggwhite as a varnish. Cennini's

249

249 Paul Gauguin, *Three Tahitian Women*,
1896, oil on wood, 24.4 x 43.2 cm.
Metropolitan Museum of Art, New York.
Walter H. and Lenore Annenberg Collection,
partial and promised gift (1987.60.3).

This painting belongs to a small group of
Gauguin's work described as *papillotant*
(butterflylike) because of the paint
handling. It is painted on a teak panel,
formerly a door to a piece of furniture.
The panel's right edge reveals a hinge
at the top, as well as missing wood
where a lower hinge was removed. The
note that Gauguin affixed to its back
instructing that it be framed under glass
has survived.

handbook includes eggwhite as a temporary varnish. Joshua Reynolds favored egg as a surface coating, although his varnishing methods were as eccentric as the rest of his technique. In an attempt to re-create the surfaces of the old masters he so admired, Reynolds recorded coating one of his portraits with wax, then varnish (presumably a resin), then egg, then another layer of varnish (this time Wolff's—a proprietary varnish), then wax again, then size, more oil, another layer of egg, and a final coat of Wolff's varnish. Reynolds' emulation of late Renaissance and Baroque paintings was hardly primitivizing. Leslie Carlyle found eggwhite varnishes mentioned throughout British painters' manuals into the late nineteenth century.[34]

Cornelia Peres made a detailed study of Van Gogh's coatings, research complicated because most of the collection of the Van Gogh Museum, Amsterdam, was routinely varnished during restoration early in the twentieth century. She cites ten paintings that survived without oil or resin varnishes, and she notes that Van Gogh used eggwhite as both an isolating layer and a final coating. Peres documents the fact that eggwhite varnish is mentioned in almost all eighteenth- and nineteenth-century painting treatises, but she cannot establish whether Van Gogh intended his eggwhite coatings to be permanent or temporary. Eggwhite varnishes turn gray with time, clouding and distorting the paint colors; their remains on nineteenth-century paintings pose the same challenge found with fifteenth-century panels coated with now-discolored eggwhite.[35]

Paint on Top of the Varnish Layer

How do we know that the artist did not add paint or glazes above the varnish layer? The simple answer is: We usually don't know. However, traditional technique entails varnishing oil paintings at least a year after they are completed; even rapidly drying temperas were allowed a significant interval to dry before varnishing. An artist who added paint or glazes after a long delay and then after varnishing would be revisiting an earlier composition. The obvious exceptions are artists who intentionally added darkening toners above the varnish. In the case of Turner, we have anecdotal accounts that he added paint and glazes to works already hanging on the Royal Academy's walls, but as Joyce Townsend writes, "the exhibited paintings which he sold would likely have been given a final coat of varnish at least a year after purchase, the minimum time considered sufficient for a painting to dry in the English cli-

mate, by nineteenth-century writers. At that time, the owner would have specified the varnish type, or asked another artist, or perhaps Turner himself, to apply varnish of his choice."[36]

Does removing varnish entail the risk of removing the artist's final finishing touches? The simple answer is yes, varnish removal may risk loss of final paint and glazes. But this answer must be qualified historically—because *if* the artist worked with paints or transparent glazes above the varnish layer, those materials would have been vulnerable the first time varnish was removed. Among centuries-old paintings that have received multiple treatments, any paint above the initial varnish was lost long ago. Technical evidence can neither detect it nor give clues to its former existence. Paint sitting above the varnish on such works is repaint.

Washington Allston (1779–1843) is known to have added darkening glazes above his varnish, which are extremely vulnerable to loss during cleaning. As conservator Joyce Hill Stoner comments, "Because of the presence of darkening megilp, soluble glazing, and the readily removable 'Titian's dirt' coatings, the first restorer who cleaned each Allston painting may have changed it significantly. Now, at least six generations of owners later, finding an Allston painting that still has his original toning is probably unlikely." An anecdote records that Allston disowned authorship of one painting that he considered ruined by a picture cleaner. Albert Pinkham Ryder (1847–1917) considered his thick and possibly tinted varnishes to be integral to his paintings— and cautioned collectors and dealers against attempting to remove them, even when they had cracked or darkened. Yet, according to Elizabeth Broun, "Despite Ryder's injunction, many of his paintings were cleaned, if not during his lifetime, then in time for the 1918 memorial exhibition. . . . Since resinous varnishes discolor within a few years of application, we may suppose that Ryder's own varnishes—tinted or not—were often removed and the yellowed surface we see today was applied by some early restorer."[37]

If the well-trained, modern conservator has reason to think that the artist's original paint and glazes may have survived above the varnish, further examination of cross-section samples is required. The individual layers can be chemically analyzed for both pigment and medium. As described above, clues to the time sequence of paint, varnish, and upper glazes are revealed by the presence or absence of intervening dirt layers, evidence of established craquelure, and interactive zones between paint and varnish layers.

6

Beyond the Painting

Art history has been increasingly interested in examining artworks within changing historical, social, institutional, economic, aesthetic, and intellectual contexts—all of which can be metaphorically termed frames. But what are the physical and optical limits of the painting? And can broadening those limits expand our historical understanding? In considering paintings as objects, where shall we set the boundaries? How can marks or labels affixed to a painting contribute to our historical knowledge? Should a painting without its original frame be considered a fragment, and does the answer change according to period? Do we need to account for the optical conditions in which we view the painting? In this chapter we look at some of these peripheral subjects in order to suggest further questions that might arise in incorpo-rating physical evidence into art history.

Labels and Collectors' Marks

We have emphasized the study of additions, reductions, and other changes that may yield clues to a painting's history. Some of these additions are so marginal that discussing them risks belaboring the obvious. However, we would like to call brief attention to the sorts of information gained from considering labels (usually affixed to the verso of a painting or its frame), collector's

marks (insignia, inscriptions, or numbers painted on the recto or verso; Figs. 6, 71), and other evidence that a painting has been owned, sold, exhibited, varnished, cleaned, framed, or otherwise passed through the hands of an identifiable individual, firm, or institution. This sort of information is routinely considered by scholars studying works on paper.[1] Although such information is less routinely found on paintings, it can yield equally valuable data.

Titian's *Supper at Emmaus* (Fig. 250) has a long and distinguished provenance, having been commissioned and owned by kings of the Holy Roman Empire, England, and France. Part of this history is confirmed by marks on the painting itself. The crest of Charles V appears at the top of the painting, and that of the Maffei family was identified with infrared examination (Fig. 251). A mark on the reverse of another early Titian in the Louvre, *Portrait of a Man* (Figs. 252, 253), records part of its treatment history. The museum's extensive archives enable the stamp of the Musées Royaux and the number "508" to be identified: they correspond to the records of Fouque's relining of 1808.[2]

We cited Raphael's famous portrait of *Julius II* (Fig. 204) as an example of using *pentimenti* to establish the London painting as the original of two variants. When Cecil Gould published the painting in his 1962 catalogue he noted an inventory number painted at the lower left of the panel, which was meaningless at that time. Seven years later, when reexamination and X-ray studies forced a reconsideration of the painting, the number had become significant. An inventory of the Borghese collections had been published, enabling Gould to trace the number to a 1693 list.[3] Thus, evidence of its provenance supported the *pentimenti* in affirming the primacy of the London painting.

A label affixed to the back of a George Inness painting alerted the Princeton Art Museum to the work's unusual support. The painting (Fig. 254) had been cradled, and the cradling had partially obscured the manufacturer's label, which revealed that the panel actually was plywood rather than conventional panel (Fig. 255). This support, an early example of plywood specifically constructed for artists, was called French's Artist Board. It was patented in 1880, but it never became widely used. It is possible that Inness received the panel as a sample from the manufacturer. Norman Muller, the conservator who published the Inness painting, said he had never come across another example.[4]

250

251

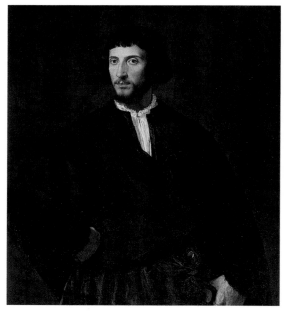

252

253

250 Titian (Tiziano Vecellio), *Supper at Emmaus*, 1535, canvas, 169 x 244 cm. Musée du Louvre, Paris.

The painting itself contains clues to its provenance.

251 Infrared photograph detail of Fig. 250.

This clarified the escuteon (partially visible here) painted on the box where the pilgrim at right sits. It was identified as that of the Maffei family.

252 Titian (Tiziano Vecellio), *Portrait of a Man*, c. 1520–22, canvas, 118 x 96 cm. Musée du Louvre, Paris.

A number of paintings in the Louvre have extensive treatment histories. Part of that history is recorded on the reverse of this canvas.

253 The stamp and number (508) on the verso of Fig. 252.

This information identifies the work's early nineteenth-century relining, according to written treatment records in the Louvre.

254 George Inness, *Albano, Italy*, c. 1872–74, oil on panel, 76 x 114 cm. Art Museum, Princeton University. Gift of Mr. and Mrs. Thomas G. Cook.

This landscape turned out to have an unusual commercially prepared and patented support.

255 Detail of label on the reverse of Fig. 254.

Support identified as plywood intended for artists' use. It states, optimistically: "These boards have been in the hands of our best Artists the past three years and all pronounce them [superior to] canvas, the cost being no more than canvas on stretchers, and [being far] superior, should bring them into general favor." If thus favored, they have not survived.

254

255

On Framing

Frames protect the edges of paintings, create an immediate visual context for the work, and mediate between the painting and the surrounding space. In addition, they can call attention to a painting's status, ownership, iconography, or provenance. The historical relation between painting and frame reflects the fluctuating demands and expectations of patrons, artists, architects, dealers, and collectors. Although frames are usually considered the domain of the decorative arts, study of these variable surroundings also contributes to the history of the paintings and of their reception.

Some frames were constructed as an integral part of the painting: panels with engaged frames, ranging from small devotional paintings (Fig. 256) to elaborate polyptychs (Fig. 257). A frame might have been constructed out of the same wood as the panel or carved separately and attached with dowels or nails. Panels with engaged frames are primed, gilded, and decorated as an ensemble, so that removing such a frame may leave a record at the join, as well as an unprimed border of wood formerly hidden by the frame (Fig. 259).

Identifying the period of a frame entails the same methods used for dating a panel: identifying the wood, the carpentry details, and the methods of gilding and painting. These may be supplemented with historical data on provenance and with any written, painted, drawn, engraved, or photographic records that survive. Examination of an engaged frame may also reveal holes, which indicate missing parts of a polyptych. Early polyptychs have often been disassembled and the surviving fragments presented in frames that are re-creations of varying accuracy (Figs. 257, 258).

The frames for very large altarpieces often were designed separately from the artwork. By the fifteenth century, frames in northern Italy were bearing elaborate sculptural decoration. These frames might have cost more

Sources on Frames

The best introduction to frames is Grimm 1992, though several more recent publications contain superior illustrations and are invaluable reference works: Adair 1983, on eighteenth- and nineteenth-century American frames, Mendgen et al. 1995 on modernist frames designed by artists; Mitchell, Roberts, and Adair 1996 (*Dictionary of Art*) on European and American frames from all periods; Simon 1996 on English frames; van Thiel and de Bruyn Kops 1995 on seventeenth-century Dutch frames; and Verougstraete-Marcq and van Schoute 1989 on Netherlandish panels.

For technical studies that extend to frames as well as panels, see van Asperen de Boer 1975, Bomford et al. 1989, Brink 1978, Dunkerton et al. 1991, Humphrey 1993, Hermsdorf et al. in *Lucas Van Leyden Studies* 1978, Sobré 1989, and *Il Tondo Doni* 1985. For further technical studies of frames, see Annette Kurella, "Bemerkungen zur ursprunglichen Aufstellung eines Altars," *Restauro* 99, no. 5 (1993): 321–24; Alistair Smith et al., "An Altarpiece and Its Frame: Carlo Crivelli's 'Madonna della Rondine,'" *National Gallery Technical Bulletin* 13 (1989): 28–43; Hélène Verougstraete and Roger A. van Schoute, "Retables sculptés et volets peintes: Examen de la menuiserie, des profils et de la polychromie des cadres du retable d'Herbais sous Piétrain," ICOM Committee for Conservation, Tenth Triennal Meeting, Washington, D.C., 1993, pp. 693–96; and Caroline Wright, "A Carved and Gilded Frame Crest," *Conservation News* 49 (November 1992): 19–21.

For several useful studies on the broad historical and theoretical aspects of frames, see Jean-Claude Lebensztejn, "Framing Classical Space," *Art Journal* 47 (Spring 1988): 37–41; Joseph Masheck, "Pictures of Art," *Artforum* 17, no. 9 (May 1979): 26–37; Brian O'Doherty, *Inside the White Cube: The Ideology of the Gallery Space* (Santa Monica: Lapis Press, 1986); José Ortega y Gasset, "Meditations on the Frame," in *Art of the Edge: European Frames, 1300–1900*, catalogue (Chicago: Art Institute of Chicago, 1986), pp. 21–25.

256 Simone Martini, *St. Luke*, 1330s, tempera and gold leaf on panel, 67.6 x 48.3 cm. J. Paul Getty Museum, Los Angeles.

The original engaged frame is still attached. As is typical for panels of this age, stress to the ensemble over time has caused a slight split in the gesso at the intersection of the panel and frame (most easily visible at the left, near the saint's name).

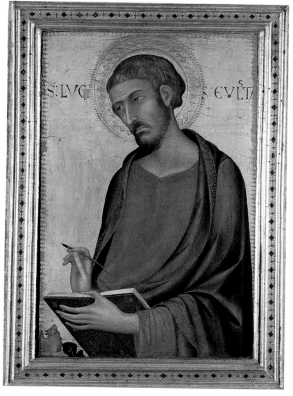

256

than the panels they surrounded. The records for both Filippino Lippi's Santissima Annunciata altarpiece and Leonardo's *Virgin of the Rocks* indicate that the craftsmen who produced the sculpted surrounds earned more than the painters. In fact, Leonardo and the da Predis brothers were commissioned to paint their Madonna for an elaborate altar frame that had already been constructed.[5]

The extent to which a painter was involved in designing an altar frame varied, but records of these decisions are rare—indeed, there is little evidence of who designed or manufactured most early frames. Two early exceptions, both of Venetian patronage, survive in their original locations: Mantegna's San Zeno triptych in Verona and Giovanni Bellini's Frari triptych in Venice (Fig. 260), as well as several other Bellini altarpieces that may have been directly influenced by Mantegna's example. In both polyptychs the architectural elements of the frames extend the illusion of

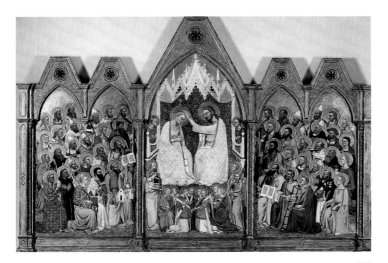

257

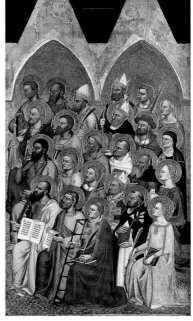

259

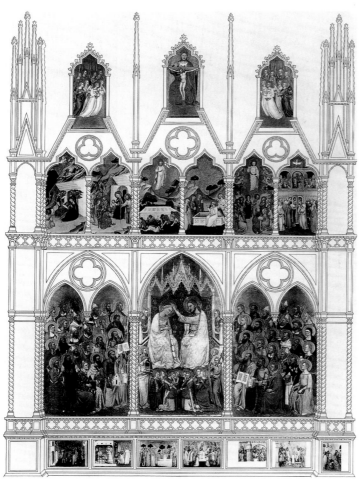

258

257 Jacopo di Cione, San Pier Maggiore
Altarpiece, 1370s, tempera and gilding on
panel (the paint has been analyzed),
169 x 113 cm, 206.5 x 113.5 cm, 169 x 113 cm.
National Gallery, London.

Main tier panels in their present frame,
which is a simplification of the nine-
teenth-century surround constructed
for three panels from a large altar-
piece. The nineteenth-century frame
was based on the surviving Strozzi
Altarpiece by Andrea di Cione (Santa
Maria Novella, Florence), and
involved altering the tops of the three
fragments.

258 Photomontage reconstruction by Jill
Dunkerton of the original arrangement of the
San Pier Maggiore Altarpiece. National
Gallery, London.

259 Jacopo di Cione, right main tier panel of
Fig. 257.

The wood borders were neither
primed nor painted, because they were
originally covered by the integral
frame. Extensive technical description
of the altarpiece is found in Bomford
et al. 1989, pp. 156–89.

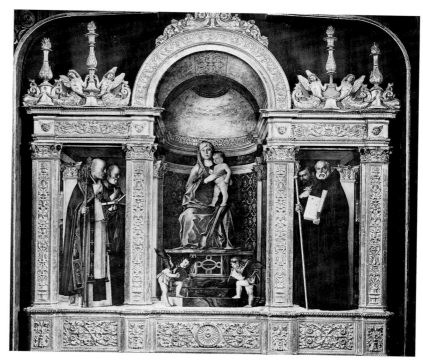

260

260 Giovanni Bellini, Frari Triptych, 1488,
Santa Maria Gloriosa dei Frari, Venice.

This rare work is still in situ and retains
its original frame. Its design is tightly
integrated with the pictorial space of the
polyptych: the cornices of frame
and background align, the frame's cen-
tral arch follows the depicted barrel
vault, and the pilasters of the frame mir-
ror those in the painting. All this sug-
gests the artist's involvement in the over-
all design. See pp. 247–51.

261

261 Marsden Hartley, *The Aero*, 1914, oil on canvas, 11.3 x 81.1 cm (107 x 87.6 cm framed). National Gallery of Art, Washington, D.C. Andrew W. Mellon Fund, 1970.

This is one of a major group of emblematic paintings that Hartley painted in Berlin at the beginning of World War I. The frame is a simple wooden liner, gessoed and painted by the artist. Hartley painted the frames on at least six other Berlin paintings.

the architecture depicted in the paintings. Mantegna is credited with the design of the San Zeno frame; for the Frari altarpiece there is a record of its frame carver, Jacopo de Faenza, but we can only suppose that Bellini was involved with the design. This integration of painting and frame is one of the characteristics of Venetian Renaissance altarpieces.[6]

Once paintings were portable, their frames were usually chosen by the patron, with possible advice from an architect, decorator, or frame maker. With the rise of academic exhibitions in the late eighteenth century, artists were required to present their paintings framed—and the choice reflected not only fashion but economics, because the artist had to front the framing cost. Beginning in the nineteenth century, independent and avant-garde artists also provided their own frames for exhibitions—and their choices combined aesthetic and economic concerns with promotional ones. The white and pale-colored frames favored by impressionists during the 1870s distinguished their paintings from the uniformly gilt-framed salon works as clearly as did their method of handling paint. The practice provoked both scorn and praise. The journalist Jules Clarétie sarcastically remarked, "The most original aspect of these revolutionaries is the surrounds of their works, which are white. Gold frames are left to old painters, tobacco-chewing daubers, opponents of light paintings." Jules Laforge described the same situation rather more sympathetically: "In the exhibitions of independent painters the empty banality of the inevitable gold frame and mouldings has been replaced by a refined and intelligent variety of imaginative frames. A sunny green landscape, a golden beach in winter, an interior shimmering with chandeliers and evening dresses each requires a different frame which is best designed by the painter."[7]

The mid-nineteenth through the early twentieth centuries was the high point of artists' involvement with frames. In choosing, designing, and occasionally fabricating or polychroming the surrounds for their work, painters reflected a number of concerns: the aforementioned issue of economy, an interest in distinguishing avant-garde from salon presentation, a breakdown in categories of fine versus applied arts (Fig. 261), an attempt to integrate the artwork with the surrounding interior (Fig. 262), and a control over the painting's visual presentation. We have further records that a number of artists during the same period were concerned enough about the visual impact that they put the finishing touches on their paintings only *after* framing them; these were not necessarily those artists who fabricated or even designed their own moldings. The American painter Edward Wheelwright described Jean-François

262 James Abbott McNeill Whistler, *Harmony in Blue and Gold (The Peacock Room)*, 1876–77. Freer Gallery of Art, Smithsonian Institution, Washington, D.C.

Whistler's concern for the presentation of his work had a significant impact on other artists. With *The Peacock Room* it led to a break with Frederick Leyland, his major patron. Leyland's architect asked Whistler to retouch the room's walls to coordinate with his painting, *The Princess from the Land of Porcelain* (1863–64). When the artist extended his involvement to the entire interior, gilding and stenciling over shelving, shutters, and antique leather wall coverings, Leyland refused to pay him.

263 Robert Ryman, *Archive*, 1980, oil on steel, 34.3 x 30.2 cm. Extended loan of the artist to San Francisco Museum of Modern Art.

The meaning of this work is inseparable from its structure and its relationship to its surroundings. It lacks a frame but has integral brackets that screw into the wall. In speaking of the presentation of Mark Rothko's and his own paintings, Ryman said: "I've seen Rothkos with Plexiglas in front, and even frames. Of course, he would never have allowed that. Any time his paintings are exhibited in public, they should be exhibited the way he painted them, and not with any additions. And that holds true for painters like Ellsworth Kelly, Yves Klein, and myself. . . . The frame isolates our experience from the wall. But that's part of the realism of the painting: it is affected by real light, and the real presence of where it is" (quoted in an interview by Jeffrey Weiss in *Mark Rothko*, catalogue [Washington, D.C.: National Gallery of Art, 1998], p. 368).

262

263

Millet's (1814–75) procedure for completing a painting: "A picture, he said, ought always to be finished in its frame. One could never know beforehand what effect the gold border would have; the picture might have to be painted up to it, and a picture should always be in harmony with its frame as well as with itself. He did, in this case, lighten the whole sky, besides making other changes, after the frame arrived." By the 1880s Monet regularly applied his finishing touches after framing; John House suggests that "many of the small touches which Monet made near the edges of his paintings are likely to have been added in the frame." Van Gogh expressed similar sensibilities in a letter to his brother: "I can only finish in a frame."[8]

Paintings tend to acquire new frames whenever they change hands, so as a general rule, the frame on any painting reflects the taste of its current owner. As Louis van Tilborch noted, when describing the reframing of Van Gogh's works, "It [the frame] is the only part of a painting that a new owner can alter in order to make an acquisition truly his own. The more expensive or important a work the greater the desire for change." This desire affects institutions as well as individuals. The historical consciousness that drives some museums to search out lost period frames for their collections—or to re-create designs when the real thing is unobtainable—is as much a reflection of contemporary taste as any other framing choice. The tendency to frame a collection uniformly, once associated with great collectors and country houses, has become almost exclusively the province of museums—whether the uniform "gallery" frames chosen by Denon for the Grand Gallery of the Louvre in 1802–3, the gilt Palladian "museum" frame of the British Museum in the 1850s, Carlo Scarpa's designs of the late 1950s to the 1970s for hanging medieval and Renaissance paintings, unframed, with visible and aggressively modern hardware, or William Rubin's decision in 1984 to hang MoMA's postimpressionist works in unornamented gold moldings (the museum reframed some of these works within a decade).[9]

A number of twentieth-century artists have so integrated the painting with its borders and means of hanging that it is impossible to separate them. One of Robert Ryman's paintings without its brackets would certainly be considered fragmentary; yet it would be equally defaced by the addition of a conventional frame (Fig. 263).

Viewing Conditions and Lighting

To what extent do viewing conditions and lighting affect our understanding of paintings? Must art historians account for these factors?[10] Light has a profound effect on our visual perception. It is literally the means by which we receive all visual data, and color perception is entirely dependent on light. The act of seeing is a complex interaction between the brain and this stimulus, some aspects of which are time-dependent. A change in the light will change what we see of a painting. This recalls Rembrandt's instructions to Ruffo (Case Study 7) to alter the light on his portrait of Alexander so as to minimize the visibility of the canvas seams.

In previous chapters we made use of ranges of the light spectrum beyond the visible to obtain *more* information than is available with unaided vision. However, X-ray, ultraviolet, or infrared studies reveal layers of paint or records of damage and repair that were never intended to be seen. But do critics or historians need to account for viewing distance, surrounding visual conditions, and light sources when they discuss a painting's tonality or the readability of details? What about such issues as the effects of changing light recorded by Monet in his serial paintings of the 1890s, the visual impact of Ad Reinhardt's (1913–67) black paintings, and the works of Bridget Riley (b. 1931), which involve afterimages? Should these factors be considered when making use of contemporaneous written accounts?[11] In other words, do lighting and viewing conditions have implications for historical interpretation?

First, let us consider to what extent works are painted for specific viewing and lighting conditions. While frescos and some wall-sized paintings are done in situ, easel paintings typically are painted in one set of lighting conditions—the artist's studio, en plein air, or a combination—always to be seen in different and possibly changing conditions: church, civic, or domestic interior, exhibition hall, gallery, or museum. Artists traditionally preferred studios with natural light from a north-facing window, but this does not give us a precise "color temperature" (a measure of the chromatic range of the light source). Artists chose northern light because it is most consistent throughout the day, although it varies with the season, the weather, and the angle of the light.

At least a few painters manipulated their studio lighting, but not necessarily in anticipation of the paintings' ultimate viewing conditions. Goya (1746–1828) added the finishing touches to his work by candlelight and showed himself doing so (Fig. 264). Gainsborough (1727–88) also painted at night to enhance the effect of contrast. John Hayes recounts: "As we know

264 Francisco Goya, *Self-Portrait in the Studio*, c. 1790–95, oil on canvas, 42 x 28 cm. Real Academia de Bellas Artes de San Fernando, Madrid.

The artist portrays himself working in a hat with candles in the brim. He may have been harking back to stories that Michelangelo worked with a candle in his hat, but according to his son, Goya put the finishing touches on his paintings by artificial light.

264

from Ozias Humphry, Gainsborough had already learnt the advantages of working by candlelight, chiefly in relation to highlighting and dramatizing his subject-matter, and 'in the latter part of his life [he] painted chiefly by candlelight, which became his inclination.'" Yve-Alain Bois credits Mondrian's choice to paint at night to the artist's preference for the evenness and "abstraction" of electric lighting. Mondrian was acutely aware of the changes that differing lighting wrought on his work; according to Bois this "led him to express the fantastic desire to paint his pictures wherever they were to be hung—'site specificity' *avant la lettre*." The great teacher and empiricist of color Josef Albers (1888–1976) painted at night "because most pictures are looked at under artificial light"; but his own practice was not thoroughly dogmatic. As he told an interviewer, "Certain colors demand cold daylight" (Fig. 265).[12]

But what about the light in which paintings are exhibited? Paintings unquestionably look different according to the light, and modern incandescent or fluorescent bulbs emit different color temperatures than do daylight, candlelight, or oil or gas lighting. The presence of readily available artificial lighting has also accustomed modern viewers to higher ambient light levels than were available in the past—higher, in fact, than some modern artists prefer. Mark Rothko was famously concerned with the viewing conditions and light levels in which his work was exhibited; on more than one occasion he specified that viewers should encounter his paintings at close range so that they were perceived as an environment rather than as a distant vista. As to lighting, Thomas Hess recounted in Rothko's obituary: "Philip Guston remembers the time when he and Rothko went to see the installation of one of Rothko's shows at Janis. They strolled into the gallery and Mark, without a word, switched off half the lights. When Janis emerged from his office, the three of them chatted a bit and, in a pause in the conversation, Janis slid off and turned all the lights back on. Rothko didn't say anything. They finished their visit; Janis went back to work, Guston and Rothko waited for the elevator, and just before they entered it, Rothko turned half the lights back off again. 'I'm positive,' Guston says, 'that Mark sneaked up there every day and turned the lights down— without ever complaining or explaining.'"[13]

The phenomenon of single-picture exhibitions, popularized by a number of American artists during the decade after Frederic Church's 1859 success with *The Heart of the Andes*, was accompanied by consciously theatrical methods of display. As Annette Blaugrund has discussed, Church and his colleagues in the Tenth Street Studio Building were the first American artists to benefit from such purpose-designed work spaces. They invited the

265 Josef Albers, *Homage to the Square*, 1956–58, oil on Masonite, 72 x 72 cm. Josef and Anni Albers Foundation, Orange, Connecticut.

Albers studied with Max Doerner in Munich and was highly concerned about technique. He used paints unmixed and direct from the tube for maximum saturation and applied them with a palette knife to achieve optimal smoothness. He described his approach in opposition to traditional practice: "no skylight, no studio, no palette, no easel, no brushes, no medium, no canvas" (quoted by Elaine de Kooning, "Albers Paints a Picture" *ArtNews* 49, no. 7 [November 1950], p. 40). He worked primarily at night on his sequential studies of color relations.

public into their skylit studios and presented their work in the central exhibition hall, which also had natural light. Viewers became sensitive to the amount and quality of light, and there were complaints in the press about the harshness of the artificial lighting in single-picture exhibitions, in contrast to the natural light where the works had been painted. As *The Heart of the Andes* traveled around the country Church usually opted for natural light during daylight hours, but even that was manipulated with curtains and screens. Kevin Avery has pointed out that the focus of critical comment was the painting's frame, which Church had designed for maximum illusionistic effect. Unlike the conventional gilt frame, the frame for *The Heart of the Andes* was dark, massive, and architectural—and surrounded with swags of drapery (Fig. 266). To further aid the illusion that viewers were looking out a window into an actual landscape, Church provided opera glasses. There is no indication, however, that Church and his contemporaries expected or intended such dramatic viewing, framing, installation, or lighting to be a permanent feature of the paintings' display in other circumstances.[14]

266

266 Installation of Frederic E. Church's *Heart of the Andes* in 1864, at the Metropolitan Fair in aid of the Sanitary Commission in New York. Stereopticon photograph (photographer unknown). Collection of the New-York Historical Society.

Three presidential portraits were hung above it, and barriers protected the painting on this occasion—but the heavy architectural frame and surrounding drapery were carried over from the painting's solo tour of 1859–61 that also employed theatrical lighting and opera glasses for viewing details. See pp. 256–57.

267 Robert Irwin, *1° 2° 3° 4°*, 1992, installation at Pace Gallery, 142 Greene Street, New York. Three voile tergal (scrim) walls, violet, green, and orange; five floating frames painted with black acrylic lacquer; front to back 42.7 x 115.8 cm. each, three walls, 30.5 x 79.2 cm. each, five frames.

Irwin's interest in the subtleties of visual phenomena led him to abandon painting. Instead, he manipulates three-dimensional environments where the lighting and viewing conditions are inseparable from his visual subject.

When artists began to be responsible for the promotion and display of their own work, some of them took particular care over not only the framing and lighting but the surrounding wall colors and surfaces as well. Whistler's (1834–1903) control over the visual field of his work extended not only to lighting (including his designs for the "velarium," a suspended canopy of silk that baffled the light) and wall colors, but occasionally to the color-coordinated livery of the footmen. One suspects that Whistler was sensitive to the commercial as well as aesthetic implications of such details. The scheme for his exhibition of Venice etchings in 1883 was yellow and white: the walls covered with white fabric and stenciled in yellow, floral arrangements of yellow daffodils and narcissus, and the catalogue vendor attired "in the tints of a poached egg," according to newspaper reports.[15]

Although the impressionists were concerned with display and lighting, it is difficult to reconstruct the optical conditions under which their paintings were seen or written about. The bright effect of impressionist paintings reportedly was enhanced by contrast with the dark walls common in nineteenth-century exhibition galleries. The lighting of these galleries has received much less comment. Both the Salon and the large independent exhibitions were usually held in skylit spaces that were also open evening hours, when gaslight would have been used. Artificial lighting was also employed in dark areas of rooms with natural light sources.[16]

A number of recent artists who focus on perceptual questions have abandoned painting altogether, finding that the only way to control the visual effect is through direct manipulation of the light and physical environment (Fig. 267).

If the foregoing raises more questions than it answers, perhaps it will at least emphasize the importance of recording the viewing and lighting conditions whenever discussion of a painting is based on close empirical study—and possibly of comparing the painting in various types and levels of light.[17] Research on visual perception is likely to reduce the uncertainty, but in the meantime it is useful to remember that vision is an active process that occurs under specific conditions and in real time.

Sources on Lighting and Color

For an introduction to issues in museum lighting, see Steven Weintraub and Gordon O. Anson, "Technics: Natural Light in Museums. An Asset or a Threat?" *Progressive Architecture* (May 1990): 9–54. Herbert Lank gives a short introduction to light in public museums in "The Function of Natural Light in Picture Galleries," *Burlington Magazine* 126, no. 970 (January 1984): 4–6. For a case study of one museum's decisions on wall colors and lighting, written for a general audience, see Christopher McGlinchey, "Color and Light in the Museum Environment," *The Changing Image: Studies in Paintings Conservation*, special issue of *Metropolitan Museum of Art Bulletin* (October 1994): 44–52. A useful overview of various disciplines' approaches to light and color is *Colour: Art and Science*, edited by Trevor Lamb and Janine Bourriau (Cambridge: Cambridge University Press, 1995); it is based on lectures by a paintings conservator, an artist, an art historian, a linguist, a physicist, and psychologists of vision. Each article has a bibliography. Rudolf Arnheim's *Art and Visual Perception: The New Version* (Berkeley: University of California Press, 1954) remains a valuable introduction to psychology of perception directed at artists and art historians. A promising study on color temperature and the viewing of paintings has been conducted by Israel Abramov, James Gordon, and Steven Weintraub. It is in publication.

Appendix 1

Pigment Identification

Because the composition and availability of artists' pigments are well documented, the identification of certain pigments with known dates of introduction and geographical distribution can help confirm or dispute a painting's identification. The following table gives art historians a general idea of the most common pigments found during certain historical spans. Unless noted, pigments have no terminal date of use, although artists tended to favor more modern substitutes that were cheaper or more stable. Virtually all pigments known from ancient times have been commercially produced in the twentieth century. Therefore, pigment studies alone can confirm that paint *cannot* be old but cannot confirm that it definitely *is* old.

The only counterexample is the presence of lead-tin yellow—a pigment used from at least the fourteenth century that inexplicably fell out of use in about 1750. Lead-tin yellow was rediscovered in 1941; hence it does not appear either in nineteenth-century paintings or in fakes produced prior to its rediscovery, such as Van Meegeren's "Vermeers." For an example of its significance, see Case Study 16. The definitive discussion is Herman Kühn's article in *Artists' Pigments* 2, pp. 83–102.

Van Meegeren was careful enough to use natural ultramarine (lapis lazuli) in his fakes; the faker was caught by the fraudulence of his supplier. Van Meegeren's paint manufacturer had adulterated the ultramarine with cobalt blue, a nineteenth-century introduction.

For more information, see Otto Kurz, *Fakes* (1948; reprint, New York: Dover, 1967), pp. 329–34.

A number of the works listed in the Bibliography include laboratory studies of pigments in the oeuvre of a particular artist or school; these would be the best starting points for scholars interested in pigment use by period, region, or artist. Gettens and Stout 1966 is an accessible source for a broad range of pigments, including those not mentioned in the table. *Artists' Pigments* has the most current and complete discussion of analytic techniques. The chapter on each pigment includes a list of notablye occurrences; these should be very useful to art historians.

Chronology of Common Pigments According to Initial Use

	Ancient Times	Renaissance	18th Century	19th Century	20th Century
White	chalk gypsum lead white			zinc white	titanium white
Black	charcoal lamp black bone black				
Red	iron oxide reds (red ochres) red lead cinnabar (vermilion) red lakes (kermes, lac, madder)	red lake (carmine)		red lakes (synthetic)	cadmium red
Yellow	yellow ochre orpiment	Naples yellow *used approx. 1600-1800* lead-tin yellow *used approx. 1300-1750*		chrome yellow cadmium yellow cobalt yellow	zinc yellow
Green	malachite verdigris terre verte	copper resinates *mostly 15th-16th cent.*	Scheel's green	cobalt green emerald green chrome green	
Blue	azurite indigo ultramarine *mostly 14th-15th cent.*	smalt *used late 15th-19th cent.*	Prussian blue	cobalt blue syn. ultramarine cerulean blue	manganese blue

Appendix 2

Paintings in Exemplary Condition in Public Collections

These lists have been assembled for readers who want to gain first-hand visual understanding of some of the issues raised by the aging and treatment of paintings. They are by no means complete. Except for the unvarnished glue-size paintings, little of this information has been published. It is generously provided by the conservation and curatorial departments responsible for these works.

1

Canvases painted prior to 1800 that have never been lined

Amsterdam (Rijksmuseum)
Abraham Genoeb *Landscape with Diana Hunting* and *Landscape with Apollo and Calliope*

attr. Aert Pietersz *Portrait of Pieter Dirksz, Longbeard*[1]

Dutch School *View of Heusden*

N. Netherlandish School *Portrait of D. H. v Sweiter*

F. van Mieris *Diederick Baron van Leyden Vlardingen* (1728)

Chicago (Art Institute of Chicago)
Greuze *Lady Reading the Letters of Heloise and Abelard*

Cleveland (Cleveland Museum of Art)
Gilbert Stuart *Baron Fitzgibbon* (1789, see fig. 35)

Terbruggen *The Weeping Heraclitus* (1621)

Lavinia Fontana *Portrait of a Couple* (1580s)

Dresden (Gallery of Old Masters)
Aert de Gelder *Ecce Homo*

Dublin (National Gallery of Ireland)
Perroneau *Portrait of a Man* (1766)

Hartford (Wadsworth Atheneum)
Leandro Bassano *The Flagellation* (c. 1585)

Christobal Villalpando *The Archangel Michael* (c. 1700)

London (National Gallery)[2]
Corrado Giaquinto *The Brazen Serpent* and *Moses Striking the Rock* (1743–44)

Moroni *Canon Ludovico di Terzi* (c. 1560)

Velázquez *Philip IV of Spain in Brown and Silver* (1630s)

Vouet *Cardinal Carlo Cerri*

Wright of Derby *Mr. and Mrs. Cottman*

Los Angeles (J. Paul Getty Museum)
Wright of Derby *John Wetham of Kirklington* (1777–79)

Madrid (Prado)[3]
Velázquez *Los Borrachos; Paisaje de Villa Medicis; Pabellón de Cleopatra Ariadna; Baltasar Carlos, a caballo* (1635, see fig. 114); *El Cardenal Infante don Fernando de Austria, calzador; El Príncipe Baltasar Carlos, calzador; La coronación de la Virgen; Mercury and Argos;* and *La Infanta Margarita*

Munich (Alte Pinakothek)
Velázquez *Portrait of a Young Man*[4]

New York (Metropolitan Museum of Art)
Canaletto *Piazza S. Marco*

David *Death of Socrates*

Luca Giordano *Flight into Egypt*

Velázquez *Juan de Pareja*

Philadelphia (Philadelphia Museum of Art)
Bartolommeo di Giovanni *St. John the Baptist Preaching* (c. 1500–10)

Vienna (Gemäldegalerie der Akademie der Bildenden Kunste)
Jan de Heem *Still Life with Parrot* (c. 1650)

Washington, D.C. (National Gallery of Art)
Wm. Claes Heda *Banquet Piece with Mince Pie*

Moroni *Gian Federico Madruzzo*

Gilbert Stuart *Robert Liston* and *Sir Joshua Reynolds*

Titian *Doge Andrea Gritti* (see figs. 112, 113)

Benjamin West *Mrs. William Beckford* and *Elizabeth, Countess of Effingham*

2

Old master paintings in distemper that have not been varnished[5]
(modernist paintings in distemper that have remained unvarnished are included in the following section)

Amsterdam (Rijksmuseum)
Pordenone *Virgin and Child*

Bergamo (Accademia Carrara)
Mantegna *Virgin and Child*

Besançon (Musée de Beaux-Arts et Archaéologie)
Baldung Grien *Head of an Old Man (Nicodemus?)*

Boston (Museum of Fine Arts)
Lucas Van Leyden *Moses and the Israelites after the Miracle of Water from the Rock* (1527)[6]

Brooklyn (Brooklyn Museum)
Netherlandish *Madonna and Child*[7]

Dublin (National Gallery of Ireland)
Mantegna *Judith and Holofernes*

London (National Gallery)
Dieric Bouts *Entombment*

Quentin Massys *Madonna and Child with St.s Barbara and Catherine*

Los Angeles (Los Angeles County Museum of Art)
Pedro Berruguete and workshop *The Last Supper* (c. 1495–1500)[8]

Los Angeles (J. Paul Getty Museum)
Dieric Bouts *Annunciation* (see figs. 104, 105)

Paris (Musée Jacquemart-André)
Mantegna *Ecce Homo*[9]

Paris (Museé du Louvre)
Mantegna T*he Judgement of Solomon*

Pasadena, Calif. (Norton Simon Museum)
Dieric Bouts *Resurrection*

Williamstown, Mass. (Clark Art Institute)
French School, 15th cent. *Virgin and Child*

3

Modernist paintings that have survived unvarnished, as the artist intended[10]
For reasons of economy we have emphasized works painted prior to 1930, although the question of varnish is equally important for many recent paintings. Paintings are oil on canvas, unless noted:

Amsterdam (Van Gogh Museum)
Gauguin *Portrait of Vincent Van Gogh Painting Sunflowers* (1888),[11] *Self-Portrait, 'Les Misérables'* (1888, see fig. 86),[12] *Women Picking Fruit* (1887)[13]

Van Gogh *The Garden of the Asylum in Saint-Rémy* (1889)[14]

Basel (Kunstmuseum)
Beckman *Nizza* (1921)

Braque *Broc et violon* (1909–10), *Le Portugais* (1911–12), *Guèridon* (1913), *Violon et verre* (1912–13), *Nature morte* (1918)

Chagall *Le Prisée* (1923–26)

Delaunay *La Tour Eiffel* (1910–11), *Hommage à Bleriot* (1914)

Gris *Femme à la mandoline, d'après Corot* (1916, oil on wood)

Jawalensky *Nacht* (1916), *Strenger Winter* (1916)

Kandinsky *Improvisation 35* (1914)

Klee *Senecio* (1922)

Kokoshka *Die Windsbraut* (1913)

Léger *La femme et l'enfant* (1922), *Nature Morte (le mouvement à billes)* (1926), *Elements möcaniques* (1918–1923)

Marc *Zwei Katzen, blau und gelb* (1912)

Miró *Le gentlemen* (1924), *Composition* (1925)

Modersohn-Becker *Selbstbildnis* (1906)

Mondrian *Composition* (1921)

Munch *Grosse Küstenlandschaft* (1918)

Nolde *Vorabend* (1916)

Picasso *Arlequin assis* (1923), *Compotier et fruits* (1908, tempera on wood), *Le Poète* (1912), *Le Guéridon* (1913–14), *Femme à la guitarre* (1911–14), *Homme, femme et enfant* (1906)

Vallotton *Trois femmes et une petite fille jouant dans l'eau* (1907)

Chicago (Art Institute of Chicago)
Bonnard *Earthly Paradise* (1916–29)

Degas *After a Costume Ball (Portrait of Mme Dietz-Monin)* (1879, in a water-based medium, distemper or gouache, with metallic paint, some oil, charcoal, and pastel on fine unprimed linen; see figs. 141, 142)

Demuth *Business* (1921)

Kandinsky *Improvisation (30 Cannons)* (1913), *Painting with Green Center* (1913), *Painting with Troika* (1911; on board), *Landscape with Two Poplars* (1912), *Houses at Murnau* (1909; on board)

Klee *Death in the Garden* (1919; on canvas attached to wood)

Man Ray *Percolator* (1917)

Miró *Circus Horse* (1927; oil and tempera), *The Policeman* (1925)

Monet *Irises* (1901)

Nolde *Figure and Flowers* (1915)

Picasso *Abstraction: Background with Blue Cloud Sky* (1930), *Head* (1927; oil and chalk)

Seurat *La Grande Jatte* (1884; under glass, as the artist intended, see fig. 100)

Cleveland (Cleveland Museum of Art)
Puvis de Chavannes *Summer* (1891)

Vuillard *Under the Trees* (1894, distemper)[15]

Copenhagen (Ny Carlsberg Glyptothek)
Gauguin *Still Life with Flower and Book*[16]

Edinburgh (National Gallery of Scotland)
Gauguin *Vision of the Sermon*[17]

Fort Worth (Kimbell Art Museum)
Braque *Girl with a Cross* (1910–11)

Léger *The Red Wheel—Eléments Mécaniques* (1919–20)

Matisse *L'Asie (Asia)* (1946)

Mondrian *Composition No. 8* (1939–42)

Hartford (Wadsworth Atheneum)
Gauguin *Nirvana, Portrait of Meyer de Hahn* (c. 1890, distemper on unprimed cotton; see figs. 40, 41, 42)

Hassam *The Flag Outside Her Window* (or) *The Boys Marching By* (1918)

Miró *Dream Painting* (1925)

O'Keeffe *The Lawrence Tree* (1929)

Vuillard *Portrait of Mme Gaboriau* (1928, distemper) and *Reading* (1893, on board)

Indianapolis (Indianapolis Museum of Art)
Seurat *The Channel at Gravelines* (1890)[18]

London (Courtauld Institute Galleries)[19]
Bonnard *The Blue Balcony* (1910)

Boudin *Deauville* (1893)

Cézanne *The Lac d'Annecy* (1896)

Renoir *Woman Tying Her Shoe* (c. 1918)

Seurat *The Bridge at Courbevoie* (1886–87) and *Young Woman Powdering Herself* (c. 1888–90)

London (National Gallery)
Monet *Irises* (1914–1917)

Seurat *Le Bec du Hoc, Grandecamp* (1885, on loan from the Tate)

Van Gogh *Wheatfield with Cypress* (1889)[20]

Los Angeles (Los Angeles County Museum of Art)
Braque *Still Life with Violin* (1913)

Dix *Leda* (1919)

Gleizes *Figure* (c. 1920; gouache)

Kirchner *Sunday in the Alps* (c. 1921), *Two Nudes in a Room* (1914)

New York (Museum of Modern Art)
Kandinsky *Painting No. 199* (panel for Edwin R. Campbell No. 2) (1914)

Miró *The Birth of the World* (1925, mixed media)

Philadelphia (Philadelphia Museum of Art)
Braque *Violin and Newspaper* (1912), *Still Life (Newspaper and Lemon)* (1913), and *Still Life (Violin)* (1913, all three are graphite, charcoal, and oil), *Still Life* and *The Table* (1918, double-sided)

D. Burliuk, numerous works

Cézanne *Large Bathers* (1906)

Léger *Contrast of Forms* (1913)

Miró *Man and Woman* (1925), *Head* (1927), *Untitled Painting* (1927), *Man, Woman and Child* (1931), *Painting* (1933), *Person in the Presence of Nature* (1935, all may contain aqueous media; the last painting is on panel)

Picasso *Old Woman (Woman with Gloves)* (1901, on board), *Still Life with Violin and a Guitar* (1913, graphite, plaster, oil, and other material)

Tamayo *The Mad Dog* (1943)

Torres-Garcia *Composition* (1929)

Van Gogh *Sunflowers*

Prague (Narodni Galeri)
Van Gogh *Wheatfield with Cypress* (1889)[21]

San Francisco (Museum of Modern Art)
Matisse *La Conversation* (1938)

O'Keeffe *Petunia* (1925)

Washington, D.C. (Hirshhorn Museum and Sculpture Garden)
Baranoff-Rossiné *Capriccio Musicale (Circus)* (1913, glue-based paint, oil, and pencil; see figs. 127, 128)

Washington, D. C. (National Gallery of Art)
Braque *Still Life: Le Jour* (1929)

Dove *Moth Dance* (1929)

Gorky *The Artist and His Mother*

Hartley *Landscape No. 5* (1922–23)

Hassam *Nude Seated* (1912)

Jawlensky *Murnau* (1910)

Kandinsky *Improvisation 31 (Sea Battle)* (1913)

Kupka *Organization of Graphic Motifs II* (1912–13)

Matisse *Pianist and Checker Players* (1924)

Miró *Head of a Catalan Peasant* (1924)

O'Keeffe *Line and Curve* (1927) and *Shell #1* (1928)

Washington, D. C. (Phillips Collection —Note: The Phillips Collection has many unvarnished paintings, from which the following list is abbreviated)
Bonnard *Early Spring* (1908) and *The Palm* (1926; see fig. 246), as well as most of the other Bonnards in the collection

Braque *Music* (1914, oil mixed with sawdust and crayon) and *The Round Table* (1929; see fig. 85) and several others

D. Burliuk, numerous works

Campendonk *Village Street*

Stuart Davis *Boats* (1930), *Still Life with Saw* (1930)

Dove, numerous works (many of which are mixed media; none of his canvases in this collection have later varnish, although one or two have the artist's varnish)

Eilshemius, numerous works (most are on board)

Graham, numerous works

Gris, *Abstraction* (1916)

Hartley *Mountain Lake, Autumn* (1912) and others

Kandinsky *Autumn II* (1912), *Sketch for Painting with White Border* (1913), and *Succession* (1935)

Klee, numerous works (some on board)

Knaths, numerous works

Kokoschka *Portrait of Lotte Franzos* (1909) and others

Walt Kuhn (several)

de la Fresnaye *Emblems* (c. 1913)

Man Ray *The Black Tray* (1914)

Mondrian *Square Composition* (1922–25)

O'Keeffe *Leaf Motif No. 1* (1924), *My Shanty, Lake George* (1922), *Ranchos Church* (c. 1940)

Picasso *Bullfight* (1934)

M. Prendergast *Autumn Festival* (1917–18) and *Snow in April* (c. 1907)

Tack, numerous works (many on canvas mounted to Masonite)

J. Villon *Machine Shop* (1913)

Vuillard *Nurse with Child in a Sailor Suit* (1895, distemper on board), and *Woman Sweeping* (c. 1892, oil on board with remains of the artist's retouching varnish)

Williamstown, Mass. (Clark Art Institute)
Toulouse-Lautrec *Dr. Péan Operating* (1891–92, on cardboard) and *Jane Avril* (on cardboard, mounted on panel)

4

A very preliminary list of unfinished paintings that reveal the artist's working order
We have confined our examples to those that clearly show the sequence of painting, avoiding the many works that raise more subtle questions about completion[22]

Aix-en-Provence (Musée Granet)
Rembrandt *Self-Portrait with Beret* (c. 1659)

Amsterdam (Rijksmuseum)
George Brietner, numerous examples

A. F. van de Meulen *Troops at Naarden* and *Madonna and Child*

Jan van Scorel *Bathsheba*

Tintoretto *Muse with Lute*

Adr. Pietersz van de Venne *Princes Maurits and Fr. Henrick*

Amsterdam (Van Gogh Museum)
T. Rousseau *Fontainebleau—Les Gorges d'Apremont* (c. 1848)

Basel (Fondation Beyeler)
Matisse *Le Pont Saint-Michel* (1900)

Basel (Kunstmuseum)
Böcklin *Portrait of Clara Böcklin* (1872–73)

Buenos Aires (Museo National de Belles Artes)
Manet *Portrait of M. Hoschede and His Daughter*

Cardiff (National Museum and Gallery)
Burne-Jones *The Wheel of Fortune* (1882)

Chicago (Art Institute of Chicago)
David *Mme de Pastoret and Her Son* (1791–92)

Cleveland (Cleveland Museum of Art)
Ingres *Antiochus and Stratonice*

Andrea del Sarto *Sacrifice of Isaac*

Coral Gables, Fla. (Lowe Art Museum, University of Miami)
Washington Allston *Jason Returning to Demand His Father's Kingdom* (1807–9)

Edinburgh (National Gallery of Scotland)
Cima da Conegliano *Virgin and Child*

Correggio *Allegory of Virtue*

Florence (Uffizi)
Leonardo *Adoration of the Shepherds*

The Hague (Gemeente Museum)
Mondrian *Victory Boogie Woogie* (1942–44)

Los Angeles (Los Angeles County Museum of Art)
Rosso Fiorentino *Allegory of Salvation* (see fig. 117)

London (Courtauld Institute Galleries)
Degas *Lady with a Parasol* (c. 1877)

Palma Vecchio *Venus in a Landscape* (c. 1520)

Perino del Vaga *Holy Family with St. John the Baptist*

London (National Gallery)
Gainsborough *The Painter's Daughters chasing a Butterfly* c. 1756

Michelangelo *Manchester Madonna* (mid-1490s) and *Entombment* (c. 1500)

Le Nain (one of the brothers), *Three Men and a Boy* (1640s-50s)

London (Tate Gallery)
Hogarth *Head of a Lady, called Lady Pembroke* (c. 1735–40)

J. S. Sargeant *Edward Wertheimer, Son of Asher and Mrs. Wertheimer* (1902)

New York (Metropolitan Museum of Art)
Dürer *Salvator Mundi* (c. 1505)

Winslow Homer *Shooting the Rapids, Saguenay River* (1905)

Manet *Mme Édouard Manet* (1860s) and *George Moore at the Café* (1878–79)

Tintoretto *Doge Alvise Mocenigo Presented to the Redeemer*

New York (Museum of Modern Art)
Picasso *The Charnel House* (1945–46)

Paris (Centre Georges Pompidou)
de la Fresnaye *Le 14 Julliet* (1914)

Paris (Musée Gustave Moreau)
Moreau *Hesiod and the Muses* 1860, *The Apparition* (1874–76–97) and others

Philadelphia (Philadelphia Museum of Art)
Fra Bartolomeo *Adam and Eve with Cain and Abel* (by 1512)

Cézanne *Winter Landscape* (1894)

Rome (Galleria Doria Pamphili)
Correggio *Allegory of Virtue*

Rome (Vatican Museum)
Leonardo *St. Jerome*

St. Louis (Washington University Gallery of Art)
Matisse *Still Life With Oranges (II)* (c. 1899)

São Paulo (Museu de Arte de São Paulo)
Delacroix *The Four Seasons* (1856–63)

Manet *Bathers on the Bank of the Seine— Study from the Nude*

Washington, D.C. (Phillips Collection)
Cézanne *Provençal Landscape Near Les Lauves* (1904–6)

Washington, D.C. (National Gallery of Art)
Rembrandt and workshop *Man in Oriental Costume* (c. 1635)

Gilbert Stuart *John Bull Ricketts* (1793–99)

Williamstown (Clark Art Institute)
Monet *Bridge at Dolceacqua* (1884)

Notes to Appendix 2

1 This image is in poor condition.

2 This list is taken from *National Gallery Technical Bulletin* 10 (1986): 29, except for the Giaquintos, which are mentioned in Bomford 1997, p. 35.

3 Garrido 1992, pp. 62–63.

4 Hubert von Sonneberg, "The Technique and Conservation of the Portrait [Juan de Pareja by Velázquez]," *Metropolitan Museum of Art Bulletin* 29, part 2 (June 1971): 478.

5 The paintings by Bouts, Massys, and Lucas van Leyden are cited in Wolfthal 1989. The Mantegna examples are published in Andrea Rothe, "Mantegna's Paintings in Distemper," pp. 80–88, in Boorsch 1992.

6 The work is *not* in pristine condition, but it merits study, according to George Shakelford and Jim Wright (conversations, December 1996).

7 The image is in worn condition.

8 Joseph Fronek notes that the painting has been lined and the upper central section impregnated with wax, much of which has been removed. This does not affect most of the painted surface (correspondence, July 1999).

9 The paint is extraordinarily fresh.

10 The question of the artist's intention for works left in an estate is always difficult. Most of Van Gogh's work falls into this category. Although serious scholars disagree on his attitude toward varnish, we have included his unvarnished paintings in this list. Some assume that was the artist's intention, as many of the unsold works were not varnished. However, he gave his brother numerous instructions about varnishing works to be sold. We are grateful to Ann Hoenigswald for discussion of the subject.

11 Vojtech Jirat-Wasiutynski and H. Travers Newton, "Gauguin's Paintings of Late 1888: Reconstructing the Artist's Aims from Technical and Documentary Evidence," in *Appearance, Opinion, Change: Evaluating the Look of Paintings*, Postprints, U.K. Institute for Conservation and Association of Art Historians, June 1990, p. 29.

12 Jirat-Wasiutynski and Newton 1989, p. 75.

13 Jirat-Wasiutynski and Newton, "Gauguin's Paintings," p. 27.

14 Cornelia Peres, "On Egg-White Coatings," in *A Closer Look* 1991, p. 42, n. 2.

15 William H. Robinson, "Vuillard's 'Under the Trees' from the Nabis Cycle, 'The Public Gardens,'" *Bulletin of the Cleveland Museum of Art* 79, no. 4 (April 1992): 111–27.

16 Jirat-Wasiutynski and Newton, "Gauguin's Paintings," p. 27.

17 Jirat-Wasiutynski and Newton, "Gauguin's Paintings," p. 27.

18 Ellen Wardwell Lee, *The Aura of Neo-Impressionism: The W. J. Holliday Collection*, catalogue (Indianapolis: Indianapolis Museum of Art, 1983), p. 30.

19 These are published in *Impressionist and Post-Impressionist Masterpieces* 1987.

20 Peres, "On Egg-White Coatings," p. 42, n. 2.

21 Peres, "On Egg-White Coatings," p. 42, n. 2.

22 This list was added because of the enthusiasm and many contributions of Laurent Sozzani.

Notes

Chapter 1: Introduction

1 For the standard translation in English, see the Bibliography. An excellent compilation of artists' treatises is Merrifield 1849; British sources are summarized in Talley 1981 and Carlyle 1999, while *Artists' Techniques in Golden Age Spain: Six Treatises in Translation* (1986) covers the Spanish sources. For a bibliography of early artist's manuals in print, see Muñoz Viñas 1998.

Chapter 2: The Support

Wood Supports

1 Information on Seurat's use of panel comes from Robert L. Herbert, *Georges Seurat, 1859–1891*, catalogue (New York: Metropolitan Museum of Art and Harry N. Abrams, 1991), pp. 105–6. For the small oil sketches for *A Sunday on La Grande Jatte*, see pp. 180–98. The catalogue's illustrations of the sketches are extraordinarily useful—revealing the edges of the panels and considerable information as to brushwork. Contrary to the published information, none of Seurat's small panels has been securely identified as an actual cigar box top (correspondence with Robert L. Herbert, November 1998). Neither visible light nor infrared examination of the Washington panel (fig. 1) yielded any clues to its prior use (courtesy of the Conservation Department, National Gallery of Art, November 1998, with special thanks to Ann Hoenigswald and Elizabeth Walmsley). Information on Vigée's technique is from Joseph Baillio, *Elisabeth Louise Vigée Le Brun, 1755–1842*, catalogue (Fort Worth: Kimbell Art Museum, 1982), p. 10, and the same author's "Vigée-Le Brun and the Classical Practice of Imitation," *Papers on Art History from Penn State* 4 (1988): 94–125. Baillio includes a catalogue of Vigée's works on panel (in European and American collections), p. 168 n. 25, in "Identification de quelques portraits d'anonymes de Vigée Le Brun aux Etats-Unis," *Gazette des Beaux-Arts* 6, no. 96 (November 1980): 157–68.

Panel Dating Through Dendrochronology

2 When using dendrochronological data, art historians factor in the drying time by adding a minimum of two to five years to the felling date. For John Shearman on recycled panels, see "The Historian and the Conservator," in *Princeton Raphael Symposium*, 1990, p. 11. For panels from the same tree attributed to different hands, see the entry on Rembrandt's *Polish Nobleman* (1937.1.78) in Arthur K. Wheelock Jr., *Dutch Paintings of the Seventeenth Century*, National Gallery of Art, pp. 222–26. The wood of the Washington painting is linked to panels in Rotterdam and Kassel (n. 1).

Aging and Treatment of Wood Panels

3 Hacquin's late eighteenth-century cradling of Titian's *Christ Crowned with Thorns* and its attendant problems are discussed in Volle et al. 1993, p. 70. The remains of the cradle are illustrated.

4 These examples are drawn from Raphael Alonso, "Restoration of the 'Madonna of the Oak' and Conservation of Raphael's Paintings in the Prado," in *Princeton Raphael Symposium*, pp. 141–47.

5 For a contemporary account of an early nineteenth-century transfer, see R. O'Reilly, "Sur la restauration des vieux tableaux: avec la description de'enlèvement d'un Tableau de Raphaël, exécuté récemment par ordre du Musée central des Arts," *Annales des Arts et Manufactures* Frimaire 30, An X [1802]: 225–39. A modern transfer is documented in clear detail with accompanying mid-treatment photographs by Martin Wyld and Jill Dunkerton, "The Transfer of Cima's 'The Incredulity of S. Thomas,'" *National Gallery Technical Bulletin* 9 (1985): 30–59. Visual evidence of a transfer can sometimes be observed in sufficiently detailed reproductions. In Jaynie Anderson, *Giorgione: The Painter of "Poetic Brevity"* (Paris: Flammarion, 1996; English ed. 1997), the Vienna *Portrait of a Young Boy with a Helmet* (pp. 46–47), the canvas texture is visible in the detail—particularly in the upper hand. Yet both the detail and full image also show signs of vertical splits from the previous panel support; one runs through the boy's right cheek, another through the knuckles of his right hand (detail). Alonso's description of the effects of transfers comes from *The Princeton Raphael Symposium*, pp. 141–42.

Technical Examination of Wood Panels

6 Hubert von Sonnenburg gives a clear description with illustrations of recent methods that minimize the effect of the cradle during X-ray studies in *Rembrandt / Not Rembrandt in the Metropolitan Museum of Art: Aspects of Connoisseurship*. Vol. 1: *Paintings: Problems and Issues*, catalogue (New York: Metropolitan Museum of Art and Harry N. Abrams, 1995), p. 13 and figs. 6–8. For an overview of the use of radiography in examining paintings, see Van Schoute and Verougstraete-Marcq 1986.

Case Study 1

7 This case has been adapted from Slive et al. 1989, cat. 1, pp. 130–31, and Groen and Hendricks, "Frans Hals: A Technical Examination," in Slive et al. 1989, pp. 109–27. For further information on Hals, see Grimm 1990.

8 Slive et al. 1989, pp. 109–10.

Case Study 2

9 This case is adapted from Gordon 1989, which illustrates all seven fragments of the altarpiece, and Keith Christiansen, "Fourteenth-Century Italian Altarpieces," *Metropolitan Museum of Art Bulletin* 40, no. 1 (1982): 50–55.

10 The panels were all gilded over a green layer, rather than the standard red bole (Gordon 1989, p. 524 and n. 6.). For red bole as the usual ground for gilding, see Chapter 3. For suggestions as to the panels' original function, see Gordon 1989, nn. 8–11.

11 Christiansen, "Italian Altarpieces," p. 53.

12 All seven X-rays are illustrated as figs. 2, 4, 6, 8, 10, 12, 14 in Gordon 1989, pp. 524–25.

Case Study 3

13 This case has been adapted from Beatson, Muller, and Steinhoff 1986. We have considerably reduced their findings in order to concentrate on examination of the panels. Their research concludes that the altarpiece resulted from the collaboration of two artists and compares the two on the basis of technique.

14 On the iconography of the altarpiece, Beatson, Muller, and Steinhoff cite H. Van Os, *Sienese Altarpieces, 1215–1460: Form, Content, Function* (Groningen: Boumas Boekhuis, 1984).

15 Beatson, Muller, and Steinhoff 1986, p. 622. For discussion of the use of tooling by art historians, see Chapter 4.

16 For another example, see S. Fehm, "A Pair of Panels by the Master of Città de Castello and a Reconstruction of Their Original Altarpiece," *Yale University Art Gallery Bulletin* 31 (1967): 22–26. For further citations, see Beatson, Muller, and Steinhoff 1986, p. 622, n. 74.

17 For the close dimensions of the various altarpieces, see Beatson, Muller, and Steinhoff 1986, p. 625. For brevity's sake we do not discuss the predella panels in Frankfurt and Paris. These were linked to the altarpiece through art historical research supported by technical information concerning punch marks and pigments rather than panel supports.

Case Study 4

18 This study has been excerpted from Marcia Goldberg, "Textured Panels in Nineteenth-Century American Painting," *Journal of the American Institute for Conservation* 32 (1993): 33–42. While Goldberg attributes the texture of Stuart's portraits in the National Gallery of Art to their grounds (p. 36), it is actually the result of scoring in the panels. See the catalogue entries in Ellen G. Miles, *American Paintings of the Eighteenth Century*, Collections of the National Gallery of Art Systematic Catalogue (1995). The

Cleveland example was published by Christina Curry, whose study confirmed Goldberg's findings ("Nineteenth-Century Portraits on Scored Panels in the Cleveland Museum," *Journal of the American Institute for Conservation* 34 [Spring 1995]: 69–75).

19 Goldberg, "Textured Panels," abstract. Curry's example is Gilbert Stuart, *Horace Binney* (1800, National Gallery of Art, Washington, D.C.), p. 74.

Fabric Supports

20 *Vasari on Technique* 1960, p. 236. For a good illustration of transporting a large rolled canvas, see the removal and replacement of *The Night Watch* from the Rijksmuseum during World War II (*All the Paintings of the Rijksmuseum in Amsterdam: A Completely Illustrated Catalogue* [Amsterdam: Rijksmuseum and Gary Schwartz, 1976], figs. 51–52, pp. 40–41).

21 For an extremely clear discussion of the technical issues and limitations of X-ray studies of canvases, see *Corpus of Rembrandt Paintings*, vol. 1, pp. 17–18. Hendricks and Groen compare the problems in taking thread counts from direct examination versus X-ray studies in "Judith Leyster: A Technical Examination of Her Work," p. 112 n. 23 in Welu and Biesboer 1993.

22 This is discussed at length by van de Wetering, *Corpus of Rembrandt Paintings*, vol. 1, pp. 19–20 and n. 3. For two rare counterexamples of seventeenth-century painters who left evidence of conscious manipulation of the fabric texture, see Groen and Hendricks, with respect to Frans Hals' *Regentesses of the Old Men's Almshouses* (Frans Halsmuseum, Haarlem), n. 32, "Frans Hals: A Technical Examination," in Slive et al. 1989; and Carmen Garrido et al., who remark on several unlined paintings by Velázquez (*The Drunkards*, *Villa Medici*, and *Coronation of the Virgin*), in which the artist's technique is responsible for the effect of the weave seen on the surface of the painting (Carmen Garrido, Maria Theresa Dávila, and Rocia Dávila, "General Remarks on the Painting Technique of Velázquez: Restoration Carried Out at the Museo del Prado," p. 51, in *Conservation of the Iberian and Latin American Cultural Heritage*, edited by John S. Mills and Perry Smith, Preprints of the Contributions to the IIC Madrid Congress, September 9–12, 1992, H. W. M. Hodges, 1992).

23 *Corpus of Rembrandt Paintings*, vol. 1, p. 20.

Expedient Choice of Support

24 Kornhauser 1991, p. 86. Stephen H. Kornhauser is chief conservator at the Wadsworth Atheneum.

25 On Turner, see Townsend 1996, pp. 18–20, 21. For another example of a plywood support, this one purposely constructed for artists' use, see figs. 254, 255 and p. 243.

Expressive Use of Unusual Fabric

26 For *Nirvana: Portrait of Meyer de Hahn*, see Jirat-Wasiutynski and Newton 1999, chap. 7. Also see Christensen 1993.

Aging of Textiles and Their Treatment

27 The step-by-step procedure of relining is extraordinarily clear in the video *Rembrandt, Part 2: The Restoration of "The Night Watch"* (1993).

28 Records at the Louvre indicate that Titian's *Woman at Her Toilet* was enlarged and lined prior to 1695. For discussion of this painting and references to several well-documented eighteenth- and nineteenth-century linings, see Volle et al. 1993, pp. 71–80. The comment on the scarcity of unlined canvases is from Martin Wyld and David Thomas, "Wright of Derby's 'Mr. and Mrs. Coltman': An Unlined English Painting," *National Gallery Technical Bulletin* 10 (1986), p. 29. The unlined paintings are included in Appendix 2. The unlined Homers were cat. 3, *The Brierwood Pipe* (1864; Cleveland Museum of Art), and cat. 186, *A Summer Night* (1890; Musée d'Orsay) (Nicolai Cikovsky Jr. and Franklin Kelly, *Winslow Homer*, catalogue [Washington, D.C., and New Haven: National Gallery of Art and Yale University Press, 1995]). Information on their unlined state is courtesy of Jim Wright, head, paintings conservation, Museum of Fine Arts, Boston, in phone conversation (December 3, 1996). This was confirmed in conversation with Franklin Kelly, Department of American Art, National Gallery of Art (December 16, 1996). In all fairness, more Homers may have survived without linings, but it is precisely those unlined works that are rarely available for touring exhibitions.

29 Bomford et al. 1990, p. 99. Bomford is senior conservator at the National Gallery, London. For a technical study that pays particular attention to the artist's lining, see David Bomford and Ashok Roy, "Manet's 'The Waitress': An Investigation into Its Origin and Development," *National Gallery Technical Bulletin* 7 (1983): 3–19. Information on O'Keeffe was conveyed by Judy Walsh, paper conservator at the National Gallery of Art, Washington, D.C. (in conversation, November 11, 1998). Walsh acquired the information from Caroline K. Keck, the conservator with whom O'Keeffe worked. Keck had met O'Keeffe in 1946 and worked on many of her paintings under the artist's instructions. Correspondence in the O'Keeffe Foundation records their discussions about treatments. Keck confirmed this information in correspondence (December 2, 1998).

30 *Loose lining* involves the addition of a canvas that is not attached or adhered to the painting; it acts as a support behind the artist's canvas. Artists may use such strengthening canvases prophylactically, a process called double stretching. Turner is known to have employed the technique; see Joyce Townsend, "The Materials and Techniques of JMW Turner: Primings and Supports," *Studies in Conservation* 39, no. 3 (1994), p. 147.

Stretchers and Strainers

31 Some mid-twentieth-century artists have used strainers rather than stretchers for very large canvases. For a clear illustration of Mark Rothko's technique, see Carol Mancusi-Ungaro, "Material and Immaterial Surface: The Paintings of Rothko," in *Mark Rothko*, catalogue (Washington, D.C.: National Gallery of Art, 1998), 284–85. For two twentieth-century artists who paid close attention to the aesthetic implications of their stretchers, see Lanchner 1993 on Miró and Upright 1985 on Morris Louis.

Technical Examination of Fabric Supports

32 For more information on linings, including a useful chart chronicling the different lining and impregnation treatments used from the seventeenth century to the 1970s, see Percival-Prescott 1974. Lining adhesives have not changed substantially since his study. A more recent survey of the subject is Alan Phenix, "The Lining of Paintings: Traditions, Principles, and Developments," *Lining and Backing: The Support of Paintings, Paper and Textiles*, Papers delivered at the UKIC Conference, November 7–8, 1995, London, UKIC (1995), pp. 21–33.

33 In England the two best sources for business directories are the British Museum and the Guildhall Library in London. American business directories are available at the New York Public Library. American materials' suppliers have been surveyed in Katlan 1987 and Katlan and Falk 1992. For French suppliers see Bomford et al. 1990.

34 For a brief study that incorporates examination of the scalloping to confirm original dimensions, see Marie-Claude Corbeil et al., "'Leopards' in Montreal: An Attribution to Rubens Disproved," *Burlington Magazine* 134 (November 1992): 724.

Case Study 5

35 This has been adapted from Brown, Kelch, and Van Thiel 1991, pp. 94–96, 150–51; and *Corpus of Rembrandt Paintings*, vol. 2, A54, A55, pp. 206–18. Brown and his colleagues were curators at the National Gallery, London, the Gemäldegalerie, Berlin, and the Rijksmuseum, Amsterdam. The authors of the Rembrandt *Corpus* were a team of art historians.

36 *Corpus of Rembrandt Paintings*, vol. 2, pp. 15–30. For a short summary, see Brown, Kelch, and Van Thiel 1991, p. 94.

37 The Vienna *Woman* had been reduced by 7 cm since its description in an eighteenth-century sales catalogue. The original height thus matches that of the man in Kassel. Following this logic, the *Corpus* authors assume a horizontal reduction of the Vienna *Woman* by at least 10 cm (*Corpus of Rembrandt Paintings*, vol. 2, p. 213).

38 Brown, Kelch, and Van Thiel 1991, p. 96.

Case Study 6

39 This is taken from Slive et al. 1989, pp. 264–65, and Groen and Hendricks, "Frans Hals: A Technical Examination," in Slive et al. 1989, pp. 109–27.

40 On threadcounts and priming layers, see Groen and Hendricks, "Frans Hals," pp. 112, 116.

41 "Houbraken (1718–21; pp. 90–92) relates how when Van Dyck visited Hals' studio unrecognized, Hals 'took up the first canvas that came to hand' to paint his portrait. Although the visit is mostly apocryphal, it is worth noting" (Groen and Hendricks, "Frans Hals," n. 32).

Case Study 7

42 This study comes primarily from Brown and Roy 1992, which discusses technical questions at length; as well as Brown Kelch, and Van Thiel 1991, pp. 258–61, which discusses iconographical questions; and Martin Bailey, "Rembrandt's 'Alexander the Great': A Salutary Warning," *Apollo* 136 (July 1992): 35–36, which discusses a history of proposed restorations. Information on Ruffo and his appreciation of Rembrandt is drawn from Seymour Slive, *Rembrandt and His Critics: 1630–1730* (The Hague: Martinus Nijhoff, 1953), pp. 59–64; and Francis Haskell, *Patrons and Painters: A Study in the Relations Between Italian Art and Society in the Age of the Baroque* (New York: Knopf, 1963), pp. 209–10.

43 Bailey, "Rembrandt's 'Alexander the Great,'" p. 36.

44 Because of the different primings, the peripheral strips responded differently to X-rays. This does *not* prove that they were later additions but simply that the primings have different radio-absorbent properties (Brown and Roy 1992, pp. 290–93). For a discussion of glazes and scumbles and of paint cross-sections, see Chapter 4. On the paint layering of the *Alexander*, see Brown and Roy 1992, p. 295.

45 *Corpus of Rembrandt Paintings*, vol. 2, p. 41.

46 Brown and Roy 1992, p. 297.

Case Study 8

47 The Art Institute of Chicago exhibits the fragment alongside *Mother and Child*, with a wall label explaining the relationship. For further details we are indebted to the staff of the Art Institute, Department of Twentieth-Century Painting and Sculpture, especially Daniel Schulman.

Case Study 9

48 This example is drawn from Jean Sutherland Boggs et al., *Degas*, catalogue (New York and Ottawa: Metropolitan Museum of Art and National Gallery of Canada, 1988), pp. 140–42.

Case Study 10

49 This account is taken from Bareau 1986, pp. 48–52, and Martin Davies, *French School: Early Nineteenth Century, Impressionists, Post-Impressionists, Etc.*, National Gallery Catalogues (London: National Gallery, 1970), pp. 95–98.

50 The early photograph of the painting is in the Bibliothéque Nationale, Cabinet des Estampes, Paris (fig. 60 in Bareau 1986). Vollard's account is cited in Davies, *French School*, n. 17. The National Gallery separated the four fragments and exhibited them independently for many years before reuniting them (Davies, p. 97).

Stone and Metal: The Support as *Paragone*

51 Michael Hirst, *Sebastiano del Piombo* (Oxford: Oxford University Press, 1981), pp. 124–26. See his n. 11 for sixteenth-century sources on the problems of stone supports.

52 Edgar Peters Bowron, "'Full of Details and Very Subtly and Carefully Executed': Oil Paintings on Copper Around 1600," catalogue of the International Fine Art Fair, New York, May 1995, p. 9. A revised version of Bowron's article is included in *Copper as Canvas* 1999.

53 The best introduction to Stubbs' enamels on copper and ceramics is Tattersall 1974. Basil Taylor situates the enamels within Stubbs' career (*Stubbs* [London: Phaidon, 1971], pp. 15–17). Taylor's comment is on p. 15.

54 The series of twelve small copper plates and Masonite panels on which Miró worked alternately are illustrated in color as cats. 130–39 in Lanchner 1993; their technique is described on pp. 65–66. They are catalogued as nos. 420–30 in Jacques Dupin, *Miró* (New York: Harry N. Abrams, 1961). For discussion of the imagery, style, and technique of Mexican devotional painting see Giffords 1992.

Artists' Board and Paper Laid to Canvas or Panel

55 On artists' boards, see Gettens and Stout 1966, p. 221.

56 The taste for paper on canvas supports among British nineteenth-century painters is discussed by conservators Angela Geary and Piers Townsend in "The Structural Conservation and Restoration of a Nineteenth-Century Painting on a Paper/Canvas Composite Support," in *Lining and Backing*,

pp. 92–95. On Lam's supports, the curator Catherine David states, "In Havana Lam worked on large gouaches on paper, which are as much studies for the paintings as they are finished works—though the term 'paintings' constitutes an abuse or trick of language here, because a great number of his major post-1942 paintings, such as 'The Jungle,' are, in fact works on paper mounted later on canvas, a material difficult to find at this time in Cuba" ("The Invention of the New World: Drawings, 1914–1942," p. 45, in *Wifredo Lam: A Retrospective of Works on Paper*, catalogue [New York: Americas Society, 1992]). While David is unusual in emphasizing their paper support (indeed, the exhibition was rare in presenting them in the context of drawings), we disagree that these works are other than paintings. While Lam made frequent use of both paper and canvas supports for his early paintings and produced a number of large paintings on paper when working in Havana during 1942–43, most of the large paintings after then were done on canvas (Lou Laurin-Lam, *Wifredo Lam: Catalogue Raisonné of the Painted Work*, vol. 1: *1923–1960* [Lausanne: Sylvio Acatos, 1996]). Both the New York and Chicago versions of *The Jungle* are on paper laid to canvas. Correspondence in the Art Institute's files records that theirs was mounted to canvas by its initial owner, in consultation with the artist. MoMA's records do not indicate when the paper was affixed to canvas.

Chapter 3: The Ground and Preparatory Layers

The Physical and Aesthetic Function of Grounds and Their Composition

1 This is clearly discussed and illustrated in Dunkerton et al. 1991, p. 163. For discussion of paintings on canvas that were originally panels with a canvas surface, see *Princeton Raphael Symposium* 1990, pp. 11–13.

2 Red bole is preferred when used as the layer beneath gilding.

3 Phillip Hendy and A. S. Lucas mention a type of paint craquelure, which results from a faulty ground—usually one that is too greasy, so that the paint does not adhere properly as it dries. This problem is characteristic of Reynolds and his English contemporaries ("The Ground in Pictures," *Museum* 21, no. 4 [1968], p. 276).

4 Percival-Prescott 1974 gives a history of impregnation going back to the seventeenth century.

Examination of Grounds

5 See *Corpus of Rembrandt Paintings* 1986, p. 25, and Slive et al. 1989, p. 116.

Colored Grounds

6 For an illustration of a brown ground visible at the edge of Vermeer's *View of Delft*, see Jørgen Wadum et al., *Vermeer Illuminated: A Report on the Restoration of the "View of Delft" and "The Girl with a Pearl Earring" by Johannes Vermeer* (Wormer and The Hague: V & K Publishing/Inmerc and Mauritshuis, 1994), p. 9, pl. 12. The Botticelli is discussed in Baldini et al. 1986. The Metropolitan Museum of Art owns a pair of Tiepolo oil sketches on differing grounds: *Apotheosis of the Spanish Monarchy* is on an ochre ground, and its companion, *Chariot of Aurora*, has a darker, cinnamon ground; both grounds are visible at the corners of the roundels. Keith Christiansen, who directed us to these examples, has published another interesting pair of paintings on differing grounds: Pompeo Batoni pendants in the Liechtenstein collection: *Hercules at the Crossroads* and *Venus Presenting Aeneas with Armor Forged by Vulcan*, both 1748, cats. 144 and 145 in *Liechtenstein: The Princely Collections*, catalogue (New York: Metropolitan Museum of Art, 1986).

Case Study 11

7 This case is drawn from Welu and Biesboer 1993, pp. 344–49, and Hendricks and Groen's article in the same catalogue, pp. 93–113. James Welu, director of the Worcester Art Museum, curated the exhibition with Pieter Biesboer, curator at the Frans Halsmuseum. Ella Hendricks is head of paintings conservation at the Halsmuseum, and Karin Groen is a conservation scientist, now at the Netherlands Institute for Cultural Heritage, Amsterdam.

8 On Rembrandt grounds, see *Corpus of Rembrandt Paintings* 1986, p. 42. During the following decade Rembrandt used a third type of ground: a single layer containing silica sand, tinted brown (Bomford, Brown, and Roy 1988, pp. 27–30). On Hals, see Groen and Hendricks in Slive et al. 1989, pp. 114–16, 124–25. Hals occasionally used gray or brown grounds.

9 Hendricks and Groen in Slive et al. 1989, pp. 100–101.

Textured Grounds

10 Jennifer Fletcher and David Skipsey give an example of palmprints visible throughout the surface of *The Assassination of St. Peter Martyr*, attributed to Giovanni Bellini in "Death in Venice: Giovanni Bellini and the Assassination of St. Peter Martyr," *Apollo* (January 1991): 4–8.

11 Charles Robertson and Co. of London (*Completing the Picture* 1982, pp. 65–68).

Case Study 12

12 This study is adapted from Elizabeth Steele and Susana M. Halpine, "Precision and Spontaneity: Jacob Lawrence's Materials and Techniques," pp. 155–60 in *Jacob Lawrence* 1993. Steele is paintings conservator at the Phillips Collection, and Halpine was biochemist in the Scientific Research Department of the National Gallery of Art, Washington, D.C.

13 Steele and Halpine interviewed Lawrence, who said he owned Max Doerner's *Materials of the Artist and Their Use in Painting* (English ed. 1934) as well as Ralph Mayer's *Artist's Handbook of Materials and Techniques* of 1940 (which postdates his use of tempera), but that his gesso recipe probably came from a colleague (n. 8). According to Ellen Harkins Wheat in *Jacob Lawrence: American Painter*, catalogue (Seattle: Seattle Art Museum, 1986), Lawrence learned of casein tempera from Romare Bearden before working on his earlier *Frederick Douglass* series. It may have been Bearden who suggested the particular gesso ground. For further information on the transmission of tempera technique, see Chapter 4.

14 For Lawrence's interest in the Mexican muralists, see Wheat, *Jacob Lawrence*, pp. 41, 46–47, 62. For information on the revival of fresco by Orozco, Rivera, and Siqueiros, see Laurance P. Hurlburt, *The Mexican Muralists in the United States* (Albuquerque: University of New Mexico Press, 1989). Lawrence's remarks are from Steele and Halpine, "Precision and Spontaneity," p. 156. Reinhold Heller suggests that an interest in material effect, including matte grounds, distinguishes symbolist painting ("Concerning Symbolism and the Structure of Surface," *Art Journal* 45 [Summer 1985]: 146–53).

Absorbent Grounds

15 The controversy over varnish has continued to the present. We discuss this at some length in Chapter 5.

16 Callen 1994, p. 741.

17 Christensen 1993, p. 71. Denis (*Nouvelles Théories*, 1922) is cited by Reinhold Heller, "Concerning Symbolism," p. 148 and n. 30. Mary Cassatt's letter to her brother, Alexander (22 June 1883), is cited by Fronia E. Wissman, "Realists Among the Impressionists," p. 350, in *The New Painting: Impressionism, 1874–1886*, catalogue (Geneva: Richard Burton, 1986). On Munch, see Thurmann-Moe 1995.

Painting on Raw Canvas

18 See Jirat-Wasiutynski and Newton 1999, chap. 7, for *Nirvana, Portrait of Meyer de Hahn*, and chap. 5 for *Self-Portrait, Les Misérables*. For Munch's use of unprimed canvas, see Thurmann-Moe 1995.

Ground Incising

19 Maryan Ainsworth, "Hans Memling as a Draughtsman," *Memling Studies*, Proceedings of the International Colloquium, Bruges, edited by Hélène Verougstraete, Roger van Schoute, and Maurits Smeyers, November 10–12, 1994 (Leuven: Uitgeverij Peeters, 1997), p. 87. Ainsworth is an art historian in the Paintings Conservation Department of the Metropolitan Museum of Art. Ella Hendricks and Karin

Groen describe incised perspective lines in Judith Leyster's *Man Offering Money to a Young Woman* (in Welu and Biesboer 1993, p. 101).

Case Study 13

20 This study is drawn from Jørgen Wadum, "Vermeer in Perspective," pp. 67–79 in *Johannes Vermeer* 1995. Arthur K. Wheelock Jr. directed us to the Dublin painting. Andrew O'Connor and Elline von Manshow were very helpful in obtaining photographs.

21 For discussion of Vermeer and the camera obscura, see Wheelock 1995, pp. 17–19 and n. 37, which cites more detailed literature, and the same author's contribution to *Johannes Vermeer* 1995, p. 25. Wadum's quote is from *Johannes Vermeer* 1995, pp. 67–68. Wadum lists all the paintings in which holes were found at the vanishing point in his n. 5. Evidence of similar pinholes indicates that the same technique was employed by seventeenth-century Dutch painters of architectural views (Jeroen Giltaij and Guido Jansen, *Perspectives: Sanredam and the Architectural Painters of the Seventeenth Century*, catalogue [Rotterdam: Boymans-van-Beuningen Museum, 1991], p. 15).

Case Study 14

22 This is taken from Kemp and Massing et al., 1991. Martin Kemp is professor of fine art, University of Oxford. His collaborators were conservators and conservation scientists from the Hamilton Kerr Institute, University of Cambridge.

23 *Lives of the Artists*, English translation by Gaston Du C. De Vere (London: Philip Lee Warner, 1912–14), vol. 2, p. 140.

24 Kemp and Massing 1991, p. 164. F. Sindona, "Introduzione alla poetica di Paolo Uccello. Relazioni tra prospettiva e pensiero teoretico," *L'Arte* 17 (1972): 97–100.

25 Kemp and Massing 1991, pp. 172–73, 175. The technique of infrared reflectography is discussed in Chapter 4.

Case Study 15

26 This study is taken from Christiansen 1986 and *Michelangelo Merisi da Caravaggio* 1991, pp. 226–37. While the latter reproduces alternate schemes of incisions by Thomas Schneider and Roberta Lapucci as well as Christiansen's for *The Sacrifice of Isaac* (which we use in illustration), it accepts his interpretation of the role of incisions in Caravaggio's working practice. Thomas M. Schneider's interpretation also accords with Christiansen's ("La 'maniera' e il processo pittorico del Caravaggio," *L'Ultimo Caravaggio e la cultura artistica a Napoli in Sicilia e a Malta*, atti del covegno, April 1985 [Siracusa: Ediprint, 1991], pp. 117–38). Christiansen is the Jayne Wrightsman Curator of European Paintings, Metropolitan Museum of Art.

27 Christiansen 1986, p. 426.

28 Christiansen 1986, p. 430. The X-rays did not reveal incisions; rather they revealed *pentimenti*. This is pertinent to the argument, since Christiansen proposes that Caravaggio adjusted the figures as he worked, resulting in changes visible both at the drawing (incision) stage, and at the painting stage (*pentimenti*).

Chapter 4: The Paint Layer

Pigments

1 For dyes to function as pigments they have to be deposited onto an inert (nonchemically reactive) base; the chemical term for the process is *adsorption*.

2 See Callen 1982, pp. 22–25, for a valuable discussion of the influence of mechanical grinding of pigments and other technological developments on the texture of paint used by the impressionists.

3 David Bjelajac, *Washington Allston, Secret Societies, and the Alchemy of Anglo-American Painting* (Cambridge: Cambridge University Press, 1997), especially chap. 2. *Sigmar Polke* 1990. On Seurat's *Grande Jatte*, see Fiedler 1989; Fiedler is conservation scientist at the Art Institute of Chicago.

Examination of the Paint Layer by Cross-Sections and Destructive Sampling

4 Roy's comments were delivered in his Forbes Prize Lecture at the Dublin Congress ("Painting Techniques: History, Materials, and Studio Practice") of the International Institute for Conservation of Historic and Artistic Works, September 7, 1998 (to be published in modified form in the Bulletin of the IIC). Roy also included useful cautions about sampling. For detailed discussion of pigment identification and use, see *Artists' Pigments* 1986. The introduction to vol. 1, pp. 11–13, gives a clear protocol and summarizes the methodology of pigment examination, including microchemical tests, X-ray diffraction analysis, various types of spectrophotometry, neutron activation, etc.

Case Study 16

5 Information on pigment analysis in this case is drawn from John M. Brealey and Pieter Meyers, "Letter: 'The Fortune-Teller' by Georges de La Tour," *Burlington Magazine* 123 (July 1981): 422, 425. The article is illustrated with an X-ray study of the painting.

6 Christopher Wright and Diana de Marly, "FAKE?" *Connoisseur* 205 (September 1980): 22–25.

7 Wright and de Marly, "FAKE?" p. 23. Wright reviewed the case in *The Art of the Forger* (New York: Dodd, Mead, 1985); photographic details of the *merde* inscription are on pp. 67 and 79.

8 Brealey and Meyers, "Letter," p. 422.

9 Brealey and Meyers, "Letter," p. 425. La Tour is one of a handful of painters whose oeuvres have been systematically studied and published. See *Georges de La Tour* 1993, and Conisbee et al. 1996; between them they include X-ray studies of a large number of La Tour's works as well as macrophotographs, paint analyses, and autoradiographic studies. For specific technical information on *The Fortune-Teller*, see *Georges de La Tour* 1993, pp. 116–17, and Melanie Gifford et al., "Some Observations on Georges de La Tour's Painting Practice," pp. 246–47 in Conisbee et al. 1996, which compares the paint handling of *The Fortune-Teller* with that in other paintings.

Binding Media

10 The existing literature on fresco is unusually complete on technique. A useful introduction is given in *Great Age of Fresco: Giotto to Pontormo*, catalogue (New York: Metropolitan Museum of Art, 1968). Laurance P. Hurlburt discusses a twentieth-century fresco revival in *The Mexican Muralists in the United States* (Albuquerque: University of New Mexico Press, 1989). See chapter on Siqueiros and appendix A. Manuscript illumination is another form of medieval painting that we do not address; for a clear and accessible introduction, see Christopher de Hamel, *Scribes and Illuminators: Medieval Craftsmen* (Toronto: University of Toronto Press, 1992). On the problems of medium analysis, Andrea Rothe explains: "The principal reason for the lack of more information has been the difficulty in analytically distinguishing egg from glue, as both are complex proteins. The analytical results can also be unreliable because infusions of glues from later relinings and consolidants make it difficult to determine whether they are part of the original medium" ("Andrea Mantegna's 'Adoration of the Magi,'" in *Historical Painting Techniques, Materials, and Studio Practice*, Preprints of a Symposium, University of Leiden, June 26–29, 1995 [Los Angeles: Getty Conservation Institute, 1996], p. 111).

11 For pigment-by-pigment mixed media, see van Eikema Hommes 1998, pp. 93–94. For examples of a mixed binding medium throughout, see Barry in *Thomas Eakins and the Swimming Picture* 1996; Carlyle and Southall in Hamlyn 1993, on British eighteenth- and nineteenth-century painting; Mosby and Sewell 1991, on Henry Ossawa Tanner; Stoner 1990, on Washington Allston; Talley in *Reynolds* 1986, on Joshua Reynolds; Shepherd in *George Stubbs: 1724–1806* 1984; and Townsend 1993, on Turner. For twentieth-century artists who used differing media in various layers, see Miller 1987 on Otto Dix and Lunde 1975 on Isabel Bishop.

Egg Tempera

12 To be absolutely correct, the first drying phase—the evaporation of the aqueous part of the egg—occurs quickly and affects the handling properties of the paint. Egg tempera has a second, gradual drying phase in which the oily components polymerize and form a hard film.

13 Del Serra 1985, pp. 4–8, provides a clear and detailed discussion of tempera technique with emphasis on the handling properties of the medium. He traces the gradual transition to an oil medium, driven by the demand for a paint that handles differently, and includes very useful black and white illustrations, mostly in detail. Dunkerton et al. 1991, pp. 188–92, also includes a useful discussion of the conventions of tempera technique, illustrated with color plates, including the means of creating color gradation, the handling of shadows, and the tendency toward single layers rather than successive glazes. Thompson 1933, chap. 1, is also very clear about tempera's handling properties and its appeal to artists.

Size (Distemper) and Other Temperas

14 *Lives of the Artists* (London: Medici Society, 1912–14). Translation by Gaston Du C. De Vere, vol. 6, p. 165. The description, which is found in the life of Giulio Romano, was brought to our attention by Andrew Morrogh. While this self-portrait cannot be identified (it is listed as 117V in Fedja Anzelewsky, *Albrecht Dürer: Das Malerische Werk* [Berlin: Deutscher Verlag für Kunstwissenschaft, 1991]), Dürer left other examples of work in distemper, including portrait heads in the Uffizi, the Louvre, and the Bibliothéque National, Paris. We thank Marco Ciatti, who confirmed the sixteenth-century usage of *guazzo* and supplied the modern term.

Drying Oils

15 While the Van Eycks did not *invent* oil painting, there is increasing evidence that their methods of handling it were significantly innovative. See Pim Brinkman, *Het geheim van Eyck: Aantekeningen bij de uitvinding van het olieverven* (Zwolle: Uitgevers Waanders, 1993). Gettens and Stout 1966 says that Aetius describes an oil varnish used by gilders and encaustic painters (p. 42). Instructions for variation in binder according to the requirements of the pigment are documented by van Eikema Hommes 1998. Botticelli's *Primavera* is analyzed by Baldini et al. 1986, p. 49. On Rembrandt, see van de Wetering 1997, chap. 9. On the very gradual transition from tempera to oil binders, see Del Serra 1985, pp. 7–8. When asked how to distinguish between sixteenth-century paintings bound in tempera and oil, Del Serra answers: "I repeat that I don't believe that true oil painting existed at that time—not even among the Venetians" (p. 8). Dunkerton illustrates an interesting comparison in which part of a figure is worked in oil and another part in tempera in Domenicho Ghirlandaio and Workshop's *Virgin and Child in Glory with Saints*, completed in 1496 (Munich, Alte Pinakothek) in *Making and Meaning: The Young Michelangelo*, figs. 101–3.

16 The most accessible source on the history, composition, and properties of various drying oils is Gettens and Stout 1966, pp. 3–88. One measure of the rate at which oil dries is the common practice of artists to wait one to three years for the paint to dry sufficiently before applying a final varnish. This will be discussed further in Chapter 5.

Paint Handling

17 Sohm's work is *Pittoresco: Marco Boschini, His Critics, and Their Critiques of Painterly Brushwork in Seventeenth-and Eighteenth-Century Italy* (Cambridge: Cambridge University Press, 1991). For the influence of Italian theory on Spanish theory and practice, see McKim-Smith, Bergdoll, and Newman 1988, pp. 15–27 for *borrones*, pp. 13–15 for *pentimenti*. Van de Wetering's remarks on Rembrandt are in Brown, Kelch, and van Thiel 1991, pp. 21–22.

18 For a useful discussion of the later two effects, see *Picasso: The Early Years, 1892–1906* 1997, pp. 299–309.

Beyond the Brush: Experimental Paint Application

19 Christopher B. Campbell, "Pissarro and the Palette Knife: Two Pictures from 1867," *Apollo* 136 (November 1992): 312–14, includes an interesting history of French palette-knife use. Lawrence Gowing, "The Logic of Organized Sensations," in *Cézanne: The Late Work*, edited by William Rubin, catalogue (New York and Boston: Museum of Modern Art and New York Graphic Society, 1977), p. 56. On the Osny landscape, see also *Impressionist and Post-Impressionist Masterpieces* 1987, cat. 21 (unpaginated), and Françoise Cachin et al., *Cézanne*, catalogue (Philadelphia: Philadelphia Museum of Art, 1996), cat. 4, p. 84, especially n. 1. Campbell, "Pissarro and the Palette Knife," p. 312, cites and translates Guillemet in correspondence with Francisco Oller, March 12, 1866.

20 See Margrit Franziska Brehm, "On the Simultaneity of Difference and the Variety of Sameness: The Evolution of Chuck Close' Work," pp. 62–100 in Poetter and Friedel 1994.

21 Carel van Mander, *Dutch and Flemish Painters: Translation from the Schilderboeck*, 2nd ed. (1618) translated by Constant van der Wall (New York: McFarlane, Warde, McFarlane, 1936), pp. 340–42, 343. Wolfgang Stechow, "'Sonder Borstel oft-Pinseel,'" in *Album Amicorum J. G. van Gelder* (The Hague: Maartinus Nijhoff, 1973). Edited by J. Bruyn et al., pp. 310–11. Stechow illustrates two paintings (in private collections) that he believes to be examples of Ketel's brushless painting, including the crying philosopher mentioned by van Mander, as well as the da Carpi altarpiece. Rudolf Ekkart suggests that Ketel had gout in *Dictionary of Art* (London: Macmillan, 1996), vol. 17., pp. 923–24. We greatly thank Melanie Gifford for bringing the Stechow article to our attention.

Case Study 17

22 This study is adapted from Brachert 1970, who based his conclusions on radiographic examination and included a number of enlarged radiograph details. When he wrote the article Brachert was director of the technology department of the Schweizerisches Institut für Kunstwissenschaft, Zürich. The National Gallery of Art, Washington, D.C., which now owns the panel, has only visible light studies in its files. For a recent study of Leonardo's early work, which includes discussion of technique and illustrations of numerous color details, radiographs, and infrared reflectograms, see David Alan Brown, *Leonardo da Vinci: Origins of a Genius* (New Haven: Yale University Press, 1998).

23 Brachert 1970, p. 93.

24 Brachert 1970, pp. 88, 94. Brachert consulted a forensic investigator who was unable to tell from the fingerprints whether they had been made with the right or left hand; nor were they suitable for fingerprint identification (n. 1).

25 Roy Lichtenstein interviewed by Gene Swenson, "What Is Pop Art?" *ARTNews* 62 (November 1963), p. 25. Pollock writing in "My Painting," *Possibilities* 1 (Winter 1947–48): 79.

26 Herbert 1979. John House, *Monet: Nature into Art* (New Haven: Yale University Press, 1986), pp. 92–96, addresses Herbert's analysis of Monet's brushwork at length and differs on a number of specifics. House details his argument, based on microscopic examination of three paintings that Herbert also studied, in chap. 5, n. 30. House summarizes: "This does not invalidate the general conclusion that Monet's technique was utterly deliberate and his pictures were often the results of many successive stages of elaboration; the freshness and spontaneity of his initial encounter with nature had, in his most highly finished paintings, to be recreated in complex acts of pictorial manipulation" (p. 96). Van de Wetering's description of Rembrandt's texture is from his 1997 monograph, p. 220. Christiansen 1993, pp. 79–80.

27 This example is drawn from Leonard and Lippincott 1995.

Case Study 18

28 This has been adapted from Michael Lloyd and Michael Desmond, *European and American Paintings and Sculptures: 1870–1970 in the National Gallery* (Canberra: Australian National Gallery, 1992), pp. 8–12, 236–45. While the discussion of Pollock's technique is given the most detailed attention, the catalogue includes technical discussion of works by Monet, Vuillard, Malevich, Arakawa, Mangold, Olitiski, Novros, and James Bishop. For recent important work on Pollock's technique, particularly his working sequence, see Karmel's article in Varnedoe with Karmel 1998.

29 The *New York Magazine* story is Stanley P. Friedman, "Loopholes in 'Blue Poles,'" 6 (October 29, 1973): 48–51. The headline was cited by Lloyd and Desmond, *European and American Paintings and Sculptures*, p. 8.

30 Lloyd and Desmond, *European and American Paintings and Sculptures*, pp. 242–43, 241.

Ideological Concerns Behind Modernist Paint Experiments

31 Seckler 1952 raises issues similar to our "idea of the medium." The author situates experimental paint media within the tradition of collage and discusses artists who experimented with traditional media (tempera and encaustic) as well as modern ones. Picasso's *Landscape with Posters* (National Museum of Art, Osaka) is illustrated in Kirk Varnedoe and Adam Gopnik, *High and Low: Modern Art and Popular Culture*, catalogue (New York: Museum of Modern Art, 1990), fig. 44. Picasso also used commercial enamel for the bottle label in *Nature morte espagnole ou Sol y Sombra* (1912), oil and enamel on canvas, Musée d'art moderne de Lille Métropole, Villeneuve d'Ascq.

32 On the ideological basis of Siqueiros' technical experiments, see Harten 1995 and Seckler 1952, p. 68, as well as Laurance P. Hurlburt, *The Mexican Muralists in the United States* (Albuquerque: University of New Mexico Press, 1989). Siqueiros' experiments with media are also discussed in Lodge 1988, p. 119.

Acrylics and Other Synthetic Media

33 Lodge 1988 gives a detailed history of artists' early experiments with commercial synthetic paints as well as of the development of synthetic paints specifically for the fine arts. Our very brief summary relies on his article. Seckler 1952 tells part of the story from the contemporary perspective. Bearor 1993 explores the contributions of federal programs in the thirties to the development of newer and better painting materials for mural commissions (pp. 95–98). Two other short but accessible discussions of modern paints that mention their specific handling properties are Roy Perry and Stephen Hackney, "The Aging of Modern Painting Materials: A Survey of Conservation Problems—and Some Approaches," *Apollo* 136 (July 1992): 30–34, and Sandra Webster-Cook, "A Short History of Pyroxylin-Based Artists' Paints," in *The Artists' Mecca: Canadian Art and Mexico*, catalogue (Toronto: Art Gallery of Ontario, 1992), pp. 49–52.

Textural Paint Additives

34 Harten 1996, pp. 178–81. For the influence of Native American art on Pollock, see W. Jackson Rushing, *Native American Art and the New York Avant-Garde: A History of Cultural Primitivism* (Austin: University of Texas Press, 1995).

Aging Effects of the Paint Layer

35 This is also true for those few paintings that, because of their materials, never thoroughly dry.

Craquelure

36 See Spike Bucklow, "The Description of Craquelure Patterns," *Studies in Conservation* 42 (1997): 129–40. This extremely useful article develops a systematic vocabulary to describe craquelure, and based on a large survey, describes and illustrates the characteristic craquelure of fifteenth-century Italian and Flemish panels, seventeenth-century Dutch canvases, and eighteenth-century French canvases.

37 On craquelure, see Bucklow, "Description of Craquelure." For visible effects of a transfer, see chap. 2, n. 4.

38 Craquelure must usually be studied in front of the paintings themselves. A rare exception is offered by the illustrations in House, *Monet*; not only do they reveal details of impasto, but they often show aging effects. Crackle from the stretcher and its cross bars is evident in pl. 201; drying cracks are visible in the details of pl. 127 (pp. 88–89) and pl. 134 (p. 99). For an illustration of a canvas distorted by the weight of the heavily impasted paint in one of Richard Pousette-Dart's works, see Hobbs and Kuebler 1990, p. 169.

39 Picasso's *Guernica* was rolled for transport up to one hundred times within its first several decades, resulting in extensive cracking that makes its future travel uncertain. The painting's condition is documented in great detail in *Estudio Sobre el Estado de Conservación del "Guernica" de Picasso* (Madrid: Museo Nacional Centro de Arte Reina Sofia, 1998). For illustrations of the cracks from rolling, see especially pp. 79, 97–100. We are grateful to Will Shank, who referred us to this publication.

40 For articles on problems with bitumen and megilp, see sources on mixed medium in n. 11, above. Carlyle and Southall (in Hamlyn 1993) compare the effects of natural and artificial asphaltum.

Increasing Transparency

41 Thomas B. Brill gives a clear and detailed explanation that necessarily includes scientific terminology; see *Light: Its Interaction with Art and Antiques* (New York: Plenum, 1980), especially pp. 89–90. Robert Feller, in a less technical article, describes increasing transparency of the medium as one of several reasons for color change in paintings. Other reasons include "yellowing of the varnish and medium, changes in the surface of the varnish, uneven varnish, change in lighting and changes to the pigments" ("Color Change in Oil Paintings," *Carnegie Magazine* [October 1954], 276–79).

42 "Jan van Goyen en de techniek van het naturalistische landschap," pp. 70–79 (English summary p. 83) in Christine Vogelaar et al., *Jan van Goyen*, catalogue (Zwolle and Leiden: Waanders Uitgevers and Stedelijk Museum De

Lakenthal, 1996). Gifford is research conservator for painting technology at the National Gallery of Art, Washington, D.C., and holds a Ph.D. in art history. We are grateful to the author for providing her English manuscript.

43 Leslie Carlyle, art historian at the Canadian Conservation Institute, inserts this caveat on the term "sinking": "In nineteenth-century texts, 'sinking' refers to when the color dries dull and loses medium at the surface; it is the very opposite of a gain in transparency. . . . I have run across contemporary artists using the term this way as well" (in correspondence, March 1997).

Fugitive Pigments and Color Changes

44 Van Eikema Hommes 1998 cites various artists' solutions to handling such changeable colors.

45 We wish to thank Barbara Berrie of the Scientific Department of the National Gallery of Art, who generously shared her research on pigments and suggested examples from the Gallery. Gerry Hedley and Caroline Villiers describe a range of changes to vermillion and red lakes in two early Italian panels and cite art historical misinterpretations based on the changes ("Evaluating Colour Change: Intention, Interpretation, and Lighting," in Hedley 1993, pp. 145–48). Although it is hard to follow the argument with the modest illustrations, the discussion is applicable to a wide range of paintings.

46 Report of the commission appointed to inquire into the Present Position of the Royal Academy, 1863, as cited in Noel Heaton, "The Permanence of Artists' Materials," *Journal of the Royal Society of Arts* 80 (1932): 416.

47 See Jo Kirby and Raymond White, "The Identification of Red Lake Pigment Dyestuffs and a Discussion of Their Use," in *National Gallery Technical Bulletin* 17 (1996): 56–80. Campbell and Dunkerton 1996 distinguish the presence of two different lake pigments by comparing the fluorescence of cross-sections (p. 167; this example is discussed in Case Study 25). The size of the samples precluded further analysis. For a rare instance in which faded lakes were analyzed, see pp. 108–12 in *Cézanne to Van Gogh* 1999. Information on the Hopper comes from conservation files at the National Gallery of Art and from Gail Levin, citing Jo Hopper: "The trees that Jo described as 'bottle green' now look blue due to a deterioration of the yellow pigments in the area" (*Edward Hopper: A Catalogue Raisonné*, vol. 3 [New York: Whitney Museum of American Art and W. W. Norton, 1995], p. 264). For another example of Van Gogh's problems with fugitive pink lakes, see Paolo Cadorin, "Color Fading in Van Gogh and Gauguin," in *A Closer Look* 1991, pp. 12–19, which com-

pares paintings by Van Gogh and Gauguin with contemporary copies (all illustrated in color). The Van Gogh and Gauguin were painted with eosine lakes synthesized in the 1870s, which were fugitive; their copyists used pinks which have retained their color. Unfaded paint hidden by the frame rebate is clearly visible in the color reproduction of Giorgione's *Portrait of a Young Man in a Pink Padded Jacket* (Giustiani Portrait) (Jaynie Anderson, *Giorgione: The Painter of "Poetic Brevity"* [Paris: Flammarion, 1996; English ed., 1997], p. 296 and fig. 159). We have not illustrated one of the most striking examples of a fugitive red lake because, being watercolor on paper, it falls outside our self-imposed limits: Raphael's tapestry cartoon for *The Miraculous Draught of Fishes* (London, Royal Collection, on loan to the Victoria and Albert Museum). The red reflection of Christ's white robe makes sense only when one knows that the reflected image was painted with vermillion, which is stable, while the robe itself was painted with a madder lake. A recent technical study of the cartoons includes X-ray studies and transmitted light and infrared photographs, and the results of recent pigment identification: Sharon Fermor and Alan Derbyshire, "The Raphael Tapestry Cartoons Re-examined," *Burlington Magazine* 140, no. 1141 (April 1998): 236–50.

48 For color changes to black pigments, see Lucy Belloli, "The Effects of Time: Georgia O'Keeffe's 'Black Hollyhock, Blue Larkspur,'" *The Changing Image: Studies in Paintings Conservation*, special issue of *Metropolitan Museum of Art Bulletin* (October 1994): 38–43, which includes comparative color photographs of the Met's painting in altered condition and a contemporaneous and unchanged variant in a private collection. Changes to blacks have also been noted in paintings by Franz Kline and Frank Stella (Gaugh 1985 and B. Richardson 1976). Unfortunately, neither case has been analyzed technically nor recorded with comparative photographs. This leaves readers aware that there are problems but uncertain just how the paintings have changed. The Rothko example is drawn from *Mark Rothko's Harvard Murals* 1988. A recent discussion of Rothko's technique, which includes a bibliography, is Carol Mancusi-Ungaro, "Material and Immaterial Surface," in *Mark Rothko* (Washington, D.C.: National Gallery of Art, 1988), pp. 282–301.

49 According to the Department of Photographic Services of the Harvard University Art Museums, which supplied the transparencies used in this book, "any reproduction of the original state of these Rothko paintings can only approximate the original colors. Since all known original transparencies have been severely discolored, one can only rely on the color memory of people who actually saw the original state and attempt to match the color bars." This may explain any difference between the present reproduction (fig. 172) and that in *Mark Rothko's Harvard Murals* 1988.

Artists' Anticipation of Color Changes

50 The anecdotes about Reynolds come from Richard and Samuel Redgrave, *A Century of British Painters*, 2nd ed. (1890; reprint, London: Phaidon, 1947), p. 55. Helen Glanville studied a painting by Gainsborough, comparing contemporary criticism of it as "over-vermillioned"; she questioned whether the artist overcompensated with fugitive lakes or later toned down the painting ("Gainsborough as Artist or Artisan," in *A Nest of Nightingales*, catalogue [Dulwich: Dulwich Picture Gallery, 1988], pp. 15–29).

51 This is discussed by Stuckey 1983, p. 167, and was elaborated in conversation, June 26, 1996. Stuckey cites Bertall, Blanche, Vollard, and Dauberville, and compares the current colors in Manet's oils to his watercolors of the same subjects. Callen 1994, p. 740, cites Jean Renoir on his father's purposely painting his reds overly bright, knowing that the lake pigments would darken.

52 Information on the Bacon work is drawn from unpublished files in the Department of Conservation, the Museum of Modern Art, New York. For a clear discussion of Bacon's background as a painter and his technique in the 1940s, see Stephen Hackney's article on *Three Studies for Figures at the Base of a Crucifixion* in *Paint and Purpose* 1999, pp. 176–91.

Visible Effects of Prior Treatment

53 Volle et al. 1993, pp. 69–80, discusses a group of Titians at the Louvre with documented treatments (including linings) from the seventeenth century.

54 For Rembrandt's *Anatomy Lesson*, see Ben Broos and Jørgen Wadum, "Under the Scalpel Twenty-One Times: The Restoration of the Anatomy Lesson of Dr. Tulp," in *Rembrandt Under the Scalpel: The Anatomy Lesson of Dr. Nicolaes Tulp Dissected*, catalogue (The Hague and Amsterdam: Mauritshuis and Six Art Promotion, 1998), pp. 39–50. The treatment history of *The Night Watch* is addressed by Van Schendel and H. H. Mertens, as cited by van de Wetering 1997, p. 195 and n. 5. Treatment following the painting's vandalization in 1975 has also been well recorded: van de Wetering cites *Bulletin van het Rijksmuseum* 24 (1976): nn. 1, 2. For a film document of the most recent treatment, see *Rembrandt, Part 2: The Restoration of "The Night Watch"* 1993. The Eakins treatments are documented in *Thomas Eakins and the Swimming Picture* 1996, pp. 106–9.

55 Cited and translated in *The Glory of Byzantium: Art and Culture of the Middle Byzantine Era, A.D. 843–1261*, catalogue, edited by Helen C. Evans and William D. Wixom (New York: Metropolitan Museum of Art, 1997), p. 122. Julius Held illustrates a range of modernized and "improved" paintings as well as victims of crime in "Alteration and Mutilation of Works of Art," *South Atlantic Quarterly* 62 (1963): 1–28. For a monograph that addresses many works repainted for iconographical reasons, see Leo Steinberg, *The Sexuality of Christ in Renaissance Art and in Modern Oblivion*, 2nd ed. (Chicago: University of Chicago Press, 1996), pp. 259–60 and passim.

56 For the visible effects of a transfer, see Chapter 2, n. 4.

Visible Light

57 We must insert a cautionary note: when attempting close study of paintings on museum walls, viewers must learn not to point; they must keep their hands behind their backs and assume a nonthreatening posture. The security staff is often alarmed by such close attention to the paintings. The authors were almost thrown out of the Metropolitan Museum of Art when viewing Velázquez' *Juan de Pareja* with an intensity that upset the guards.

Beyond Visible Light

58 Hoenigswald 1982, p. 29. For an art historical discussion, see Hans Belting, "The 'Byzantine Madonnas': New Facts About Their Italian Origin and Some Observations on Duccio," which precedes Hoenigswald in *Studies in the History of Art* 12 (1982): 7–22.

59 Alan Burroughs, *Art Criticism from a Laboratory* (1938; reprint, Westport, Conn.: Greenwood Press, 1965). The best overview of the history of radiographic examination of paintings and of current techniques is van Schoute and Verougstraete-Marcq 1986, which includes an excellent bibliography.

60 Jill Dunkerton and Ashok Roy used paint sampling to help interpret otherwise unclear X-ray studies which revealed significant changes to a portrait; they discovered not one, but two earlier figures hidden beneath the final version ("Interpretation of the X-ray of du Jardin's 'Portrait of a Young Man,'" *National Gallery Technical Bulletin* 6 [1982]: 19–25). Their argument is methodical and very clear. Note that the paint samples are reproduced in color (p. 25), which is necessary to follow the analysis.

61 Van Asperen de Boer et al. 1990, p. 10. For changes of style within the underdrawing of a Virgin and Child panel in Frankfurt, see pp. 11–12, for the Beaune Polyptych, p. 27, and for the Columba Altarpiece, pp. 29–30. Molly Faries has also documented multiple hands within a single underdrawing ("Technical Investigation of Some Panels in the Master of the Holy Kinship Group: A Progress Report," *Le dessin sous-jacent dans la peinture*, Colloque VI [September 12–14, 1985], Louvain-la-neuve: College Erasme [1987]: 63–69+). Regarding Rogier van der Weyden's Philadelphia diptych and *Crucifixion* at El Escorial, van Asperen de Boer finds "no direct link in the underdrawing between the two 'authenti-

cated' paintings that would permit their 'rapprochement'" (p. 24). Burton Fredericksen in *Princeton Raphael Symposium* 1990, p. 102.

The Uses of Radiographic Studies

62 Gould 1970. This article clearly outlines the problems of variants. More detailed technical information on London's *Julius II* is included in the entry in Gould's collection catalogue, *The Sixteenth-Century Italian Schools* (1975; reprint, London: National Gallery, 1987), pp. 208–10. Gould was curator at the National Gallery, London.

Case Study 19

63 This is taken from Philip Conisbee, *Masterpiece in Focus: Soap Bubbles by Jean-Siméon Chardin*, brochure (Los Angeles: Los Angeles County Museum of Art, 1990), and Marcia Kupfer, *Soap Bubbles of Jean-Siméon Chardin*, brochure (Washington, D.C.: National Gallery of Art, 1991), both of which reproduce the X-radiographs of all three paintings. The authors were curators at their respective museums. The Washington and New York variants are included in Pierre Rosenberg, *Chardin: 1699–1779*, catalogue (Cleveland: Cleveland Museum of Art with Indiana University Press, 1979), as cats. 59 and 61. Although the technical discussion is not as current as the later exhibition brochures, the paintings are placed within a fuller discussion of Chardin's work.

64 Kupfer, *Soap Bubbles*, p. 6.

Case Study 20

65 This is taken from McKim-Smith, Garrido Pérez, and Fisher 1985. The authors mention that technical examination of the three paintings included X-rays, infrared reflectography, and paint sampling. They concentrate on the X-ray studies, and we follow their example, focusing on the two paintings in Washington and Madrid. Their study is a considerably subtler interweaving of technical and historical investigation than we are able to suggest in this short adaptation. McKim-Smith is professor of art history at Bryn Mawr College, Garrido is head of the Department of Technical Documentation at the Prado, and Fisher is head of paintings conservation at the National Gallery of Art, Washington, D.C. For another technical examination of El Greco, see Susanna P. Griswold, "Two Paintings by El Greco: 'St. Martin' and 'The Beggar': Analysis and Comparison," *Studies in the History of Art* 41 (1993): 132–55.

66 McKim-Smith, Garrido Pérez, and Fisher 1985 notes a change to the Virgin's middle finger that is not clear in the radiograph as reproduced in the article (p. 70).

67 McKim-Smith, Garrido Pérez, and Fisher 1985, pp. 72–73.

68 McKim-Smith, Garrido Pérez, and Fisher 1985, p. 75. McKim-Smith elaborates this topic in her later work on Velázquez: McKim-Smith, Anderson-Bergdoll, and Newman 1988.

Case Study 21

69 This case has been adapted from Michael Swicklik, "Interpreting Artist's Intent in the Treatment of John Constable's 'The White Horse' Sketch," *Journal of the American Institute of Conservation* 37, no. 3 (Fall–Winter 1998): 362–72. We are grateful to the author, who is paintings conservator at the National Gallery of Art, for discussing the findings with us.

70 Rhyne 1990. Rhyne is professor of art history emeritus at Reed College, Portland, Oregon.

71 Swicklik, "Interpreting Artist's Intent," p. 369. The article is illustrated with a cross-section in ordinary light and in ultraviolet light. These reveal two thin layers of paint that had already dried and produced cracks before a varnish layer was applied. A layer of thick paint sits above this varnish. The established craquelure was convincing evidence that the paint above the varnish was not Constable's (pp. 356–67 and Figs. 6 and 7).

72 Swicklik, "Interpreting Artist's Intent," pp. 369–70. On Courbet's patchwork canvases, see MacDonald 1969. On Picasso, see Ann Hoenigswald, "Works in Progress: Pablo Picasso's Hidden Images," in *Picasso: The Early Years, 1892–1906* 1997, pp. 299–309.

Case Study 22

73 This is adapted from Carmean 1979, which uses a former title for the painting: *Diamond Painting in Red, Yellow and Blue*. Carmean was curator at the National Gallery of Art, Washington, D.C., where his collaborator, Leischer, was paintings conservator. Authors of the more recent publication, Yve-Alain Bois et al., *Piet Mondrian: 1872–1944*, catalogue (Washington, D.C., and Milan: National Gallery of Art and Museum of Modern Art, New York, in association with Leonardo Arte, 1994), accept Carmean's and Leischer's findings. For further technical studies of Mondrian, see "Mondriaan Special," *Km (Kunstenaarsmateriaal)* 12 (Winter 1994). The English supplement includes J. R. J. van Asperen de Boer, "On the Scientific Examination of Some Mondriaan Paintings," pp. 26–30, and Pien van der Werf, "The Working Methods of Piet Mondriaan," pp. 31–35. Note that illustrations follow the Dutch text only. The authors analyze a group of paintings in the Haags Gemeentemuseum with raking light, UV, radiography, infrared reflectography, and paint samples to follow Mondrian's materials and technique. Their research confirms Carmean and Leischer's findings that Mondrian made formal adjustments as he painted.

Case Study 23

74 This is adapted from Szafran 1995 and John Farrell, "A Tale
of Two Paintings," *Getty Trust Bulletin* 7 (Spring 1992): 6–7.
Szafran is paintings conservator at the J. Paul Getty Museum.

Case Study 24

75 This case is drawn from Garrido 1992. The discussion is sum-
marized in English in Brown and Garrido 1998.

76 Carmen Garrido, Maria Theresa Dávila, and Rocia Dávila,
"General Remarks on the Painting Technique of Velázquez:
Restoration Carried Out at the Museo del Prado," in *Conser-
vation of the Iberian and Latin American Cultural Heritage*,
edited by John S. Mills and Perry Smith. Preprints of the Con-
tributions to the IIC Madrid Congress, September 9–12, 1992.
H. W. M. Hodges 1992, p. 49.

Chapter 5: The Varnish Layer

The Physical and Aesthetic Function of the Varnish Layer

1 *The Journal of Eugene Delacroix: A Selection*, trans. Lucy
Newton (London: Phaidon, 1951; reprinted 1995), p. 353.

2 *Moby Dick or The White Whale* (1851; Boston: St. Botolph
Society, 1892), p. 16.

3 In describing an effect of varnish, the term *saturation* refers
to an optical property—hence darkening. This is distinct
from chemical saturation.

A Note on the Use of Varnish for Purposes Other than Coatings

4 Swicklik 1993, pp. 157–59. Swicklik is a paintings conserva-
tor at the National Gallery of Art, Washington, D.C. He pro-
vides an excellent survey of French attitudes toward varnish
in the eighteenth- to nineteenth-centuries. The subject is
fairly complex, and his article should be essential reading for
scholars of the period. On Van Gogh's use of eggwhite, see
Cornelia Peres, "On Egg-White Coatings," *A Closer Look*
1991, pp. 39–40.

5 Swicklik 1993, pp. 159–60, cites Jean François Léonore
Mérimée's *Art of Painting in Oil and Fresco* (1830).

The Composition of Varnishes

6 Swicklik 1993, p. 162, refers to Delacroix's experimentation
with wax in preference to traditional varnish. Also see quote
from Gauguin, p. 234.

Aging of the Varnish Layer

7 Readers aware of the varnishing debates of the early 1960s
will recall Ernst Gombrich's history of dark, presumably
tinted varnishes, going back to Classical Greece (Gombrich
et al. 1962–63, "Dark Varnishes: Variations on a Theme by
Pliny," pp. 51–55). Gombrich's article received a detailed
rebuttal by Joyce Plesters (pp. 452–60). Plesters takes into
account the fact that Pliny was writing three centuries after
the painting practice he describes; so that even if Apelles'
paintings had retained their original varnishes, they would
have darkened substantially. She also discusses the possibility
that Pliny, or *his* source, is describing varnish in a vial. Even
such apparently "dark" varnishes are usually clear when
applied, because the layer is very thin (pp. 452–53). Alistair
Smith documents the changing descriptions that several gen-
erations of art historians (Weale to Panofsky) gave of Gerard
David's *Virgin and Child with Three Saints and a Donor*
(National Gallery, London). Smith attributes some of the dis-
parities to intervening varnish removal and cleaning (Martin
Wyld, Ashok Roy, and Alistair Smith, "Gerard David's 'The
Virgin and Child with Saints and a Donor,'" *National Gallery
Technical Bulletin* 3 [1979], pp. 63–65. Note: View this arti-
cle in its original form, because the color plates are essential).

Renewing the Varnish Layer

8 *The Elder Pliny's Chapters on the History of Art* (1896;
reprint, Chicago: Argonaut, 1968), trans. K. Jex-Blake, p.
135, book 35, l. 99–100. Caley 1990, pp. 71, 72. Caley is a
paintings conservator in private practice in London.

9 Mid-treatment photographs that demonstrate the effect of
removing disfigured and discolored varnish can be found in
Bomford et al. 1990, pp. 101–2, for examples by Cézanne
and Pissarro; Callen 1982, p. 111, for an example by Sisley; *A
Closer Look* 1991, pp. 54–56, for several Van Goghs; numer-
ous color plates in *Princeton Raphael Symposium* 1990; Volle
et al. 1993, for a group of Titians; as well as Ellen Wardwell
Lee, *The Aura of Neo-Impressionism: The W. J. Holliday
Collection*, catalogue (Indianapolis: Indianapolis Museum of
Art, 1983), pp. 30–31, for mid-cleaning illustrations of works
by Seurat and Luce. See also the splendid visual documenta-
tion of Jørgen Wadum et al., *Vermeer Illuminated: A Report
on the Restoration of the "View of Delft" and "The Girl with
a Pearl Earring" by Johannes Vermeer* (Wormer and The
Hague: V & K Publishing/Inmerc and Mauritshuis, 1994),
and Jill Dunkerton, "The Cleaning and Technique of Two
Paintings by Sassoferrato," *Burlington Magazine* 128, no. 997
(April 1986): 282, 284–89, 291. For dramatic before and
after illustrations of varnish removal from a Botticelli, see
Baldini et al. 1986, p. 34.

Examination of the Varnish Layer with Natural Light

10 Quoted by René Gimpel, *Diary of an Art Dealer* (New York:
Farrar, Straus and Giroux, 1966), trans. John Rosenberg,
entry for November 28, 1918, p. 75.

Partial Varnish Removal and Selective Cleaning

11 "On Humanism, Aesthetics, and the Cleaning of Paintings," in Hedley 1993.

Case Study 25

12 This example is taken from Campbell and Dunkerton 1996; Campbell is curator and Dunkerton is senior paintings conservator at the National Gallery, London. Their study contains details of paint sampling that we have omitted, including the use of UV in distinguishing the type of red glaze characteristic of paintings done in Antwerp in the sixteenth century from that commonly used in the nineteenth century. The sample was too small for chemical testing to be performed. Another well-illustrated use of ultraviolet examination is Baldini et al. 1986.

Has the Painting Been Varnished?

13 Callen 1994, p. 740. John Richardson suggests that the glossiness of modern book illustrations conditioned the public to a shiny look, and this in turn encouraged varnishing of paintings, against the artists' wishes ("Your Show of Shows," *New York Review of Books* [July 17, 1980], p. 19). Note Robert Motherwell's disparaging comparison between the shininess of varnished paintings and illustrations in popular women's magazines (p. 237). We are profoundly grateful to Ann Hoenigswald at the National Gallery of Art, Washington, D.C., and to Will Shank and Dawn Steele Pullman at the San Francisco Museum of Modern Art for arranging mid-treatment photographs; to Lillie Steele of the Phillips Collection for photographing the unvarnished surfaces of the Bonnard and the Braque; and to Jim Coddington of the Museum of Modern Art, New York, for supplying a mid-treatment slide.

"Original" Varnish: A Caution

14 Poussin is cited and translated in Swicklik 1993, p. 163 (*Lettres et propos sur l'art*, edited by Anthony Blunt [Paris: Hermann, 1964], p. 86). Carlyle's comment on varnish and the patron's realm is from her work in publication. Joyce Townsend confirms this in relation to Turner's work. Carlyle notes that nineteenth-century British artists' handbooks "generally advised waiting at least a year after completing a painting to varnish it—some suggest a delay of two to three years" (1999).

15 Townsend 1996, p. 66.

16 Ambrose Vollard, *Renoir: An Intimate Record* (1925; English ed., New York: Knopf, 1934), translation by Harold L. Van Doren and Randolph T. Weaver, pp. 96–97.

17 "'I'll tell you,' Monet replied, 'that when we were starting out, Durand-Ruel said to us: 'The collectors find your canvases too chalky. To sell them, I'm obliged to varnish them with bitumen.' You'll understand, M. Gimpel, that we weren't exactly delighted with that, but one had to live!" Quoted by René Gimpel, *Diary of an Art Dealer*, entry for February 1, 1920, p. 130.

Varnish on Early Panels

18 Renate and Paul Woudhuysen-Keller, "The History of Eggwhite Varnishes," *Hamilton Kerr Institute Bulletin* 2 (1994): 90–141; this article lists fifty-seven recipes, from the fourteenth through twentieth centuries.

19 Marco Ciatti, "Some Observations on Panel Painting Technique in Tuscany from the Twelfth to the Thirteenth Century," in *Painting Techniques* (see Examples of Varnish Identification), p. 3. On the Jacopo del Casentino, see Del Serra 1985, p. 4. On the San Pier Maggiore Altarpiece, see Jill Dunkerton, Jo Kirby, and Raymond White, "Varnish and Early Italian Tempera Paintings," *Painting Techniques*, pp. 63–69. The questions about varnish and the documentary evidence concerning the altarpiece were clearly detailed in Bomford et al. 1989, pp. 182–85, prior to tests that confirmed the presence of an oil varnish. Marta Presa, Rocío Bruquetas, and Marco Connor, "Oil Painting in the Late Middle Ages in Spain: The Relationship of Style to Technique in the Epiphany Altarpiece of St. Paul's Convent in Toledo," in *Painting Techniques*, p. 80. Hodge, Spring, and Marchant, *Painting Techniques*, p. 75. The information on varnish and Flemish paintings was supplied by Hélène Verougstraete, in conversation and correspondence.

Nineteenth-Century Darkening Glazes and Tinted Varnishes

20 "To Sir Godfrey Kneller," 1694, *The Poetical Works of John Dryden*, edited by George R. Noyes (Boston: Houghton Mifflin, 1909), p. 413.

21 Stoner 1990, p. 5, cites Charles R. Leslie, *Autobiographical Recollections*, edited by Tom Taylor (Boston: Ticknor and Fields, 1860), p. 22, and describes Wilson's toning varnish, p. 8. Ryder's practice is recounted by the painter Philip Evergood in Kendall Taylor, "Ryder Remembered," *Archives of American Art Journal* 24, no. 3 (1984): p. 15 n. 2. D'Uklanski is cited by Hugh Honour ("Canova's Studio Practice—II: 1792–1822," *Burlington Magazine* 114, no. 829 [April 1972]: 219).

22 Sarah Cove (in Parris and Fleming-Williams 1993, p. 516) cites *John Constable's Correspondence: IV*, edited by R. B. Beckett (Ipswitch, 1968), p. 106. William Hogarth, *The Analysis of Beauty*, rev. ed., edited by Joseph Burke (Oxford: Clarendon, 1955,), p. 130 n. 1.

23 Mansfield Kirby Talley Jr. quotes Reynolds (in *Reynolds* 1986, p. 67). Callen 1994, p. 740. Broun 1989, p. 130 and n. 23. Broun has a useful discussion of the varying nineteenth-century attitudes toward darkened varnish (p. 130).

Nineteenth- and Twentieth-Century Opposition to Varnishing

24 Swicklik 1995 and Callen 1994. Swicklik is a conservator at the National Gallery of Art, Washington, D.C., and Callen is an art historian at Warwick University. On the commercial connotations of shininess, see David Bjelajac: "To compete for the attention of the crowd, some artists painted for an immediate brilliant effect, as if they were trying to catch the eye of casual-window shoppers. By contrast, Allston praised Titianesque glazing for producing an 'internal light,' one that appealed to the man or woman of true feeling who ignored the fickle court of public opinion" (David Bjelajac, *Washington Allston, Secret Societies, and the Alchemy of Anglo-American Painting* [Cambridge: Cambridge University Press, 1997]). The same connotations might accrue to the popular appeal of varnished paintings. For another commercial simile, see Robert Motherwell's comment (p. 237), in which he associates the shininess of a varnished surface with advertising directed at a female audience.

25 Swicklik 1995, p. 171. On American tonalists and impressionists: "The research indicates that the techniques used by the two groups were more complex than has been generally thought and that the artists varied widely in their approach to important technical issues. . . . Barbizon-influenced Henry Ward Ranger painted into and on top of mastic resin and advocated varnishing previously unvarnished paintings by other artists, including paintings by Monet. While some sources document John Twachtman's preference for matte surfaces on paintings of certain periods, a number of the impressionist painters may have added media to their paint to make it glossier, perhaps to avoid varnishing later. Of the impressionist painters studied, only Childe Hassam made it clear that he wanted some of his paintings varnished" (Lance Mayer and Gay Myers, "Understanding the Techniques of American Tonalist and Impressionist Painters," *Journal of the American Institute for Conservation* 32 [1993]: 129–39, abstract).

26 For a discussion of neo-impressionist attitudes toward varnish, the later addition of varnish by others, and the results of aging on unvarnished surfaces, see David Miller, "Conservation of Neo-Impressionist Paintings," pp. 29–31, in Lee, *Aura of Neo-Impressionism*. On Gauguin, see Christensen 1993, p. 92, which cites and translates Gauguin's letter to de Montfreid (February 25, 1901). Further information about Gauguin's use of wax is found in Jirat-Wasiutynski and Newton 1999. Thurmann-Moe 1997, pp. 60–61, cites Nilssen's letter in *Dagens Nyt*, June 14, 1909. Information on the directions not to varnish Bonnard's "The Bathroom Mirror" (see fig. 246, caption) was supplied by the Department of Paintings, Museum of Modern Art, New York.

27 For an example of problems presented by an artist's estate, see John Elderfield, *Morris Louis*, catalogue (New York: Museum of Modern Art, 1987), especially pp. 181–82.

28 Richardson 1983, p. 32.

29 *Max Beckmann: Retrospective* 1984, p. 136 n. 13.

30 Kenneth B. Katz, "The Artist's Intention and the Varnishing of German Expressionist Paintings: Two Case Studies," in *Cleaning, Retouching, and Coatings* (see Examples of Varnish Identification), p. 158. Katz decided to use a light, synthetic varnish on the Nolde, despite the artist's written prohibition against varnishing his works. Instead, Katz based his decision on Nolde's written desire that the pictures look as if they had just been painted, as well as his practice of using rich (that is, shiny) paint.

31 The late Harry Gaugh states categorically that "Klein did not varnish his paintings" but does not attribute the basis of his certainty (1985, p. 161). Steven Bonaides, conservator at the Cincinnati Art Museum who worked on the Klein retrospective, said that the paintings themselves confirmed Gaugh's statement; most were unvarnished, and the rest were probably varnished later. Bonaides believes that Klein favored a matte, chalky surface (phone conversation, March 25, 1997). The conservator for Rothko's estate, Dana Cranmer, describes his technique: "He added unbound powdered pigments and whole eggs to his paint formula and often diluted the paint film with solvent, so much so that the effect of the binding element in the paint mixture was compromised: the pigment particles were almost dissociated from the paint film, barely clinging to the surface. Rothko ignored the limits of physical coherence to achieve a translucency unique to his paintings. . . . Physically, these surfaces are extremely delicate if not ephemeral." (*Mark Rothko* 1983, p. 192). Cranmer cites Elizabeth Jones' report that "Rothko was adamantly opposed to her suggestion of applying a protective varnish" (p. 193). The Rothko Chapel at Houston was painted with an initial layer bound in glue, followed by a layer bound in oil plus egg with turpentine and dammar added—but no varnish coating. See Carol Mancusi-Ungaro, "The Rothko Chapel: Treatment of the Black-Form Triptychs," in *Cleaning, Retouching, and Coatings* (see Examples of Varnish Identification), pp. 134–37. Michael Auping in Kellein 1992, pp. 41–42. The technical study of Still is Dee Ardrey and J. William Shank, "The Paintings of Clyfford Still: What Was the Artist's Intent?" *1994 AIC Paintings Specialty Group Postprints*, Papers presented at the 22nd Annual Meeting of the American Institute for Conservation, Nashville, June 10, 1994 (Washington, D.C.: American Institute for Conservation, 1994), p. 6. Ardrey and Shank studied Still's work in depth, drawing information from large groups of surviving paintings, from the artist's written instructions, and from interviews with his widow, students, and colleagues.

32 Quoted in E. A. Carmean Jr., *Robert Motherwell: Reconciliation Elegy* (New York: Skira/Rizzoli, 1980), p. 55.

Glazing as an Alternative to Varnish

33 Bomford et al. 1990, p. 101, cites the inscription "please do not varnish this picture, C. Pissarro" on the reverse of *Land-scape at Chaponval* (1880, Paris, Musée d'Orsay). Gonzague-Privat describes Pissarro's landscapes framed under glass as being "in the English style" in his *L'Evénment* review of the Sixth Impressionist Exhibition (April 5, 1881). The review is printed in *The New Painting: Impressionism, 1874–1886. Documentation*, edited by Ruth Berson (San Francisco: Fine Arts Museum of San Francisco, 1996), vol. 1: *Reviews*, pp. 345–46. Callen 1994, pp. 740–41, discusses the critical response to glazed paintings in the impressionist exhibitions of 1881–82. Gauguin's letter with framing instructions (translation from wall label, Metropolitan Museum of Art) is no. 98 in John Rewald, *Gauguin: Drawings* (New York: T. Yoseloff, 1958). *Henry Ossawa Tanner* 1991, pp. 242–51, 286. The Irish painter Jack B. Yeats also favored glass to protect his unvarnished surfaces. See Brian P. Kennedy, "The Oil Painting Technique of Jack B. Yeats," *Irish Arts Review Yearbook* (1993): 115–23.

Revivalist Eggwhite Varnish

34 M. Kirby Talley Jr., in *Reynolds* 1986, p. 63. Carlyle, 1999. See also Woudhuysen-Keller and Woudhuysen-Keller, "History of Eggwhite Varnishes."

35 Peres in *A Closer Look* 1991. The unvarnished works, listed in n. 2, are largely in private collections. Since most of Van Gogh's work remained unsold at his death, the question of his intent is open. Peres quotes recipes for eggwhite from thirteen treatises published between 1754 and 1932. For two studies on what to do with the discolored remains of early eggwhite varnish, see Dunkerton, Kirby, and White, "Varnish and Early Italian Tempera Paintings," in *Cleaning, Retouching, and Coatings* (see Examples of Varnish Identification), and Alfio Del Serra, "Il restauro della Nascita di Venere," *La Nascita di Venere e l'Annunciazione del Botticelli restaurate*, Gli Uffizi Studi e Richerche 4 (1987): 49–58.

Paint on Top of the Varnish Layer

36 Townsend 1996, p. 66.

37 Stoner 1990, p. 9, discusses one counterexample: a painting in the Philadelphia Museum of Art for which cross-section analysis leads conservators to believe that it has retained its original glazes. The "ruined" painting is *Diana in the Chase*, or *Swiss Scenery* (Fogg Art Museum). See Elizabeth Johns, "Washington Allston's 'Dead Man Revived,'" *Art Bulletin* 61 (March 1979): 78–99, n. 79; she quotes R. H. Dana on Allston's rejection of the work. Broun 1989, pp. 131–32.

Chapter 6. Beyond the Painting

Labels and Collectors' Marks

1 The standard reference to collector's marks for works on paper is Fritz Lugt, *Les Marques de Collection de dessins et d'estampes* (Amsterdam: Vereenigde drukkerijen, 1921), *Supplement* (The Hague: Martinus Nijhoff, 1956). For a discussion of the clues to provenance found on the mounts, see Carlo James et al., "Collectors and Mountings," in *Old Master Prints and Drawings: A Guide to Preservation and Conservation*, translated and edited by Marjorie B. Cohn (Amsterdam: Amsterdam University Press, 1997), pp. 2–35.

2 On the *Supper at Emmaus*, see Volle et al. 1993, pp. 60, 75. Volle cites Arnaud Brejon de Lavergnée (*L'inventaire de Le Brun de 1683: La collection des tableaux de Louis XIV* [Paris: Réunion des Musées Nationaux, 1987], p. 123), who says that X-ray studies were used to identify the Maffei crest. On *Portrait of a Man*, see p. 72 and n. 44. For an example in which infrared studies revealed an inscription, hidden by the lining canvas, that identified both the sitter and the painter, see R. I. Goler, "An Early Reynolds Rediscovered," *Burlington Magazine* 129, no. 1016 (November 1987): 727–28.

3 Gould 1970, p. 188. See also Cecil Gould, *The Sixteenth-Century Italian Schools* (London: National Gallery, 1975), pp. 208–10.

4 See Norman E. Muller, "An Early Example of a Plywood Support for Painting," *Journal of the American Institute for Conservation* 31 (1992): 257–60.

On Framing

5 On the Lippi, see Grimm 1992, p. 19. The altarpiece was contracted to Filippino and completed by Perugino. The contract for the frame maker, Baccio d'Agnolo, is cited in *Le Opere di Giorgio Vasari con Nuove Annotazioni e Commenti di Gaetano Milanesi* (Florence: G. C. Sansoni, 1906), vol. 5, p. 350. On the Leonardo, see Hannelore Glasser, *Artists' Contracts of the Early Renaissance* (New York: Garland, 1977), especially chap. 4.

6 Humfrey 1993, pp. 175–76, 218–20. He gives other examples of Bellini's involvement with altar frames: the St. Catherine of Siena Altar at Sts. Giovanni e Paolo, the St. Giobe altarpiece (reconstructions illustrated in Humfrey 1993, figs. 176, 191), and the St. Zaccaria altarpiece (fig. 207).

7 Isabelle Cahn cites both Clarétie from "La Vie à Paris," *Le Temps* (April 5, 1881) and Laforge from "L'Impressionnisme" (1883), *Mélanges posthumes*, Paris, 1903, p. 145 ("Edgar Degas: Gold or Colour," translated by Ranalda Robson, in Mendgen et al. 1995, p. 132 and n. 27).

8 Mendgen et al. 1995 contains a group of superbly illustrated articles on artist-designed frames. Edward Wheelwright, "Personal Recollections of Jean-François Millet," *Atlantic Monthly* 38 (September 1876): p. 273. John House, *Monet: Nature into Art* (New Haven: Yale University Press, 1986), p. 181. Ann Hoenigswald cites *The Complete Letters of Vincent Van Gogh*, 2nd ed. (Boston: New York Graphic Society, 1978), LT 547, vol. 3, p. 69 ("Vincent van Gogh: His Frames, and the Presentation of Paintings," *Burlington Magazine* 130, no. 1022 [May 1988], p. 370).

9 Louis Tilborch, "Framing Van Gogh," in Mendgen et al. 1995, p. 176. D'Angiviller had adopted uniform frames for display of the royal collections at the Louvre in the 1770s (Germain Bazin, *The Museum Age* [New York: Universe Books, 1967, translation of French edition], p. 154). Denon also used uniform frames for the Grand Gallery of the Napoleonic Louvre (Christopher Rowell, "Display of Art: Paintings," *Dictionary of Art* [London: Macmillan, 1996], vol. 9, p. 18). For extensive discussion of the political implications of hanging and of conservation policy at the Louvre, see Andrew McClellan, *Inventing the Louvre: Art, Politics, and the Origins of the Modern Museum in Eighteenth-Century Paris* (New York: Cambridge University Press, 1994). On the British Museum frames, see Simon 1996, p. 121, fig. 131. He offers examples of both institutional and private collections in which uniform framing policy underlined the paintings' common ownership. Carlo Scarpa designed the painting galleries at the Museo Correr, Venice, in 1957–60. His best-known installation, for the Museo de Castelvecchio, Verona, dates from 1957–74. All of his exhibition designs are illustrated in Bianca Albertini and Sandro Bagnoli, *Scarpa: I Musei e Le Esposizioni* (Milan: Jaca Book, 1992). For a discussion of MoMA's framing policy of the mid-1980s, see Grace Gluck, "What's In a Frame? Less and Less at the Modern," *New York Times* (July 15, 1984). Susan Moore, *Framing Modern Masters: A Conversation with Heinz Berggruen* (London: Arnold Wiggins & Sons, 1991), interviews a collector and dealer whose choices in framing modernist paintings differ from Rubin's choice for MoMA's presentation.

Viewing Conditions and Lighting

10 The authors are extremely grateful to Steve Weintraub of Art Preservation Services, New York, for long discussions on these questions and for directing us to a range of useful sources, and to Alison B. Snyder, assistant professor of interior architecture, University of Oregon, for discussions on light and lighting.

11 For a rare study that considers light conditions, see Helen Glanville, "Varnish, Grounds, Viewing Distance, and Lighting: Some Notes on Seventeenth-Century Italian Painting Technique," in *Historical Painting Techniques, Materials, and Studio Practice*, Preprints of a Symposium, University of Leiden, June 26–29, 1995 (Los Angeles: Getty Conservation Institute, 1996), pp. 53–55.

12 According to Goya's son, "Los últimos toques para el mejor efecto de un cuadro los daba de noche, con luz artificial" (P. Beroqui, "Una biografía de Goya escrita por su hijo," *Archivo Español de Arte* III [1927], p. 100). We are grateful to Suzanne Stratton-Pruitt for her help with research and translation. John Hayes, *Gainsborough: Paintings and Drawings* (London: Phaidon, 1975), p. 25. Hayes cites Humphry's *Farrington Diary*, October 29, 1784, p. 238 n. 67. Yve-Alain Bois, "Piet Mondrian 'New York City,'" *Painting as Model* (Cambridge: MIT Press, 1990), p. 176; citation from Bois' n. 48 in "The Iconoclast," *Piet Mondrian: 1972–1944*, catalogue (Washington, D.C., and Milan: National Gallery of Art and Museum of Modern Art, New York, in association with Leonardo Arte, 1994), pp. 313–72. Albers is quoted by Elaine de Kooning, "Albers Paints a Picture," *ArtNews* 49, no. 7 (November 1950): 57. For a conservator's discussion of Albers' technique, see Patricia Sherwin Garland, "Joseph Albers: His Paintings, Their Materials, Technique, and Treatment," *Journal of the American Institute of Conservation* 22, no. 2 (Spring 1983): 62–67.

13 Marjorie Cohn cites Rothko's instructions that a patron view his paintings from eighteen inches away (*Mark Rothko's Harvard Murals* 1988, p. 15). John Gage discusses various possible reasons for Rothko's concern for viewing conditions, including contemporary research in Gestalt psychology, and the artist's severe myopia ("Rothko: Color as Subject," in *Mark Rothko*, catalogue [Washington, D.C.: National Gallery of Art, 1998], pp. 254–55, 260–63). Dominique de Ménil describes Rothko's interest in controlling the lighting and the building surfaces of the chapel in Houston, which provoked the architect, Philip Johnson, to bow out of the building commission ("The Rothko Chapel," *Art Journal* 30 [Spring 1971]: 249–51). See also Sheldon Nodelman, *The Rothko Chapel Paintings: Origins, Structure, Meaning* (Austin: University of Texas Press, 1997). Thomas Hess, "Editorial: Mark Rothko (1903–1970)," *ArtNews* 69 (April 1970): 29. In directives for his 1960 retrospective at the Whitechapel Art Gallery, London, Rothko wrote, "The Light, whether natural or artificial, should not be too strong. The pictures have their own inner light and if there is too much light, the color in the picture is washed out and a distortion of their look occurs. The ideal situation would be to hang them in a normally lit room—that is the way they were painted" (cited by Bonnie Clearwater, "How Rothko Looked at Rothko," *ArtNews* 84, no. 9 [Novem-

ber 1985], p. 102). In fact, Rothko seems to have changed his studio lighting over time. Robert Motherwell described Rothko's earlier practice of working in the early morning under intense artificial lighting (cited by Gage, "Rothko," p. 262).

14 On the exhibition and critical response to *Heart of the Andes*, see Avery 1986. See also Annette Blaugrund, *The Tenth Street Studio Building: Artist-Entrepreneurs from the Hudson River School to the American Impressionists*, catalogue (Southampton: Parrish Art Museum, 1997), chap. 2. Church's second largest painting, *Icebergs*, was displayed in London in 1863 in an elaborately carved frame. It later carried a plain dark walnut frame. Avery suggests that the plainer molding was fabricated after the exhibition, when the painting was sold (n. 40).

15 See David Park Curry, "Total Control: Whistler at an Exhibition," *Studies in the History of Art* 19 (1987): 77–78. The velarium is illustrated in Curry, figs. 1, 15. Curry cites the press response to the footman, p. 78. Curry comments (p. 67): "Many of today's familiar exhibition design techniques and museum practices were introduced to London a hundred years ago in one-man and group shows partially or entirely orchestrated by Whistler. These techniques include indirect lighting, color-coordinated walls, uniform framing, elegant spacing, large banners outside the exhibition space, the sale of specially designed catalogues and photoreproductions of art, elaborate evening openings, and admission charges for temporary exhibitions." For further discussion of Whistler's attitude toward the display of his work, see Robin Spencer, "Whistler's First One-Man Exhibition Reconstructed," in *The Documented Image: Visions in Art History*, edited by G. P. Weisberg and L. S. Dixon (Syracuse: Syracuse University Press, 1987), pp. 27–49; and Joyce Hill Stoner, "Whistler's Views on the Restoration and Display of His Paintings," *Studies in Conservation* 42, no. 2 (1997): 107–14.

16 Paul Tucker describes the walls of Nadar's studio, used for the first impressionist exhibition, as "flocked reddish-brown" ("The First Impressionist Exhibition in Context," in *The New Painting: Impressionism, 1874–1886* catalogue (Geneva: Richard Burton, 1986), p. 106. John House comments that "such dark, warm walls were the norm in the later nineteenth century, and the painters would thus have anticipated a light-toned or brightly coloured canvas standing out as the most vivid thing in its surroundings" ("Impressionism and Its Contexts," in *Impressionist and Post-Impressionist Masterpieces* 1987, p. 15). Bomford et al. 1990 discusses various aspects of exhibition practice, lighting conditions, and

viewing distance as they applied to impressionist painting, pp. 107–9. Martha Ward also describes interior decoration, lighting, viewing conditions, and framing practices in an article on the social dimension of installations ("Impressionist Installations and Private Exhibitions," *Art Bulletin* 73 [December 1991]: 599–622).

17 A rare example that does so is Charles Rhyne, "Discoveries in the Exhibition," *John Constable, R. A. (1776–1837)*, catalogue (New York: Salander-O'Reilly Galleries, 1989), pp. 11–27.

Bibliography

This bibliography is for readers who wish to take their study of technical examination to the next level. We emphasize literature written for art historians rather than technical information directed at conservators, and we have sought out works that are well illustrated and readily available in art history and general research libraries. Most are in English. Important sources that fall outside these criteria are cited in the thematic bibliographies in the text. In this bibliography we list videotapes that illustrate technical examination procedures, conservation treatments, and artists' techniques.

A few art history journals can be counted on to include technical information and illustrations: *Apollo, Burlington Magazine, Nederlands Kunsthistorisch Jaarboek*, and *Studies in the History of Art*, as well as a number of museum bulletins, particularly those of the Cleveland Museum of Art, Detroit Institute of Arts, the Louvre, Metropolitan Museum of Art, Philadelphia Museum of Art, and the Prado. For detailed technical literature (which often includes a fair amount of scientific terminology), see the journals of various professional associations for conservators and conservation scientists, as well as bulletins of several museum research laboratories, including *The Bulletin of the Hamilton Kerr Institute, The Conservator, Bulletin de l'Institut Royal du Patrimonine Artistique, Journal of the American Institute for Conservation, kM (kunstenaarsmateriaal), Maltechnik-Restauro* (which regularly has summaries in English; formerly *Restauro* [Zeitschrift für Kunsttechniken, Restaurierung und Museumsfragen, Mitteilungen der IADA]), *National Gallery Technical Bulletin, Restauro (Rivista dell'Opificio delle Pietre Dure e Laboratori di Restauro di Firenze), Studies in Conservation, Techne: La Science au service de l'histoire de l'art* (previously *Bulletin du Laboratoire du Musée du Louvre* [1956–68]; since 1970, *Annales du Laboratoire de Recherche des Musées de France*), and conference proceedings for the American Institute for Conservation of Historic and Artistic Works (AIC), the Canadian Conservation Institute, International Institute for the Conservation of Historic and Artistic Works (IIC), the United Kingdom Institute for Conservation of Historic and Artistic Works, the International Council of Museums, and the biennial conference, Le Dessin Sous-jacent dans la Peinture. These publications and others directed at conservators and art historians are indexed in *Art and Archaeology Technical Abstracts*. The art historical and some technical literature is indexed in *International Repertory of the Literature of Art (RILA)* and *Bibliography of the History of Art (BHA)*.

Adair, William. 1983. *The Frame in America, 1700–1900: A Survey of Fabrication Techniques and Styles*. Catalogue. Washington, D.C.: American Institute of Architects Foundation.

The most complete reference work on American frames, although hard to obtain. Illustrates a history of characteristic designs (drawn from various collections), many isolated from the works they surrounded. Discusses the history of fabrication techniques and includes molding profiles.

Ades, Dawn, and Andrew Forge. 1985. *Francis Bacon*. Catalogue. London: Tate Gallery and Thames and Hudson.

See Andrew Durham, "Note on Technique," pp. 231–33. Discusses Bacon's choice of media for their visual properties, mentioning the influence of Picasso's "rawness" on Bacon's use of additives to alter the paint's texture.

Ainsworth, Maryan W. 1989. "Northern Renaissance Drawings and Underdrawings: A Proposed Method of Study." *Master Drawings* 27, no. 1 (Spring): 5–28.

Ainsworth explores the contribution of underdrawings visible through infrared reflectography to the study of Northern Renaissance art. She discusses their use in resolving questions of authenticity, authorship, dating, and workshop practice, with emphasis on the varying functions of drawings. Extensively illustrated with UV studies that are often compared with independent drawings as well as with paintings.

——. 1982. *Art and Autoradiography: Insights into the Genesis of Paintings by Rembrandt, Van Dyck, and Vermeer*. New York: Metropolitan Museum of Art.

The standard introduction to autoradiography, addressing thirty-nine paintings by three artists. Sections on art historical findings (with extensive illustrations), on the use of autoradiography in identifying painting materials, and on the technical methodology.

Albano, Albert. 1988. "Art in Transition." Preprints of American Institute of Conservation's Sixteenth Annual Meeting, New Orleans, June 1–5, pp. 195–204. Reprinted in *Historical and Philosophical Issues in the Conservation of Cultural Heritage*. Los Angeles: Getty Conservation Institute, 1996, pp. 176–84.

Gives historical context to criticism of twentieth-century painting technique. Albano quotes earlier criticism of artists' techniques during periods of stylistic and technical innovation. He also compares the attitudes of artists during various periods to changes that may occur in their paintings. Not illustrated.

Allden, Mary, and Richard Beresford. 1989. "Two Altar-Pieces by Philippe de Champaigne: Their History and Technique." *Burlington Magazine* 131, no. 1035 (June): 395–406.

Study in connection with the cleaning of two paintings.

Historical and stylistic arguments suggest that they date from the same period despite different color tonalities; technical studies do not contradict this. Emphasis on paint sampling; cross-sections illustrated.

Alonso Sánchez Coello y el Retrato en la corte de Felipe II. 1990. Catalogue. Madrid: Museo del Prado.

See Carmen Garrido, "Estudio Técnico," pp. 215–43. Study of twelve portraits in the Prado and two from a private collection, all produced for the court of Phillip II. Technical studies support the reattribution to Sofonisba Anguissola of a royal portrait previously attributed to Sánchez Coello. Thoroughly illustrated with X-ray studies, occasional infrared studies, many paint cross-sections, pigment analyses, and a study of ten canvas supports.

Artists' Pigments: A Handbook of Their History and Characteristics. vol. 1, 1986; vol. 2, 1993; vol. 3, 1997. Vol. 1 edited by Robert L. Feller; vol. 2 edited by Ashok Roy; vol. 3 edited by Elizabeth West FitzHugh. Washington, D.C.: National Gallery of Art.

Articles directed at conservators and scientists. Combines historical information and detailed scientific analysis. Art historians should be able to make ready use of information on each pigment's permanence, history of use, and list of notable occurrences. Also contains an equally complete discussion of examination methods. Extensive illustrations include examples of pigments as used, color changes, microphotographs of pigment samples, and cross-sections.

Artists' Techniques in Golden Age Spain: Six Treatises in Translation. 1986. Edited and translated by Zahira Veliz. Cambridge: Cambridge University Press.

Makes available the major Spanish artists' treatises that had been ignored in prior translations of European painters' manuals, notably Merrifield 1849. These reveal the materials available, how they were used, and regional variations. Contributions by Nuñes, Carducho, Pacheco, Garcia Hidalgo, and Palomino.

van Asperen de Boer, J. R. J. 1975. "A Technical Examination of the Frame of Engebrechtsz's 'Crucifixion' and Some Other Sixteenth-Century Frames." *Nederlands Kinsthistorisch Jaarboek* 26: 73–87.

Includes construction details, dendrochronological studies, and cross-sections of paint and ground. The article emphasizes the importance of using several different approaches; n. 3 cites other technical studies of frames.

van Asperen de Boer, J. R. J., J. Dijkstra, R. van Schoute et al. 1990. *Underdrawing in Painting of the Rogier van der Weyden and Master of Flemalle Groups*. *Nederlands Kunsthistorisch Jaarboek* 41.

Illustrated with comparative infrared reflectography studies of fifty paintings from two much-disputed circles; excellent

bibliography. The opening section provides crucial discussion of the complexities of comparing paintings on the basis of their underdrawings.

Avery, Kevin. 1986. "'The Heart of the Andes' Exhibited: Frederic E. Church's Window on the Equatorial World." *American Art Journal* 18, no. 1 (Winter): 52–72.
This study of the painting's solo exhibition concentrates on the importance of Church's dark, elaborate, windowlike frame. Avery relates Church's use of the frame, the lighting (both natural and artificial), and the viewing distance to the illusionistic precedents of dioramas and panoramas. Illustrated with photographs showing the original frame and surrounding draperies.

Baetjer, Katherine, and J. G. Links. 1989. *Canaletto.* Catalogue. New York: Metropolitan Museum of Art and Harry N. Abrams.
See Viola Pemberton-Pigott, "The Development of Canaletto's Painting Technique," pp. 53–63. Description of Canaletto's choice of pigments, supports (including several coppers), and technique of paint application, as well as his use of incised guidelines for the architecture.

Baldini, Umberto, et al. 1986. *"Primavera": The Restoration of Botticelli's Masterpiece.* 1984; English ed., New York: Harry N. Abrams.
Thoroughly illustrated study of the technique and restoration of a major work; this monograph is also a useful introduction to Florentine fifteenth-century painting. Profusely illustrated in color, including details; macrophotographs; raking-light, X-ray, and UV studies (mid–varnish removal); and paint cross-sections. For a videotape documenting the examination, see *Botticelli: A Second Spring* (1987). Another study, with material on thirteen paintings by Botticelli, is *L'Incoronazione della Vergine del Botticelli: Restauro e richerche.* Florence: Edifir, 1990.

Bareau, Juliet Wilson. 1986. *The Hidden Face of Manet: An Investigation into the Artist's Working Processes.* Catalogue. *Burlington Magazine* 128, no. 997 (April).
This small but focused exhibition paid particular attention to Manet's changing ideas about composition and format. Uses X-radiography to study major changes in "state," and compares fragments.

Bareau, Juliet Wilson, and Manuela B. Mena Marqués. 1994. *Goya: Truth and Fantasy. The Small Paintings.* Catalogue. London and New Haven: Royal Academy and Yale University Press.
See pp. 343–75. The entries contain precise descriptions of technique, condition, and some treatment history. With the exceptions of several X-ray studies reproduced in the catalogue essay, the technical studies are not specifically illustrated.

Bearor, Karen. 1993. *Irene Rice Periera: Her Paintings and Philosophy.* Austin: University of Texas Press.
Bearor investigates at length the influence of theories of art practice and pedagogy on Periera's use of nontraditional materials. Chap. 3 locates the origin of her interest in textural effects primarily in the Bauhaus teachings of Moholy, and chap. 4 explores the importance of the Design Laboratory to Periera, the general contributions of the WPA in developing new artist's materials, and Periera's paintings on glass.

Beatson, Elizabeth H., Norman E. Muller, and Judith B. Steinhoff. 1986. "The St. Victor Altarpiece in Siena Cathedral: A Reconstruction." *Art Bulletin* 68, no. 4 (December): 610–31.
A major early altarpiece is identified from five fragments, and a reconstruction is proposed. Findings based on style, iconography, and several technical features (panel joining, tooling of haloes, and pigment studies). Detailed attention given to Sienese panel construction.

Bergeon, Ségolène. 1990. *Science et patience, ou, la restauration des peintures.* Catalogue. Paris: Editions de la Réunions des Musées Nationaux.
Documents the conservation treatments of a range of paintings in the Louvre, with particularly complete color illustrations. These include before- , after- , and mid-treatment views of both structural and surface problems. Volume provides an exceptional visual survey of the methods and possibilities of conservation. A useful section on color changes (pp. 154–66) gives comparative illustrations for those pigments that commonly discolor over time (lapis, azurite, smalt, copper resinate greens, and silver leaf).

Bomford, David. 1997. *Conservation of Paintings.* Pocket Guides. London: National Gallery Publications and Yale University Press.
This brief guide is the clearest introduction for the general reader to conservation history, principles, and methods. Bomford gives examples of specific treatment problems and controversies, such as the 1967–68 cleaning of Titian's *Bacchus and Ariadne.* Includes wonderful full-color illustrations, many of them mid-treatment.

Bomford, David, Christopher Brown, and Ashok Roy. 1988. *Art in the Making: Rembrandt.* Catalogue. London: National Gallery Publications.
The catalogues to this series of exhibitions from the gallery's collection are splendid resources for art historians and function as ideal introductions to the technique of a particular period. Each Art in the Making volume includes profuse illustrations, valuable bibliographies, and glossaries. Plates include numerous color details of paint handling, raking light photographs, macrophotographs, X-ray and infrared studies, and paint cross-sections. This volume addresses

twenty paintings that span Rembrandt's career. Van de
Wetering 1997 includes more recent technical research.

Bomford, David, Jill Dunkerton, Dillian Gordon, and Ashok Roy. 1989. *Art in the Making: Italian Painting Before 1400.* Catalogue. London: National Gallery Publications.
See note to Bomford, Brown, and Roy 1988. This volume covers eight thirteenth- to fourteenth-century works, including fragments from Giotto and Duccio altarpieces. Background on the paintings' functions, patronage, and workshop practice, and a step-by-step illustration of the techniques of panel preparation, gilding, and punching. Catalogue entries pay detailed attention to condition and the extent to which all or part of the frame is original.

Bomford, David, Jo Kirby, John Leighton, and Ashok Roy. 1990. *Art in the Making: Impressionism.* Catalogue. London: National Gallery in association with Yale University Press.
See note to Bomford, Brown, and Roy 1988. Covers fifteen paintings by Manet, Monet, Pissarro, Sisley, Renoir, Morisot, and Cézanne. Sets impressionist technique within a framework of traditional practice and innovation. Includes background on the artists' studios, on commercial colormen, on canvases, primings, and paints, on color theory, on framing, and on changes to paintings over time. The chapter titled "The Paint Layers and Surface of Impressionist Paintings" illustrates various degrees of "wet-in-wet" paintwork, a variety of textural effects, and the methods used to produce them.

Boorsch, Suzanne, et al. 1992. *Andrea Mantegna.* Catalogue. New York and London: Metropolitan Museum of Art and the Royal Academy of Arts.
See Keith Christiansen, "Some Observations on Mantegna's Painting Technique," pp. 68–78, and Andrea Rothe, "Mantegna's Paintings in Distemper," pp. 80–88. Christiansen discusses Mantegna's choice of fabric support and medium and their aging problems. He studies Mantegna's procedure of preliminary drawing and compares two paintings through X-ray studies. Rothe's article is the definitive introduction to Mantegna's tempera-on-linen painting. It includes a technical catalogue of forty-one works.

Brachert, Thomas. 1970. "A Distinctive Aspect in the Painting Technique of the 'Ginevra di Benci' and of Leonardo's Early Works." *Report and Studies in the History of Art 1969,* 85–104.
Discusses Leonardo's experimentation with the new oil-based medium. Illustrated with enlargements from X-ray studies showing that Leonardo made extensive use of his fingers to spread the paint.

Braun, Emily, and Thomas Branchick. 1985. *Thomas Hart Benton: The "America Today Murals."* Catalogue. Williamstown, Mass.: Williams College, Museum of Art.
See "The Restoration of 'America Today,'" pp. 66–82. Example of an unusual twentieth-century work in egg tempera. Discusses three restorations carried out by Benton himself as well as the latest restoration by the authors.

Brink, Joel. 1978. "Carpentry and Symmetry in Cimabue's Santa Croce Crucifix." *Burlington Magazine* 120, no. 907 (October): 645–53.
Following major damage from the 1966 flood the paint was removed from the support, enabling a study of the wood superstructure. This revealed Cimabue's compositional adjustments and the interaction between the painter and his carpenter.

Broun, Elizabeth. 1989. *Albert Pinkham Ryder.* Catalogue. Washington, D.C.: Smithsonian Institution Press.
See "Chaos Bewitched," pp. 122–32. A model interweaving of technical, historical, and aesthetic questions concerning an artist whose methods were notably problematic. Discusses Ryder's attitude toward the aging of his works. Illustrated with macrophotographs, autoradiographic studies, and paint cross-sections.

Brown, Beverly Louise. 1989. "Replication in the Art of Veronese." *Studies in the History of Art* 20: 111–24.
Focuses on the question of master versus workshop in the production of variants. Uses X-ray studies to investigate workshop participation in Veronese's studio.

Brown, Christopher. 1996. *Making and Meaning: Rubens's Landscapes.* Catalogue. London: National Gallery Publications and Yale University Press.
See especially chap. 8, "The Making of the Landscapes," and the appendix, "The Structure of Rubens's Landscapes" (by Brown and Anthony Reeve). This monograph focuses on the landscapes that the artist painted for himself and friends on notably multipart supports. Brown suggests that the reason was economy rather than an "organic" development of the composition, as previously supposed. The appendix includes diagrams of the construction of fourteen panels, with notes on their materials and techniques, X-ray and IR studies, ground and pigment analyses, and dendrochronology.

Brown, Christopher, Jan Kelch, and Pieter van Thiel. 1991. *Rembrandt: The Master and His Workshop.* Catalogue. New Haven and London: Yale University Press and National Gallery Publications.
Technical concerns employed throughout as part of the art historical investigation. Two articles by van de Wetering (reprinted with revisions in his 1997 monograph, below) discuss the aesthetic and historical implications of

Rembrandt's technique and the methods of scientific analysis. Excellent photographs include numerous color details of paint handling, X-ray and autoradiography studies, and paint cross-sections.

Brown, Christopher, and Ashok Roy. 1992. "Rembrandt's 'Alexander the Great.'" *Burlington Magazine* 134, no. 1070 (May): 286–97.
Report following cleaning discloses a significant finding: the canvas was enlarged in Rembrandt's workshop, linking the painting to a famous, documented commission. Illustrated with X-ray studies and paint cross-sections.

Brown, Jonathan, and Carmen Garrido. 1998. *Velázquez: The Technique of Genius*. New Haven: Yale University Press.
The abundance of color details of twenty-seven paintings constitutes both an investigation of and an homage to Velázquez' painterly skills. This book condenses the technical information from Garrido 1992 and presents a clear narrative in English on the artist's developing technique. Brown and Garrido interpret the artistic results of changes in technique in a manner that should be extremely useful to all art historians, and indispensable to scholars of seventeenth-century painting. In addition to the many details, illustrations include radiographs, infrared reflectograms, raking-light views, and cross-sections.

Burnstock, Aviva, Neil MacGregor, Lucia Scalisi, and Christine Sitwell. 1993. "Three Le Nain Paintings Re-examined." *Burlington Magazine* 135, no. 1087 (October): 678–87.
Technical studies associated with cleaning attempt to clarify which brother painted what. Illustrated with X-ray studies and paint cross-sections, which confirm major reworking of canvases and suggest joint participation but no certain identification of each hand.

Caley, Tom. 1990. "Aspects of Varnishes and the Cleaning of Oil Paintings Before 1700." *Cleaning, Retouching, and Coatings*. Edited by John Mills and Perry Smith, IIC Preprints of the Contributions to the Brussels Congress, September 3–7, pp. 70–72.
A good historical discussion with full references to period documents. Percival-Prescott 1974 gives a comparable history of conservation of the canvas support. Not illustrated.

Callen, Anthea. 1994. "The Unvarnished Truth: Mattness, 'Primitivism,' and Modernity in French Painting, c. 1870–1907." *Burlington Magazine* 136, no. 1100 (November): 738–46.
Discussion of the history, theory, and aesthetic debate about varnishing which demonstrates the importance of understanding technical concerns. The author acknowledges the problem of illustrating the visual subtleties that distinguish a varnished from an unvarnished surface. The article is minimally illustrated but cites many examples of unvarnished impressionist and fauve works.

———. 1982. *Techniques of the Impressionists*. Secaucus, N.J.: Chartwell.
A thorough, scholarly, and approachable introduction to impressionist technique, indispensable for students of the period. Callen gives fully illustrated comparisons of thirty artists, including their individual palettes and many details. Introduces changing practice from the 1860s–90s with a table of standard canvas formats, illustrations of common canvas types, and a chronology that integrates technical developments with artistic events. The range is broader than the title implies; it includes impressionists from Pissarro and Monet to Caillebotte and Cassatt, as well as Courbet, Toulouse-Lautrec, Derain, and Matisse.

Campbell, Lorne, and Jill Dunkerton. 1996. "A Famous Gossaert Rediscovered." *Burlington Magazine* 138, no. 1116 (March): 164–73.
Ultraviolet studies help distinguish repaint that hid the quality of the original. Illustrated with details, cross-sections, and UV studies.

Carlyle, Leslie. 1999. *The Artist's Assistant: Oil Painting Instruction Manuals and Handbooks in Britian, 1800–1900, with Reference to Selected Eighteenth-Century Sources*. London: Archetype.
Carlyle surveys manuals written for both professional and amateur artists. She provides detailed information on the materials and applications methods recommended and compares them with colormen's catalogues to establish the actual availability of materials. Particular attention is given to the variety of paint mediums. Her final chapter addresses the artists' anticipation of changes and steps taken to counter them.

Carmean, E. A. Jr. 1989. *Helen Frankenthaler: A Paintings Retrospective*. Catalogue. Fort Worth, Texas, and New York: Modern Art Museum of Fort Worth and Harry N. Abrams.
Carmean discusses Frankenthaler's varying paint application (pouring, dripping, brushing, sponging), sequential layering of colors, her choice to work alternately against the wall and on the floor, her use of tape both for drawing and blocking out paint, and her cropping of already-painted canvases.

———. 1980. *Picasso: The Saltimbanques*. Catalogue. Washington, D.C.: National Gallery of Art.
See E. A. Carmean Jr. and Ann Hoenigswald with Barbara Miller, pp. 65–74. An art historical study in which technical evidence is crucial: contemporary accounts recorded that Picasso had reworked the composition several times, but X-ray studies confirm two entirely different paintings, as well as evolving versions of the final work.

———. 1979. *Mondrian: The Diamond Compositions*. Catalogue. Washington, D.C.: National Gallery of Art.

See E. A. Carmean Jr. and William R. Leisher with Barbara Miller, pp. 73–89. X-radiography and paint sampling demonstrate two instances in which "lost" paintings are actually earlier states of extant works.

Carmean, E. A. Jr., and Eliza E. Rathbone, with Thomas B. Hess. 1978. *American Art at Mid-Century: The Subjects of the Artist*. Catalogue. Washington, D.C.: National Gallery of Art.

Discussion of technique in entries on Gorky, Motherwell, Pollock, De Kooning, and Rothko—with particular emphasis on the sequence of paint application and in the case of de Kooning—in evolving states of a work. Hess addresses Barnett Newman's choice and preparation of his canvases for *Stations of the Cross*. Rathbone covers Rothko's attitudes toward installation and lighting of his paintings.

Cash, Sarah, with Claire M. Barry. 1994. *Ominous Hush: The Thunderstorm Paintings of Martin Johnson Heade*. Catalogue. Fort Worth, Texas: Amon Carter Museum. See pp. 69–82.

Technical notes on seven works by an artist who left no written record of his technique. Extensive discussion of paint application as well as conservation history. Supporting illustrations include details and raking-light and infrared studies.

Castedo, Leopoldo. 1976. *The Cuzco Circle*. Catalogue. New York: Center for Inter-American Relations and the American Federation of Arts.

See pp. 41–47 for a discussion comparing painting technique and materials in one of Spain's New World colonies with Iberian peninsular practice.

Cennini, Cennino d'Andrea. 1960. *The Craftsman's Handbook: The Italian "Il libro dell'arte."* Translated by Daniel V. Thompson Jr. 1933; reprint, New York: Dover, 1960.

Cennini's is one of the first systematic handbooks for artists' techniques. Written in Padua in the late fourteenth century, it codifies late medieval practice in Italy. Thompson's translation made Cennini available to American readers. Together with Thompson's modern manual adapted from Cennini (Thompson 1962) it also influenced artists.

Cézanne to Van Gogh: The Collection of Doctor Gachet. 1999. Catalogue. New York: Metropolitan Museum of Art.

See Danièle Giraudy, "'A Modern Olympia': Technical Comparison of Cézanne's Painting and Its Copy by Paul van Ryssel (Dr. Gachet)," pp. 39–43, Elisabeth Ravaud, "The Use of X-Radiography to Study Paintings by Cézanne and Van Gogh in the Gachet Collection," pp. 65–70, and Jean-Paul Rioux, "The Discoloration of Pinks and Purples in Van Gogh's Paintings from Auvers," pp. 104–13. Unusually well-documented technical studies employed to distinguish paintings by two masters from copies by their contemporaries that had occasionally been questioned as fakes. Rioux's article is a rare analysis of an unstable nineteenth-century lake pigment.

Christensen, Carol. 1993. "The Painting Materials and Technique of Paul Gauguin." *Studies in the History of Art* 41: 63–103.

A valuable reference for Gauguin's materials and technique (supports, primings, paint medium and application, surface coating, frames, retouching, and conservation history) based on a survey of one-third of his paintings. Christensen attempts to distinguish conscious experimentation from the effects of the artist's poverty or isolation, using the paintings themselves as a more accurate guide to the artist's technique than his statements. Includes bibliography and appendix of pigment analysis but lacks detailed illustrations.

Christiansen, Keith. 1986. "Caravaggio and l'esempio davanti del naturale." *Art Bulletin* 68 (September): 421–45.

A demonstration of the art historical implications of technique that has attracted much debate. Based on a study of ground incisings, Christiansen suggests that Caravaggio's use of live models was part of his radical method and contributed to his approach to content and style. Illustrations include raking-light photos, X-ray studies, and infrared reflectography. With a catalogue of twenty-four works attributed to Caravaggio that include incisions or other noteworthy technical features.

A Closer Look: Technical and Art Historical Studies on Works by Vincent Van Gogh and Gauguin. 1991. Edited by Cornelia Peres, Michael Hoyle, and Louis van Tilborgh. Cahiers Vincent 3. Amsterdam and Zwolle: Rijksmuseum Vincent Van Gogh and Waanders.

Extensive treatment report includes technical and historical discussion of paintings by both artists; special attention is paid to their use of fugitive synthetic lakes, to Van Gogh's palette and to his use of eggwhite coatings. Some essays have much more scientific information than the beginner will want. Excellent color illustrations include details, macrophotographs, raking-light photographs, mid-treatment photographs, and paint cross-sections. Useful technical information can also be found in *Cahiers Vincent* 5, *"The Potato Eaters" by Vincent Van Gogh*.

Cole, Bruce. 1983. *The Renaissance Artist at Work*. New York: Harper and Row.

See pp. 57–76. A clear narrative description of painting practice within a monograph that also describes the social world of the Renaissance artist, his training, and the function, location, and patronage of art. Cole also discusses the

changes that can distort our understanding of how the paintings originally looked.

The Collections of the National Gallery of Art Systematic Catalogue (multiple volumes since 1990). Washington D.C.: National Gallery of Art.
All contain technical notes for each painting; some volumes make extensive use of such information, with illustrations giving scholars access to data normally hidden in conservation department files. See John Oliver Hand and Martha Wolff, *Early Netherlandish Painting* (1986), which contains many infrared and some X-ray studies, all of which are discussed in the text, plus an appendix on scientific methodology; John Oliver Hand, *German Paintings of the Fifteenth Through Seventeenth Centuries* (1993), which is supported with many infrared and occasional X-ray studies; Ellen G. Miles et al., *American Paintings of the Eighteenth Century* (1995), which includes X-ray and infrared studies; and Arthur K. Wheelock Jr., *Dutch Paintings of the Seventeenth Century* (1996), which illustrates numerous X-ray studies and includes an appendix of signatures and monograms.

Completing the Picture: Materials and Techniques of Twenty-Six Paintings in the Tate Gallery. 1982. Catalogue. London: Tate Gallery.
Clear narrative descriptions, addressed to a general public, of the techniques of twenty-six painters whose work is represented in the Tate. Authors also discuss changes to the paintings over time. Includes British art from Gainsborough through Hockney and international modernism from Cézanne through Stella. Illustrations include cross-section diagrams, raking-light photographs, and X-ray studies.

Conisbee, Philip, et al. 1996. *Georges de La Tour and His World.* Catalogue. Washington, D.C.: National Gallery of Art.
See Edmund P. Pillsbury, "Condition and Quality," 233–37; Melanie Gifford et al., "Some Observations on Georges de La Tour's Painting Practice," 239–57; and Claire Barry, "Appendix: La Tour and Autoradiography," 288–301. Pillsbury emphasizes the importance of condition in attributing paintings to an artist whose secure works are few and for which numerous variants and copies exist. Technical studies emphasize the development of La Tour's practice. Does not duplicate the extensive X-ray studies published in *Georges de La Tour ou les chefs-d'oeuvre révélés* (1993).

Copley in America. 1995. Catalogue. Boston: Museum of Fine Arts.
See Morrison H. Heckscher, "Copley's Picture Frames," pp. 143–59. Extensive discussion of the "first American artist who took an active role in the design, manufacture and marketing of the frames" for his pictures.

Copper as Canvas: Two Centuries of Masterpiece Paintings on Copper, 1525–1775. 1999. Catalogue. Phoenix and New York: Phoenix Art Museum and Oxford University Press.
An exceptional interdisciplinary survey of the use of copper supports by artists in Europe and in Spain's New World colonies. Essays address technology, economics, and art history. There is a thorough essay on materials and techniques by Isabel Horovitz (pp. 63–92) and another on Antwerp copper plates by Jørgen Wadum (pp. 93–116), as well as Clara Bargellini's comparison of technique in Mexico and Peru with that used in Europe (pp. 31–44). Throughout, the authors attempt to distinguish the aesthetic qualities of a copper support and the reasons behind its use. Illustrated with details, photomicrographs, cross-sections, and infrared reflectography.

A Corpus of Rembrandt Paintings. 1982, 1986, 1989. Vol. 1, 1625–31; vol. 2, 1631–34; vol. 3, 1635–42. The Hague and Dordrecht: Stichting Foundation, Rembrandt Research Project, Martinus Nijhoff Publishers.
This constitutes the most systematic and fully illustrated body of technical information in English on any artist. See Ernst van de Wetering, "Painting Materials and Working Methods," vol. 1, pp. 11–33 (which includes a survey of panel dimensions) and "The Canvas Support," vol. 2, pp. 15–43 (which includes a survey of threadcounts in Dutch seventeenth-century painting, a threadcount survey of the Rembrandt school, and a survey of canvas sizes and strip widths for Rembrandt's early work), and catalogue entries throughout for comparative radiographs and infrared photographs of most works. The articles discuss the artist's materials and technique and the methodology of their examination.

de Couëssin, Charles. 1987. "Le dessin incise d'Henri Matisse." *Le dessin sous-jacent dans la peinture* Colloque VI, September 12–14, 1985. Louvain-la-neuve: Collège Erasme, pp. 75–80, pls. 50–59.
De Couëssin uses X-ray and infrared studies to examine the incised underdrawings in five Matisse paintings of the human figure. Discusses Matisse's incisions as a means of altering forms as he painted, as a manipulation of contour lines free from spacial considerations, and as an influence from his printmaking.

Cox-Rearick, Janet. 1982. "Bronzino's 'Young Woman with Her Little Boy,'" *Studies in the History of Art* 12: 67–79.
Art historical study following cleaning reveals two campaigns of work; the child was an addition during the second phase. Cox-Rearick compares this to Bronzino's more usual procedures. Illustrated with X-ray and infrared studies.

Danto, Arthur C. 1992. *Mark Tansey: Visions and Revisions.* New York: Harry N. Abrams.
See "Notes and Comments," pp. 127–35. From an interview with the artist by Christopher Sweet in which

Tansey addresses his technique, particularly his choice of a fluid, quick-drying paint. He also mentions the influence of Max Ernst's technique and improvised tools.

Doerner, Max. 1984. *The Materials of the Artist and Their Use in Painting with Notes on the Techniques of the Old Masters*. 1921; rev. English ed. translated by Eugen Neuhaus. San Diego: Harcourt Brace Jovanovich.
Doerner's guide to the range of traditional materials and techniques inspired many twentieth-century artists to try aspects of earlier practice. His section on "Old Master Technique" has been superseded by more recent research.

Driscoll, John Paul, and John K. Howatt. 1985. *John Frederic Kensett: An American Master*. Catalogue. Worcester and New York: Worcester Art Museum in association with W. W. Norton.
See Diane Dwyer, "John F. Kensett's Painting Technique," pp. 163–80. Study of twenty-one mostly late paintings by Kensett in the Metropolitan Museum. Largely uses visual examination aided by a microscope, some paint sampling, and infrared reflectography (illustrated). Discusses Kensett's methods, materials, degree of finish, and problems of aging and conservation.

Dunkerton, Jill, et al. 1991. *Giotto to Dürer: Early Renaissance Painting in the National Gallery*. London and New Haven: National Gallery Publications and Yale University Press.
See part 2, "The Making of Paintings," particularly pp. 152–204. The clearest and best-illustrated introduction to early Renaissance painting practice employed in both southern and northern Europe. Includes information on workshop practice, tools and equipment, frames, and contracts and commissions. Splendid illustrations include reverses of panels; micro- and macrophotographs; raking-light, X-ray, and infrared studies, and paint cross-sections. Very useful bibliography.

Dynasties: Painting in Tudor and Jacobean England, 1530–1630. 1995. Catalogue. London: Tate Gallery.
See Rica Jones, "The Methods and Materials of Three Tudor Artists: Bettes, Hillard, and Ketel," pp. 231–40. Author attempts to explain the original production and appearance of a range of Tudor painting for which documentary information is slight. Illustrations include numerous details; microphotographs; raking-light, X-ray, and infrared studies; and paint cross-sections.

Edgerton, Judy. 1990. *Joseph Wright of Derby: 1734–1797*. Catalogue. New York and London: Metropolitan Museum of Art and Tate Gallery.
See Rica Jones, "Wright of Derby's Techniques of Painting," pp. 263–71, which discusses Wright's materials and methods and their historical precedents according to genre. The only illustrations are paint cross-sections.

van Eikema Hommes, Margriet. 1998. "Painters' Methods to Prevent Colour Changes Described in Sixteenth to Early Eighteenth Century Sources on Oil Painting Techniques." In *Looking Through Paintings: The Study of Painting Techniques and Materials in Support of Art Historical Research*. Baarn and London: Uitgeverij de Prom and Archetype Publications.
See pp. 91–131. Using artists' recipe books, van Eikema Holmes demonstrates awareness of color changes, and she surveys the approaches taken to counter them. Illustrated with several useful color details and cross-sections documenting changes.

Faries, Molly. 1975. "Underdrawings in the Workshop Production of Jan van Scorel: A Study with Infrared Reflectography." *Nederlands Kunsthistorisch Jaarboek* 26: 89–228.
Compares underdrawings and inconsistencies of underdrawing style as a reflection of their function in the working process. See pp. 92–97 for a clear introduction to infrared reflectography.

Fiedler, Inge. 1989. "A Technical Evaluation of the 'Grande Jatte.'" *Art Institute of Chicago Museum Studies* 14, no. 2: 173–79, 244–45.
Report on a technical examination of Seurat's masterpiece illustrated with one X-ray study and several color details and photomicrographs. Fielder compares Seurat's pigment use in the three stages of the painting and discusses how it reflects evolving ideas on color theory.

Francis, Richard. 1984. *Jasper Johns*. New York: Abbeville.
See pp. 113–15. Includes discussion of Johns' choice of encaustic and details of the method.

Frinta, Mojmír S. 1993. "Observations on the Trecento and Early Quattrocento Workshop." *Studies in the History of Art* 38: 18–34.
Frinta suggests that punchwork may have functioned as a form of signature, intentionally tying a panel to a specific workshop. Based on his own research and on that of others (all cited, for a useful bibliography), Frinta suggests that workshops were more fluid than supposed, involving varying numbers of specialists as the commission demanded. Illustrated with many punchwork details.

Furth, Leslie. 1993. *Augustus Vincent Tack: Landscape of the Spirit*. Catalogue. Washington, D.C.: Phillips Collection.
See pp. 137–43. Notes, compiled by Elizabeth Steele, on the technique of each of the fifty-six works in the exhibition, illustrated with several infrared photographs and one detail. Discusses the influence of Tack's training as a mural painter, his frequent reuse of canvases, his interest in the borders and frames, and his use of cartoons and projections.

Garrido, María Carmen. 1992. *Velázquez: Técnica y Evolución*. Madrid: Museo del Prado.

An extraordinarily illustrated and invaluable systematic study of the technique of fifty-seven works by Velázquez in the Prado. Emphasizes how the artist's technique changed as he developed. Illustrated with X-ray and infrared reflectography studies, pigment and ground analyses of each painting, as well as many microphotographs and views of canvas edges. For an abridged English version that draws on the same technical material, see Brown and Garrido 1998.

——. 1984. "Algunas consideraciones sobre la técnica de las Pinturas Negras de Goya. *Bolletín del Museo del Prado* 5, no. 13 (January–April): 4–40.

Study of the Black Paintings, extensively illustrated with X-ray studies (including details), raking-light photographs, spectroscopy, and paint cross-sections that reveal how Goya changed the compositions as he worked.

Gaugh, Harry F. 1985. *The Vital Gesture: Franz Kline*. Catalogue. Cincinnati and New York: Cincinnati Art Museum and Abbeville.

See pp. 155–62, 173. A useful discussion of aging problems with post–World War II paintings even though it gives only a single example and does not illustrate the changes.

George Stubbs: 1724–1806. 1984. Catalogue. London: Tate Gallery.

See Robert Shepherd, "Stubbs: A Conservator's Note," pp. 20–21, and Ian McClure and Rupert Featherstone, "The Cleaning of Stubbs' 'Hambeltonian,'" pp. 22–23. Shepherd gives a brief account of the changes in Stubbs' technique after 1770 when he embarked on a search for a better paint medium. Paintings usually described as "oils" are found to be bound with a mixture of pine resin, beeswax, and nondrying oils, leading to great conservation problems. McClure and Featherstone report an examination associated with cleaning.

Georges de La Tour, ou, les chefs-d'oeuvre révélés: Les dossiers du Laboratoire de Recherche des Musées de France. 1993. Catalogue. Vic-sur-Seille: Editions Serpenoise.

Catalogue of an exhibition addressing the technical study of La Tour's work. Extensive illustrations include comparative X-ray studies of eighteen paintings by or after La Tour and several infrared studies, numerous details, and some paint cross-sections.

Gerhard Richter: Painting in the Nineties. 1995. London: Anthony d'Offay Gallery.

With an essay by Peter Gidal: "The Polemics of Paint." Gidal's discussion of Richter's process in terms of both the artist's intent and the viewer's reception is supplemented with illustrations of thirty-three successive stages of one abstract painting, *Red(821)*.

Gettens, Rutherford J., and George L. Stout. 1966. *Painting Materials: A Short Encyclopaedia*. 1942; reprint, New York: Dover, 1966.

Still invaluable, despite more recent research on some topics. Entries are arranged by material, so this is useful for art historians who wish to follow up on specifics. For discussion of pigments, *Artists' Pigments* 1986, 1993, 1997 are more current.

Giffords, Gloria Fraser. 1974. *Mexican Folk Retablos*. Albuquerque: University of New Mexico Press, 2nd ed., 1992.

Includes a thorough discussion of the technique as well as of the style and iconography of vernacular Mexican devotional paintings. Giffords discusses economics and developments in metallurgy as they affected the use of copper and tin-laminated supports.

Gombrich, Ernst H. et al. 1962–63. "Cleaning Controversies of 1962–63." *Burlington Magazine* 104–5 (February, June, November 1962, March, July, and September 1963).

A group of articles and responses provoked by the cleaning of paintings at the National Gallery, London. The authors debate the attitudes of Renaissance artists toward varnishing. The February '62 issue includes Gombrich, "Dark Varnishes: Variations on a Theme by Pliny," pp. 51–55; Otto Kurz, "Varnishes, Tinted Varnishes, and Patina," pp. 56–59; and S. Rees Jones, "Science and the Art of Picture Cleaning," pp. 60–62. The November '62 issue includes Joyce Plesters, "Dark Varnishes—Some Further Comments," pp. 452–60; Denis Mahon, "Miscellanea for the Cleaning Controversy," pp. 460–70; J. A. van de Graaf, "The Interpretation of Old Painting Recipes," pp. 471–75; and Michelangelo Muraro, "Notes on Traditional Methods of Cleaning Pictures in Venice and Florence," pp. 475–77. The March 1963 issue includes further articles by Gombrich, Kurz, Rees Jones, and P. L. Jones (pp. 90–103); responses are in the issues of June '62 (pp. 265–66) July '63 (p. 327) and September '63 (pp. 410–13). No illustrations.

Gomez-Moreno, Carmen, Arthur K. Wheelock Jr., Elizabeth H. Jones, and Millard Meiss. 1969. "A Sienese St. Dominic Modernized Twice in the Thirteenth Century." *Art Bulletin* 51: 363–66.

Technical information is crucial to this art historical study of a fragment that was updated twice in its early history. Places this work in the context of other early panels that were overpainted as style and iconography changed. Includes visual examination of the panel and X-ray studies. For a recent study that discusses a range of updated paintings, see Hoeniger 1995.

Gordon, Dillian. 1989. "A Dossal by Giotto and His Workshop: Some Problems of Attribution, Provenance, and Patronage." *Burlington Magazine* 131, no. 1037 (August): 524–31.

The cleaning of a small panel prompted inquiry about its original context. X-ray studies confirm its association with six other fragments and identify their format—supporting the art historical investigation.

Götz, Stephan. 1992. *American Artists in Their New York Studios: Conversations About the Creation of Contemporary Art.* Cambridge and Stuttgart: Center for Conservation and Technical Studies, Harvard University Art Museums, and Daco-Verlag Günter Bläse.

Götz emphasizes work on paper in his interviews, but many artists' attitudes toward change in their works over time apply equally to their paintings. Among the painters interviewed are Donald Baechler, Ross Bleckner, Moira Dryer, Jonathan Lasker, and Brice Marden.

Gould, Cecil. 1970. "The Raphael Portrait of Julius II: Problems of Versions and Variants, and a Goose that Turned into a Swan." *Apollo* (September): 186–89.

A famous case of a rediscovered original. X-ray studies enhance *pentimenti* visible to the naked eye and provoke further research on provenance, all of which support the primacy of the London variant.

Grimm, Claus. 1992. *The Book of Picture Frames.* 1981; 2nd English ed., with supplement by George Szabo, New York: Abaris Books.

Grimm's essay is an excellent introduction to the history of frames, their functions, and ideas to which they responded. Includes discussion of technical examination of frames and a good bibliography. The visual survey of frames has been surpassed by more recent literature.

———. 1990. *Frans Hals: The Complete Work.* English ed., New York: Harry N. Abrams.

This catalogue raisonné contains two useful sections concerning the physical aspects of Hals' work: pp. 13–24 list a number of paintings whose restoration revealed significant insights, and pp. 56–61 include a clear discussion of the types of changes that occur in paintings over time.

Habert, Jean, and Nathalie Volle. 1992. *Les noces de Cana de Véronèse: Une oeuvre et sa restauration.* Paris: Réunion des Musées Nationaux.

This extensive monograph includes a full spectrum of historical and technical approaches, documenting the painting's history of treatment as well as the recent cleaning. Extremely complete illustrations, many in color, include macrophotographs, paint cross-sections, mid-cleaning records, and X-ray, ultraviolet, and infrared studies. Discusses the decision of the conservation commission of 1990.

Hackney, Stephen. 1994. "Colour and Tone in Whistler's 'Nocturnes' and 'Harmonies,' 1871–72." *Burlington Magazine* 136, no. 1099 (October): 695–99.

A discussion of Whistler's palette and paint application in two series of paintings. Should be used with Townsend 1994, which addresses the artist's materials.

Hall, Marcia B. 1991. *Color and Meaning: Practice and Theory in Renaissance Painting.* Cambridge: Cambridge University Press.

Hall begins her definitive work on color within Renaissance painting with a cautionary chapter describing inevitable changes over time and the implications that these can have for historians. She covers chromatic changes, as well as damage from previous restorations. Includes an extensive discussion of the palette and handling properties that characterize tempera, fresco, and oil painting, as well as local traditions of using the various techniques.

Hamlyn, Robin. *Robert Vernon's Gift: British Art for the Nation, 1847.* 1993. Catalogue. London: Tate Gallery.

See Leslie Carlyle and Anna Southall, "No Short Mechanic Road to Fame: The Implications of Certain Artists' Materials for the Durability of British Painting, 1770–1840," pp. 21–26. An interesting historical discussion that emphasizes aging problems as a function of choice of materials and technique with particular reference to bitumen and megilp—hence also applicable to nineteenth-century American paintings.

Hanson, Anne Coffin. 1977. *Manet and the Modern Tradition.* New Haven: Yale University Press.

See especially pp. 137–76. Hanson analyzes Manet's technique in terms of academic methods and contemporary as well as subsequent criticism. She uses accounts of the artist's practice, X-ray studies, and analyses of unfinished paintings to demonstrate that Manet's technique was as influential as his new approach to subject matter.

Harley, R. D. 1970. *Artists' Pigments c. 1600–1835: A Study in English Documentary Sources.* London: Butterworths.

Provides a review of sources on English pigments with fascinating narrative detail of their history, manufacture, and the reception of new pigments. More general information on British technique can be found in Carlyle 1999 and Talley 1981.

Harten, Jürgen. 1995. *Siqueiros-Pollock, Pollock-Siqueiros.* Catalogue. Düsseldorf: Kunsthalle Düsseldorf.

Vol. 1 contains essays in German; vol. 2 is a catalogue in German, Spanish, and English. See Harten article, "When Artists Were Still Heroes," vol. 2, and catalogue entries throughout. Harten analyzes the relationship of the two

painters, including their use of commercial synthetic paints and new varnishes, and their interest in keeping up with scientific and industrial developments.

Hedley, G. 1993. *Measured Opinions: Collected Papers on the Conservation of Paintings*. London: United Kingdom Institute for Conservation.
Part 4, which far exceeds its stated subject of Varnish Removal, contains a number of essays that should be read by art historians interested in the aesthetic and philosophical issues around the cleaning of paintings. See particularly pp. 152–66 and 172–78. Hedley makes important distinctions about attitudes toward change and artistic intent that underlie competing approaches to cleaning. While directed at conservators, these articles contain neither jargon nor scientific data, and they fit very well within the literature on collecting, aesthetics, and artistic intent. Minimal illustrations.

Hendricks, Ella, Anne van Grevenstein, and Karin Groen. 1991–92. "The Painting Technique of Four Paintings by Hendrick Goltzius and the Introduction of Coloured Ground." *Nederlands Kunsthistorisch Jaarboek* 442–43: 481–98.
Technical study followed historical research that suggested a relationship between stylistic and technical changes by the Haarlem mannerists. Investigation of canvases, grounds, and paint layers (illustrated with numerous cross-sections) show how they adapted Venetian technique.

Herbert, Robert. 1979. "Method and Meaning in Monet." *Art in America* 67, no. 5 (September): 90–108.
Herbert analyzes Monet's paintwork and finds that its effect of spontaneity was the product of a complex layering that involved intermediate drying periods. Extensively illustrated, in color, with details.

Hess, Thomas. 1952. "Dubuffet Paints a Picture." *ArtNews* 51, no. 3 (May): 30–33, 66–67.
Photos and text document the artist building up a highly textured ground then working in successive layers of color, sometimes adding and sometimes removing previous work. The artist discusses his concerns about how his materials dry.

———. "Ben Shahn Paints a Picture." 1949. *ArtNews* 48, no. 3 (May): 20–21, 55–56.
Shahn discusses his choice of a gum-based tempera medium that allows him to work quickly, and the surface qualities he achieves with additions of eggwhite and other substances.

Heydenryk, Henry Jr. 1993. *The Art and History of Frames: An Inquiry into the Enhancement of Paintings*. 1963; 2nd ed., New York: Lyons and Burford, 1993).
A clear introduction to European and American frames from the middle ages through the early 1960s. The illustrations and bibliography have been superseded.

Hobbs, Robert, and Joanne Kuebler. 1990. *Richard Pousette-Dart*. Catalogue. Indianapolis and Bloomington: Indianapolis Museum of Art and Indiana University Press, 1990.
See David A. Miller, "Genesis and Metamorphosis: Materials and Techniques," pp. 168–77. A useful discussion of Pousette-Dart's choices of media and techniques and how they have withstood time. Illustrations include color details, the reverse of an early strainer, a series documenting twenty-five progressive states in the development of one painting, and a raking-light photo showing a canvas sagging under the weight of the paint.

Hobbs, Susan, Yu-tarng Cheng, and Jacqueline S. Olin. 1990. "Thomas Wilmer Dewing: A Look Beneath the Surface." *Smithsonian Studies in American Art* 4, nos. 3–4 (Summer–Fall): 62–85.
Study of Wilmer Dewing's changing methods of achieving similar effects throughout his career. Illustrated with autoradiograph, infrared, and X-ray studies.

Hoeniger, Cathleen. 1995. *The Renovation of Paintings in Tuscany, 1250–1500*. Cambridge: Cambridge University Press.
This study, following Gomez-Moreno et al. 1969, places a number of modernized works into historical context and examines the questions that such hybrid works pose to modern notions of originality. A historical assessment that depends on technical studies and raises philosophical questions for conservators and custodians of such paintings.

Hoenigswald, Ann. 1997. "Kazimir Malevich's Paintings: Surface and Intended Appearance." *Studies in the History of Art* 57: 108–25.
Study of the artist's materials and methods reveals frequent revisions and great attention to his surfaces, including variable sheen achieved through use of different paints or selective varnishing. Profuse illustrations, many in color (several showing extraordinarily subtle effects of varnish, craquelure, and *pentimenti*), as well as an X-ray study and a transmitted-light photograph.

———. 1982. "The 'Byzantine' Madonnas: Technical Investigation." *Studies in the History of Art* 12: 25–31.
A short, clear technical study that addresses an art historical problem and concludes that the Mellon and Kahn Madonnas are not by the same artist. Studies of the panel construction, priming and ground incising, gilding and paint application through visual examination, UV studies, photomicrographs, X-ray studies, and pigment analysis.

Hours, Madeleine. 1976. *Conservation and Scientific Analysis of Painting*. New York: Van Nostrand (English ed.).
A clear introduction, directed at nonscientists, to the various methods of scientific examination. Contains many useful black and white and color illustrations.

van Hout, Nico. 1998. "Meaning and Development of the Ground Layer in Seventeenth Century Painting." In *Looking Through Paintings*, cited under van Eickema Holmes 1998, pp. 199–225.

Van Hout far exceeds his title, giving the best overview available of grounds used by medieval through Baroque painters. Discusses the composition and application of grounds for panels and canvases, paying particular attention to the implications of a colored layer and the transition from a variably colored ground layer to the dead-coloring stage in the painting process. Illustrated with useful details, some in color.

Humfrey, Peter. 1993. *The Altarpiece in Renaissance Venice*. New Haven: Yale University Press.

This monograph on painted and sculpted altarpieces of early Renaissance Venice gives particular attention to their liturgical and physical context. Humfrey's discussion of the framing of altarpieces is exemplary. Chap. 4 includes sections on painters and frame makers and methods of altarpiece construction (illustrated with both diagrams and verso photographs of several examples). Illustrations throughout (many in color) include the frames and architectural settings, where extant, as well as treatment histories and subsequent changes to the altarpieces.

Humfrey, Peter, Mauro Lucco et al. 1998. *Dosso Dossi: Court Painter in Renaissance Ferrara*. Catalogue. New York: Metropolitan Museum of Art.

Three essays on Dosso's technique (Andrea Rothe and Dawson W. Carr, pp. 55–64, Jadranka Bentini, pp. 65–71, Anna Coliva, pp. 72–80) are illustrated with radiography, infrared reflectography, and details. They emphasize his significant changes of composition at the painting stage and situate Dosso firmly within the Venetian tradition described by Vasari. Most of the catalogue entries include technical observations, many of which are illustrated. Rothe and Carr's essay is a lucid discussion of the introduction of oil painting into Italy and its aesthetic implications. See pp. 82–83 for a clear description of the methodology.

I Tell My Heart: The Art of Horace Pippin. 1993. Catalogue. Edited by Judith E. Stein. Philadelphia and New York: Pennsylvania Academy of the Fine Arts in association with Universe Publishing.

See Mark F. Bockrath and Barbara A. Buckley, "Materials and Techniques," pp. 166–83. Information gained from more than sixty paintings forms the basis for understanding Pippin's materials and techniques, including his burnt-wood panels. A short discussion addresses conservation issues and problems with fakes.

Impressionist and Post-Impressionist Masterpieces: The Courtauld Collection. 1987. Catalogue. New Haven: Yale University Press.

See Robert Bruce-Gardner, Gerry Hedley, and Caroline Villers, "Impressions of Change," pp. 1–34, and catalogue entries throughout. Authors study forty-five paintings to assess their condition and the techniques the artists used to achieve their effects. Emphasis on compositions that evolved as the artist worked, as well as on changes that the paintings have undergone with time. Profusely illustrated with useful details, raking-light photographs, and X-ray studies. Catalogue entries document whether each painting has been lined and varnished.

Ingamells, John, and Herbert Lank. 1983. "The Cleaning of Watteau's 'Les charmes de la vie.'" *Burlington Magazine* 125, no. 969 (December): 733–38.

A short, highly readable article following treatment illustrated with an X-ray study and a photo of the painting stripped during restoration. Includes a discussion of the effects of Watteau's idiosyncratic technique on the aging of his paintings.

Italian Primitives: The Case History of a Collection and Its Conservation. An Exhibition Celebrating the Centenary of Yale University's Acquisition of the Jarves Collection. 1972. Catalogue. New Haven, Yale University Art Gallery.

An unusually honest condition study that greatly enhances the didactic value of a collection with many well-worn works. Black and white illustrations compare paintings with misleading repaint and in stripped state; includes some X-ray studies. This catalogue contributes to the discussion of the appropriate manner and degree of repainting.

Jacob Lawrence: The Migration Series. 1993. Catalogue. Edited by Elizabeth Hutton Turner. Washington, D.C.: Rappahannock Press in association with Phillips Collection.

See Elizabeth Steele and Susana M. Halpine, "Precision and Spontaneity: Jacob Lawrence's Materials and Techniques," pp. 155–60. Discusses Lawrence's choice and handling of materials to achieve unity throughout a sixty-painting series. Contrasts his tempera technique with that of contemporaries Ben Shahn and Romare Bearden. Illustrated with photomacrographs showing Lawrence's use of accidental pitting in the ground layer, his means of transferring preliminary drawings, an infrared photo that reveals underdrawing, and a number of details.

Jirat-Wasiutynski, Vojtech, and H. Travers Newton Jr. 1999. *Technique and Meaning in the Paintings of Paul Gauguin, 1783–1889*. Cambridge: Cambridge University Press.

A collaborative investigation by an art historian and conservator that looks at the historical and cultural context

of Gauguin's response to impressionism and exploration of both primitivist and decorative tendencies. The authors examine the range of meanings that the physical appearance of the paintings had for the artist and his early viewers. Extensively illustrated with raking-light photographs, X-ray, infrared, and UV studies, transmitted light photographs, and details. Appendices on Gauguin's materials orders and his instructions on restoration and presentation of his paintings.

Jirat-Wasiutynski, Vojtech, H. Travers Newton et al. 1984. *Vincent Van Gogh's Self-Portrait Dedicated to Paul Gauguin: An Historical and Technical Study*. Cambridge: Center for Conservation and Technical Studies, Harvard University Art Museums.
A fascinating example of the historical implications of repaint. Uses documentary research combined with paint sampling to establish that Gauguin performed the rather crude repairs to the portrait given him by his friend.

Johannes Vermeer. 1995. Catalogue. Edited by Arthur K. Wheelock Jr. Washington, D.C.: National Gallery of Art.
See Wheelock's "Vermeer of Delft: His Life and His Artistry," pp. 15–29; Jørgen Wadum, "Vermeer in Perspective," pp. 67–79; and catalogue entries throughout. The exhibition attempted to provide a better understanding of this mysterious artist by studying his methods, particularly in regard to perspective. Wadum's article uses evidence of ground pricing to re-create Vermeer's means of constructing perspective lines on the canvas. All entries include technical descriptions and are illustrated with useful details and X-ray and infrared studies, with emphasis on *pentimenti*.

Jones, Rica. 1997. "Gainsborough's Materials and Methods: A 'Remarkable Ability To Make Paint Sparkle.'" *Apollo* 146, no. 426 (August): 19–26.
Based on a study of twenty paintings, including eight early conversation pieces. Jones pays particular attention to Gainsborough's grounds, practice of painting in a single layer, paints, and paint mixing. She attempts to distinguish his practice from that of his British contemporaries, and she suggests possible influences from Dutch technique. Illustrated with details and microphotographs of paint samples.

Katlan, Alexander. 1987. *American Artists' Materials: Suppliers Directory, Nineteenth Century*. Park Ridge, N.J.: Noyes Press.
An essential reference for identifying and dating nineteenth-century American canvases that have evidence of colormen's marks.

Katlan, Alexander, and Peter Hastings Falk, eds. 1992. *American Artists' Materials*. Vol. 2: *A Guide to Stretchers, Panels, Millboards, and Stencil Marks*. Madison, Conn.: Sound View Press.
As with the previous volume, this is the standard reference on American panels and millboards that were commercially manufactured or distributed.

Katz, Melissa R. 1998. "Holman Hunt on Himself: Textual Evidence in Aid of Technical Analysis." In *Looking Through Paintings* (cited under van Eikema Hommes 1998), pp. 415–44.
Katz compares Hunt's many comments on his technique in articles, lectures, memoirs, and correspondence with the sometimes conflicting evidence of the paintings. This lively discussion examines not only Hunt's practice but also the motivation behind his many public statements. Discusses his campaign against artists' materials manufacturers and the mythology of the Pre-Raphaelite technique of painting on a wet ground (pseudo-fresco).

Kellein, Thomas, ed. 1992. *Clyfford Still, 1904–1980*. Catalogue. Munich: Prestel-Verlag.
See Michael Auping, "Clyfford Still and New York: The Buffalo Project," pp. 23–46, especially pp. 41–42, where Auping describes Still's paints and their handling, particularly his control of glossy versus matte areas. He cites Still's concern that his paintings not be overlit.

Kemp, Martin. 1994. "From Scientific Examination to the Renaissance Market: The Case of Leonardo da Vinci's 'Madonna of the Yarnwinder.'" *Journal of Medieval and Renaissance Studies* 24, no. 2 (Spring 1994): 259–74.
Kemp employs technical examination to study patronage and workshop practice in the production of variants of small, devotional paintings. Comparison of the underdrawings of two versions leads him to suggest a more complex relationship than assumed, suggesting that "the way we have tended to discuss 'originals,' 'copies,' 'versions,' and 'variants' may be too simplistic." Illustrated with infrared reflectograms.

Kemp, Martin, and Ann Massing, with Nicola Christie and Karin Groen. 1991. "Paolo Uccello's 'Hunt in the Forest.'" *Burlington Magazine* 133, no. 1056 (March): 164–78.
Report following treatment with significant historical results. Study of the ground incisions proves crucial in reconstructing Uccello's perspective system. Illustrated with details, infrared reflectography and X-ray studies, paint cross-sections, and diagrams.

King, Antoinette. 1992. "Kurt Schwitters's 'Cherry Picture': Material Change and an Ethical Problem." In *Essays on Assemblage*. New York: Museum of Modern Art.
See pp. 31–41. A discussion of the conservation ethics in restoring a collage. Problems center on a signature that was not visible in early photographs of the work, an affixed cork that has migrated, and the inevitable drying of the glue over time.

Kleeblatt, Norman, Kenneth E. Silver et al. 1998. *An Expressionist in Paris: The Paintings of Chaim Soutine*. Catalogue. Munich and New York: Prestel and the Jewish Museum.

See Ellen Pratt, "Soutine Beneath the Surface: A Technical Study of His Painting," pp. 119–35. Pratt compares the physical evidence of twenty-two paintings with comments on the artist's technique by colleagues, contemporaries, and later writers. She pays particular attention to Soutine's reuse of old canvases, his enlargement of supports, and the destruction of his own work. Illustrated with six X-ray studies.

Kornhauser, Elizabeth Mankin. 1991. *Ralph Earl: The Face of the Young Republic*. Catalogue. New Haven and Hartford: Yale University Press and the Wadsworth Atheneum.

See Stephen H. Kornhauser, "Ralph Earl's Working Methods and Materials," pp. 85–91. Uses a patron's account book, contemporary painting manuals, the artist's letters and physical analysis of the paintings to understand the implications of Earl's technique. Discusses varying availability and cost of materials as Earl traveled from London to New York and to rural New England. Single illustration of a canvas seam.

Lanchner, Caroline. 1993. *Joan Miró*. Catalogue. New York: Museum of Modern Art and Harry N. Abrams.

Lanchner emphasizes Miró's material experiments as means of developing his radical ideas about painting as well as methods of working out compositions. She relates his unprecedented use of the trace of the stretcher-bar showing through the canvas to ideas from collage. The catalogue is very well illustrated, although the technical points are not specifically illustrated.

Laughton, Bruce, and Lucia Scalisi. 1992. "Millet's 'Wood Sawyers' and 'La République' Rediscovered." *Burlington Magazine* 134, no. 1066 (January): 12–19.

Report following conservation discloses an earlier painting beneath the present one. Discusses the painting's history, development, and treatment history, and the significance of the underlying composition.

Leighton, John, and Colin J. Bailey. 1990. *Caspar David Friedrich: Winter Landscape*. Catalogue. London: National Gallery.

Leighton's article incorporates technical evidence that the recently discovered London variant is original, throwing the status of Dortmund's painting into question. Bailey's article addresses Friedrich's technique more generally, particularly his use of new and unusual pigments. Illustrated with infrared reflectography.

Leonard, Mark, and Louise Lippincott. 1995. "James Ensor's 'Christ's Entry into Brussels in 1889': Technical Analysis, Restoration, and Reinterpretation," *Art Journal* 54, no. 2: 18–27.

A study following cleaning that forces a reconsideration of the place of this major work within late nineteenth-century art. Close visual examination reveals that Ensor executed the entire fourteen-foot painting according to preconceived plan, using straightforward technique. This contradicts previous suggestions that the painting was proto-modernist in execution.

Leonard, Mark, et al. "Dieric Bouts' 'Annunciation' Materials and Techniques: A Summary." *Burlington Magazine* 130, no. 1024 (July): 517–22.

The best study readily available of a glue-size painting on canvas (*Tüchlein*), with wonderful illustrations, including photomicrographs, macrophotographs, X-ray, and UV examinations, and a view of the reverse of the canvas.

Levenson, Rustin Steele. 1983. "Materials and Techniques of Painters in Québec City, 1760–1850," *Journal of Canadian Art History* 7, no. 1: 1–54.

Discusses the techniques and materials of a group of Canadian painters, the availability of local versus imported artist's supplies, the literature on technique available to Quebec artists, and the artists' contact with European art. A rare attempt to examine the relationship between British and colonial painting in terms of materials and technique.

Lodge, Robert G. 1988. "A History of Synthetic Painting Media with Special Reference to Commercial Materials." Preprints of the American Institute for Conservation Sixteenth Annual Meeting, New Orleans, June 1–5, pp. 118–27.

An interesting and detailed history of twentieth-century synthetic paints, beginning with the needs of the Mexican muralists for paints that would survive outdoor display. Also discusses the economic motivation behind the development of synthetic paints under the WPA. Article contains no scientific terminology other than the chemical names for various synthetic paints. Not illustrated.

Lucas Van Leyden Studies. 1978. *Nederlands Kunsthistorisch Jaarboek* 29.

See particularly J. P. Filedt Kok, "Underdrawing and Other Technical Aspects in the Paintings of Lucas van Leyden," pp. 1–184. This volume contains a great deal of technical information—probably more than the beginner wants, but very useful comparative material. Filedt Kok illustrates the examination of fifteen paintings attributed to van Leyden with stereomicroscope, X-ray, and infrared studies. Hermsdorf et al., "The Examination and Restoration of 'The Last Judgement' by Lucas van Leyden," pp. 311–424, is an exhaustive study and treatment report on the material history of the altarpiece, past restoration, panel and frame construction, and chemical and physical analyses.

Lunde, Karl. 1975. *Isabel Bishop*. New York: Harry N. Abrams.
See pp. 62–65. Describes Bishop's use of old master techniques (which she adapted from Doerner's description of Rubens' technique) in preparing her panels, her use of varnish to manipulate the ground absorbency, her method of glazing, and her mixed tempera and oil media. Good illustrations include two details that reveal specifics of paintwork.

MacDonald, Bruce K. 1969. "The Quarry by Gustave Courbet." *Bulletin, Museum Fine Arts, Boston* 67: 52–71.
Analyzes Courbet's "synthesizing" method of developing paintings from a group of fragments. Uses technical analysis, including X-ray studies and direct examination of the canvas. N. 17 includes a catalogue of Courbet's works on pieced canvas.

McEvilley, Thomas. 1995. *Pat Steir*. New York: Harry N. Abrams.
See especially pp. 61–77 for an analysis of Steir's drip and poured Waterfall paintings as a response to Pollock and the modernist tradition of paint handling.

McKim-Smith, Gridley, Greta Andersen-Bergdoll, and Richard Newman. 1988. *Examining Velázquez*. New Haven: Yale University Press.
A pioneering integration of technical studies, historical studies, and aesthetics. McKim-Smith shows how technical examination elucidates analysis of period texts as well as larger theoretical issues, such as the status of painting. Subtle discussion of the debate around the concept of "sketchiness"—with general implications about the meaning of brushwork in the Baroque. Illustrations include details, cross-sections, X-ray studies, and color plates. The technical studies were done from a narrower sample than that used by Garrido 1992.

McKim-Smith, Gridley, María del Carmen Garrido Pérez, and Sarah Fisher. 1985. "A Note on Reading El Greco's Revisions: A Group of Paintings of the Holy Family." *Studies in the History of Art* 18: 67–77.
Technical examination reveals that El Greco often revised paintings as he worked. This article poses three different uses of X-ray studies in comparing variants: to study working procedures, iconography, and El Greco's stance within contemporary theoretical debates. Exemplary in its sophisticated demonstration of how the historian must bring the questions to the technical data.

Making and Meaning: The Young Michelangelo. 1994. Catalogue. London: National Gallery Publications and Yale University Press.
See Jill Dunkerton, "Michelangelo as a Painter on Panel," pp. 83–133. Study of the two unfinished paintings in London compares them with the technique of the Doni Tondo as well as that of Michelangelo's Florentine contemporaries. Illustrated with extraordinary color plates and details of the London and Florence panels, which demonstrate a clear comparison of color changes over time. Also illustrates panel edges and reverses, raking-light views, infrared and X-ray studies, and paint cross-sections.

Mancinelli, Fabrizio. 1979. *Primo Piano di un Capolavoro: La Transfiguration di Rafaello [A Masterpiece Closeup: "The Transfiguration" by Raphael]*. Vatican City: Libreria Editrice Vaticana.
Profusely illustrated conservation report with many life-size details and X-ray studies. Documents the 1970s restoration, revealing details left incomplete by Raphael, and discusses earlier treatments.

Manners and Morals: Hogarth and British Painting, 1700–1760. 1987. Catalogue. London: Tate Gallery.
See Rica Jones, "The Artist's Training and Techniques," pp. 19–28. Discusses the early British academies, including Kneller's, Thornhill's, and St. Martin's Lane, and changes in technique during the seventeenth century as manifest in the work of Hogarth, Ramsay, Reynolds, and their contemporaries.

Marette, Jacqueline. 1961. *Connaissance des primitifs par l'étude du bois*. Paris: Editions A. and J. Picard.
The standard reference on European panels as painting supports through the sixteenth century. Includes information on type of wood and cuts favored by region; extensive illustrations include the reverses of panels. Marette's discussion of preferred cuts of wood according to region are given in English translation in R. H. Marijnissen, *Paintings: Genuine, Fraud, Fake: Modern Methods of Examining Paintings* (Zaventum: Elsevier Librico, 1985), p. 61.

Mark Rothko. 1983. Catalogue. London: Tate Gallery.
See Dana Cranmer, "Painting Materials and Techniques of Mark Rothko: Consequences of an Unorthodox Approach," pp. 189–97. Discussion by the conservator of Rothko's estate of his experimental approach to paint films, manipulation of media, and stretching of canvases—and the resulting instability of his paintings. Documents the technique of his three mural commissions as well as the evolution of his easel paintings. Cranmer writes clearly about the range of changes that had occurred within two decades, and the dilemma they present their caretakers. Includes one raking-light photograph illustrating stress cracks.

Mark Rothko's Harvard Murals. 1988. Cambridge: Center for Conservation and Technical Studies, Harvard University Art Museums.
A beautifully documented account of a major loss—the fading of Rothko's Harvard murals. The existence of before and after color plates eloquently illustrates changes

in unstable pigments through prolonged exposure to unfiltered light. This should be required reading for potential painters and patrons of public commissions.

Max Beckmann: Retrospective. 1984. Catalogue. St. Louis, Munich, and New York: St. Louis Art Museum in association with Prestel-Verlag and W. W. Norton. Edited by Carla Schulz-Hoffman and Judith C. Weiss.

See Bruno Heimberg, "Beckman's Painting Technique," pp. 129–36. Quotes excerpts from the artist's diaries to support study of his method of working on a canvas over time, and traces his increasingly layered paint application. Discusses Beckmann's manipulation of surface gloss from one area to another and his aversion to varnish. Includes results of paint sampling. Illustrated with an unfinished painting and multiple details.

Mendgen, Eva, et al. 1995. *In Perfect Harmony: Picture + Frame, 1850–1920.* Catalogue. Amsterdam and Zwolle: Van Gogh Museum and Waanders Uitgevers.

Individual articles on artists who designed their own frames, including Lenbach and Böclkin, Pre-Raphaelites and Arts and Crafts movements, Whistler, the Vienna Secession, Degas, Pissarro, Seurat, Van Gogh, Les XX, and modernists from Suprematism and Cubism through De Stijl. Artists are shown to respond to various issues: the idea of an autonomous artwork, the increasing status of paintings as consumer products, the decline of design and craftmanship in mass-produced frames, an interest in integrating painting and interior, a loosening hierarchy of fine and applied arts, and an attempt by artists to control the presentation and promotion of their work. Splendid illustrations, mostly in color, as well as numerous black and white period views of artists' homes, studios, and early exhibitions. Useful bibliography.

Merrifield, Mary P. 1849. *Original Treatises Dating from the XIIth to the XVIIIth Centuries on the Arts of Painting.* Reprint, New York: Dover, 1967.

A useful anthology of original-language texts, facing translations, of a range of artists' manuals.

Michelangelo Merisi da Caravaggio: Come nascono i capolavori. 1991. Catalogue. Florence and Milan: Palazzo Pitti and Electa.

Focuses on the close, technical examination of Caravaggio's work. Very well illustrated throughout with both black and white and color details, raking-light photographs, infrared and X-ray studies. Technical studies address the meaning of ground incisings and the relation among variants. Useful bibliography for technical studies of Caravaggio. For fur-

ther discussion, see the conference papers, *Come dipingeva il Caravaggio; Atti della giornata di studio,* edited by Mina Gregori (Milan: Electa, 1996).

Miller, Bruce. 1987. "Otto Dix and His Oil-Tempera Technique." *Bulletin of the Cleveland Museum of Art* 124, no. 8 (October): 332–51.

Study of a prominent Neue Sachlichkeit painter known for his distinctive technique. Traces the development of Dix's *Lazurtechnik* (glaze technique) and rejection of *alla prima* painting. Miller shows that Dix likely derived his recipes from Doerner's writing rather than from studying the old masters. Supported with the artist's own written instructions about technique and illustrated with X-ray studies, infrared reflectography, and raking-light photographs of a painting in Cleveland.

Mitchell, Paul, and Lynn Roberts. 1996. *Frameworks: Form, Function, and Ornamentation in European Portrait Frames.* Catalogue. London: Paul Mitchell in association with Merrell Holberton.

Extensively illustrated catalogue, fully in color, to an exhibition surveying a range of Renaissance through modern frames. The authors address frames in the context of interior decoration and in formal relationship to the paintings. This is less a reference work than the same authors' *History of European Picture Frames* (following entry), but its illustrations, which emphasize frames as they surround actual paintings rather than as isolated moldings, are invaluable.

Mitchell, Paul, Lynn Roberts, and William Adair. 1996. "Frames." In *Dictionary of Art.* London: Macmillan.

Vol. 11, pp. 372–499. Mitchell and Roberts' introduction and discussion of European frames is reprinted as *A History of European Picture Frames* (London: Paul Mitchell in Association with Merrell Holberton, 1996). Adair's entry on American frames summarizes his 1983 monograph but gives few details. Mitchell and Roberts emphasize style in their detailed history of the principal types of European frames, with essays arranged by country. Black and white illustrations include photographs of framed paintings, but most are drawings emphasizing the detailed morphology of moldings. The bibliographies after each section are extremely useful.

Mosby, Dewey F., and Darrel Sewell. 1991. *Henry Ossawa Tanner.* Catalogue. Philadelphia and New York: Philadelphia Museum of Art and Rizzoli.

See discussion of the late work, pp. 242–89. Text and catalogue entries examine Tanner's experimental technique, which included emulsions and layering of different media to produce surfaces that are at once textured and enamel-like. Includes some discussion of aging problems and quotes the artist on the ideal way to preserve the paintings.

Muñoz Viñas, Salvador. 1998. "Original Written Sources for the History of Mediaeval Painting Techniques and Materials: A List of Published Texts." *Studies in Conservation* 43, no. 2: 114–24.
Annotated bibliography of twenty-two important medieval recipe books and treatises, with comments on the various editions and translations into English, French, German, and Italian. Directed at conservators who want to review original sources, this should be equally useful to historians.

National Gallery of Art, Washington, D.C. 1990–. See *The Collections of the National Gallery of Art Systematic Catalogue* (multiple volumes since 1990).

National Gallery, London. 1988–. *National Gallery Schools Catalogues* (multiple volumes since 1988).
Previous editions have set a standard by including technical and condition information for each entry. This revised series is illustrated, and some volumes include specifically technical photographs. *The Early Italian Schools Before 1400* (1988) by Martin Davies, revised by Dillian Gordon, contains limited technical photographs (two radiographs and several panel reverses); *The Dutch School: 1600–1900* (1991) by Neil MacLaren, revised and expanded by Christopher Brown, includes an appendix of details of signatures; *The British School* (1998) by Judy Edgerton illustrates the collection in color but with no specific technical photographs; *The Fifteenth-Century Netherlandish Schools* (1998) by Lorne Campbell contains color illustrations and extensive technical photographs, including panel reverses, radiographs, numerous infrared studies, and photomicrographs.

Newbery, Timothy J., George Bisacca, and Laurence B. Kantor. 1990. The Italian Renaissance Frames. Catalogue. New York: Metropolitan Museum of Art and Harry N. Abrams.
Describes the construction techniques of frames (and sometimes panels), including diagrams of frame profiles and details of condition for each entry. Text traces the evolution of frame types based on structural and stylistic needs. Useful bibliography.

Nicolaus, Knut. 1998. *The Restoration of Paintings*. English ed., Cologne: Könemann, 1999.
Nicolaus, who developed a conservation training program, gives a detailed and useful survey of current and historical methods of treating European paintings, primarily old masters. Extraordinary illustrations, mostly in color, include diagrams, details, and microphotographs focusing on treatments rather than analysis. Also includes unusual documentation of damage from faulty treatments. This volume will be useful in enabling curators and art historians to follow detailed descriptions in treatment reports (although the translation results in terminology that is not always standard English).

———. 1982. *DuMont's Bild-Lexikon zur Gemäldebestimmung*. Cologne: DuMont Buchverlag.
Dictionary of terms in the examination of paintings with splendid illustrations, primarily in black and white. Extremely useful reference work for art historians to back up the more difficult technical literature. This and the following are hard to obtain in U.S. libraries.

———. 1979. *DuMont's Handbuch der Gemäldekunde: Material, Technik, Pflege*. Cologne: DuMont Buchverlag.
An excellent introduction to materials, technique, and examination of old master paintings, giving detailed information on subsequent aging effects. The thorough illustrations, in black and white and color, contain annotations that increase their legibility. They include numerous details (including backs and sides of paintings), macrophotographs, and X-ray and infrared studies.

Paint and Painting. 1982. Catalogue. London: Tate Gallery.
This catalogue directed at a general public gives a clear introduction to the history of painting materials, including discussion of pigments and media, artists' colormen, and artists' equipment and studios. Many illustrations include a full-color chart of the development of colors and examples of palettes, early paint tubes, studio practice, and paint technology.

Paint and Purpose: A Study of Technique in British Art. 1999. London: Tate Gallery. Edited by Stephen Hackney, Rica Jones, and Joyce Townsend.
Studies of thirty paintings in the Tate's collection by British School artists of the sixteenth through twentieth centuries. Artists whose technique is little studied elsewhere include William Blake, John Everett Millais, George Frederic Watts, Gwen John, Duncan Grant, David Bomberg, Walter Sickert, Stanley Spencer, and Ben Nicholson. Extremely clear narrative accompanied by a range of details and technical photographs addresses both the painters' technique and choice of materials as well as questions of aging. This volume, the next best thing to being able to walk through the galleries with museum conservators, should be extremely useful to artists and art historians interested in a range of painting.

Parris, Leslie, and Ian Fleming-Williams. 1993. *Constable*. Catalogue. New York: Cross River Press, originally London: Tate Gallery, 1991.
See Sarah Cove, "Constable's Oil Painting Materials and Techniques," pp. 493–529. Study based on the examination of fifty paintings that cover the range of Constable's work. Evidence from the paintings is considered in light of the artist's studio practice, contemporary artists' handbooks, published information on technique by Constable's contem-

poraries, and his own writings. It includes evidence of Constable's attitudes toward varnish. Extensively illustrated in color with details, microphotographs, infrared and raking-light photography. Also includes a table of the artist's pigments and one of his binding media, both based on scientific examinations, and detailed case studies of two paintings.

Paul Klee. 1987. Catalogue. Edited by Caroline Lanchner. New York: Museum of Modern Art.
See Ann Temkin, "Klee and the Avant-Garde 1912–1940," pp. 13–37. Temkin pays close attention to Klee's experiments with a wide variety of supports, grounds, paints, and their means of application throughout his career. She relates this to the artist's changing concerns and to parallel technical experiments by the dadaists and the surrealists.

Penny, Nicholas, with Michael Gregory. 1986. "Frame Studies: I. Reynolds and Picture Frames." *Burlington Magazine* 128, no. 1004 (November): 810–25.
A clear history of the development of the professional framer in the mid-eighteenth century, discussing the transition from frames designed by architects or artists to those designed by framers and dealers and selected by patrons. Penny mentions the reaction against frame makers' taste by later artists, including Ingres, the Nazarenes and Pre-Raphaelites, Whistler, and Seurat.

Percival-Prescott, Westby. 1974. "The Lining Cycle: Fundamental Causes of Deterioration in Painting on Canvas. Materials and Methods of Impregnation and Lining from the Seventeenth Century to the Present Day." Conference on Comparative Lining Techniques. Greenwich: National Maritime Museum. Reprinted in *Lining of Paintings: A Reassessment*, edited by M. Ruggles (Ottawa: National Gallery of Canada, 1976), pp. 1–47.
Historical account of the development of canvas supports, grounds for painting on canvas and their subsequent deterioration, and the historical response in the form of improved artists' techniques, as well as a history of impregnation and lining treatments for aged paintings. Percival-Prescott emphasizes the ongoing need for treatment, hence the cyclicality. While detailed and directed at conservators, this should be of great use to art historians and crucial to those interested in the history of collecting. Not illustrated, and unfortunately hard to obtain. Complemented by Caley 1990, which gives a parallel history of treatments of the varnish layer.

Pérez, María del Carmen Garrido. *See* Garrido, María Carmen, and Garrido, Carmen.

Picasso: The Early Years, 1892–1906. 1997. Catalogue. Washington, D.C., and New Haven: National Gallery of Art and Yale University Press.
See Ann Hoenigswald, "Works in Progress: Pablo Picasso's Hidden Images," pp. 299–309. Examines Picasso's technique of reworking images into significantly different compositions. Illustrated with X-ray studies, infrared reflectograms, and raking-light studies that reveal his earlier states. The article is particularly clear about the visual clues to changes in composition. These include impasto from the earlier layer, earlier colors showing through upper paint, and different colors revealed by cracks and losses. N. 4 contains a bibliography of technical studies of early Picasso.

Plesters, Joyce. 1993. "Examination of Giovanni Bellini's 'Feast of the Gods': A Summary and Interpretation of the Results." *Studies in the History of Art* 45: 374–91.
The clearest summary of the recent examination and cleaning (with more interpretation of the technical results than previously published in *Studies in the History of Art* 40, a monograph on the painting). Shows three separate campaigns in the painting's development. Articles in the same volume by David Alan Brown and David Bull include discussion of technical questions.

———. 1968. "Microphotographs of Cross-Sections of Paint and Ground Samples." *Museum* 21, no. 4: 257–65.
Fully illustrated in color. While fairly scientific, this is the most accessible body of comparative cross-section studies across a range of European paintings. For ground studies this article should be used in conjunction with Phillip Hendy and A. S. Lucas' article in the same journal volume, "The Ground in Pictures," pp. 266–76.

Poetter, Jochen, and Helmut Friedel, eds. 1994. *Chuck Close.* Catalogue. Baden-Baden and New York: Staatliche Kunsthalle Baden-Baden and Distributed Art Publishers.
See Margrit Franziska Brehm, "On the Simultaneity of Difference and the Variety of Sameness: The Evolution of Chuck Close' Work," pp. 62–100. Documents Close's technical changes over time, his use of his fingers to apply paint, and the relationship of the artist's thinking and technique across painting, drawing, printmaking, and photography.

Poussin et la peinture francaise du XVIIe siècle, special issue of *Techne: La Science au service de l'histoire de l'art* 1. 1994.
This bulletin of the Louvre's Research Laboratory contains twelve articles, with detailed illustrations, addressing Poussin's technique and its examination. Includes important comparative data on Poussin's canvases and grounds as well as articles on La Tour and Le Seur. Some entries are directed at scientists, but the photographs and bibliography of technical literature (pp. 75–76) should make this

volume invaluable for students of seventeenth- and eighteenth-century French painting.

Princeton Raphael Symposium: Science in the Service of Art History. 1990. Edited by John Shearman and Marcia B. Hall. Princeton: Princeton University Press.
A dialogue among art historians, conservators, and scientists. The articles take a variety of approaches, including art historical studies, treatment reports, and results of scientific studies. This is a particularly accessible body of technical information on a single artist supported with excellent illustrations, including color details and paint cross-sections, mid-treatment views, reverses of panels, and comparative UV, X-ray, and infrared studies.

Revue de l'Art 76. 1987.
Special issue devoted to frames includes an overview by Claus Grimm, eight articles on specific periods (fifteenth through nineteenth centuries) and a useful bibliography, all in French.

Reynolds. 1986. Catalogue. Edited by Nicholas Penny. London: Royal Academy of Arts with Weidenfeld and Nicolson.
See M. Kirby Talley Jr., "All Good Pictures Crack," pp. 55–69. Discussion of Reynolds' materials, technique, workshop practice, commercial activities, and attitudes to change. Charts Reynolds' impatience in emulating the effects rather than the actual techniques of the old masters and the consequent stability problems and necessary restorations that date from the artist's own lifetime, including those by Reynolds himself.

Rhyne, C. S. 1990. "Constable's First Two Six-Foot Landscapes." *Studies in the History of Art* 24: 109–29.
Technical studies make a major art historical contribution: X-ray examination exposes the beginning of Constable's first six-foot landscape, which he overpainted with his earliest large oil sketch. This enables a reconstruction of the origin of the six-foot sketches and an interpretation of their function within Constable's oeuvre. For a general introduction to Constable's technique, see Parris and Fleming-Williams 1993.

Richardson, Brenda. 1976. *Frank Stella: The Black Paintings*. Catalogue. Baltimore: Baltimore Museum of Art.
See p. 12, "Chronology," for discussion of technique, and p. 15, "Physical Condition." Catalogue entries do not have condition notes, but this brief introduction makes explicit mention that "few of the paintings remain in their *original* condition"—less than two decades after they were painted. It includes details of the types changes in the paintings and

keys to identifying restored or repainted works. Although the changes are not illustrated, the authors note the general difficulty of reproducing this series and the variable accuracy of the catalogue illustrations.

Richardson, John. 1983. "Crimes Against the Cubists." *New York Review of Books* 30, no. 10 (June 16): 32–34. Reprinted in *Historical and Philosophical Issues in the Conservation of Cultural Heritage* (Los Angeles: Getty Conservation Institute, 1996), pp. 185–92.
A polemical article criticizing museums for varnishing cubist paintings. The author, who knew Picasso and Braque, cites anecdotal evidence of their objection to varnish, their attitudes to changes in their paintings over time, and their skepticism over restoration.

Ridge, J., and J. H. Townsend. 1998. "John Singer Sargent's Later Portraits: The Artist's Technique and Materials." *Apollo* 148, no. 439 (September): 23–30.
Study prior to treatment of eleven works at the Tate compared with examples elsewhere. Shows how Sargent developed his compositions at the painting stage, adjusting the figures as well as the size of the canvas itself and adding paint even after framing. Includes results of paint analysis, an illustration of a cross-section, and one reverse.

Ringgold, Faith. 1995. *We Flew Over the Bridge*. Boston: Little, Brown.
See "The 1960s—Is There a Black Art?" pp. 143–64. Brief comments on Ringgold's adapting her painting technique to a large-scale canvas and developing a new palette to reflect her concept of "black light."

Roberts, Brady M., James M. Dennis, James S. Horns, and Helen Mar Parkin. 1995. *Grant Wood: An American Master Revealed*. Catalogue. Davenport and San Francisco: Davenport Art Museum and Pomegranate Artbooks.
See James S. Horns and Helen Mar Parkin, "Grant Wood: A Technical Study," pp. 67–98. A thorough study of Wood's changing technique illustrated with details, raking-light photographs, photomacrographs, cross-sections, and infrared and X-ray studies. Includes a technical appendix that summarizes scientific analyses of Wood's materials.

Robinson, Amy. 1949. "Grosz Paints a Picture." *ArtNews* 48, no. 8 (December): 35–37, 63.
Follows George Grosz working for six months on a single canvas. Details his complex method of painting in layers, his techniques of creating texture (including paint additives and sanding between layers), and his concern with brushes.

Rodas Estrada, Juan Haroldo, ed. 1992. *Pintura y Escultura Hispánica en Guatemala*. San Carlos: Universidad de San Carlos, Guatemala.
Includes a thorough discussion of painting materials and techniques of colonial art in Guatemala (pp. 131–67), with

particular emphasis on the interaction between peninsular practice and indigenous materials. Includes detailed discussion of supports (including fabric, wood, vellum, metal, and paper), the different uses to which they were put, and several diagrams of typical panel joinery.

Samuels, Peggy, Harold Samuels, Joan Samuels, and Daniel Fabian. 1990. *Techniques of the Artists of the American West*. Secaucus, N.J.: Wellfleet.
Well-illustrated examination (including many details, microphotographs, and some infrared and X-ray studies and cross-sections) of the technique of twenty-one nineteenth- and twentieth-century artists whose only commonality was their subject matter. Includes Bierstadt, Catlin, Moran, O'Keeffe, Remington, and Whittredge.

van Schoute, Roger, and Hélène Verougstraete-Marcq. 1986. "Radiography." *Scientific Examination of Easel Paintings PACT (Journal of the European Study Group on Physical, Chemical and Mathematical Techniques Applied to Archaeology)* 13: 131–53.
The clearest overview of various radiographic techniques in the examination of paintings. Van Schoute and Verougstraete-Marcq systematically illustrate the variety of information obtained by radiography, including structural information about panels and frames, works painted on both sides, reused supports, changed compositions, and prominent condition problems. Includes a useful bibliography of the major radiographic studies of bodies of works. May be hard to obtain in art historical libraries.

Seckler, Dorothy Gees. 1953. "Stuart Davis Paints a Picture." *ArtNews* 52, no. 4 (June): 30–33, 73–74.
Traces the evolution of *Rapt at Rappaport's* over several months through successive photographs and text. Seckler discusses Davis' use of tape to block out the composition, as well as his color mixing and paint application.

——— . 1952. "Changing Means to New Ends." *ArtNews* 51, no. 4 (June–August): 66–69, 89–91.
Surveys experiments with technique by twentieth-century artists and examines the intellectual motivation as well as the handling issues behind their choices. Seckler discusses the use of new pigments and media (vinyl and acrylic resins) developed by artists' manufacturers, and looks at artists' revivals of earlier techniques such as tempera, casein, and encaustic. She cites the work of Picasso, Pollock, Reginald Marsh, Moholy-Nagy, Siqueiros, Masson, Dubuffet, I. Rice Periera, and Karl Zerbe, among others.

Del Serra, Alfio. 1985. "A Conversation on Painting Techniques." *Burlington Magazine* 127, no. 982 (January): 4–16.
Emphasizing fourteenth- and fifteenth-century Italian pan-

els, a conservator discusses technical issues with a group of art historians. Includes evidence of the remains of eggwhite varnish on a fourteenth-century panel. Illustrated with detailed comparisons of tempera handling and condition.

Sigmar Polke. 1990. Catalogue. San Francisco: San Francisco Museum of Modern Art.
See John Caldwell, "Sigmar Polke," pp. 9–16, and Michael Oppitz, "Ochre, Gold, Cinnabar and Ink, Tourquoise," pp. 26–33. Caldwell addresses the technique of a notably experimental artist who paints in materials that change with light, temperature, and humidity. He discusses Polke's influential use of patterned fabric supports and the ideas behind the artist's choices. Oppitz discusses Chinese alchemy and Tibetan color classifications for the historical and anthropological perspective they bring to Polke's experimental materials.

Simon, Jacob. 1996. *The Art of the Picture Frame: Artists, Patrons, and the Framing of Portraits in Britian*. Catalogue. London: National Portrait Gallery.
This catalogue not only addresses framing style and technique but attempts a historical inquiry into how framing decisions were made and by whom—artist, architect, patron, or frame maker. Using portraits as the paradigmatic English genre, Simon attempts to locate framing decisions about a range of English paintings and compare them to continental examples. Its many color illustrations of paintings in frames as well as details of moldings and an appendix of frame sections contribute to a major reference work.

Simone Martini: Atti del covegno. Siena, March 27–29, 1985. Edited by Luciano Bellosi. Florence: Centro Di, 1988.
Although many of the papers address Simone's work in fresco, the following articles are very useful for his panel technique. Alessandro Conti, "Oro e tempera: Aspetti della tecnica di Simone Martini," pp. 119–29. Concentrates on Simone's use of colors and gilding to create a more realistic sense of materiality than did his predecessors. Illustrations include many details, including some in color. Norman E. Muller, "The Development of Scrafito in Sienese Painting," pp. 147–50. Traces the development of *sgraffito*, a method for simulating metallic brocaded fabrics, Simone's contribution to the technique and the establishment of the technique in Siena. Joseph Polzer, "'Symon Martini et Lippus Memmi me pinxerunt,'" pp. 167–73. Attempt to distinguish the two hands is based in large part on scrutiny of the incised halo patterns. Illustrated with many details.

Slive, Seymour et al. 1989. *Frans Hals*. Catalogue. London and Munich: Royal Academy of Arts and Prestel-Verlag.
See Koos Levy-van Halm and Liesbeth Abraham, "Frans

Hals: Militiaman and Painter," pp. 87–102; Martin Bijl, "'The Meagre Company' and Frans Hals' Working Method," pp. 103–8; and Karin Groen and Ella Hendricks, "Frans Hals: A Technical Examination," pp. 109–27. Levey-van Halm and Abraham use X-ray examination and *pentimenti* to study the evolution of Hals' group portraits. Bijl's article is a study following treatment of one work. Groen and Hendricks examined forty paintings prior to an exhibition, enabling conclusions about Hals' conformity to standard practice as well as the marks of his individual virtuosity. Clear discussion with numerous examples. Illustrated with X-ray studies, details, photomacrographs, and paint cross-sections. Includes a table comparing ground color and composition of all forty paintings.

Sobré, Judith Berg. 1989. *Behind the Altar Table: The Development of the Painted Retable in Spain, 1350–1500*. Columbia: University of Missouri Press.
Pp. 49–71 contain a clear narrative description of the construction methods of early Spanish altarpieces, including the frames. Sobré addresses painting materials, interactions between carpenter and painter, and evidence from surviving contracts.

Sofonisba Anguissola e le sue Sorelle catalogue. 1994. Cremona: Centro Culturale and Leonardo Arte.
See cats. 23, 24, 26, 27, and 30 for a group of royal portraits by Sofonisba in the Prado. The five paintings are illustrated with X-ray studies and some technical discussion comparing their execution. The technical information largely derives from Garrido's contribution to *Alonso Sánchez Coello y el Retrato en la corte de Felipe II* (1990), which includes cross-sections for two of the paintings now attributed to Sofonisba.

Stavitsky, Gail. 1999. *Waxing Poetic: Encaustic Art in America*. Catalogue. Montclair, N.J.: Montclair Art Museum.
While this catalogue opens with an essay by Daniel Rice on earlier encaustic revivals, it concentrates on the use of the medium by painters and printmakers during the past twenty years. An article by paintmaker Richard Frumess addresses the handling properties of the medium, and Stavitsky discusses the ideas behind its most recent revival, emphasizing thematic concerns of body issues, landscape, and the environment. Includes Karl Zerbe's notes on the medium in an appendix.

Stoner, Joyce Hill. 1990. "Washington Allston: Poems, Veils and 'Titian's Dirt.'" *Journal of the American Institute for Conservation* 29, no. 1 (Spring): 1–12.
Combines history and theory of Allston's technique with discussion of aging problems. Examines the influence of darkened varnishes on old master paintings and Allston's consequent use of darkening toners, which present a major challenge to conservators. This article raises questions important for a range of nineteenth-century paintings.

Storr, Robert. 1993. *Robert Ryman*. Catalogue. London and New York: Tate Gallery and Harry N. Abrams.
Storr includes unusually detailed notes of the media of each work and often extensive comments by Ryman on how he achieved the effects on a painting-by-painting basis.

——. 1986. *Philip Guston*. New York: Abbeville.
See "Notes on Technique," pp. 111–13. Addresses the sources of Guston's technique, his working procedures, and his increasing simplification of palette.

Stuckey, Charles. 1983. "Manet Revised: Whodunnit?" *Art in America* 71, no. 10 (November): 158–77, 239, 241.
A lively account of Manet's frequent revisions of his work and an alarming warning that some paintings were posthumously "finished." Stuckey discusses a variety of problems with color fading and the artist's own response in the form of a consciously higher-keyed palette. Extensive illustrations include X-ray studies.

Swicklik, Michael. 1993. "French Painting and the Use of Varnish, 1750–1900." *Studies in the History of Art* 41: 156–74.
Excellent theoretical and historical background to this vexed subject. Swicklik surveys the contemporary literature on the transition from eighteenth- to nineteenth-century French attitudes concerning varnishing. Not illustrated.

Szafran, Yvonne. 1995. "Carpaccio's 'Hunting on the Lagoon': A New Perspective." *Burlington Magazine* 137, no. 1104 (March): 148–58.
Art historical and technical study pairs a newly acquired panel fragment at the Getty with another in Venice because of the continuity of the image, matching wood grain, and craquelure. Furthermore, infrared studies reveal diagonal perspective lines that confirm the formal perspective scheme and enable a reconstruction of the composition—half of which is lost.

Talley, Mansfield Kirby. 1981. *Portrait Painting in England: Studies in the Technical Literature Before 1700*. London: Paul Mellon Centre for Studies in British Art.
Surveys eleven printed texts and ten manuscripts describing painting technique in England prior to 1700. While several were directed at amateurs, the collection includes a treatise by Nicholas Hilliard, observations of Van Dyck, account books of Peter Lely, and the manuscript of Theodore Turquet de Mayerne, a royal physician who recorded the techniques of foreign artists in England, including Van Somer, Mytens, Rubens, Van Dyck, Orazio, and Artemesia Gentileschi.

Tattersall, Bruce. 1974. *Stubbs and Wedgewood: Unique Alliance Between Artist and Potter.* Catalogue. London: Tate Gallery.

Includes Stubbs' paintings in vitreous enamel on both copper and ceramic supports. It attempts to understand "why . . . Stubbs decide[d] to use a material that no other painter of comparable talent has employed, not only in the 18th century but at any time." Includes history and documentation of Stubbs' relationship with Josiah Wedgwood and an article on technical aspects of Stubbs' enamel painting.

van Thiel, Pieter J. J., and C. J. de Bruyn Kops. 1995. *Framing in the Golden Age: Picture and Frame in Seventeenth-Century Holland.* Catalogue. Amsterdam: Rijksmuseum Amsterdam and Waanders Uitgevers.

English ed. (with addenda) of the catalogue to a pioneering exhibition, Prijst de Lijst (1984), which is now the standard reference work. Emphasizes how Dutch paintings were framed in the seventeenth century. Extraordinary illustrations include many color comparisons of paintings in both later and period frames, several frame versos, and a catalogue of molding sections.

Thomas Eakins and the Swimming Picture. 1996. Catalogue. Fort Worth, Texas: Amon Carter Museum.

See Claire M. Barry, "'Swimming' by Thomas Eakins: Its Construction, Condition, and Restoration," pp. 98–116. Examination and treatment report illustrated with details, diagrams, X-ray studies, and a photo of the reverse of a canvas. Barry details a collaborative methodology, comparing technical evidence to historical research on Eakins' instructions to his students. Studies Eakins' optical research, working procedure, and the painting's treatment history. Distinguishes ordinary aging from changes due to unstable materials (n.18 is very clear about megilp and its problems). For another technical study of Eakins, see Christina Currie, "Thomas Eakins Under the Microscope: A Technical Study of the Rowing Pictures," pp. 90–101 in Helen Cooper et al., *Thomas Eakins: The Rowing Pictures.* Catalogue. New Haven: Yale University Art Gallery, 1996.

Thompson, Daniel V. Jr. 1962. *The Practice of Tempera Painting.* 1936; reprint, New York: Dover, 1962.

A modern manual for tempera painting, directed at artists. Thompson bases his recipes on Cennini supplemented with his own extensive practical and teaching experience. Chap. 1, "Uses and Limitations of the Tempera," explains the scale appropriate to tempera as well as its handling and chromatic characteristics with a clarity that should be useful to historians. This handbook had a demonstrable influence on American painters of the 1930s and later who wished to paint in tempera.

Il Tondo Doni di Michelangelo e il suo restauro. 1985. Florence: Uffizi, Studi e Ricerche 2.

Monograph documenting the research leading up to and following the painting's restoration during the 1980s. Extensive discussion of the panel's history and interpretation and the restoration of both the painting and the elaborate, original frame. Illustrated with many details, X-ray, infrared, ultraviolet, and raking-light studies, and paint cross-sections. Useful along with the National Gallery's Making and Meaning: The Young Michelangelo (1994), which analyzes Michelangelo's extant easel paintings.

Townsend, Joyce. 1996. *Turner's Painting Techniques.* 2nd ed. Catalogue. London: Tate Gallery.

An exemplary study of a painter who was technically experimental and secretive. Directed at scholar and layman, this clearly written monograph includes a beautifully illustrated discussion of Turner's materials, technique, and changes to his paintings over time. The second edition includes updated research.

———. 1994. "Whistler's Oil Painting Materials." *Burlington Magazine* 136, no. 1099 (October): 690–95.

A short and clear introduction to Whistler's materials. Most useful in association with Hackney 1994, which emphasizes Whistler's method of paint application.

Thurmann-Moe, Jan. 1995. *Edvard Munchs "Hesteketur": Eksperimenter med teknikk og materialer [Edvard Munch's "Kill or Cure" Treatment: Experiments with Technique and Materials].* Catalogue. Oslo: Munch-Museet.

In addition to X-ray studies of eight early works documenting Munch's reuse of canvases, Thurmann-Moe cites contemporary accounts and evidence from the paintings to describe Munch's eccentric technique after 1893. This included experiments with casein and mixed binding media, scratched surfaces, spatter-and-spray technique, squeezing paint directly from the tube, as well as exposing paintings to the elements (sun, rain, snow, and bird droppings), the kill-or-cure technique. This catalogue is hard to obtain but contains essential information.

Trotta, Geri. 1951. "Tamayo Paints a Picture." *ArtNews* 50, no. 6 (October): 28–31, 67.

The Mexican painter explains his choice of tropicals colors, distinguishing them from those in vernacular use, which are chosen largely because of their cheapness.

———. 1950. "Wifredo Lam Paints a Picture." *ArtNews* 49, no. 5 (September): 42–44, 51–52.

Documents Lam in his Havana studio discussing his choices of paints and brushes and the layering he uses to achieve coloristic effects.

Upright, Diane. 1985. *Morris Louis: The Complete Paintings*. New York: Harry N. Abrams.

See "The Technique of Morris Louis," pp. 49–58. An essay on the development of acrylic paints, Louis' use of Magna and its characteristics, and his working methods. Upright covers Louis' choice of canvases, decisions about whether to size them, various methods of paint application from one series to another, and questions of his stretcher reinforcements as they affect the look of the paintings. Illustrated with color chart of Bocour Magna paints, photos of stretcher braces, and several details of surface paint effects.

van de Wetering, Ernst. 1997. *Rembrandt: The Painter at Work*. Amsterdam: Amsterdam University Press.

A review of thirty years' systematic research on Rembrandt's technique. This volume examines the historical and theoretical background for the artist's methods and provides a lucid discussion of the developing methodology of technical examination—which should be valuable for art historians in many areas. Illustrated with many color details and macrophotographs, X-ray studies, and paint cross-sections; the captions are complete and useful for scholars beginning to use technical information. Chap. 5 reprints "The Canvas Support" from vol. 2 of *Corpus of Rembrandt Paintings* (1986), and chap. 7 is a revised version of the author's contribution to the 1991–92 London exhibition catalogue (Brown, Kelch, and Kelch, and van Thiel 1991).

Varnedoe, Kirk, with Pepe Karmel. 1998. *Jackson Pollock*. Catalogue. New York: Museum of Modern Art.

The catalogue emphasizes close observation of the paintings and is supported with invaluable color details of many paintings reproduced at life size. Karmel's article "Pollock at Work: The Films and Photographs of Hans Namuth" uses novel computer reconstructions of Namuth's footage (see the videotape *Jackson Pollock*, below) to analyze Pollock's working sequence. He compares various phases of several paintings to drawings by Pollock, as well as to the diagrams of Thomas Hart Benton, and demonstrates that Pollock used a figurative armature to structure his large, abstract canvases.

Vasari on Technique. 1960. Translated by Louisa S. Maclehose, edited by G. Baldwin Brown. 1907; reprint, New York: Dover.

Taken from the expanded introduction to Vasari's 1568 edition of his *Lives*; this is material that Vasari considered theoretical but which we would more likely characterize as technical. The topics include architecture, sculpture, painting, and the decorative arts. Vasari's section on painting is a brief and less detailed manual for the working artist than are writings by Cennini and others.

Veliz, Zahira. 1981. "A Painter's Technique: Zurbarán's 'The Holy House of Nazareth.'" *Bulletin of the Cleveland Museum of Art* 68, no. 8 (October): 271–85.

Detailed discussion of Zurbarán's technique based on study of a painting in Cleveland and information from ten other public collections. Situates him within the Sevillan tradition of Pacheco and Velázquez and questions whether Zurbarán's simpler painting style was due to provincial tradition, necessity for ease of copying, or a response to his subjects.

Verougstraete-Marcq, Helène, and Roger van Schoute. 1989. *Cadres et supports dans la peinture flamande aux 15e et 16e siècles*. Heure-le-Romaine: H. Verougstraete-Marcq.

An essential reference work for scholars of Netherlandish panels, fully illustrated with small black and white photographs and many diagrams. It covers materials and construction techniques of panels and frames. Discusses the articulation of wings and evolving forms in response to problems with the wing construction of Van Eyck's Ghent altarpiece. Illustrates every known variation of molding profile and join.

Volle, Nathalie, Christiane Naffah, Lola Faillant-Dumas, and Jean-Paul Rioux. 1993. "La restauration de huit tableaux de Titien du Louvre." *Revue du Louvre* 43, no. 1 (February): 58–80.

A series of articles documenting the scientific analysis and subsequent restoration of a group of eight Titians at the Louvre, concentrating on his early works. Findings include threadcounts of seven canvases, numerous *pentimenti*, and the discovery of one underdrawing (illustrated). The final article, by Volle and Faillant-Dumas, emphasizes the larger institutional concerns that determine restoration policy, with particular attention to issues of varnish removal. Extensively illustrated with many X-ray studies, UV studies, paint-cross sections, and color details during varnish removal.

de Vos, Dirk. 1994. *Hans Memling: The Complete Works*. Ghent: Ludion.

All entries include technical descriptions, and a short chapter on technique offers a remarkably clear discussion of the artist's methods and the extent to which they resembled those of his contemporaries. Surveys information gained from a study of the panels themselves, the underdrawings, and the paint layering. The only technical illustrations are in this chapter, although many of the catalogue illustrations are clear enough that one can study *pentimenti* and craquelure.

The Voyage of Life by Thomas Cole: Paintings, Drawings, and Prints. 1985. Catalogue. Utica, N.Y.: Munson-Williams-Proctor Institute.

See Dan A. Kushel, "Some Observations on Thomas Cole's Voyage of Life Using Infrared Reflectography and X-Radiography," pp. 54–65. Infrared studies reveal crossed

diagonals, which Cole used to structure his composition, as well as significant underdrawings for the landscape but not the figures. Changes are detected between the drawn designs and the final painting, but no reworking was observed within the painted layer. Illustrated with numerous infrared and X-ray studies.

Waldman, Diane. 1993. *Roy Lichtenstein*. Catalogue. New York: Guggenheim Museum and Rizzoli. Pp. 57–58.
Studies Lichtenstein's experiments with paint medium, palette, and method of paint application to achieve the look of Benday dot printing.

Watteau Technique Picturale et Problèmes de Restauration. 1986. Catalogue. Brussels: Université Libre de Bruxelles.
This catalogue of an exhibition for the general public serves as a clear and useful introduction to the artist's technique. It contains many color illustrations, details, and X-ray studies.

Welu, James A., and Pieter Biesboer. 1993. *Judith Leyster: A Dutch Master and Her World*. Catalogue. Worcester, Mass.: Worcester Art Museum.
See Ella Hendricks and Karin Groen, "Judith Leyster: A Technical Examination of Her Work," pp. 93–114. This clear discussion of Leyster's materials and technique, and the methodology of examining them, should be useful as a general introduction to seventeenth-century Dutch technique. Based on a study of sixteen paintings. Illustrated with details, paint cross-sections, one X-ray study, and a table of information on the ground layers studied.

Wheelock, Arthur K. Jr. 1995. *Vermeer and the Art of Painting*. New Haven: Yale University Press.
Monograph based on the analysis of the technique of seventeen paintings in an attempt to understand Vermeer's attitude to his work. Wheelock pays close attention to compositional changes, paint application, and Vermeer's sources and relation to his contemporaries. Fine color plates and details throughout.

William M. Harnett. 1992. Catalogue. Edited by Doreen Bolger, Marc Simpson, and John Wilmerding. New York: Metropolitan Museum of Art and Harry N. Abrams.
See Jennifer Milam, "The Artist's Working Methods," pp. 169–75. Emphasis on infrared reflectography to study how Harnett increasingly worked out his compositions as he painted.

Wilson, Carolyn C. 1996. *Italian Paintings: XIV–XVI Centuries in the Museum of Fine Arts, Houston*. Houston and London: Rice University Press in association with the Museum of Fine Arts, Houston, and Merrell Holberton.
Houston's catalogue enables many aspects of its collection to be used for teaching purposes, even at a distance. Every entry has lengthy technical notes supported with illustrations. These include many life-size details of punchwork, X-ray studies, and infrared reflectograms, which constitute the most accessible published group of infrared studies of Italian paintings.

Wolfthal, Diane. 1989. *The Beginnings of Netherlandish Canvas Painting: 1400–1530*. Cambridge: Cambridge University Press.
The standard reference to these fairly rare works. Wolfthal avoids the commonly used German term, *Tüchlein*, which specifically refers to glue-size medium, focusing instead on the use of a canvas support. While the medium is usually glue, some are in oil. Includes a catalogue of 135 paintings, most of which are illustrated in black and white, including some details and several photographs of canvas reverses. All entries include condition notes. For a thorough examination of a single work, see Leonard et al. 1988.

Wolters, Christian. 1960. "The Care of Paintings: Fabric Paint Supports." *Museum* 13, no. 3: 135–71.
The best overall introduction to artists' canvases. Includes canvas preparation, deterioration, methods of care, and treatment. Many small illustrations in black and white. Wolters' discussion of the use of the fabric's texture has been superseded by van de Wetering (*Corpus of Rembrandt Paintings* 1986, pp. 19–20; reprinted in van de Wetering 1997).

Zilczer, Judith. 1993. *Willem de Kooning from the Hirshhorn Museum Collection*. Catalogue. Washington, D.C., and New York: Hirshhorn Museum and Sculpture Garden and Rizzoli.
See Susan Lake and Judith Zilczer, "Painter and Draughtsman," pp. 172–79. An imaginative and useful technical study of a recent painting. The investigation supplements infrared reflectography with paint cross-sections to study de Kooning's unusual method of drawing and painting in tandem and follows his successive reworkings of *Seated Man* and *Queen of Hearts*.

Videotapes Illustrating Technical Examination, Conservation Treatment, and Artists' Techniques

The best current source for information on videos is the Program for Art on Film, Inc., whose Art on Screen Database is available on the internet (www.artfilm.org). Although some titles are also available on film, we have confined this list to those available on video.

Art in the Making: Italian Painting Before 1400. **National Gallery (1989). 20 min.**
Using computer graphics, as well as a modern re-creation, this video demonstrates the step-by-step process of painting a medieval altarpiece. An extremely clear and graphic presentation of technique along with brief information on workshop practice, contractual issues, and the installation of major religious works.

Art in the Making: Rembrandt. **National Gallery (1988). 20 min.**
This introduction to Rembrandt's studio practices and techniques is most useful for its re-creations of panel and canvas preparation, grinding of pigments in oil, and the handling techniques of glazing and scumbling. X-ray studies and cross-sections of paint are shown and studio lighting discussed.

Botticelli: Una Seconda Primavera [*Botticelli: A Second Spring*]. **A film by Folco Quilici. (1987). 29 min. (available in English).**
Records the examination and cleaning of the painting in Florence in 1981, which is so clearly documented in Baldini 1986. The video follows study of the panel and its construction, raking-light and ultraviolet examination of the surface, infrared reflectography, X-ray studies, and the subsequent cleaning. Brief attention is given to the *tratteggio* method of inpainting losses.

Exploring a Renaissance Masterpiece by Masaccio and Masolino in the John G. Johnson Collection. **Philadelphia Museum of Art (1993). 18 min.**
This is an excellent introduction to the examination of two panels, prior to treatment, that demonstrates the interaction of technical and art historical study. Includes use of an infrared vidicon system and X-ray studies to help distinguish two hands. Uses computer simulation to re-create an earlier version of the panels with their original colors and to reassemble the entire altarpiece from fragments in Europe and America. Shows removal of dirty varnish, discolored repaint, and later regilding. Follows the process of gilding the new frame.

The Feast of the Gods. **Byron McKinney Associates, in association with the National Gallery of Art (1990). 27 min.**
Conservator David Bull studies the painting with magnification, paint cross-sections, X-ray studies, and infrared reflectography. This examination during cleaning revealed that Dosso repainted Bellini's original composition prior to Titian's repainting. Using computer graphics, it reproduces the successive stages and re-creates them in situ in Alfonso d'Este's *camerino*. This visually enriches the documentation provided by Plesters 1993.

The Fine Art of Faking It. **Films for the Humanities and Sciences (1992). 60 min.**
Originally broadcast by WGBH Educational Foundation (1991) as part of the *Nova* series. Documentary on fakes and scientific means of detecting them. Discusses questionable objects and paintings in various public collections, including the Metropolitan Museum of Art, Cleveland Museum of Art, and Getty Museum of Art. Re-creates the process by which a copyist painted and "aged" a panel that was mistaken as a Grünewald. Briefly shows the Rembrandt Research Project's investigations.

Georges Seurat: A Sunday on La Grande Jatte—1884. **A film by Alain Jaubert. Britannica Videocasettes (1991). 30 min.**
As part of a general introduction to the painting, the video shows its development from sketches to finished work. Includes information on the canvas, ground, palette, and paint application, as well as color changes with aging and X-ray studies that reveal Seurat's enlargement of the painting's border.

Jackson Pollock. **Produced and directed by Paul Falkenberg and Hans Namuth. Museum at Large, Ltd. (1951). 10 min.**
In this unique and famous footage Pollock demonstrates and discusses his preference for various methods of paint application, referring to "technique as a means of arriving at a statement." Pepe Karmel uses Namuth's data to analyze the sequential development of Pollock's paintings in Varnedoe with Karmel 1998.

Rembrandt, Part 2: The Restoration of "The Night Watch." **A film by Theo Kok. Kultur (1993). 36 min.**
An extraordinary step-by-step document of restoration following the 1976 vandalism. Shows removal of the relining canvas, the mending of the cut canvas, the relining with a wax resin adhesive (which would probably not be used two decades later), and the cleaning, filling, and inpainting. This is the clearest possible introduction for art historians to the amount of physical manipulation involved in relining. For written documentation on the treatment history of *The Night Watch*, see Chapter 4, n. 54

Titian: Venus and Adonis. **Getty Museum (1994). 16 min.**
This introduction to a recently acquired painting includes an interview with conservator Andrea Rothe. Briefly shows the use of cross-sections, infrared and X-ray studies, and records the painting's cleaning and minor restoration.

Glossary

These definitions do not replace the excellent and detailed information found in a number of reference works listed in the Bibliography, particularly Gettens and Stout 1966, or the glossaries in the National Gallery's Art in the Making series (Bomford, Brown, and Roy 1988, and Bomford et al. 1989, 1990).

ACADEMY BOARD Pasteboard or millboard with a surface prepared for painting; sometimes textured.

ACRYLIC RESIN The most common of the synthetic paint media, distributed for artists' use since the 1940s under such brand names as Magna and Liquitex.

ADDITIVES Materials added to paint to affect its handling properties and texture. Common paint additives include waxes, sand, and palette scrapings.

ADHESION Stickiness or bonding. Adhesion problems can lead to ground or paint flaking.

ADHESIVE A sticky substance, such as wax or glue (natural or synthetic), used to attach one material to another. Some form of adhesive is used when attaching linings to canvases. Adhesives are also used in consolidation treatment.

AIRBRUSH A tool, commonly used by commercial illustrators, that uses pressurized air to produce a fine spray of paint. Modern versions were developed in the 1930s, although prototypes date to the 1890s.

ALKYD RESIN Another synthetic paint medium, less commonly used than acrylics.

ALLA PRIMA PAINTING Painted in one sitting. Also called direct painting.

ALLIGATORING A type of paint craquelure caused by a drying problem in the paint; the upper layers pull away in a reptilian pattern and reveal the layer below.

AMBIENT LIGHT Ordinary or available light.

AQUEOUS Water-based.

ASPHALTUM A tarry substance used as a pigment; also known as bitumen. Asphaltum never truly dries, which can lead to cracking in paint (such as "alligatoring").

AUTORADIOGRAPHY An examination method used since the late 1970s. Paintings are exposed to low levels of radiation, then successive images record the rates at which different pigments emit the radiation. With this method one can detect some underdrawings done in pigments that are not sensitive to infrared, revealing the manner of paint application; distinguish pigments; and recover paintwork within dark areas that have faded or sunk.

AZURITE A blue pigment made from a ground stone.

BARBE French for "beard."

BEARD A lip of gesso formed at the join when a panel with an engaged frame is primed. The beard will sometimes remain, even if the frame is missing.

BINDING MEDIUM Also known as binder. The substance that carries the pigments to form paint. Common binding media used by Western artists include egg, vegetable gums and glue (size)—all of which are classified as temperas—as well as wax, oils, and synthetic resins.

BITUMEN See asphaltum.

BLANCHING A permanent disfiguration of a varnish (and possibly the paint layer) in which it turns white and opaque.

BLOOM A condition of varnish, usually caused by moisture and sometimes reversible, that results in a cloudy surface.

BOLE A colored clay, usually red or ochre. Red bole was commonly used as a ground for gilding.

BUCKLING Warping of a fabric support caused by changes in humidity.

CANVAS The general term for fabric used as a painting support.

CANVAS BOARD A type of academy board faced with canvas, manufactured since the late nineteenth century.

CARTOON A full-scale drawing used to transfer a composition to wall, panel, canvas, or other surface.

CASEIN A glue derived from milk that is occasionally used as a binding medium for paint or grounds.

CHALK Whiting or lime; used as a component in grounds, as an extender in some paints, and as a base for certain lake pigments.

CLEAVAGE Refers to the detachment of paint or ground, leading to flaking.

COLOR TEMPERATURE A measure of the chromatic range of light.

COMPENSATION General term that encompasses filling and inpainting.

CONSOLIDATION Treatment using an adhesive to reattach localized areas of ground or paint that are flaking.

COPAL A fossilized resin, similar to amber, from a variety of trees. Copal is used to make a hard varnish.

COVERING POWER The extent to which a paint will hide, or cover, another paint. Covering power is a function of both the pigment and the binding medium.

CRAQUELURE The pattern of cracks in a painting.

CRADLE A lattice of wood attached to a panel from behind to impede the panel's cracking and warping.

CRAZING A fine pattern of cracks in a painting.

CROSS-SECTION A minute sample taken perpendicular to the surface through multiple layers of a painting. Viewed under magnification, cross-sections are useful in identifying pigments, in studying the sequence of ground and paint layers, and in detecting intervening dirt and varnish that indicate additions.

CUPPING Distortion of the paint surface resulting in raised areas adjacent to the cracks.

CUSPING Another term for scalloping.

DAMMAR A vegetable resin that produces a softer varnish than copal.

DEAD COLORING Historical term for the stage in certain painting techniques during which the composition is built up in *grisaille* before the colors are added. A form of monochrome underpainting.

DENDROCHRONOLOGY A method of dating wood by examining the annual growth rings.

DISTEMPER A form of tempera employing glue (or size) as the binding medium. The glue can be derived from animal bones, innards, skin, or parchment, or from the air bladders of certain freshwater fish (notably sturgeon). The German term for the technique, *Tüchlein*, is sometimes used.

DRYING AGENTS Substances (usually mineral salts) added to oil-based paint to accelerate the chemical processes involved in drying. Also called siccatives.

DRYING CRACKLE A form of craquelure caused by stress to the paint as it dries, also known as shrinkage or traction crackle.

DRYING OILS Oils that will dry to form a hard surface, usually with the help of drying agents. Those used in Western painting include linseed, poppy, and walnut oils.

EGG TEMPERA The most common form of tempera, in which the paint is bound with egg yolk. Sometimes eggwhite or vegetable gums are added to alter the handling properties.

EGGWHITE See glair.

ENAMEL A hard and shiny paint developed for commercial purposes and occasionally employed by artists. Enamel paint imitates the effect of true enameling, which is a technique of firing a glass-like material onto a metal or ceramic base (also known by more specialized names, such as champlevé or cloisonné).

ENCAUSTIC Paint bound in wax.

ENGAGED FRAME A frame made of the same piece of wood as the panel or attached when the panel is constructed. A panel and engaged frame are prepared (gessoed) at the same time. Also called an integral frame.

FILLING Addition of new gesso to even out the surface of losses.

FLAKING Loss of paint or ground. Paint flakes because of adhesion problems.

FRIABLE Powdery or crumbly; describes one effect of underbound paint.

FUGITIVE The term used to characterize a pigment or dye that fades.

GARLANDS Another term for scalloping.

GESSO, GESSO GROSSO, GESSO SOTTILE The Italian for gypsum (plaster of Paris), which is used as a ground for paintings. *Gesso grosso* is coarsely ground and suitable for the initial layers; *gesso sottile* is finely ground and used for the final layer. While not technically correct, the term *gesso* was sometimes applied generically to any aqueous priming, including the chalk grounds used in northern Europe.

GILDING The technique of applying metal leaf or powdered metal as a pigment to the surface of a panel. Gilding was commonly done with gold foil, but silver, tin, and aluminum were also used.

GLAIR Eggwhite. Glair was a common binding medium for manuscript illumination and was also used as a varnish.

GLAZE 1. A transparent layer of paint applied to affect the color beneath it; the technique of glazing is associated with oil painting. 2. To frame a work under glass.

GLAZING AND SCUMBLING Methods of paint handling associated with certain oil techniques. Both methods use multiple layers of paint that need intervening time to dry. Hence, glazing and scumbling are not *alla prima*, or done all at once. Glazing involves transparent upper layers (see glaze) that influence the color of the layer or layers below and is usually done with dark, translucent paint over lighter, opaque paint. Scumbling involves the thin and uneven application of a layer of paint that also affects the paint below, usually done with light, opaque paint over a darker layer.

GLUE-SIZE TEMPERA See distemper.

GOUACHE An opaque, water-based paint (distinguished from conventional watercolors, which are transparent). The term can describe either watercolors on paper or opaque, vegetable gum–based paint on paper or canvas.

GROUND Also called priming. The layer or layers used to prepare the support to hold the paint. Grounds are commonly plaster or chalk mixed with water. See also gesso.

HIDING POWER See covering power.

HYGROSCOPIC Responsive to humidity. Wood and fabric are both hygroscopic— they expand and contract with changing humidity.

IMPACT CRACKLE A pattern of cracks in a painting caused by a blow—typically indicated by radiating circles.

IMPREGNATION A treatment in which the canvas and ground layers are saturated with an adhesive from the back. Impregnation is performed to counter adhesion problems of the ground and paint layers.

IMPRIMATURA A colored, oil-based priming layer used to establish the tonality of the painting.

INCISING Lines scratched into the ground to mark areas for gilding or to lay out the perspective scheme or the composition.

INFRARED Part of the light spectrum particularly useful in detecting underdrawings (and on rare occasions, *pentimenti*). Paintings used to be photographed with infrared-sensitive film. Better results have been achieved with a closed-circuit video system sensitive in the infrared range (see infrared reflectogram).

INFRARED REFLECTOGRAM Also designated IRR. Photographic or digitized image taken from the video screen of an infrared vidicon system.

INFRARED REFLECTOGRAM ASSEMBLY A patchwork of multiple details taken with an infrared vidicon system (see infrared).

INHERENT VICE Structural problems of a painting caused by the materials chosen or the way they were used—as opposed to problems caused by such external factors as light or accidental damage.

INPAINTING Retouches to areas of loss. The term is sometimes used interchangeably with "retouching," although modern conservators reserve "inpainting" for later paint that covers only the actual losses, as opposed to later paint that also covers original paint.

INTEGRAL FRAME See engaged frame.

INTERLAYER CLEAVAGE A form of inherent vice that causes layers of paint to separate and flake.

ISINGLASS A fish-based glue, sometimes used as a binding medium (see distemper) or as an adhesive in treatments.

LINING A second canvas attached to the back of a painting canvas for physical support.

LAKE PIGMENTS Pigments that derive their color from animal or vegetable dyes, or from synthesized mineral dyes.

LAY-IN Also called underpainting. A stage in some painting techniques used to establish the composition.

LAYERING Technique of painting in multiple layers, at least some of which are transparent or translucent. Glazing and scumbling are aspects of a layering technique.

LOUPE A low-magnification lens. Often employed by jewelers and photographic printers, it is useful in examining paintings.

MACROPHOTOGRAPHY Photography done with the aid of an enlarging lens.

MALRAND German for "beard."

MASTIC A vegetable resin used as a varnish and occasionally as a paint medium.

MEDIA Generally, the technique employed (painting and photography are different media), or, in the specific context of painting materials, the substance that carries the pigments to form paint (see binding media).

MEDIA-RICH See rich.

MEGILP A jelled paint medium made from mastic, turpentine, and oil. Although painters liked its consistency, it is often associated with drying problems.

MILLBOARD Compressed pasteboard that can be used as a painting support.

MIXED MEDIA Either the use of a combination of media to bind the paint throughout a work, or the use of tempera for one part of a painting and oil-based paint for another (color by color or layer by layer).

MORDANT GILDING Gilding in which the metal foil is attached with a glue or mordant, as opposed to water gilding, in which the foil is applied to the wetted layer of bole.

NONDESTRUCTIVE EXAMINATION Scientific examination without taking samples. X-radiography, infrared reflectography, and ultraviolet examination are the most common nondestructive methods used in the examination of paintings.

OIL GILDING Another term for mordant gilding.

OIL VARNISH A mixture of a hard resin and oil that forms a tough varnish.

OVERPAINT A layer of paint that covers original paint, applied by the artist or by someone else.

OXIDATION The chemical reactions of combining with oxygen. Associated with aging and drying of paintings.

PALETTE KNIFE A long, thin, flexible spatula used for mixing paint, for transferring paint to the palette, and occasionally used, for particular effect, to apply paint to the canvas.

PANEL A hard painting support, usually wood. Panels can be constructed of a single plank, from multiple pieces of wood, from laminates (plywood), or from chipboard.

PARTIAL CLEANING A method of treatment in which some discolored varnish is left on the painting to compensate for various changes to the pigments (and hence the color balance of the painting). Occasionally used to describe "selective cleaning."

PASTIGLIA Decorative technique associated with gilding in which relief is built up in plaster before the area is gilded.

PEINTURE À L'ESSENCE Term used to describe oil paint from which some of the binding medium has been removed; it is then thinned with turpentine to alter its handling properties.

PENTIMENTO, PENTIMENTI An artist's change in the painting (occasionally used in Anglicized form: pentiment, pentiments).

PHOTOMICROSCOPY Photography taken through a microscope.

PIGMENTS Finely ground minerals used as coloring agents in paint.

PINPOINT FLAKING Very small areas of local loss.

PLASTER Gypsum, also called gesso. It is commonly mixed with water as a ground for paintings.

PREPARATORY LAYERS Various layers used to modify the absorbency, texture, or color of the support. Sizing, grounds, priming, and *imprimatura* can all be considered preparatory layers.

PRIMARY SCALLOPING Distortions from the initial stretching of a canvas, also known as cusping or garlands. See also scalloping.

PRIMING The term can refer to the entire ground layer or, more specifically, to the final ground layer, which may be colored. See also ground.

PUNCHES Tools used to create indented decoration associated with gilding.

RABBET The edge of the frame that sits against the face of the painting.

RADIOGRAPHY The study of paintings with X-rays.

RAKING LIGHT Sharply angled light used to study subtle variations in a painting's surface.

REGILDING Areas where later gilding has been added.

RELINING In the strictest sense, the removal and replacement of a previous lining canvas. The term is also used to describe the addition of a lining canvas or even a second such canvas (see lining).

REPAINT Paint applied after a work has left the artist's studio.

RESIN Plant saps, commonly used in varnishes.

RETICULATION Conservator's term for a drying effect in which the upper layer of paint or varnish adheres unevenly to the layer below, pulling apart in a netlike pattern. While usually unintentional, the effect has occasionally been exploited by contemporary artists.

RETOUCHES Losses that have been inpainted. The term has a different meaning in French academic practice, in which the final painting stage, when glazes were applied, was called *retoucher* —sometimes translated as "to retouch."

RICH Oily. Paint with a high proportion of oil to pigment. Also known as media-rich, or richly bound.

SAMPLING Obtaining a small, representative specimen for physical or chemical testing.

SCALLOPING Distortions near the edges of a canvas caused by uneven tension from the nails or tacks that hold it to the stretcher or strainer. Also called cusping or garlands.

SCUMBLE Opaque paint applied so that it partially covers the color below. See glazing and scumbling.

SECONDARY SCALLOPING Distortions to a canvas when it is restretched. Secondary scalloping presupposes the presence of primary scalloping (see also scalloping and primary scalloping).

SELECTIVE CLEANING A superficial treatment in which dirty varnish is removed only from the highlights.

SGRAFITTO Color applied over gilding and partially scratched off, to simulate brocade or tooled leather.

SHELL GOLD Finely ground gold used as a pigment and applied with a binder.

SHELLAC An insect secretion used as a varnish.

SHRINKAGE CRACKLE See drying crackle.

SICCATIVES See drying agents.

SINKING Term used to describe increased transparency in dark colors of paint. Sinking changes a picture's balance and produces muddy and indistinct areas.

SIZE Gelatin or glue used in the preparation of canvases to influence their absorbency. Size can also be used as a binding medium (see distemper).

SMALT Blue pigment made from ground glass.

SPECULAR LIGHT Reflected light.

SPIRIT VARNISH Soft resin dissolved in alcohol or turpentine (spirit), which produces a softer varnish than oil varnish.

STAMPS Marks applied by materials manufacturers or suppliers, and occasionally by restorers, dealers, or owners of paintings.

STRAINER A frame with fixed corners on which a canvas is stretched.

STRESS CRACKLE See impact crackle.

STRETCHER A frame on which a canvas is stretched. Its corners can be adjusted to even the tension as the canvas expands.

STRETCHER MARKS Evidence of the stretcher bars visible on the face of the canvas—either because the fabric itself is distorted or because a crackle pattern has formed along the stretcher bars.

STRIP LINING New borders added to a canvas to strengthen or replace tacking margins.

STRIPPED STATE The phase of painting treatment when all the old retouches have been removed and the areas of loss filled but not inpainted. In this stripped state the extent of loss is starkly revealed.

SUPPORT The physical structure on which a painting is executed—e.g., the panel or canvas.

TACKING MARGIN The border of a canvas that is wrapped around the stretcher or strainer and tacked or stapled to the wood.

TECHNICAL EXAMINATION Study of the materials, technique, and condition of a work of art by various means, from unaided viewing to physical and chemical testing.

TEMPERA Paint bound in a water-based binder: egg, gums, or glue.

TRACTION CRACKLE See drying crackle.

TRANSFER Removal of the paint and sometimes ground layer and attachment to a new support. It is a major treatment usually performed on degraded panels, but transfers from canvas are also known.

TRATTEGGIO A method of inpainting with stripes of differing colors distinguishable at close range.

TÜCHLEIN German for distemper.

ULTRAMARINE A costly blue pigment made from ground lapis lazuli. A synthetic version was developed in the nineteenth century.

ULTRAVIOLET LIGHT "Black light." Part of the light spectrum used to study varnishes and identify repaint.

UNDERBOUND PAINT Paint with insufficient medium. Underbound paint can powder and fall off. See friable.

VARNISH A surface coating used to protect a painting or to give it a uniform gloss.

VEGETABLE GUM See resin.

VERMILION A red pigment made from ground or synthesized cinnabar.

WATER GILDING The most common method of gilding, in which metal foil is applied to the wet layer of bole. Water gilding, which can be burnished (polished), was used for gilding large areas.

WAX Wax can be used as a binding medium (see encaustic) or as a varnish and has been used as an adhesive in lining treatments.

WET-IN-WET PAINTING Paint over another color that is not yet dry. Wet-in-wet produces a characteristic blurring where the paints meet.

WINDOW Also called "cleaning window." Term used when a small area of darkened varnish is removed, revealing the painting's colors.

X-RADIOGRAPHY The study of paintings with X-rays. Also called radiography. Film images produced by X-radiography are termed X-radiographs or radiographs.

X-RAYS Part of the spectrum useful in studying monochrome underpainting, in detecting *pentimenti*, and in studying the condition of the support, ground, and paint layers. X-rays are blocked by dense pigments, such as lead.

Index

Page numbers in *italics* refer to illustrations and captions.

Photography Credits

Uncredited photographs and artwork were provided by the authors. Unless noted otherwise, permission to reproduce has been provided by the sources of the photographs and original artwork. Photographs and original artwork for the figures listed were provided by the following.

Josef and Anni Albers Foundation, Orange, Conn., 265 (© Joseph and Anni Albers Foundation/Artists Rights Society, New York)

Art Institute of Chicago, 44 (permission courtesy of Sigmar Polke); 58, 59 (© Pablo Picasso/Artists Rights Society, New York); 60; 67, 68 (© Joan Miró/Artists Rights Society, New York); 79, 80, 100, 141, 142 (all © 1998 The Art Institute of Chicago. All Rights Reserved)

Art Resource, New York, 10, 98, 225, 260 (© 1999 Alinari/Art Resource, New York); 2, 54, 264 (© 1999 Girardon/Art Resource, New York); 24, 106, 250, 252 (© Erich Lessing/Art Resource, New York); 48 (© Foto Marburg/Art Resource, New York); 219 (© 1999 Scala/ Art Resource, New York); 66 (© 1999 Tate Gallery, London/Art Resource, New York); 70 (© 1999 Victoria and Albert Museum, London/Art Resource, New York)

Art Museum, Princeton University, 254; 255 (photo by Norman Muller)

Ashmolean Museum, Oxford, 94

Baltimore Museum of Art, 163

Bayerischen Staatsgemäldesammlungen, Munich, 14, 15, 16, 17

Brooklyn Museum of Art, 64

Cleveland Museum of Art, 11, 31, 32, 35, 36, 47, 174 © 1999 Cleveland Museum of Art

Courtauld Gallery, London, 121, 185, 186

Delaware Art Museum, Wilmington, 118

Editions Haan, Paris, 45

Freer Gallery of Art, Smithsonian Institution, Washington, D.C., 262

J. Paul Getty Museum, Los Angeles, 63, 65, 75, 81, 82, 89, 104, 105, 107, 108, 109, 119, 120, 135, 136, 224, 226, 227, 256

E. Melanie Gifford, Washington, D.C., 164 (permission courtesy Baltimore Museum of Art)

Frans Halsmuseum, Haarlem, 12

Glasgow Museums, 55, 56

Hamilton Kerr Institute, University of Cambridge, 95

Harvard University Art Museums, 20; 172 (photo by James K. Ufford and Michael Nedzewski); 173 (photo by Rick Stafford) (all © 1999 President and Fellows, Harvard College)

Hirshhorn Museum and Sculpture Garden, Smithsonian Institution, Washington, D.C., 127, 128, 194, 195; 198 (© 1999 The Willem de Kooning Revocable Trust/Artists Rights Society, New York), 199; 127, 194, 198 (photos by Lee Stallsworth)

Staatliche Museen Kassel, 50

Yves Klein Archives, Paris, 129; 130 (photo © 1998 Harry Strunk)

Kitakyushu Municipal Museum of Art, 61

Laboratoire de Recherche des Musées de France, 251, 253 (© 1999 RMN)

Los Angeles County Museum of Art, 77, 117, 207, 211

Lowe Art Museum, University of Miami, Coral Gables, 144, 145

Metropolitan Museum of Art, New York, 13, 71, 72, 76, 101, 171, 206, 249

Miami Art Museum of Dade County, 87, 88 (permission courtesy of Helen Frankenthaler)

Norman Muller, Princeton, 25, 27, 28

Munch Museum, Oslo, 143, 248 (© 1999 Munch Museum/Munch-Ellingsen Group/Artists Rights Society, New York. Photo © 1999 Munch Museum; Svein Andersen/Sidsel de Jong)

Museum for Kunst, Copenhagen, 21, 22, 26

Museum of Modern Art, New York, 69, 75, 83, 84, 131, 132, 133, 134, 139, 140, 148, 150, 175 (© 1998 The Museum of Modern Art, New York)

National Gallery of Art, Washington, D.C., 1, 4, 8, 9, 29, 30, 43, 112, 113, 125, 126, 150, 151, 155, 156, 157, 165, 166, 167, 168, 169, 170, 176, 177, 181, 182, 183, 184, 187, 188, 189, 190, 191, 192, 193, 200, 201, 202, 203, 208, 212, 213, 215, 217, 218, 220, 222, 223, 244, 261 (© 1998 Board of Trustees)

National Gallery, London, 18, 19, 62, 204, 205, 239, 241, 242, 243, 257, 258, 259

National Gallery of Australia, Canberra, 137, 138 (© Jackson Pollock/Artists Rights Society, New York)

National Gallery of Ireland, Dublin, 92, 93, 110, 111

National Museum of American Art, Smithsonian Institution, Washington, D.C., 37, 38, 39, 122, 123, 159, 160, 161

New-York Historical Society, 266 (© 1998 Collection of the New-York Historical Society)

PaceWildenstein, New York, 124 (permission courtesy of Chuck Close); 263 (permission courtesy of Robert Ryman, photo by Ben Blackwell); 267 (permission courtesy of Robert Irwin, photo by Bill Jacobson)

Philadelphia Museum of Art, 178, 179, 180

Phillips Collection, Washington, D.C., 85, 246, 247

Prado, Madrid, 5, 6, 7, 46, 49, 114, 115, 116, 214, 216, 228, 229, 230, 231, 232, 233, 234, 235, 236

Rijksmuseum, Amsterdam, 52, 53

Royal Cabinet of Paintings, The Hague, 151, 152, 153

San Francisco Museum of Modern Art, 33, 34 (photos courtesy of Conservation Department; permission courtesy of University of California, Berkeley, Art Museum); 196, 197, 245

Städelsches Kunstinstitut, Frankfurt, 23 (photo © 1998 Ursula Edelman)

Staatliche Kunsthalle, Karlsruhe, 78

Tate Gallery, London, 158, 238

Van Gogh Museum, Amsterdam, 86

Wadsworth Atheneum, Hartford, Conn., 40, 41, 42